Picturing War in France, 1792–1856

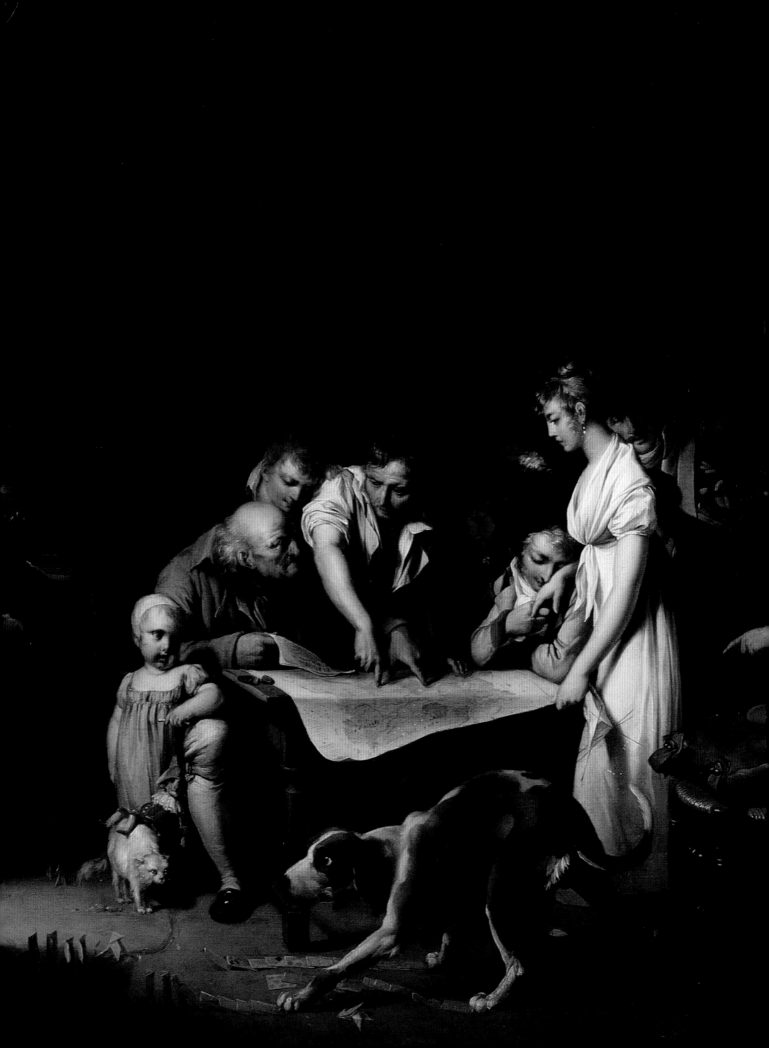

Picturing War in France, 1792–1856

Katie Hornstein

Yale University Press New Haven and London

Publication of this book has been aided by a grant from the Millard
Meiss Publication Fund of the College Art Association.

yalebooks.com/art

Designed by Leslie Fitch and Jo Ellen Ackerman
Printed in China by Regent Publishing Services Limited

Library of Congress Control Number: 2017930841
ISBN 978-0-300-22826-7
A catalogue record for this book is available from the British Library.
This paper meets the requirements of ANSI/NISO Z39.48-1992
(Permanence of Paper).

10 9 8 7 6 5 4 3 2 1

Jacket illustration: Horace Vernet, *The Crossing of the Arcole Bridge* (detail,
fig. 59)
Frontispiece: Louis-Léopold Boilly, *The Reading of the Bulletin of the
Grande Armée* (detail, fig. 12)
Page x: Anonymous, after Jean-Charles Langlois, *The Panorama of the
Battle of Eylau* (see fig. 1)

Dedicated to
Captain Edward James "Ed" Chaffin III
1987–2014

Contents

Acknowledgments

It is my pleasure and honor to thank the people and institutions who made this book possible. My decision to study French nineteenth-century art history owes everything to Darcy Grimaldo-Grigsby, whose mentorship I was lucky enough to receive as an undergraduate at UC Berkeley. This project first began as my doctoral dissertation in the Department of the History of Art at the University of Michigan under the supervision of Susan Siegfried and was directly inspired by her pioneering scholarship on Napoleonic battle painting. Ever since my graduate student days, Susan's intellectual generosity, encouragement, and razor-sharp feedback has been constant. I will forever be grateful for the privilege of having her as my adviser. I am also delighted to thank Patricia Simons, Michèle Hannoosh, and Howard Lay for their advice, encouragement, and critical guidance.

Conversations over the years with Marie-Claude Chaudonneret and David O'Brien have enriched this book immeasurably. My thinking has also benefited from intellectual exchanges with Allan Doyle, Nina Dubin, Steve Edwards, Jacqueline Francis, Marc Gotlieb, Mechthild Fend, Amy Freund, Jessica Fripp, Lela Graybill, Deena Goodman, Jason Hill, Laura Kalba, Nina Athanassaglou-Kallmyer, Anne Lafont, Ségolène Le Men, Diana Martinez, Ellen McBreen, Neil McWilliam, Satish Padiyar, Alex Potts, François Robichon, Nicolas Schaub, Vanessa Schwartz, Richard Taws, Melanie Vandenbrouck, and Sue Walker. Collaboration with Daniel Harkett has helped me articulate what is at stake when art history takes Horace Vernet and other artists like him seriously. Jacob Lewis alerted me to the existence of the Charles Nègre photograph of the assistant that was crucial for my thinking about war imagery and intermediality. In February 2015, this book underwent a manuscript review at the Leslie Center for the Humanities at Dartmouth College that proved to be fundamental to its present form. I thank Mary Coffey, Adrian Randolph, Katherine Hart, Keith L. Walker, and Collen Boggs for their encouragement and rigorous engagement with my project. Special thanks also go to the two external readers at the manuscript review,

David O'Brien and Marc Gotlieb, whose feedback helped me look at my material with a fresh eye and has been invaluable in the final stages of writing.

My research would not have been possible without the curators and librarians who graciously made materials available to me. At Versailles, Fréderic Lacaille helped me access military paintings that have been indispensable to my research; I thank him for his time and his deep knowledge about nineteenth-century French military painting, which has informed the writing of this book at every stage. Thanks also to Caroline Joubert at the Musée des Beaux-Arts in Caen and to the librarians in the Department des Estampes et de la Photographie at the Bibliothèque Nationale, the library of the Institut National d'Histoire de l'Art, the Service Historique de la Défense, the McGill Special Collections Library, and Peter Harrington at the Anne S. K. Brown Military Collection of Brown University. Special thanks to Elizabeth Kurtulik Mercuri at Art Resource for helping me locate essential images for this book.

At Dartmouth, generous funding was provided by the Leslie Center for the Humanities and the Office of the Associate Dean of the Arts and Humanities. This book's publication was also funded through a Millard Meiss publication grant from the College Art Association. At earlier stages, generous financial support was provided through predoctoral fellowships from the American Council of Learned Societies, Fulbright, the Samuel H. Kress Foundation, and the Georges Lurcy Foundation. An American Council on Learned Societies/Andrew Mellon Foundation Fellowship for Recent Doctoral Recipients gave me a year to revise the dissertation in Paris. I am grateful to Amy Canonico at Yale University Press, who has shepherded this book through the publication process and was enthusiastic about it from my first contact with her. At Yale, I would also like to thank Heidi Downey, Mary Mayer, Raychel Rapazza, and my copyeditor, Miranda Ottewell. I would also like to extend a heartfelt thanks to the two anonymous peer reviewers, whose incisive feedback, suggestions, and encouragement made this a better book.

The Department of Art History at Dartmouth College has been the ideal place to bring this project to completion. My colleagues are a model of collegiality and good humor; they provided feedback and encouragement when I needed it most and made it a complete joy for me to come to work. Special thanks to Nick Camerlenghi, Allen Hockley, Ada Cohen, Holly Schaffer, Joy Kenseth, and Mary Coffey. Thanks to Samantha Potter, Betsy Alexander, and Janice Chapman Allen for supporting my research at every turn. Outside of the Art History Department, I thank the members of the Nineteenth-Century Studies Group at the Leslie Center. I would also like to thank Lucas Hollister, David Laguardia, Eng-Beng Lim, Lawrence Kritzman, Robert St. Clair, and Barbara Will. Teatime and scholarly disquisition with Yasser Elhariry proved essential to the completion of this book.

My friends and family have sustained me throughout my days in graduate school up through the present. I would like to thank Christina Chang, Kathy Zarur, Heidi Gearhart, and Jessica Fripp for friendship at Michigan and far beyond. Thanks also to Isidora Gunbill and Lucia Urso, Eva Macali, and Anthony Viti. My deepest gratitude to the Hanover Sandwich and Salad Society cofounders Jonathan Mullins and Aaron Thomas. Since the dawn of the current millennium, Elena Byhoff has never stopped telling me that everything would work out. Victoria Diamantidis, Jim and Nick Hornstein, Betsy Mosteller and Mark Freedman have been my biggest cheerleaders on this journey. Their empathy and encouragement kept me going. Myszka Hornstein-Witkowski's playful feline distractions were essential to my writing process. Viktor Witkowski has been a presence in my life since the first day of graduate school, when I met him outside Susan Siegfried's office. He is in this book in so many immeasurable ways, and it is no exaggeration to say that he made its completion possible.

When I was writing this book, my cousin, Captain James Edward Chaffin, was killed in action while serving with the Eighty-Second Airborne Division in Kandahar, Afghanistan. Ed loved military history and would have read this book from cover to cover. I dedicate it to him.

Portions of this book have appeared in modified forms in the following publications: "Suspended Collectivity: Horace Vernet's *The Crossing the Arcole Bridge* (1826)," *Art History* 72, no. 3 (June 2014): 429–53 (I am grateful to the Association of Art Historians for granting me permission to reproduce it here); "Horace Vernet's *Capture of the Smalah* (1845): Reportage and Actuality in the Early French Illustrated Press," in *Getting the Picture: The History and Visual Culture of the News*, edited by Jason Hill and Vanessa Schwartz (London: Bloomsbury, 2015), 246–51; and "The Territorial Imaginary of the Revolutionary and Napoleonic Wars," in *Visual Culture and the Revolutionary and Napoleonic Wars*, edited by Philipp Shaw and Satish Padiyar (London: Ashgate, 2016).

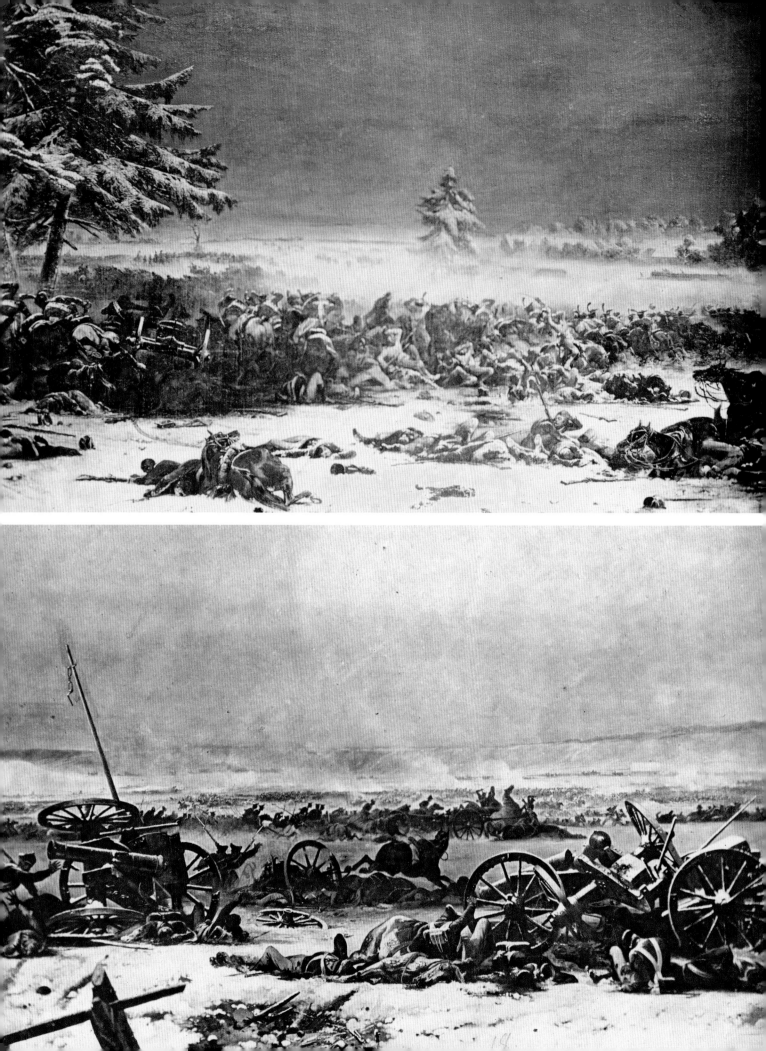

Introduction

A unique series of eighteen photographs is the most complete extant visual record of Jean-Charles Langlois's *Panorama of the Battle of Eylau,* which opened in a specially appointed rotunda on the Champs-Elysées on June 25, 1843, to great fanfare (figs. 1, 2). The albumen paper photographs were made around 1850 and were conserved in Langlois's personal archives; they are counterproofs of daguerreotypes (now lost) that were taken of the panorama at some point in its existence before it met the same fate as all of Langlois's other panoramas, each destroyed to make way for another. Over the course of his lengthy career, Langlois executed eight monumental 360-degree painted panoramas, all related in some way to contemporary or retrospective (much of it Napoleonic) French military history. The disposability of Langlois's panoramas aligns them with other emblematic nineteenth-century forms, such as advertising, fashion, and newspapers, all of which were premised on a constant production of novelty for public consumption in an ever-expanding marketplace. These albumen photographs were carefully reproduced by an anonymous photographer from unique positive daguerreotypes that were, like Langlois's panorama, materially resistant to any process of duplication.

The resulting photographs present us with a rich confluence of experiments in nineteenth-century image making: in addition to two photographic techniques, these anonymous images also exceptionally show the convergence between Langlois's painted canvas and the actual objects that he often placed in front of it. The use of false terrain was one of the innovations that Langlois introduced into nineteenth-century panoramas; it was intended to bolster the verisimilitude of the viewing experience and reduce viewers' opportunities for discerning representation from reality. At the same time, the use of real objects also challenged viewers to locate the split between the two registers of representation, which had the effect of heightening visual attention to the panorama itself. Théophile Gautier, for example, recognized the difference when he viewed the *Battle of Eylau,* but still maintained that "the passage from real objects in the front to the objects painted on the circular canvas is truly imperceptible, even for the most attentive and watchful of eyes."[1] Several of the photographs give current-day viewers the chance to participate in this exercise in illusionistic credulity anew. The mundane debris that Langlois put in the service of crafting his illusions can be spotted in the foreground of several of

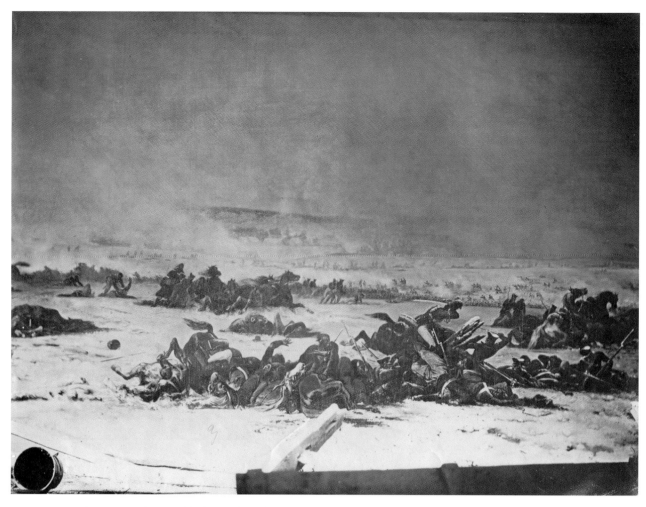

FIGURES 1 AND 2 Anonymous, after Jean-Charles Langlois, *The Panorama of the Battle of Eylau*, c. 1850. Albumen paper prints made from daguerreotypes (now lost), 18 prints in total, each 8¼ × 9¾ in. (21 × 25 cm). Fonds Jean-Charles Langlois, Collection ARDI, Caen.

these images: a partially destroyed wooden fence, a wagon turned on its side, and a stray bucket act as material *repoussoirs*. The artist's recourse to false terrain, and his impulse to preserve his panorama first as daguerreotypes and then as counter-proof albumen photographs are just two stray examples from a long-buried image archive that tells the story of how the visual representation of warfare was precociously susceptible to being modernized in terms of formal appearance, medium of production, and its solicitation and cultivation of a broad contingent of viewers in a deeply divided society.

Artists working across different domains—printmakers looking to sell cheaply and quickly produced maps of the French army's movements, history painters trained in the classical French tradition, military panorama painters hoping to dazzle their ticketholders—courted the public's

hunger for contemporary military events by making their works appealing, engaging and accessible. For most observers in the nineteenth century, war imagery went unquestioned as a symbol of France's identity as a military power and as an integral component of its artistic life. Visual representations of France's contemporary and recent military conflicts enjoyed unprecedented popularity, proliferating across a remarkable range of traditional and emergent media. They not only filled the exhibition spaces of the Salon but were also displayed in shop windows of print sellers, in rotundas where panoramas were installed, and on the pages of luxurious folio books and illustrated newspapers. Whereas pictures of contemporary warfare during the ancien régime were made for mostly elite audiences of aristocrats and royalty and consisted of tapestries, small-scale battle paintings, and luxurious original and reproductive

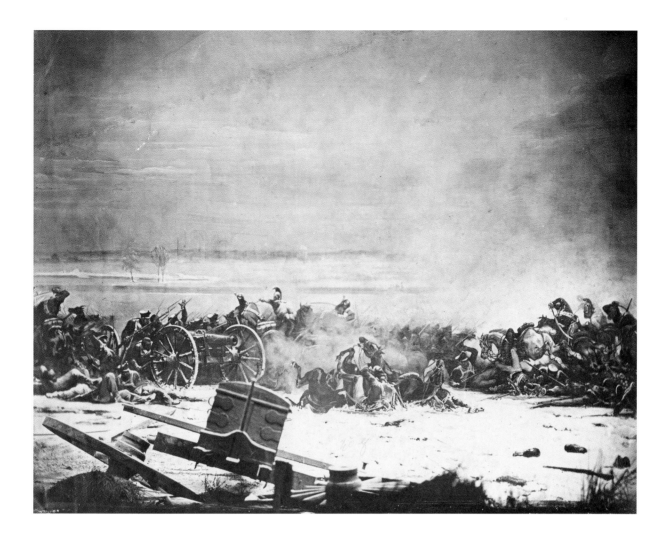

engravings, by the mid-nineteenth century war imagery quickly assumed the status of a nascent mass cultural form that was addressed to and consumed by a much larger audience—and often for a price.[2] The present study accounts for the shift in the status of visual representations of warfare during the first half of the nineteenth century in France in terms of the ideas that underpinned its production, circulation, and reception. I take into account government-sponsored battle painting as well as a more diverse body of objects produced by enterprising image makers who capitalized on public interest in French military endeavors. My arguments are rooted in a double preoccupation with the relationships and points of contact between different visual forms used to represent war on the one hand, and the political meanings generated by pictures of war on the other. Thus, in addition to telling the story of an increasing

intermingling between emergent and established media and between government-sponsored and privately produced war imagery over the course of the nineteenth century, this book also considers the ways in which representations of armed conflict functioned as "communicative spaces" in which French audiences might take an unofficial stake in politics and negotiate their relationship to the fledgling idea of the nation—an idea that was continuously being defined and redefined amid the political upheaval of the period.[3]

Two important dates that seemingly have more to do with military history than with the history of art–1792, the beginning of the French Revolutionary Wars, and 1856, the end of the next major war among European powers, the Crimean War, which broke out in 1854—anchor the chronological frame of this book. The nearly half a century

witnessed several revolutions (1789, 1830, 1848), multiple regime changes, and sweeping social and cultural transformations ushered in by the industrial age. France, during the French Revolution, was the first European country to equate the waging of war with a nationalist political agenda, making it a particularly interesting place for examining the production and circulation of war imagery in relationship to politics. The first half of the nineteenth century in France also possesses a privileged position within art history as the start of a long teleological march toward the establishment of artistic modernism. The period is still viewed in terms of a steady stream of exceptional rule-breaking artists, and more specifically painters—from Jacques-Louis David to Théodore Géricault to Eugène Delacroix to Gustave Courbet—who are celebrated for challenging the authority of classicism and official French institutions of art in favor of greater creative autonomy for artistic practice, and the cultivation of progressive values for art and its publics. This heroic narrative of the toppling of tradition remains an important paradigm for explaining the development of nineteenth-century French art, but its valorization of individual artistic achievement and a narrowly conceived idea of stylistic evolution fails to account for other important factors that are crucial for understanding the "visual economy" of the period.[4] The first half of the nineteenth century witnessed the introduction of new forms of visual reproduction that commercialized the visual and introduced new patterns of image consumption premised upon abundance and accessibility. This is where the visual representation of warfare can help tell a different kind of story about the first half of the nineteenth century in France, as one of the cultural areas where a new idea of the visual began to take root that had little to do with the rejection of illusionistic space or the articulation of an oppositional, counterdiscursive politics for art. Nineteenth-century war imagery instead provides a basis for understanding a new set of interrelationships that emerged between traditional forms of artistic practice, such as battle painting, and new modes of visual production, such as lithography, panoramas, and photography. I use the visual thematic of war to bring these emergent and more established forms together, to uncover the sites of unexpected intermingling, and to propose new ways of thinking about the dialogue between emergent and established media as a two-way street (or perhaps even a roundabout) of negotiation and exchange.

The research and arguments of this book are based on a corpus of works (and their relevant reproductions) that I have reconstituted from long-buried image archives by a group of artists who have not featured prominently within art-historical accounts of the period. These artists include the battle painters Jean-Baptiste Henri Durand-Brager, Louis-François Lejeune, and Horace Vernet and the panoramist Jean-Charles Langlois, all of whom were well regarded during their lifetimes and were widely discussed by nineteenth-century critics, yet remain on the margins of contemporary art-historical inquiry. This can be explained in part by the fact that they did not work in the tradition of grand manner history painting established by David and his students—a mode of artistic practice that has dominated art-historical approaches to the study of visual representations of armed combat during the period.[5] The artists examined in this book do not fit comfortably in the school of Davidian classicism, but nor do they fit into other categories commonly used to conceptualize nineteenth-century artistic practice, including romanticism and realism. Instead of focusing on the exemplary movements and styles traditionally emphasized in art-historical scholarship, the study of artists who represented armed combat and the range of their works across different visual media has allowed me to identify and interrogate the structures that sustained the interest of both artists and viewers in war, both as a mode of artistic practice and as a dominant cultural narrative, over the course of the nineteenth century. To this end, Horace Vernet's status as the period's most important, yet critically scorned, official battle painter will be a recurring issue in the pages that follow. Vernet's career, which spanned the first half of the nineteenth century, provides an important site of the kinds of "border crossings" that are at the heart of this book's preoccupations. Perhaps more than any other nineteenth-century artist, Vernet did more to transform war imagery into a publicly oriented, distinctly popular form of visual production, which explains why he occupies an especially important role in this book.

Over the course of this period, the visual representation of warfare earned a reputation as a distinctly popular form of imagery and came to embody a cultural vernacular that, depending on one's position, was either cause for celebration or could be seen as a troubling harbinger of the erosion of the traditional standards of artistic production. In the case of a writer like Charles Baudelaire, his deep suspicion of official institutions and power on high made him an especially potent critic of its publics. In his

review of the Salon of 1846, Charles Baudelaire sarcastically skewered the crowds of onlookers who gathered around the work of the period's most prolific and popularly adored battle painter, Horace Vernet: "What an immense public and what joy! As many publics as there are different makers of army uniforms, shakos, swords, guns and cannons! And all of these bodies united in front of a Horace Vernet by a common love of glory! What a spectacle!"[6] Baudelaire's disdain for the publics who enjoyed Vernet's paintings is an early manifestation of a tendency that would later develop within theories of modernism: a deep suspicion of visual objects that are popular in their appeal, are subject to commodification under industrial capitalism, and operate seemingly in support of officialdom. From Theodor Adorno's denigration of the "culture industry" to the reified, commercialized images that produce the alienated social configurations of Guy Debord's spectacle, there is a long and distinguished line of thinking that would interpret nineteenth-century war imagery as a denatured, complicit form of degraded culture. This critical tradition would equate the mass appeal of war imagery, as identified by Baudelaire and other nineteenth-century critics, with passive modes of spectatorship that prevent critical thought and ultimately work to support existing power structures rather than contest them. Though many of the works examined in this book were produced for the explicit purpose of bolstering public support for France's "military spirit," it would be a mistake to view them according to the pessimistic terms of Debord and Adorno, or to condemn them because of their popularity in the vein of Baudelaire.[7]

Rather than taking critics like Baudelaire at their word or assuming that pictures of war must necessarily align with officially sponsored political agendas, the goal of this book is to investigate what they reveal about the transformations of art, its audiences, and its production more broadly during the nineteenth century. For this, a different sort of theoretical frame is needed: How does the historian address the formation of political subjectivities in spaces like galleries, print shops and panorama rotundas? What are the politics of an active, embodied viewership for war pictures? In his recent work on visual art, Jacques Rancière has argued that the question of the politics of art is above all a question of how the aesthetic can be experienced as a part of life and as an occasion for creating new communities of sense. For Rancière, the aesthetic is "the system of *a priori* forms determining what presents itself

to sense experience"; it "simultaneously determines the place and the stakes of politics as a form of experience" and is a precondition for determining who can "have a part in the community of citizens."[8] In the case of war imagery, we might think of the viewing of such pictures along these lines, where "politics" is not enacted or determined solely through government institutions and politicians (Rancière calls these entities, which enforce dominant norms, the police). Instead, "the possibility of politics" first emerges through "the distribution that determines those who have a part in the community of citizens." In this sense, a battle painting depicts an image (a "surface of depicted signs") that a viewer sees as a particular historical event, but it also has the potential to do more: "as forms of art *and* as forms that inscribe a sense of community," visual representations can reconfigure a viewer's perception of the meaning of Napoleonic history, French militarism, the function of art, the role of the individual within a larger collective, and beyond. This act of reconfiguration (which he calls the "distribution of the sensible") is the foundation of what he understands as politics and is the basis for the transformation of collective values and the bringing together of communities. In this reading, objects of cultural production do not reflect an already extant set of political values, but rather have the potential to alter what is seeable and sayable, what is "common" within a culture, and to bring new regimes of sensibility into being. Nineteenth-century war imagery, because of its material abundance, its popularity, and the relative familiarity that audiences would have had with its subject matter, is one of the cultural sites where viewers could forge a relationship to matters of state without necessarily having to commit themselves to official or revolutionary forms of political participation. In this sense, we might think of this body of visual production as important for informing and preceding more direct political acts, like voting, taking to a barricade, singing a Bonapartist song, and so on.[9]

The arguments presented in what follows focus on new forms of spectatorship that emerged around nineteenth-century war imagery. Starting in the revolutionary period, French audiences increasingly came to expect that war could be experienced through authoritative images that were understood to provide a thrilling and edifying visual experience. In reviews of battle paintings exhibited at the Salon, in contemporary accounts of battle panoramas and other textual sources that I have identified, the

viewing of representations of contemporary war was repeatedly likened to a participatory encounter with the military event. This powerful illusion, often characterized by a willingness to temporarily forget the boundaries between representation and reality, between telling and showing, dominated the critical discourse. In contrast to grand manner history paintings that represented France's contemporary wars, the vast majority of the works examined in this book were valued for their facticity and understood to convey special knowledge about the look and experience of battle. I ask questions about the value systems and political function of the belief systems that allowed war pictures to be valued for their capacity to tell the "truth" about war. At a time when universal suffrage was beyond the pale for even the most progressive politicians, this book proposes that war imagery provided an opportunity for viewers to come into contact with state authority by visualizing one of its most illustrious manifestations of power, its ability to mobilize armies and conquer territory through officially sanctioned violence. As I will show, this body of imagery did not always implicate an obedient, passive form of reverence for French military glory; sometimes it even offered a direct path for questioning it. In prioritizing lively debates about how military combat should be pictured, this book is also an attempt to reconsider the relationship between art and politics more broadly during the period. My arguments do not take it as a given that official power structures could control the meaning and use of representations of warfare. Though the state had a monopoly on the exercise of military force and often had a direct hand in producing official imagery of contemporary warfare, the reception of military imagery was often unpredictable and subject to the whims of public opinion. I also interrogate the paradoxical forms of pleasure derived from beholding pictures of armed combat, and the formal strategies artists employed to keep viewers looking.

My focus on the visual thematic of war across the first half of the nineteenth century also offers a way to challenge the chronological segmentation that has dominated the study of France's visual production. This book's four chapters each deal with a different French government regime, from the revolutionary period through the Second Empire. This allows me to emphasize the multiplicity of meanings that war pictures could occupy at different historical moments and to posit the relationship between politics and war imagery as contingent and shifting, not

ever stable. In the first chapter, I discuss war imagery from the Revolution and First Empire. I focus on a series of topographical battle paintings, inexpensive military maps, and a proliferation of prints devoted to visualizing the territorial spaces of French military action. These works have been marginalized from art-historical discussions of the period, and have often been seen as less illustrious because of their use of an instrumental, seemingly antisubjective visual language that is more associated with the "low" form of the document than with the epic visual language of history painting. I argue that these works offered French audiences an opportunity to participate in contemporary geopolitical events and made the expansion and eventual retraction of France's national borders into a visual, symbolic discourse. These works of the "territorial imagination" permitted postrevolutionary French publics to confront and engage with the conflicts that were, according to the government's rhetoric, being fought on their behalf.

My second chapter focuses on the picturing of the recent military past during the Bourbon Restoration (1815–30), the governing regime that replaced the First Empire after 1815. This chapter asks what values slightly retrospective pictures held at a particular historical moment when, after the cessation of major international armed engagements and the advent of an inter-European peace, France remained a deeply divided society. Images of Napoleonic military exploits continued to appear at Salon exhibitions and in illustrated books, and were sold (often illicitly) as individual prints (the nascent medium of lithography also encouraged their circulation). This chapter examines these images as sites of political sensibility and shows how they offered a form of unofficial political participation to viewers through the experience of the visual. I show how battle paintings (and their relevant reproductions) of Napoleonic subjects by artists such as Horace Vernet depicted a new model of the agency of the collective in a political climate in which French liberals were in search of a governing ideology capable of forging consensus and finally stabilizing France's government after decades of turmoil.

In my third chapter, I examine the failure of King Louis-Philippe's use of large-scale battle painting to deflect criticism of his regime's handling of the colonization of Algeria and its refusal to go to war with its European neighbors during the 1830s and 1840s. While state-sponsored war imagery has often been seen as reflective of political

intentionality, this chapter argues that the government's efforts to use representations of war to elicit public support ultimately resulted in unwanted attention to the mechanisms of state propaganda, leading to more penetrating critiques of bourgeois social values. Another crucial factor that altered the reception of battle paintings commissioned by the government was the increasing tendency during the July Monarchy for audiences to encounter military imagery in unofficial spaces and contexts, including inside panorama rotundas and on the pages of newly invented illustrated newspapers. This chapter considers how these for-profit visual representations, blending entertainment, actuality, and fine art, interacted with the more traditional and official versions of war imagery, such as Horace Vernet's monumental battle paintings of the Algerian campaign, *The Siege of Constantine* and *Capture of the Smalah of Abd-el-Kader* (see figs. 90, 91).

The last chapter of this book deals with the visual production of the Crimean War (1854–56), which acted as a proving ground for a new configuration of modes of visual representation that had recently come into social use. When the war broke out in 1854, image makers had at their disposal a dazzling and unprecedented array of visual media for the representation of a major contemporary armed engagement. In addition to occasioning several important battle paintings, this was the first major conflict to be widely photographed and to receive continuous coverage in the illustrated mass press. My analysis puts these emergent and established visual modes back in dialogue with one another, showing how this intermedial context is crucial for understanding the values that were attached to these images when they circulated. This chapter analyzes the discourse surrounding French war

photography and illustrated reportage before turning to battle paintings of the Crimean War. In it I examine how, far from rendering the practice of battle painting obsolete, photography and other novel reproductive technologies breathed new life into this traditional artistic practice during the era of high industrial capitalism.

By discarding the binary between "high" and "low" forms of cultural production in my analysis, and by taking cultural objects such as newspaper illustrations as seriously as I do large-scale battle paintings, I hope to emphasize the idea of permeability, which Jacques Rancière has aptly termed "border crossings."[8] In *The Politics of Aesthetics,* Rancière repudiates the tendency on the part of cultural theory, and the discourse of modernism in particular, to make "clear-cut distinctions in the complex configuration . . . of the arts," and to isolate works of art from "the contexts that allow for their existence: history, interpretation, patrimony, the museum, the pervasiveness of reproduction."[9] Within studies of nineteenth-century art history, such "clear-cut distinctions" have most often been made by isolating some forms of visual practice, notably oil painting, from others, such as reproducible media. This has led to the historically anachronistic impression that oil painting occupied a position of cultural autonomy, as though it were insulated from phenomena exterior to itself.[10] This book is an attempt to place nineteenth-century visual forms, including painting, back into conversation with each other, as they once were. Because of its topicality and broad address, and its pervasiveness as a subject across different forms of visual practice, nineteenth-century war imagery is an ideal site for examining the new modes of visual production and spectatorship that helped make "society, or 'the social' more visible" in the modern age.[11]

1 Visual Participation by Proxy in the Revolutionary and Napoleonic Wars

An extraordinary engraving entitled *The Triumph of the French Armies,* published in 1797, represents four French army generals in the process of reconfiguring a monumental map of Europe (fig. 3). The map's pieces are seized by four French generals: Jean-Charles Pichegru, Jean-Victor Moreau, Lazare Hoche, and Napoleon Bonaparte. Bonaparte dominates the composition by way of his animated demeanor, the fact that he stands apart from the other generals, and the portion of the map he holds, by far the largest and most illustrious, since it represents the territories won during his Italian campaigns. Made by the little-known printmaker Antoine Maxime Monsaldy just after a series of important French military victories in Italy, and right before Napoleon Bonaparte's ill-fated invasion of Egypt, the engraving represents the map of Europe as subject to a process of redefinition and transmutation under the pressure of keeping pace with French military ambitions. The European continent has been literally taken apart; the process of military conquest is reduced to a nearly effortless tearing of paper, obscuring the violent struggle required to wage war. The composite map pictured in Monsaldy's print was based on two made by Jean-Baptiste Poirson that were conveniently available for

purchase (for between 2 francs 50 centimes and 3.50) at the same shop where the print could be purchased, Chez Jean, *marchand d'estampes et de géographie.*[1] Like the engraving, these inexpensive military maps were published and marketed in direct response to the latest developments of France's nearly continuous military campaigns between 1792 and 1815. In depicting the maps as fragments in the print, the publisher enacted the imaginative destruction of his own commodities, showing their documentary authority to be contingent, shifting, and open to political redefinition. Given a new kind of value apart from their identity as cartographic objects of knowledge, they become instead representations of the instability of national borders, which were constantly being modified, updated, and recast according to the latest political and military developments.

As the Annales historian Lucien Febvre has argued, the meaning of the word *border— frontière,* in French—took on a new set of connotations in the wake of the French Revolution, when imprecise and irregular boundaries or empty zones between territories gave way to "the projection on the ground of the external outlines of a nation fully conscious of itself." This implied not only sharp separations

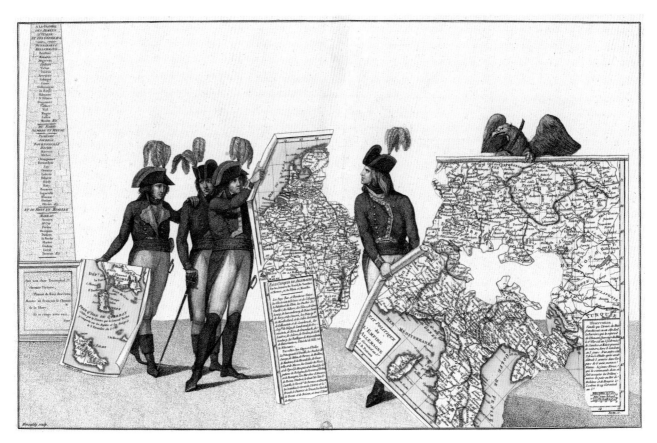

FIGURE 3 Antoine Maxime Monsaldy, *The Triumph of the French Armies,* 1797. Engraving, 17¾ × 13¾ in. (45 × 35 cm). Bibliothèque Nationale de France, Paris.

between nationalities but also the precise demarcation of a territory worth defending through military means.[2] Though Monsaldy's print was intended to honor the achievements of Napoleon Bonaparte and his successful conquest of Italy, it also unintentionally hinted at the gap between official propagandistic intentions and the more diffuse and less predictable reception of nineteenth-century war imagery. If maps were supposed to help "citizens imagine the state as a unified territory," then the map pictured in this print suggests that national imagining may have been troubled by the constant revision to cartographic documents occasioned by endless war.[3] When French borders shifted according to the latest treaties and military campaigns, enterprising image makers were at the ready to produce and circulate maps, prints, and paintings to feed the public's eagerness to view works that claimed to be authoritative and up-to-date. This chapter focuses on the emergence of these artists and the publics they catered to; it looks to a body of imagery that sought to keep viewers engaged with constantly unfolding events, that invited

them to view war not in grandiose, moralizing terms, but rather as a visible form of knowledge that might even prove entertaining. Even though much of this visual material was produced outside the official channels of state power, it often functioned in support of its overall aim—legitimizing contemporary military engagements for a broad viewing public. The proliferation of war imagery that began during the revolutionary and Napoleonic wars and continued throughout the nineteenth century—even after France's defeat at Waterloo in 1815—allowed French audiences to negotiate their relationship to the fledgling nation, but not always in ways that were directly in line with the aims of official state power. Such is the case with Monsaldy's engraving, which despite functioning at its most basic level as propaganda in support of French military ambitions in general and those of Bonaparte in particular, also implicates the provisionality of borders reconfigured through military means.

Around the same time that Monsaldy's print was published, another group of prints made their way onto the

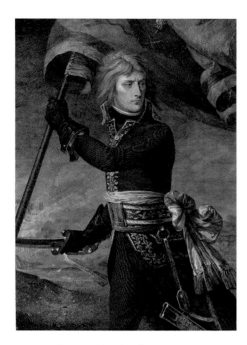

FIGURE 4 Giuseppe Longhi, after Antoine-Jean Gros, *Bonaparte on the Bridge of Arcole*, 1798. Engraving, 16⅞ × 12⅝ in. (43 × 32 cm). Bibliothèque Nationale de France, Paris.

FIGURE 5 Jacques-Louis David, *Napoleon Crossing the Alps*, 1801. Oil on canvas, 40¼ × 34¼ in. (102 × 87 cm). Chateaux de Malmaison et Bois-Preau, Reuil-Malmaison.

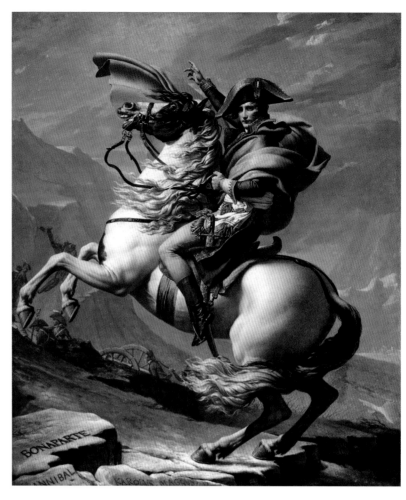

market: reproductions of Antoine-Jean Gros's *Bonaparte on the Bridge of Arcole* (fig. 4). Today one of the most well-known military images from the Napoleonic period, this portrait depicted General Bonaparte in a three-quarter pose in the midst of charging across the Arcole bridge under heavy enemy fire. Instead of focusing on the topographic particulars of the battle or including other key actors in relationship to Bonaparte's charge across the bridge, the image presents an enigmatic, singular hero and equates his action and dashing appearance with the quality of his dynamic character. Along with works such as Jacques-Louis David's *Napoleon Crossing the Alps* (fig. 5) and later works by Gros that were produced after the French government encouraged postrevolutionary history painters to turn to contemporary subjects that honored military achievements, this portrait helped to create a cult of mythologized personality around Bonaparte. If Gros's famed portrait can be called a war picture, it would appear to have little in common with Monsaldy's print, other than the fact that both were made in enthusiastic response

to the victories of the French army abroad. In terms of genre and relative prestige, Gros's portrait occupied a high position of cultural eminence, since it was made by a history painter and circulated in an established artistic tradition of honorific portraits of French leaders. Monsaldy's comparatively less prestigious print, on the other hand, bridged two different areas of late-eighteenth-century print culture that became increasingly prominent during the revolutionary and Napoleonic wars: images of contemporary military events and the practice of mapping. Despite these apparent differences, audiences would have encountered works like Gros's and Monsaldy's together in exhibition spaces like the Salon and in the windows of print sellers. Even if not seen at the same time, such works would have been understood in relationship to one another. In this sense, Monsaldy's French army generals reconfiguring the map of Europe and Gros's *Bonaparte on the Bridge of Arcole* or David's *Napoleon Crossing the Alps* were part of a larger image economy that took as its subject contemporary warfare. Rather than visual forms like

topographical battle painting, maps, and prints playing second fiddle to the distinguished medium of oil painting and practices of history painters, this chapter will focus on how these more abundant works offered audiences another basis for comprehending and negotiating their spatial relationship to the conflicts being waged in their name. The works that are the focus of this chapter deploy an instrumental, seemingly antisubjective visual language that is more associated with the low form of the document than the epic visual language of history painting. As Molly Nesbit has argued in her pioneering account of Eugène Atget's photographs, the document is a relational category that exists in dynamic tension with the category of "art." It is a visual form so commonplace as to be seemingly below the threshold for examination: because of their "openness" as forms that are put to use by users and viewers who bring their expectations to bear upon them, documents establish new "models for the relationship between pictorial form and knowledge."[4] Though the photograph came to be understood as the emblematic medium of the document in the late nineteenth century through works made by photographers like Atget, my discussion of topographical battle painting and mapping practices looks to the document as a conceptual category whose authority and claims to truth were not rooted in the specificity of a particular medium. The paintings and prints discussed in this chapter produced a different kind of viewing experience than the one made possible by grand manner oil painting because of their deployment of a set of conventions for seeing knowledge about contemporary warfare. These images were prized for their perceived ability to provide viewers with an insider's view of war and a source of knowledge about the pictured conflict; they were also understood as antisubjective visual works, more fact than art. They anchored a new set of expectations around modern war imagery that persist to this day, namely that it be clear, informative, and engaging. Many of these works depended on the expertise of skilled military observers who depicted the conflicts they had participated in. History painters such as Gros would come to depend on the labor of topographical battle painters and mapmakers when composing (and even exhibiting) their works. While my aim in this chapter is to put these "minor" genres back into dialogue with large-scale battle painting, I also want to emphasize their importance as a regime of images unto themselves and shed light upon the broader visual culture of the revolutionary and Napoleonic wars.

DRAWN ON THE SITE: EYEWITNESS OBSERVERS AND THE VISUAL REPRESENTATION OF BATTLE IN POSTREVOLUTIONARY PRINT CULTURE

Soon after the abolition of the monarchy in September 1792, warfare gripped France and continued nearly without pause until 1815, with the defeat of Napoleon Bonaparte at Waterloo. Carl von Clausewitz, author of *On War,* the most influential military treatise in the nineteenth century, understood firsthand the impact of the French Revolution on European warfare, having fought for Prussia and Russia against France in the Napoleonic Wars. Clausewitz contrasted so-called cabinet wars, conflicts waged by aristocratic officers and small mercenary armies during the ancien régime, with the new character of postrevolutionary warfare, which suddenly became what he called "the business of the people." According to Clausewitz, this new form of nationalized warfare now implicated "a people of thirty millions, all of whom considered themselves to be citizens. . . . The people became a participant in war; instead of government and armies as heretofore, the full weight of the nation was thrown into the balance."[5] Clausewitz argued that the uniqueness of the revolutionary and Napoleonic wars stemmed from the high degree of ideological commitment demanded from those who fought as well as from civilians. Indeed, the outbreak of war in 1792 acted as a "powerful instrument of political acceleration" to consolidate and advance the aims of the French Revolution. These revolutionary ideals permeated the early rhetoric of warfare during the French Revolution and culminated with the rise to power in the 1790s of Napoleon Bonaparte, who promoted himself as the inheritor of the meritocratic ideals of the revolutionary era.[6]

The revolutionary and Napoleonic wars differed from their eighteenth-century predecessors in their reliance on popular mobilization: revolutionary soldiers no longer fought for a king or a local aristocrat but for a newly constituted entity called a nation. In exchange for citizenship rights, men agreed to give their life for their country by fighting in its wars.[7] Between 1791 and 1794, the French army of the ancien régime, dominated by aristocratic officers and mercenary soldiers, was transformed into the first army of citizens recruited through a series of volunteer drafts that later became compulsory. In August 1793 the National Convention proposed a mass conscription, the *levée en masse,* to which all French citizens were subject: "Henceforth, until the enemies have been driven from the

territory of the Republic, the French people are in permanent requisition for army service. The young men shall go to battle; the married men shall forge arms and transport provisions; the women shall make tents and clothes and shall serve in the hospitals; children shall turn old linen into lint; the old shall repair to the public places to stimulate the courage of the warriors and preach the unity of the Republic and the hatred of kings."[8] The *levée en masse* was adopted by the convention and recruited approximately 300,000 soldiers. As the decree made clear, this new brand of war now implicated every man, woman, and child in France; their ideological commitment was also summoned. Even though the French revolutionary army was more democratic and meritocratic than the army of the ancien régime and offered the potential for men of lower rank to advance, the devotion of the new recruits to *la patrie* and their zeal for fighting has been overstated. Military historians have noted that even after the early years of the Revolution and through the end of the First Empire, France's armies were ill-equipped, undernourished, and poorly trained. The citizen-soldier ideology that attended Bonaparte's armies did not mitigate the need to use harsh tactics to recruit soldiers. Desertion was endemic. A shortage of muskets meant that soldiers had to fight their enemies up close with bayonets and pikes. Food shortages also plagued the revolutionary and Napoleonic armies.[9]

In his study of the wars of this period, which he calls the first "total war," David Bell argues that the rhetoric of social inclusivity and mass participation in war—as expressed by the *levée en masse*—gradually gave way to a sharp division in French society between members of the military and a "sphere that could now be fully characterized, in opposition to it, as 'civilian.'" The age of intense and sustained warfare between 1792 and 1815 made it necessary for the French military to develop its own institutions, such as schools, archives, courts, and more, which excluded civilians by necessity. Despite the apparent cleavage between France's military and "civilian" society, there were also important areas of overlap in the domain of culture, especially the production, circulation, and reception of military imagery. This is one such area where civilian and military interests came together, and where they would remain throughout the nineteenth century and arguably up through today.[10]

When war became the "business of the people" after 1792, so too did its visual representation. With the outbreak of war during the French Revolution, war imagery assumed a prominence that it had not attained during the ancien régime, when it was by and large the province of elite audiences, and especially monarchs. In France, military subjects, including battles, sieges, and parades, were traditionally commissioned by kings or high-ranking nobles who were also military commanders. In terms of genre, battle painting during the ancien régime occupied a lowly rung within the French hierarchy of genres, situated between landscape and portraiture. Its relatively undistinguished artistic status reflected the status of war itself in eighteenth-century France, a period when Enlightenment reformers were suspicious of warfare's violence and critiqued the moral decay of the "courtier-warrior."[11]

Scholars have also characterized the eighteenth century as an era of limited warfare in France, during which elites sought to suppress the scale of war, diminish its chaotic aspects, and bring it in line with aristocratic cultural ideals of honor and corporeal control. The necessary reliance of battle painting on contemporary history placed it outside the elevated and erudite domain reserved for the representation of ancient and mythological history by history painters, whose duty it was, according to the seventeenth-century academician André Félibien, "to cloak under the veil of a story the virtues of great men and the most hidden mysteries."[12] When history painters approached the subject of contemporary battles, it could only be dealt with obliquely, lest their paintings be considered lacking in imagination. This was the strategy adopted by Charles Le Brun to honor the military achievements of his patron, Louis XIV. To avoid depicting a series of literal actions based on contemporary feats, Lebrun relied on allegorical allusions to the feats of Alexander the Great in his *Alexander* cycle of monumental battle paintings, which easily fit into the category of history painting owing to their classical subject. Le Brun's use of antique allegory to stand in for Louis XIV's military achievements, such as in *The Triumph of Alexander* (fig. 6), suggests that battle painting might accommodate itself within history painting, but this was an exceptional practice and not widely adopted by other painters at the time.

The more typical ancien régime representation of contemporary military subjects referred directly to the deeds of high-ranking generals, kings, and princes.[13] This nonallegorizing mode of battle painting was popularized in France during the reign of Louis XIV by Adam Frans van der Meulen, a Flemish artist who found favor with the French court; it remained the standard for French military painting

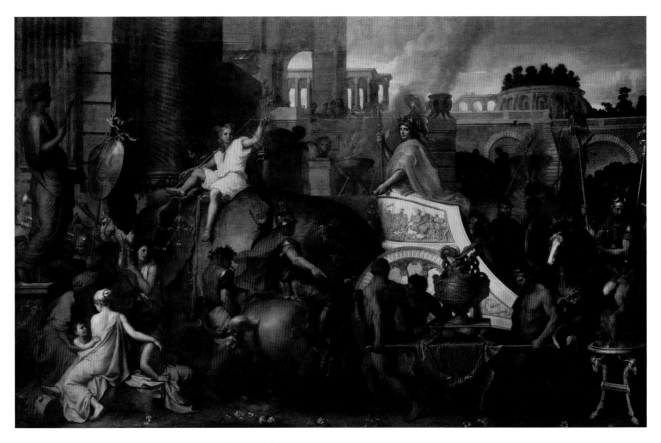

FIGURE 6 Charles Le Brun, *The Triumph of Alexander*, 1665. Oil on canvas, 177 × 278¼ in. (450 × 707 cm). Musée du Louvre, Paris.

up through the Revolution. In *Louis XIV Crossing into the Netherlands at Lobith* (fig. 7), for example, Van der Meulen depicted the French king directing the course of battle, set apart from the action upon a hill. This separation between the king and the men who carry out his orders makes them seem to be doing the bidding of a "roi de guerre," in Julie Plax's phrase.[14] In terms of space, Van der Meulen prioritizes the foreground; the middle distance and background, where the actual cavalry battle between the Dutch and French soldiers is taking place, appear compressed and schematic. In this instance, Van der Meulen focused more on Louis XIV's person than on the episodic or topographical details of the battle—elements that only distracted from the monarch's importance. In other paintings, especially those dealing with sieges, more focus is given to the topographic particulars of the site. In Van der Meulen's *Siege of Besancon by Condé* (fig. 8), for example, the view is widened and deepened to include figures of command in the foreground, encampments in the middle ground, and in the background the fortified town of Besançon, whose walls are included in the representation of the town. As scholars have noted, Van der Meulen blended landscape painting with visual conventions borrowed from maps and siege engraving. The resulting sense of authoritative knowledge about the topographical particulars of the battle furthered the service of glorifying the monarchy, whose ability to conquer territory was directly connected to the authority of the king.[15]

Van der Meulen's paintings were often reproduced for a wider viewing public as tapestries and as fine reproductive engravings. This guaranteed the topographical mode of battle painting a degree of public currency—though, apart from being seen in print seller's stalls and windows by viewers who might not have been able to afford to possess them as prints, by and large such reproductions (as well as the original paintings) would have decorated the interiors of official residences and institutions, and were intended for a largely elite public of consumers.[16] The limited dissemination of military imagery guaranteed battle painting marginal status up through the end of the ancien régime. The last time that it was officially encouraged before the Revolution was in 1746, when the battle painter Joseph Parrocel was commissioned to represent a series of paintings related to Louis XV's conquest of Flanders.[17] The traditional approaches

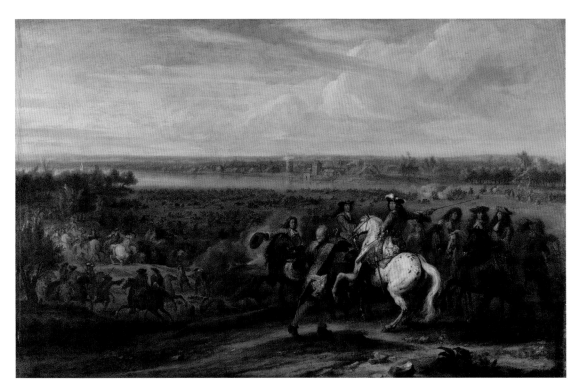

FIGURE 7 Adam Frans van der Meulen, *Louis XIV Crossing into the Netherlands at Lobith*, c. 1672. Oil on canvas, 40⅝ × 62⅝ in. (103 × 159 cm). Rijksmuseum, Amsterdam.

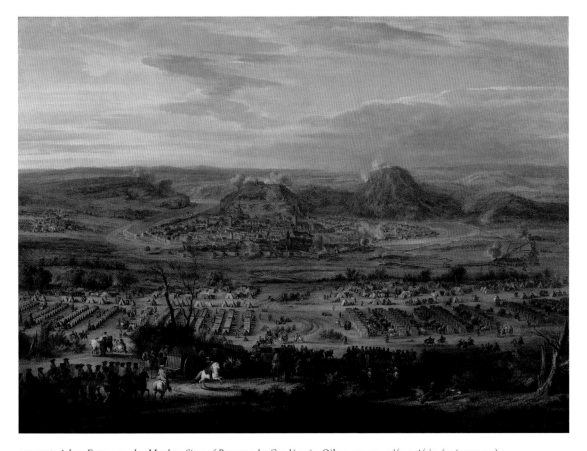

FIGURE 8 Adam Frans van der Meulen, *Siege of Besançon by Condé*, 1764. Oil on canvas, 41¾ × 57⅛ in. (106 × 145 cm). Fitzwilliam Museum, University of Cambridge.

used to represent a small elite fighting in the name of a supreme monarch were ill suited to the depiction of contemporary conflicts fought on behalf of a larger social body. Over the course of the revolutionary and Napoleonic period, the visual conventions of representing warfare would transform as new publics beyond aristocratic elites began to take an interest in viewing and possessing pictures of French contemporary military conflicts.

Soon after the first major offensive French military victory of the French Revolutionary Wars—the battle of Jemappes, fought on November 6, 1792, against the Austrian army outside Mons, Belgium—prints depicting the battle began to proliferate. To a greater degree than artists who worked in the time-consuming and costly media of oil painting, printmakers were in a better position to produce imagery in direct response to the outbreak of war. This was true for the representation of contemporary subjects in general during the French Revolution. When, five days after the battle, the National Convention got official word of the victory, representing the military's success for the public took on a sense of political urgency. "Today the first victorious pitched battle has been won by the soldiers of liberty," announced one of the deputies, Pierre-Joseph Cambon. "The sovereign, the people, must be instructed at this very instant of this success."[18] While public interest in the battle likely ran quite high, the victory also helped to legitimize the fledgling French republic as an autonomous power that was now backed by a capable army. Imagery would come to play an important role in supporting this perception.

Two prints issued immediately after the battle of Jemappes show the awkward fit between the topographical tradition of Van der Meulen and the novel revolutionary ideology of warfare, which was premised on the leveling of hierarchy and social inclusivity. An etching depicting the battle (fig. 9) struggles to locate the center of action and lacks a central narrative or topographical focus. Instead of focusing on one point of military authority, the artist dispersed the center of action across the composition. The king, with his commanding authority, has been replaced by two officers who look nearly identical to one another. One is pictured on a horse, gesturing in a way that recalls Louis XIV in Van der Meulen's *Lobith*. A second officer stands next to his mounted counterpart in the middle ground, pointing toward the background. His body mimics his mounted colleague's pose, inviting visual comparisons between the two and marking them as potential equals in terms of their actions—a formal

ambivalence toward the chain of command that betrays the unease accompanying questions of political representation during the revolution. The emphasis is placed upon multiple points of commanding authority, less than on specific episodic events or geographical indicators. The radical newspaper *Révolutions de Paris* published its own woodblock engraving (fig. 10) of the battle to accompany its reproduction of General Dumouriez's official dispatch to the minister of war. As befitting the newspaper's political coloring, the print almost entirely effaced any element of commanding authority in favor of masses of soldiers moving together, without identifiable actors or incidents. The detritus of direct combat litters the foreground; columns of French soldiers in formation advance horizontally across the middle ground, moving in harmony with one another. General Dumouriez is not easily identifiable: he could be any one of the three men mounted on white horses. By trading hierarchy for an image of the collective movements of the French army, the *Révolutions de Paris* engraving sacrificed any sense of narrative clarity.

Just two and half months after the victory at Jemappes, a prospectus in the *Moniteur universel* announced the publication of a series of prints of the battle that differed in character from others that circulated at the time. Readers were offered the opportunity to help finance three engravings that had been "drawn on the site" (*dessiné sur les lieux*) by two gunners who had fought in the battle. Readers could pay seven *livres* (a sum well out of reach for a laborer or artisan) to help finance and eventually procure an engraving that claimed to represent the event as it had been seen and experienced by those present. As the prospectus's authors claimed, they constituted objects of knowledge that were vested with a high level of reliability, since they had been "authorized by the generals and main officers of the army." This ingenious marketing strategy distinguished the prints as superior to any images of the battle not produced in this manner, which "would not have the same degree of authenticity. These young artists . . . have endeavored to put into their drawing the heat with which they were animated on the battlefield joined together with the most exact truth."[19] Map publishers traditionally used the phrase *desinné sur les lieux* (sometime written as *fait sur les lieux*) to demonstrate that their maps were based on information taken by surveyors in the field, not simply copied from extant sources.[20] Mention of the phrase in the prospectus thus conflated participation in the battle and the subsequent act of representing it with

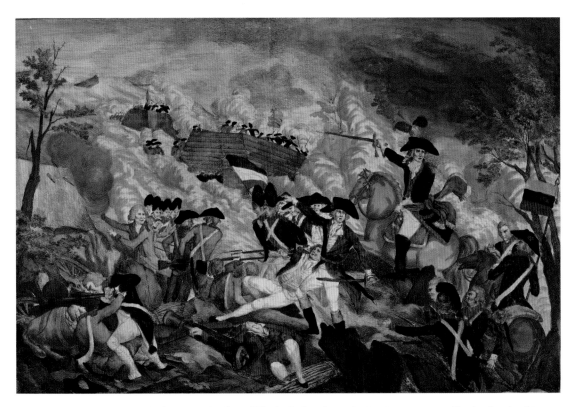

FIGURE 9 Anonymous, *The Battle of Jemappes Fought and Won by the French over the Austrians*, c. 1792–93. Hand-colored etching, 12⅜ × 18¼ in. (31.5 × 46.5 cm). Bibliothèque Nationale de France, Paris.

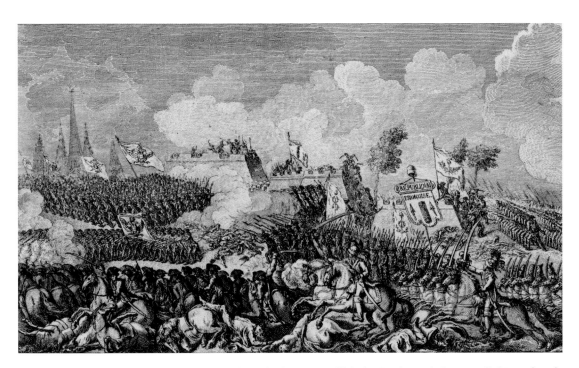

FIGURE 10 Anonymous, *The Victory of the French at the Battle of Jemappes*, published in *Révolutions de Paris*, 1793. Etching, 3¼ × 6½ in. (8.5 × 16.5 cm). Bibliothèque Nationale de France, Paris.

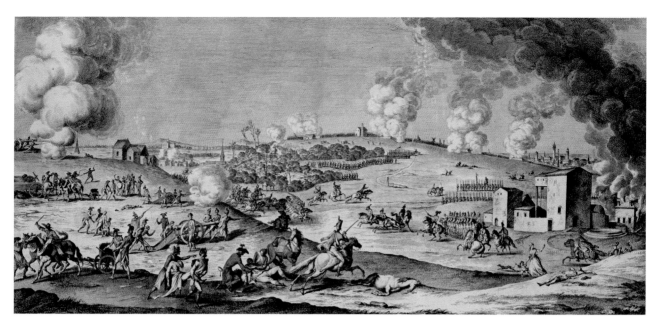

FIGURE 11 Antoine-Honoré Boizot, Marie-Alexandre Duparc, and Gerbel, engraved by Jean Duplessi-Bertaux, *First View of the Battle of Jemappes*, 1792–97. Etching and engraving, 9⅜ × 20½ in. (24 × 52 cm). Bibliothèque Nationale de France, Paris.

the scientific authority of the surveyor. This allowed the publisher to bolster the "presumed autonomy of observed facts," and amplified the claim that the print could be a direct reflection of what the artist-soldiers observed.[21] The idea that the artists depicted the battle as it appeared to them supposes an immediate act of transcription that takes the subjective process of representation and casts it as a nearly automatic act of direct rendering.

This attempt to reduce the obstacles to war's recount-ability and collapse the divide between first-person experience and impartial representation is akin to what historian of science Lorraine Daston has called "asymmetrical objectivity," defining it as a rhetorical position originating in late eighteenth-century aesthetic philosophy that attempts to efface the effects of mediation from the process of observation in the name of "communicability."[22] In the only print of the three announced in the *Moniteur* ever to be published (fig. 11), the battle of Jemappes is represented in a horizontal format well suited to combating the chaos of illegibility. In its measured distribution of episodic details across the expansive landscape, the print evinces a cold, almost calm detachment. At the same time, the placement of this compendium of actions within an expansive landscape, so that they can be seen in a single glance, fosters the illusion of an all-seeing vision. Several clusters of figures crowd the

left foreground; a hill cuts diagonally through the composition, revealing a pitched battle with lines of cavalry about to face off against each other in the middle ground; in the background, barely visible lines of infantry appear. It is impossible to discern the allegiances, whether Austrian or French, of any of these figures.

Consistent with the topographical tradition of battle painting, the scene is shown from a slightly elevated perspective. The viewer is placed at a comfortable distance from the zones of conflict, most of which are situated in the landscape's middle and background. The relative distance between the viewer and the action is challenged, however, by the immobile men being carried off in the foreground: this establishes a sense of temporal progression for the battle and helps mark its development toward the background, effectively protecting the viewer from physical danger. Motion is indicated through the thrusting and pointing of swords into the air and the mid-gallop of horses. Cannons are calmly and orderly loaded, unleashing plumes of smoke that manage to cohere into rotund, balloon-like orbs—a far cry from the thick layers of smoke that would have turned nineteenth-century battlefields into what one military historian has called "the equivalent of a late Victorian pea-souper fog."[23] In the middle ground a woman and small child can be seen fleeing, along with a dog. The dog, to some extent the woman and child, and

the line of anonymous wounded men being taken off the battlefield represent what Roland Barthes would call "insignificant notations"; "We are the real," they announce to the viewer.[24] These seemingly inconsequential details, in conjunction with the claim that these details had been seen and transcribed by impartial eyewitness combatants, bolstered the credibility of prints such as this one and made them enormously popular during the Revolutionary Wars and later, during the First Empire. The complete absence of any clear leader in this print sets it apart from the topographical tradition of French battle imagery. The viewer is invited to enter the scene not in the place of a king in the foreground, as a figure of supreme authority, but rather as an informed participant, privileged to access a space formerly reserved only for the king. Such a viewing position complemented the newly nationalized ideology of warfare that implicated all citizens of France, even if they did not actually take part in the fighting.

The French term for the eyewitness, or *témoin oculaire*, had been in wide use since the eighteenth century, when it merited an entry in Denis Diderot and Jean Le Rond d'Alembert's *Encyclopédie.* For witnesses to be "ocular," they needed to be not only contemporary to the events in question but also "on the actual site where the events occurred." *Témoins oculaires,* according to the *Encyclopédie,* were the most authoritative of all witnesses because "they are witnesses for themselves."[25] Seeing an event take place absolved the *témoin oculaire* from relying on the "narrations" of others, a view that is consistent with the importance of vision as a privileged vehicle of knowledge in the Enlightenment period. The vision of an eyewitness was therefore thought to be direct and reliable: this made it especially attractive for publishers seeking to transform it into a desirable commodity that might appeal to the nascent demographic of "the people," who were eager to take part in important political and historical events within which they were now ideologically implicated. The wars of the French Revolution and the Napoleonic Empire spurred the publication of countless books and prints that offered viewer-consumers the opportunity to become eyewitnesses by proxy. In the words of the prospectus for one such compendium, "The editors' goal is to transport, so to speak, the reader on the actual sites and to make them an eyewitness of the events."[26]

How did French audiences assume the role of spectator-eyewitnesses? What did it mean to be "transported" to site of military action by way of an image? An 1807 genre painting by Louis-Léopold Boilly, *The Reading of the Bulletin of the Grande Armée* (fig. 12), depicts one of the Napoleonic cultural practices that permitted audiences to take part in such image-based experiences of war: using a map and an official military bulletin to follow the movements of the French army. While these bulletins were often publicly read in town squares, in schools and churches, Boilly represents this activity as a form of private, domestic sociability. On the table of a modest interior, an unfolded map serves as a visual aid to the family's reading of the twelfth *Bulletin de la Grande Armée,* an official document that recounted the successful campaign of the French army in Prussia. The map depicted by Boilly (fig. 13) is likely an example of a genre of cartographic documents that were made quickly and cheaply by enterprising mapmakers seeking to capitalize on the actuality of military campaigns; they were marketed by private publishers as supplements to official government accounts of the French army's exploits, and made for the public, not for official military use in the field. The value of such maps derived from their actuality; that is, their ability to reflect current military events. As one contemporary observer related in 1806, "After our armies have crossed the banks of the Niemen, many newspapers in the capital have been charged with teaching us about the geography and topography of these sites where our brave legions carry our victorious eagles. At the same time, all of the print sellers on the banks of the Seine are covered with maps representing the theater of war."[27]

The eagerness of mapmakers to respond to public interest in the war often resulted in maps of dubious quality. The geographer Conrad Malte-Brun cautioned the public about the "insolent quackery" of enterprising mapmakers who sought profit from quickly produced maps. "As soon as the name Spain had been repeated in the newspapers," he warned, "twenty old copper plates plagued by rust were pulled from the storeroom, and twenty apprentices, armed with their scrapers, erased any traces that might betray the actual age of these maps. In a matter of fifteen days the walls of Paris were covered with the likes of ten to twelve maps of Spain, faked to look new and dated from 1809, whereas we know that it takes fifteen MONTHS to produce a new and high-quality map."[28] Malte-Brun's objection to unscrupulous mapmakers who sought to profit from the actuality of military campaigns is an implicit plea for standards of professionalism in mapmakers' practices. The steady proliferation of inexpensive

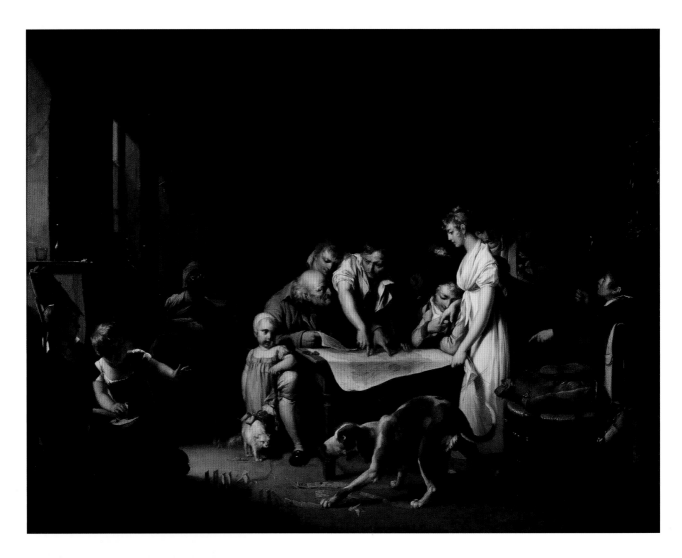

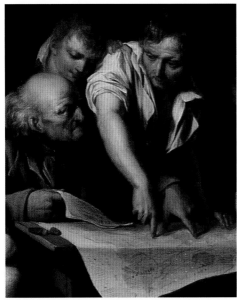

FIGURE 12 Louis-Léopold Boilly, *The Reading of the Bulletin of the Grande Armée*, 1807. Oil on canvas, 17½ × 23 in. (44.5 × 58.5 cm). Saint Louis Art Museum, Funds given by Mr. and Mrs. R. Crosby Kemper through the Crosby Kemper Foundations.

FIGURE 13 Louis-Léopold Boilly, *The Reading of the Bulletin of the Grande Armée*, detail.

military maps suggests that his calls went unheeded. Perhaps even more than their accuracy, these hastily produced military maps gave audiences like the family pictured in Boilly's painting a way to keep up with unfolding military events.

In terms of color, scale, and subject, this map corresponds to one made in 1806 by the mapmaker Eustache Hérisson (fig. 14), available only a few short months after the start of the War of the Fourth Coalition in Prussia. It sold for 2 francs and 50 centimes, a price that would have been affordable for middle-class households at the time.[29]

FIGURE 14 Eustache Hérisson, *Map of the Kingdom of Prussia, Poland and Lithuania, Where One Can Follow the Exact Path Taken by the French Army*, 1806. Hand-colored engraving, 30 × 22 in. (76 × 56 cm). Bibliothèque Nationale de France, Paris.

Boilly's painting represents the way that military cartography offered those on the home front a corporeal encounter with an imagined, expansive, foreign terrain. In the painting, the family patriarch holds the text of the bulletin in one hand and points at a map with the other. A younger man to the right indicates a different location on the map; the grimace on the older man's face and his outstretched finger suggest that the two may be having a disagreement over the location of the geographical terrain described in the bulletin. While the room is busy with other activities, such as a nursing woman to the left, a dog and a cat facing off nearby, and children playing at war in the foreground, the light in the center of the composition directs the viewer's gaze toward the map. This bright stream of diagonally cast light also illuminates the white dress of the young woman and the lovesick soldier who nuzzles her hand affectionately; while he is absorbed in a moment of sentimental revelry, the expression on her face is serious as she stares down at the map on the table, perhaps eager to see the land from

which this young man has returned or interested in another loved one still in the field. The words of the bulletin narrate the maneuvers and episodes of the Prussian campaign, but the map allows these details to be visualized, translating them into spatial, geographical terms and forming the family's perception of the territory covered by the French army. While Boilly's painting treats the disagreement between the patriarch and the younger man with light-hearted humor, it is worth pausing to consider the import of such a difference of opinion. These rival gestures, through which the two men attempt to outshine each other's understanding of the positions of the French army and thus claim a personal and authoritative stake in its endeavors, underscore the value of such knowledge for audiences on the home front. Their uncertainty over the exact location, which implies the limitations of cartographic knowledge for a viewing public that might not have had a thorough understanding of European geography, is almost beside the point: what is most important here is the idea of

solicitation. For civilians, France's contemporary wars could be experienced in part through humble commodities like this map; these objects gave their audiences a relatively accessible way of maintaining what Susan Sontag has called "a perch for a particular conflict in the consciousness of viewers."[30] It is worth recalling that Boilly's painting was exhibited at the same Salon as Gros's monumental history painting *Napoleon on the Battlefield of Eylau* (see fig. 22), which represented Bonaparte inspecting the grisly aftermath of a battle that took place on the same Prussian front shown in the map on the table in Boilly's painting. Viewers of Gros's *grande machine* would have been primed to view it in relationship to the kinds of social, familial and more quotidian experiences that Boilly represented in his comparatively "minor" painting.

Even before the outbreak of war in 1792, France already led Europe in the science of cartography, having produced a full survey of its territory for military purposes, something that was unprecedented on the continent at the time; at the behest of the Louis XV in 1747, three generations of the Cassini family undertook a systematic triangulation of French territory within the hexagon, completed in 1789, which resulted in a massive 180-page topographic map on a scale of 1:86,400 (¼12 inch to 600 feet); put together, the pages would measure 33 by 34 feet.[31] Since Cassini's survey of France contained a trove of accurate information about France's territory, this made it a valuable instrument of military intelligence, which helps to explain why the survey was quickly classified as a state secret when war broke out in 1792 and not published until 1815.[32] France also possessed an advanced administrative institution of official mapmaking, known as the Dépôt de la Guerre, and a corps of military engineers, or *ingénieurs-géographes,* who were responsible for producing visual documents for conducting and commemorating military campaigns, including maps of strategically important parcels of land as well as landscape *vues* of battlefields.[33] As Anne Godlewska has argued, cartography was easily harnessed by the authority of the state during the Directory and was quickly put into its service.[34]

Maps and other topographical information became crucially important for the postrevolutionary French army, whose legendary mobility enabled it to outflank and outmaneuver opponents.Accurate, detailed maps were required for moving tens of thousands of soldiers across foreign territories, for the construction of roads, and for the effective use of detached divisions of skirmishers

known as *tirailleurs* and field artillery, who placed their mobile guns at strategically chosen locations.[35] Bonaparte's corps of *ingénieurs-géographes* worked tirelessly to respond to this need; expediency became the order of the day. A letter sent from the director of the Dépôt de la Guerre, General Nicolas Sanson, to the assistant director, Colonel Muriel, however, reveals that the pressure to make maps quickly may not have stemmed from purely operational concerns: "I repeat to you, my dear Muriel, get as many engravers as you can, good and mediocre. . . . This is what the Dépôt de la Guerre will be known for, the utility that the government and the military can gain from it. Engravings are a luxury, and they must be made quickly so that we can benefit from them as soon as possible."[36] The focus of Sanson's letter on engraving as an obstacle to dissemination of cartographic knowledge hints at the importance of the Dépôt de la Guerre's engraved maps, beyond their function in the planning and execution of campaigns. Only through engraving could these maps be disseminated to a larger public. The military administrators at the Dépôt understood that the production of engraved maps functioned as a sign of the stability of France's state military institutions and as an archive of cartographic knowledge. Up until 1803, only high-ranking members of the military had regular access to the maps made by the *ingénieurs-géographes*. After this point, Bonaparte made military maps available to a wider civilian audience, in an effort to standardize cartographic language across military and civilian domains and publicize the exploits of his military.[37]

The civilian interest in maps, geography, and topography related to French military campaigns was encouraged by print media such as newspapers and engravings. People with a few francs to spare could also view foreign territories conquered by Napoleon's armies in the new panorama rotundas erected by the panoramist Pierre Prévost in Paris. Starting in 1799, Prévost used the emergent visual technology of the panorama—only recently patented in 1787 by the Englishman Robert Barker—to cater to public interest in viewing the topographical details of contemporary warfare. In these rotundas, visitors encountered monumental 360-degree canvases representing the evacuation of Toulon by the English in 1793 (1799), the fleet at Boulogne preparing to invade England (1806), the meeting of the French and Russian emperors at Tilsit (1809), and the battle of Wagram (1810). Little is known about this early phase of battle panoramas in France except that

Napoleon Bonaparte viewed them as an effective form of propaganda and sought to erect a series of rotundas to represent his victories, an ambition that went unrealized.[38] In the face of the silence of the archive, the panoramas can nevertheless be understood as part of the intermedial phenomenon of public enthusiasm for viewing the topographical details of French warfare. As Boilly's painting makes clear, part of the value of this kind of visual material rested in its ability to be up-to-date and authoritative. Thus, newspapers routinely reported the whereabouts of Pierre Prévost and his efforts to erect new panoramas as he traveled to the sites of battles, to produce documents that would be as reliable as possible.[39]

ARTIST-OFFICERS: LOUIS-GUISLAIN BACLER D'ALBE AND LOUIS-FRANÇOIS LEJEUNE

Over the course of the revolutionary and Napoleonic wars, a new generation of battle painters emerged with a dual professional identity: military officer and battle painter. The battle painters who customarily accompanied French kings on military campaigns during the ancien régime had done so to imbue their works with royal authority in the name of documenting and glorifying the exploits of the king. Postrevolutionary battle painters who took to the field did so as military professionals, backed by the broader institutional authority of the French army. This insider status lent a veneer of authenticity to the works they made for broader consumption by the French public, for whom these works functioned as technologies of witnessing. Two of the most prominent battle painters working in the topographical mode, Louis-Albert Guislain Bacler d'Albe and Louis-François Lejeune, were high-ranking officers who possessed a set of professional military skills related to surveying, mapmaking, and intelligence gathering. Both men successfully leveraged their status as officers in the French army to benefit their artistic careers. Before joining the army in 1793 as an artillery officer, Bacler d'Albe trained as an Alpine landscape painter and portraitist. He was then appointed as the head of the corps of military engineers, the *ingénieurs-géographes*, during the first French conquest of Italy in 1797, and eventually secured the important position as director of Napoleon Bonaparte's private map room from 1799 until 1814. D'Albe's close association with the emperor afforded him privileges that proved beneficial to his private publishing ventures—this was the case with his publication in 1802 of the first synthetic map of Italy, *Map of the Theater of War in Italy* (fig. 15). This elaborate 54-page map was based largely

on older maps, many of which were looted by the French army from map rooms in Milan and Venice. After its completion, French military officials noted that the map might contain errors, but that these would be "of little consequence, since we must follow victory with rapid footsteps and one does not have enough time to verify every single detail."[40] Although the Dépôt did not correct the errors in the map until the Bourbon Restoration, the document was widely publicized and praised in the French press after its publication, and helped earn its author recognition as one of France's preeminent cartographers.

Artist-officers like Bacler d'Albe used the skills that they had acquired through military service to forge identities in the marketplace for art; close connections to powerful institutions and rulers also proved beneficial for producing prints and paintings alike. To finance the cost of engraving his 1802 map, Bacler d'Albe took up a subscription. Bonaparte reportedly provided the bulk of the funding, with 84,000 francs. But after publishing the first four *livraisons* of the map, the artist ran into financial difficulties; 44,000 francs in debt, he was being sued by his creditors. The Dépôt de la Guerre agreed to purchase 160 copies and allowed Bacler d'Albe to retain the copper plates. The frontispiece proclaimed the map's author to be "Chef des Ingénieurs-Géographes du Dépôt Général de la guerre, Rue des Moulins, no. 542." The address was that of Bacler d'Albe's own shop, not the Dépôt Général de la Guerre, but the association between the two was no doubt intentional. Bacler d'Albe also sold one portrait of Bonaparte and two related landscape *vues* of armed encounters—the battle of Lodi and the crossing of the river Po at Plaisance—that took place in areas depicted in the map. Reasonably priced at 12 francs each (compared with 150 francs for the map), these engravings disclosed episodic and topographical particulars otherwise beyond the purview of the map.

By virtue of being made by the hand of an officially sanctioned expert observer of military operations, landscape *vues* could lay claim to the status of eyewitness images, a quality that one anonymous writer claimed could be seen in the engraving *Passage of the Po at Plaisance* (fig. 16). The print combined "a precious exactitude of style and detail with a rich and knowledgeable composition. Drawn on the actual site of the battlefield, by a man who is both an artist and a member of the military, you can see everywhere the touch of an eyewitness."[41] For this anonymous writer, the "touch of an eyewitness" was produced

FIGURE 15 Louis-Albert Guislain Bacler d'Albe, frontispiece, *Map of the Theater of War in Italy*, 1802. Engraving, 25⅞ × 20¾ in. (66 × 53 cm). McGill University Special Collections Library, Montreal.

visibly by the image and invisibly through Bacler d'Albe's status as an artist-officer. The engraving was based on the painting (fig. 17) that Bacler d'Albe made almost two years after the May 1796 crossing, in which he had participated as an *ingénieur-géographe*. While the print claims its status as product of eyewitness observation with the phrase "Peint sur le lieu par Bacler d'Albe" in the bottom left corner, the painting's signature, "Bacler d'Albe pinxit, 1798," openly discloses its retrospective nature. Though the print and painting were both made well after the battle, both of them satisfied contemporary expectations of how eyewitness war imagery should appear, staging a viewing experience that simultaneously satisfied desires for proximity, particularity, and a broad overview. As a mapmaker, Bacler d'Albe's topographical battle painting collapses a long-range, penetrating view into the depths of the landscape with a series of up-close details of the site as well as its actors into one cohesive image of territory seized by the French army. In the background, the French army, depicted as tiny, colorful sticklike figures, waits to cross. Soldiers are shown in the process of crossing, disembarking on the riverbank in the foreground, where they fight the Austrian army. The depiction of several simultaneous stages of the crossing implies an elapsed temporality and shows that events are in the process of occurring; plumes of white smoke add to this effect, acting as an index of duration. This proliferation of information about site and action is offset by a deeply recessed landscape, above which a wide, open sky dominates the top two-thirds of the composition. While these devices invite the viewer into the space, a series of barriers in the foreground, including a dead horse and a pile of debris, creates a distancing effect, keeping the chaos of war at a secure, slightly hovering remove. In the context of the map that it was sold with and the artist's occupation as an *ingénieur-géographe*, Bacler d'Albe's print of *Passage of the Po at Plaisance* constituted a powerful technology for picturing contemporary war, carefully merging visual information about the event with the traditional trappings of topographical landscape painting. Images such as these enticed viewers to look to them as confirmation that the territory of the French empire was continuously expanding.

During a time of nearly uninterrupted warfare in France, topographical battle painting was valued for its capacity to reproduce military combats as they had been experienced on the ground—an illusion made possible by

FIGURE 16 Michelangelo Mercoli, after Louis-Albert Guislain Bacler d'Albe, *Passage of the Po at Plaisance,* c. 1800–1801. Etching and engraving, 20¼ × 27⅜ in. (51.5 × 69.5 cm). Bibliothèque Nationale de France, Paris.

FIGURE 17 Louis-Albert Guislain Bacler d'Albe, *Passage of the Po at Plaisance,* 1798. Watercolor, 26 × 17 in. (66 × 43.2 cm). Service Historique de la Défense/Centre Historique des Archives, Vincennes.

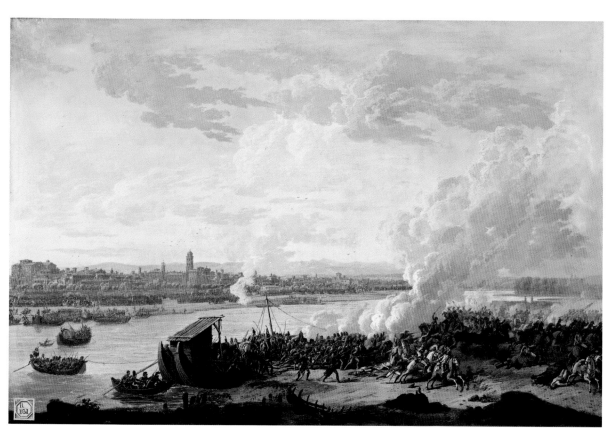

the conviction that such images contained more fact than art. The believability of topographical battle paintings and related prints as transparent images of site, action, and experience derived in part from their status as credible foils to the grand manner history paintings the French government commissioned to glorify Napoleon Bonaparte's military deeds. In a discussion about the truth value of photography, Richard Shiff has argued that "at any moment of history, the value of all representation depends on the existence of some representation that can be regarded as transparent, realistic or natural."[42] Topographical battle painting constituted one such area of cultural production that played the role of what Shiff calls the "proper" to the "figured" visual language of history painting. Monumental in scale, metaphorical in address, and reserved for the most talented of artists who had received years of training in the strictures of French academic painting, history painting also carried with it a

moralizing imperative. Prior to the Napoleonic Empire, battle painting had occupied a lowly rung in the French hierarchy of genres, closer to portraiture and landscape, since it represented the particulars of site and action, including uniforms, topography, and sometimes tactical maneuvers. History painting, by contrast, required painters to represent subjects that had to be imagined in the mind of the artist: Greek and Roman mythology, classical history, and biblical scenes. The distinction between subjects that could be seen and subjects that had to be imagined allowed for the genre of history painting to claim a degree of prestige to which portraiture, landscape, still life, and genre painting could not aspire. The livelihoods of French history painters in the seventeenth and eighteenth centuries were ensured by government support for works that maintained these traditional definitions of their practice. With the abolition in 1792 of the Académie Royale de Peinture et de Sculpture, this centralized source of support for history painting disappeared. Not until nearly a decade later, during the Consulate, were history painters once again supported by the French government, but with a new directive. Napoleon Bonaparte recognized early in his rise to power that the arts could be used to promote his status as an exemplary military leader. In an unprecedented departure from tradition, France's government elevated the status of battle painting and encouraged its most distinguished artists to represent contemporary military subjects using the visual vocabulary and scale of classical history painting. The nearly continuous state of warfare in France thus became the basis for revising the strictures of history painting to admit contemporary

subjects. For these kinds of artworks, the moral lessons of classical history painting were subsumed into narratives that supported the justness of French warfare, the propagation of empire, and the superlative nature of its leader. It was implicit that these scenes were not personally witnessed by the artists but rather imagined and composed to great artistic effect.

In composing works not based on direct observation, history painters relied on documents provided by *ingenieurs-topographes* and battle painters like Bacler d'Albe. This was the case in 1801, the first time that history painters were called upon by the French government to depict a contemporary French battle, at the urging of the minister of war, Alexandre Berthier.[43] Artists were asked to submit sketches for a history painting that was to measure 7 by 7 meters—an unprecedented scale for a battle painting—of the 1799 battle of Nazareth, one of the few battles that the French army managed to win during the ill-fated Egyptian campaign.[44] All ten of the submitted sketches were exhibited at the Salon of 1801, and a winner was chosen: a young student of David's, Antoine-Jean Gros (fig. 18). Though Gros never completed the painting, the competition provides an illuminating example of the difficulties faced by history painters who wanted to take on the subject of contemporary battle. Gros's sketch was faulted by critics who found it lacking in metaphor and not sufficiently elevated to be acceptable as a history painting. As David O'Brien has argued, Gros's sketch struck critics as excessively violent, implying that "barbarity lay in the hearts of Frenchmen too."[45] Nor was it sufficiently detailed to satisfy the conventions of

topographical battle painting. To prepare his sketch, Gros had at his disposal a set of documents furnished by the government, including a textual account of the battle's general progression, followed by a list of incidents that had occurred. Artists could also request a map of the battle from the Dépôt de la Guerre, drawn up by one of the generals who participated in it. Gros, more than any other artist, tailored his painting to the government's official version of the battle; he even exhibited a series of documents of his own creation underneath his final sketch at the Salon of 1801 (figs. 19, 20), including a textual account of the episodes depicted in the painting, a hand-drawn replica of the map drawing by a general who had participated in the battle, and a topographical battle plan.[46] These corroborating documents disclosed empirical information that was otherwise extraneous to history painting's main task of representing the transcendent and epic aspects of a historical event.

The other important battle painting on display at the Salon of 1801, Louis-François Lejeune's *Battle of Marengo* (fig. 21), did not need to rely on authenticating documents outside the frame because the artist had also been an eyewitness to the battle: in this sense, the *Battle of Marengo* appeared to be an authenticating document unto itself. The positive reception of Lejeune's painting was informed by two important pieces of information disseminated in the guidebook for the Salon of 1801—the artist's status as the aide-de-camp to the minister of war, Alexandre Berthier, and Lejeune's participation in the battle of Marengo. Lejeune's close professional association with Berthier would have permitted him easy access to the numerous maps produced by the Dépôt de la Guerre. Just as Lejeune's status as a member of the military benefited the reception of his paintings, his status as an artist worked to his advantage when it came to securing the favor of his military superiors. While Gros's *Nazareth* was castigated by critics, the reaction to Lejeune's *Battle of Marengo* was more positive: he received numerous favorable reviews and was even awarded a *prix d'encouragement* in the amount of 3,000 francs by the government.

The Salon of 1801 marked the beginning of Lejeune's illustrious career as a battle painter. Over the course of the Napoleonic Empire and into the early years of the Bourbon Restoration, Lejeune parlayed his experience as a high-ranking military officer with connections to France's military elite, including Bonaparte and minister of war Alexandre Berthier, into a career as the most esteemed

and prolific practitioner of topographical battle painting. Lejeune commenced his formal artistic training at the age of thirteen in the studio of the academic landscape painter Pierre-Henri de Valenciennes, who in 1800 published his influential treatise on linear perspective, *Elements of Practical Perspective.* In his section on battle painting, Valenciennes declared a deep understanding of military operations and tactics essential for artists wanting to excel in the genre. But above all, he advised future battle painters that they had to take part in a battle, lest they "find themselves far from the truth, and even the lowliest soldier would be able to see the faults in the composition."[47] In 1792 Lejeune would have the opportunity to heed his teacher's advice. After the declaration of the *patrie en danger* in 1792, Lejeune enlisted in the army and commenced his military training, first as a foot soldier. Rising quickly in the ranks owing to his drafting skills and an urgent demand for engineers, in a few short years he became an officer in the engineering corps, a so-called *officier du génie.* More than any other artist working at the time, Lejeune deftly negotiated between the role of artist and officer, using his artistic career to burnish his military credentials and his status as an artist to benefit his career in the military. Lejeune's military personnel dossier is filled with numerous letters to superiors requesting an elevation to a rank that would allow him access to the documents housed at the Dépôt. In 1800, he wrote to Berthier, "I ask that you employ me to work at the Dépôt de la Guerre so that I can obtain the necessary information for the historical work I am doing to honor the government." A year later he wrote to Berthier yet again, asking to be elevated in rank "at the necessary level so as not to be distracted from the work that I have taken up again on the collection of paintings on the principal battles won by the French armies at which I was present."[48]

From his very first foray into exhibiting at the Paris Salon in 1801, Lejeune earned praise by art critics, who believed his paintings to be surrogates for viewing a battle in person. In the words of one critic, "There is nothing here that can be studied, combined, or calculated in a studio. . . . All of these details are too real for the imagination to compose them or for the spirit to intuit them; one must have seen them to render them with such truth." This sentiment became a cliché of art criticism of Lejeune's battle paintings during the First Empire. In the words of the art critic Pierre Chaussard, Lejeune "created his own genre" and reformulated "the boundaries of painting." His

FIGURE 19 Antoine-Jean Gros, *Map of the Battlefield of Nazareth Sent by General Junot*, 1800. Pen, ink, and wash, 12⅝ × 10 in. (32 × 25.5 cm). Musée des Beaux-Arts, Nantes.

FIGURE 20 Antoine-Jean Gros, *Schematic Drawing of the Battle of Nazareth Based on the Map Sent by General Junot*, 1800. Pen, ink, and wash, 12⅝ × 10 in. (32 × 25.5 cm). Musée des Beaux-arts, Nantes.

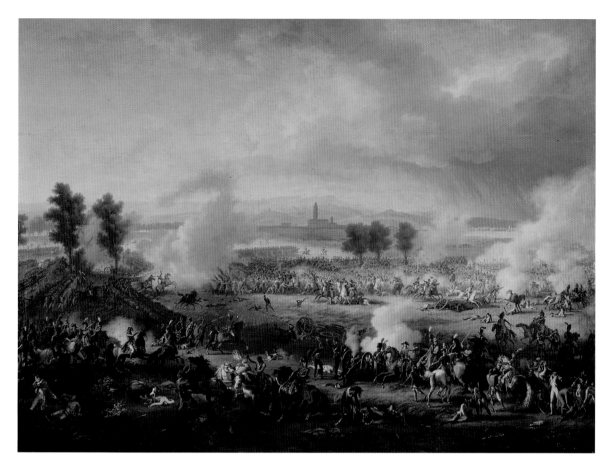

FIGURE 21 Louis-François Lejeune, *The Battle of Marengo,* 1801. Oil on canvas, 70¾ × 98⅜ in. (180 × 250 cm). Musée National des Châteaux de Versailles et de Trianon.

achievement was to "combine the exact and geometric rendering of places and battle, in one word, the truth of action, with all of the magic of picturesque effects."[49] Returning to Richard Shiff's terms, Lejeune's paintings played the role of the "proper" to the "figured" visual rhetoric of history painting; critics often regarded them as having the ability to depict war more truthfully and transparently because they seemingly required much less artistic transformation on the part of the officer-artist than would be required of a history painter whose duty was to aestheticize and elevate. The claim that Lejeune's paintings were truthful because they did not betray an interpretative, aestheticizing hand effectively ignored any artistic intervention that he had made to portray his works as unmediated transcriptions of military events. In other words, critics minimized his creative labor in making a picture by viewing it as a series of eyewitness facts.

This understanding of Lejeune's paintings stood in stark contrast to the sets of expectations surrounding

history paintings of contemporary military events. These larger, more rarefied, and exceptional paintings implied moral and intellectual operations on the part of the artist, whose duty it was to abstract from particularities and arrive at a sublime, generalizing ideal through which great deeds might become intelligible. The realm of the ideal, in the words of the staunch classicist Antoine Quatremère de Quincy, "is where the artist abandons the sterile domain of reality, where men, events, and objects only appear as they are." The duty of the history painter is to transform the familiar and "create a new world," using metaphor.[50] Defenders of the classical tradition of history painting, such as Quatremère, forthrightly rejected contemporary military subjects on the grounds that they deprived painters of the ability to metaphorize and transform. Quatremère was especially irritated by the idea that history painters should have to debase their genre by depicting contemporary military uniforms, which required detailed focus on the particularities of rank and a servile

documentation of accessories, weapons, and other trappings of military service.[51] More problematic for critics such as Quatremère was the issue of violence; in his remarks on the life and career of Gros after the painter's suicide in 1835, Quatremère advised battle painters not to paint "the physical action" of a battle, but rather "its definitive result." The only acceptable way to depict war for a history painter was to rely on "one of these metaphoric means, or *transposition*, that only speak to the eyes so as to transmit through them to the spirit of the spectator the result of the action, instead of the impossible image of its reality."[52] While there are other important exceptions to the reluctance of history painters to depict violent military clashes, including Anne-Louis Trioson Girodet's *Revolt of Cairo*, the majority of the period's most celebrated history-cum-battle paintings follow the kinds of prescriptions laid out by Quatremère and do not picture direct fighting. Such is the case for two of the period's most celebrated "battle paintings:" Gros's *Napoleon on the Battlefield of Eylau* and François Gérard's *Battle of Austerlitz*, both of which represent moments after the major bloodshed has occurred (figs. 22, 23). When history painters did take on the subject of direct fighting, critics were often troubled by the overt violence, which called into question the benevolence and humanity of the French war effort. This was especially the case with battle paintings of Napoleon's Egyptian campaign intended to portray the French army as the enlightened counterpoint to North African barbarity, and thus justify Napoleon's civilizing mission there. Battle paintings, according to one critic, "present nothing more than a confused mix of weapons and fighters, where the most extraordinary of attitudes are thrown together randomly, where death multiplies in so many bizarre forms that the most terrible of images make no impression on spectators."[53] This complaint about the state of contemporary battle painting was in response to Gros's *Battle of Aboukir* (fig. 24), exhibited at the Salon of 1806 and commissioned by one of Napoleon's most trusted generals, Joachim Murat. Gros's *Battle of Aboukir* represents one of the few victorious battles waged by the French army in Egypt during an otherwise disastrous military campaign. Depicting a direct clash between opposing armies on a monumental scale, the painting focuses on the cavalry charge led by the painting's patron, Joachim Murat. The critic saw in *The Battle of Aboukir* "an incoherent mass of turbans and helmets" and "confused movements." He reasoned that Gros had run out of time and

had "covered his canvas without trying to make his details submit to a general intention."[54] In response to a perceived excess of violence in the ex-Jacobin history painter Philippe-Auguste Hennequin's *Battle of the Pyramids* (fig. 25), one critic wished for more restraint: "It is not only about grand sword strikes and killing in painting, but there is also the manner of killing; and when one looks at a painting, [it is as difficult as] these Roman women who desired their dying gladiators to fall with grace so that, in other words, they would have learned how to die."[55] Even though the cultural inferiority of non-Western peoples was implicit in orientalist attitudes of the French imperializing mission in Egypt, it was still expected that history painters maintain a sense of decorum in their battle paintings and not display too much bloodlust. History painting's traditional didactic mission of moral instruction was thus troubled by the pressure of depicting the violence that came from warfare.

Working outside the elite domain of history painting, Lejeune had no such responsibility to guide viewers toward moral lessons about France's contemporary armed engagements and the extraordinary character of a few of its leading participants. Topographical battle paintings like Lejeune's could therefore show subjects outside the purview of history painting, such as violent, hand-to-hand combat; they placed a different set of ethical demands on viewers, who were encouraged to take visual pleasure in the spectacle of contemporary warfare without being directed to contemplate its higher meaning. Lejeune's status as a military insider also made the violence depicted in the paintings more palatable because it was seen as dispassionate and empirical–in the words of one critic, "less picturesque compositions than exact representations of combats as they happened."[56] In his works, "it is easy to recognize that he has had the [military] camps for his atelier and the battlefield as a model."[57] Lejeune took an active role in cultivating a belief that the episodic and topographic details depicted in his battle paintings were based on eyewitness experience, a fact that, according to critics, accounted for the throng of spectators who reportedly surrounded his paintings at Salon exhibitions. This was accomplished through textual claims he made in the Salon *livrets* and through his signature, which often featured his rank. In his version of *The Battle of Aboukir* (fig. 26), after the date and name of the battle, Lejeune publicized his *métier:* "Lejeune, officier du génie." The *Battle of the Pyramids* (fig.

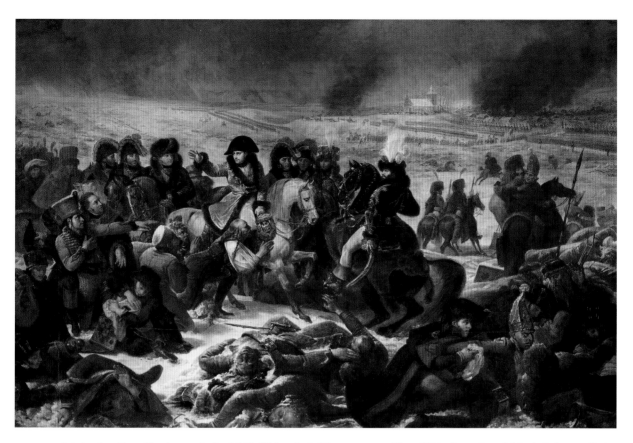

FIGURE 22 Antoine-Jean Gros, *Napoleon on the Battlefield of Eylau*, 1808. Oil on canvas, 205⅛ × 308⅝ in. (521 × 784 cm). Musée du Louvre, Paris.

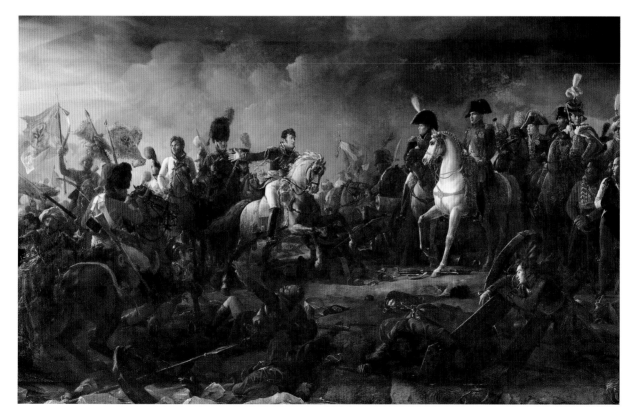

FIGURE 23 François Gérard, *The Battle of Austerlitz*, 1810. Oil on canvas, 200¾ × 377¼ in. (510 × 958 cm). Versailles, Musée National des Châteaux de Versailles et de Trianon.

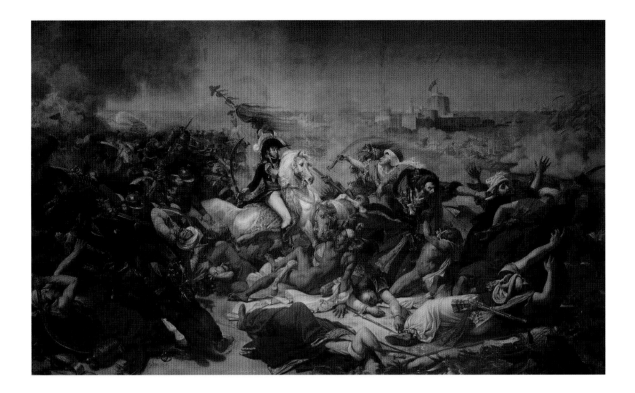

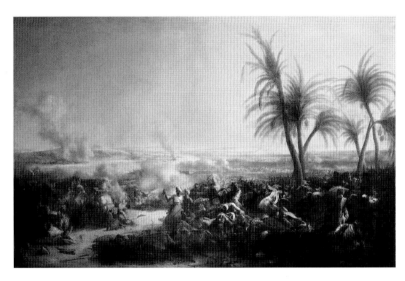

27), Lejeune's 1806 Salon entry, was signed, "Lejeune, Chef de bataillon, au corps impérial du génie." Though Lejeune did not actually participate in the Egyptian campaign, he produced three paintings of its battles—*The Battle of Aboukir, The Battle of the Pyramids,* and *The Battle of Mont Thabor*—and even dared to claim that two of them were painted "d'après nature," or on the site of the battles. This caused confusion among critics who reviewed his paintings and persisted in the *Biographie universelle ancienne et moderne,* which stated incorrectly that Lejeune had served in Egypt.[58]

Lejeune exhibited three paintings at the Salon of 1804, including *The Battle of Aboukir,* the style of which is representative of Lejeune's other battle paintings. While Gros's painting of the same battle directs viewers to focus on General Murat's charge at the center of the painting and then out toward the secondary clashes on the sides, Lejeune's version of the same battle is represented through a proliferation of episodes that occur in the foreground, middle ground, and background, without a clearly determined pictorial hierarchy. Instead of a culminating center of action, Lejeune spread dozens of separate episodes of

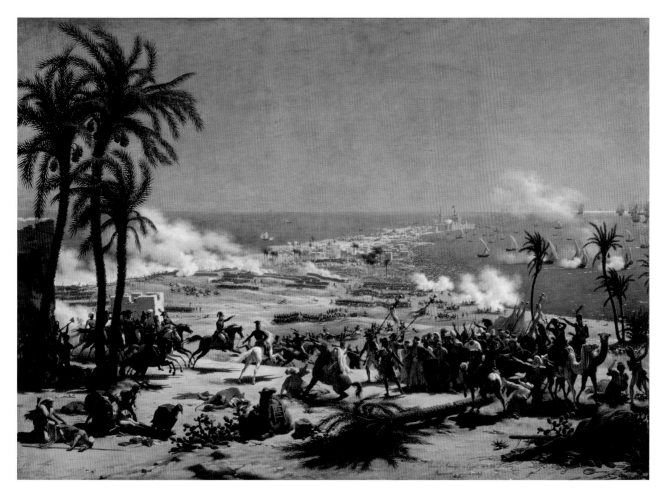

FIGURE 26 Louis-François Lejeune, *The Battle of Aboukir*, 1804. Oil on canvas, 72¾ × 100⅜ in. (185 × 255 cm). Musée National des Châteaux de Versailles et de Trianon.

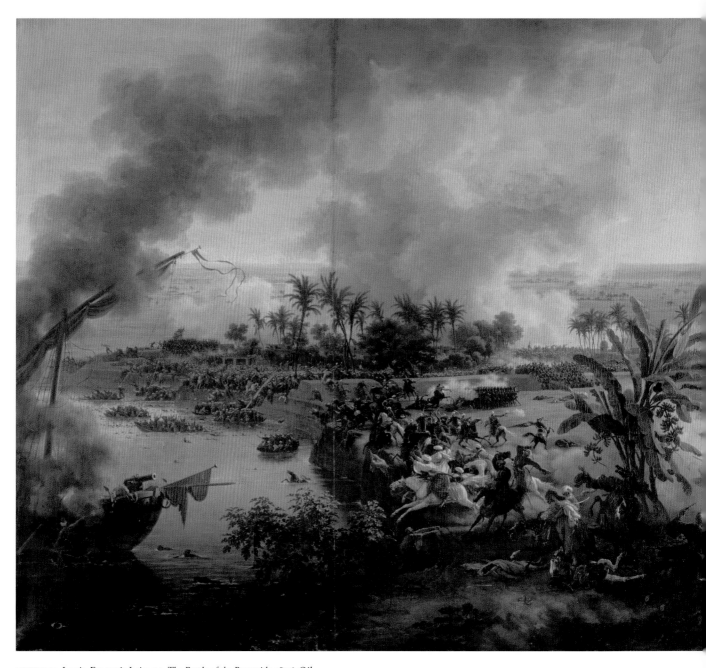

FIGURE 27 Louis-François Lejeune, *The Battle of the Pyramids*, 1806. Oil on canvas, 70¾ × 101½ in. (180 × 258 cm). Musée National des Châteaux de Versailles et de Trianon.

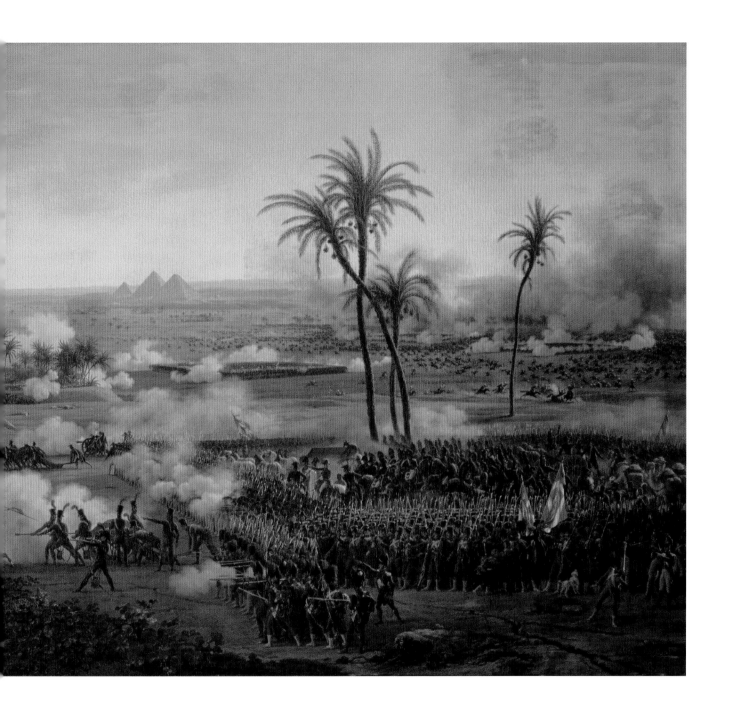

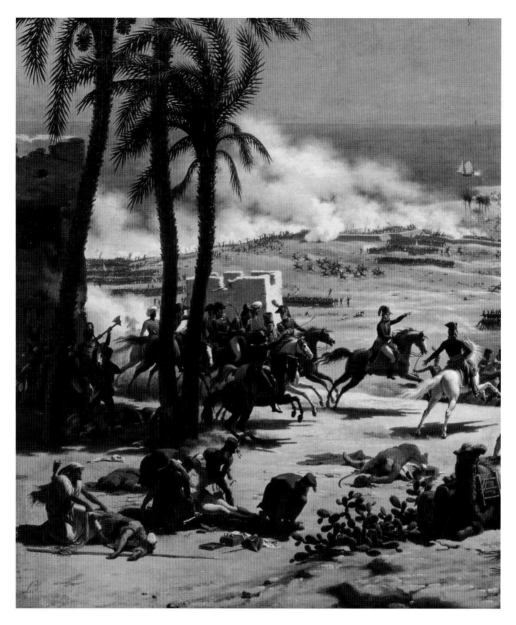

FIGURES 28 AND 29 Louis-François Lejeune, *The Battle of Aboukir,* details.

direct combat across the foreground and middle ground (fig. 28). Departing from the hierarchizing narrative of a classical history painting, he accorded little compositional priority to the two highest-ranking military commanders, Bonaparte and Lejeune's patron, Alexandre Berthier, who survey the line on horseback from the left foreground. Directly to their left, the field doctor, M. Larrey, dresses the wound of General Fugières, who has lost an arm in the battle. Near the center of the foreground, Lejeune has placed a single meditative camel, who returns the gaze of the

viewer—a far cry from the monumental charging General Murat featured at the center of Gros's *Aboukir.* A fallen tree to the right of the camel leads to a figure group of captured Turkish soldiers and their French captors (fig. 29). Directly to the right of this group, isolated scenes of action take place: a Turkish soldier on the ground single-handedly fights a mounted French soldier as his comrade ducks to get out of the way of the raised sword; directly to their right, two French soldiers ride on camels and drink water. This seemingly happenstance arrangement of violent

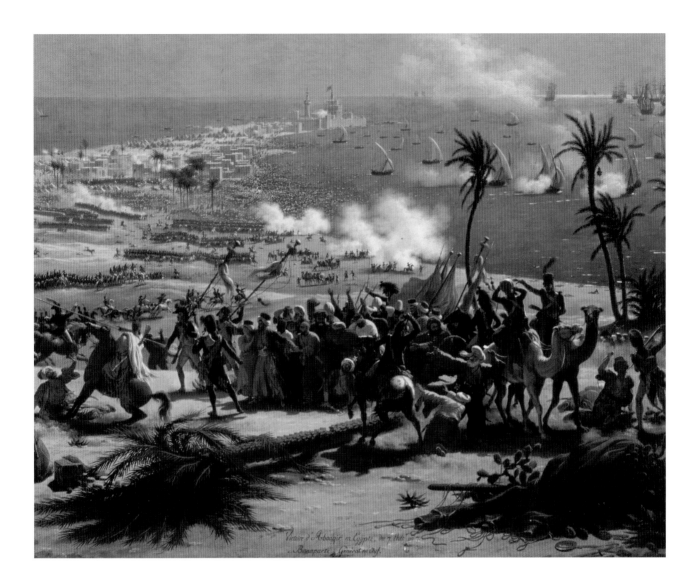

action next to commonplace incidents bolstered the credibility of Lejeune's eyewitness representational strategy, giving it the appearance of an unfigured, artless arrangement. The soldier with the water jug tips it over, dramatizing the degree of his thirst. His companion gestures toward him, no doubt a plea to leave some for him. In another characteristic nod to the humorous expressivity of animals, the camels ridden by the soldiers are not left out of the narrative action; their heads turn toward each other, and the mouth of one stays slightly open, as if he is engaging in a

conversation with his companion. The conversant camels are oblivious to the violent episode occurring right next to them: a French and a Turkish soldier in a violent struggle to the death. Lejeune depicts the moment just before the French soldier thrusts his bayonet into the Turkish soldier's mouth.

Viewers who encountered Lejeune's *Battle of Aboukir* at the Salon of 1804 would have also seen the standout history painting of that year's exhibition, Gros's monumental *Bonaparte Visiting the Plague Victims at Jaffa* (fig. 30).

FIGURE 30 Antoine-Jean Gros, *Bonaparte Visiting the Plague Victims at Jaffa*, 1804. Oil on canvas, 209⅜ × 283⅜ in. (532 × 720 cm). Musée du Louvre, Paris.

Together they present two very different accounts of the Egyptian campaign. While Gros's painting emphasized Bonaparte's active, upright singularity in contrast to the languid passivity of his plague-ridden soldiers, Lejeune's *Aboukir* insisted on the mutually productive roles played by commanding officers and soldiers alike. Both Gros and Lejeune represented Bonaparte interacting with his subordinates, but Lejeune's painting showed him in a more symbolically secure role: on the battlefield, as a participant in the action, represented on a horse in midgallop, as one figure among many other active soldiers and officers within the heat of battle. Lejeune's *Aboukir* thus aligns more directly with the cherished mythology of revolutionary meritocracy that surrounded the institution of the French military and the stunning ascent to power of its leader. Both paintings attempted to fulfill different and complementary facets of Bonapartist propaganda,

although with mixed outcomes, especially in the case of *Jaffa*, which represented a devastating military loss rather than a victory. As Darcy Grigsby has argued, Gros's painting disclosed the challenges and dangers of empire, including most palpably the threats that came with contact with forces beyond rational control, since the plague effectively transformed French soldiers into fearful, defenseless victims; their passivity, as she argues, was a sign that the Orient had effectively taken over their bodies. If Gros's painting showed the potential violation of the French bodies beset by inveterate passivity and disease, Lejeune's painting maintained a binary opposition between the Ottoman and Egyptian forces and those of the French. In Grigsby's account of Gros's painting, even the centrality and authority of Bonaparte is rendered suspect, since he was an "extremely vulnerable new term competing for preeminence." As Grigsby and other

scholars of Napoleonic history painting have argued, the task facing history painters involved reducing the volatility and uncertainty of Bonaparte's authority as a pictorial sign; this was made difficult, since they had to do so within the traditional strictures of a form of painting whose visual codes resisted the particularities of representing contemporary figures and events. The fact that Napoleon was a sovereign whose authority was defined by his achievements and rank, but not his bloodline, also posed a challenge to artists. While Gros's painting was more illustrious because of its genre, scale, and ambition, Lejeune's painting of Aboukir was better positioned to claim directly to the French public that the newly crowned emperor had earned his status through his superlative actions. The message of Gros's history painting was comparatively much more ambiguous.[59] Lejeune's *Aboukir* employed a series of formal strategies that encouraged a powerful illusion of open access to a battle's manifold episodic details, which afforded the chance for spectators to participate by proxy in the battle, as it unfolded. As Chaussard noted when reviewing Lejeune's 1806 Salon entry, *The Battle of the Pyramids,* "lucky citizens can enjoy the spectacle of a battle without exposing themselves to danger. . . . They will follow all these events with their eyes. . . . Everything is correct, everything is truthful; one takes part in the action."[60] When Chaussard turned his attention to a reproductive engraving of Lejeune's 1801 Salon submission, *The Battle of Marengo,* the critic found that the affective power of his painting translated seamlessly into Jacques-Joseph Coiny's print; it was "the exact representation of the object, that is to say the truth, history, of which we thus become eyewitnesses."[61]

This idea that Lejeune's paintings allowed spectators to "take part in the action" produced a powerful illusion of participation in France's contemporary wars that audiences found approachable, comprehensible, and above all, truthful. While this impression stemmed in part from the decentered narrative strategy used to depict the episodes of a military encounter, Lejeune also enticed viewers by representing the business of imperialism as a matter of territorial possession made possible through a form of uninhibited, expansive vision, similar to the visual rhetoric of maps. Lejeune often achieved this by using a slightly hovering bird's-eye point of view to produce a deeply recessive landscape in the background and a stagelike wide foreground, where the majority of the fighting takes place. In his 1806 *Battle of the Pyramids,* for example,

Lejeune employed a dramatic rectangular format that verged on the panoramic; the plunging space of the background, the broad sky, and the horizon line produce the illusion of distance that opens up to the viewer's gaze. This impression of territorial mastery is complemented by the broad foreground, where the slightly hovering point of view places the viewer above and behind the action, yet close enough to be privy to it all. Groups of strategically placed palm trees and plumes of smoke enact a push and pull of visual attention across the space of the painting, which makes the sections of open landscape appear as chance opportunities for uninhibited viewing. "From one look," wrote Chaussard, "one sees everything: no episode has escaped one's vision, not a single detail; everything can be found here without confusion." Lejeune rendered "an exact account of everything . . . everywhere a perfect clarity."[62] This mode of viewing would have been especially prized by audiences who encountered his three Egyptian campaign paintings at the Salons of 1804 and 1806.

The unqualified military disaster of Bonaparte's 1798–99 conquest of Egypt was cast by Napoleonic propaganda as a cultural triumph. The campaign was instrumental in supporting orientalist theories about the superiority of Europe over what was taken to be a depraved and degraded Orient. The French military conquest of Egypt was accompanied by an elaborate scientific mission to discover, classify, and study the flora, fauna, ancient monuments, and contemporary customs of Egypt. The findings of the hundreds of scientists, draftsmen, and other experts would be used to publish the *Description de l'Egypte* as a luxurious multivolume folio monument to the imperial ambitions of France. As Edward Said has famously argued, the project provided a benevolent and intellectual cover for French military intervention and obscured the true rationale for invading Egypt, territorial conquest. Military engineers also took part in this effort to classify Egypt as a French object of knowledge. As an extension of the civilian scientific mission, the French army's *ingénieurs-géographes* undertook a geographic survey of the territory, for which no accurate map existed. The survey, though intended for official use and not reproduced for the broader market, was part of an effort to make the constantly expanding French empire available as an object of military knowledge. Once finished, the geographic survey of Egypt comprised a three-sheet geographic map and a 47-page topographic map, an unusually large size. Though Napoleon's armies encountered armed resistance from

FIGURE 31 Anonymous, *Bonaparte, First Consul, Standing on the Tallest Pyramid in Egypt*, c. 1798–1801. Etching, 5¼ × 12⅜ in. (13.5 × 31.5 cm). Bibliothèque Nationale de France, Paris.

Egyptians, found the country logistically difficult to conquer, and were ultimately driven out of Egypt in a humiliating defeat, the survey presented the French military with an occasion to master the land symbolically through the practice of mapping.[63]

An anonymous print made shortly after Napoleon's failed military conquest of Egypt represents the collusion between mapping and France's military intervention in Egypt; it encapsulates the allure of imaginary projection in a vast landscape that was also a component of Lejeune's paintings of the Egyptian campaign. *Bonaparte, First Consul, Standing on the Tallest Pyramid in Egypt* (fig. 31) shows Bonaparte at the top of a pyramid, with his back turned away from the viewer, looking toward a vast, empty landscape that recedes into the background. To underscore the impressive height of the pyramid, the print reveals only its tip. In addition to depicting the topography of the Egyptian landscape and the up-close features of the top of a pyramid, this highly unusual point of view reproduces the gaze of the viewers on the pyramid. Bonaparte is shown using a telescope to look out into the landscape. An aide-de-camp standing next to him holds a

map and points out in the same direction. A group of men to Bonaparte's right look out and gesture toward pyramids in the distance. Another man, whose uniform and activity designate him as an *ingénieur-géographe,* is seated, intently sketching the landscape in front of him. Two men to the right also participate in these activities of looking, pointing at the land in the distance. Here, the violence of military intervention is subsumed into the activity of looking at and recording the particularities of an expanse of land. The various instruments employed for this purpose in the print, whether a telescope, a map, a pointing finger, or an intently sketching *ingénieur-géographe,* all underscore the importance of long-range, accurate vision in the practice of imperial conquest. In this way, the print suggests that the discourse of imperialism is premised as much upon the imperative of literal territorial expansion as it is upon the representation of this fact in spatial, visual terms. As W. J. T. Mitchell has proposed, "Imperialism conceives itself precisely (and simultaneously) as an expansion of landscape. . . . Empires move outward in space as a way of moving forward in time; the 'prospect' that opens up is not just a spatial scene but a projected

future of 'development' and exploitation." Mitchell's argument implicates the genre of landscape painting but could be equally appropriate for maps as well as battle painting, which both involve the visual representation of expanses of land in varying scales and vantage points. The importance of imagined spatial projection to nineteenth-century imperialism also helps to explain the prized status of maps during the period. Maps, like landscapes and topographic battle paintings, suggest spaces to which bodies can gain access, and in the case of representations of recently conquered land, they also function as a metaphor for military power.[64]

Lejeune's paintings of the Egyptian campaign translated this more instrumental mapping impulse into the visual language of topographical battle painting for spectators back in Paris. Lejeune's paintings played upon this impulse to view Egypt in term of its territorial availability and offered up a sense of spatial mastery. While Lejeune would have had access to the unpublished geographic survey of Egypt undertaken by the *ingénieurs-géographes* for his three paintings of the Egyptian campaign, *The Battle of Aboukir*, *The Battle of Mont Thabor*, and *The Battle of the Pyramids*, it is more likely that his paintings are based on a well-known nonmilitary source, Dominique Vivant Denon's *Voyage dans la basse et haute Égypte*. Denon's lavish multivolume book was first published in 1802, the year he was appointed by Bonaparte as director of the Central Museums of France. Four of the illustrations in *Voyage dans la basse et haute Égypte* are devoted to the battle of Aboukir, including a battle plan, an up-close representation of the fort at the end of the peninsula, a bird's-eye view of the peninsula (fig. 32), and a general view of the battle (fig. 33) that resembles the kind of topographical views produced by the *ingénieurs-géographes*. The prominent outline of the Aboukir peninsula that extends into the background of Lejeune's painting was likely directly inspired by Denon's bird's-eye view of the same parcel of land. The key difference is that Lejeune has taken Denon's landscape and reversed it. This produces a startling spatial illusion that trumps the limits of vision and provides an impossible view into the depths of the landscape, verging on the cartographic. But strangely, the peninsula's surface features—the hill that leads to the background, the architecture of the fort, waves, boats, and individual trees—are also depicted topographically. Lejeune thus merged the cartographic and topographic features of the Aboukir peninsula into a single image that

presents itself as one sweeping, naturalized point of view (fig. 34). The landscape depicted in *The Battle of Aboukir* offered audiences a vantage point that goes above and beyond the idealized conditions enjoyed by the observers perched atop the pyramid in *Bonaparte, First Consul*. In the print, these viewers are privy to an unobstructed view of the Egyptian landscape that extends into a distant horizon line, but they are not high enough to perceive the geographic outlines of the territory they intend to conquer. For this, only Lejeune's highly inventive painting would do.

THE PROMISE AND PERIL OF PROXIMITY

Art critics consistently described the experience of viewing Lejeune's battle paintings as a thrilling encounter revolving around the promise of proximity to France's contemporary armed combats. As we have already seen, this understanding of Lejeune's work stemmed from its formal features and from the belief that it was a document of his experience rather than a product of his artistic invention. The value of proximity associated with Lejeune's battle paintings, it goes without saying, was deeply paradoxical, since the illusion of being close to a battle was premised upon the audience's physical remove from the theater of war and the mediating presence of an image. The "prospect" of imperialism, to invoke Mitchell's term, was attractive because it opened up the possibility of participating as a viewer in far-flung conflicts, while guaranteeing a safe distance from the violence. This enticing visual illusion helped to ensure these paintings' popularity at Salon exhibitions: art critics often referred to the throngs of spectators gathered in front of them. The small scale of Lejeune's paintings, moreover, physically encouraged viewers to approach them to see their details more clearly. As one critic who reviewed the Salon of 1804 warned, "If you like battles, then you will try, if you are able, to break through the crowd to see the paintings of Lodi, Mont Thabor, and Aboukir by Lejeune."[65] At the Salon of 1806, one critic marveled that Lejeune's small-scale works managed to hold the attention of the public. Even though its genre is less esteemed than history painting, Lejeune's *Battle of the Pyramids* "is always besieged by a large number of spectators who enjoy contemplating, outside of harm's way, a spectacle made to strike every imagination."[66] Another writer reflected on the value of Lejeune's paintings for members of the military, who "do not recognize their maneuvers" in large-scale epic history paintings of battle. He argued that Lejeune's battle paintings were

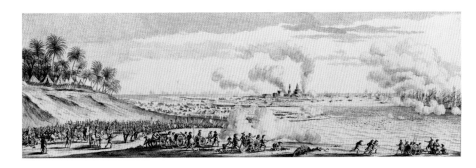

FIGURE 32 Dominique-Vivant Denon, *The Battle of Aboukir*, from *Voyage dans la basse et haute Égypte pendant les campagnes de Bonaparte en 1798 et 1799*, Paris, 1802. Etching, 6¼ × 19½ in. (16 × 49.5 cm). Bibliothèque Nationale de France, Paris.

FIGURE 33 Dominique-Vivant Denon, *The Peninsula of Aboukir*, from *Voyage dans la basse et haute Égypte pendant les campagnes de Bonaparte en 1798 et 1799*, Paris, 1802. Etching, entire sheet: 15⅞ × 21¼ in. (40.5 × 54 cm). Bibliothèque Nationale de France, Paris.

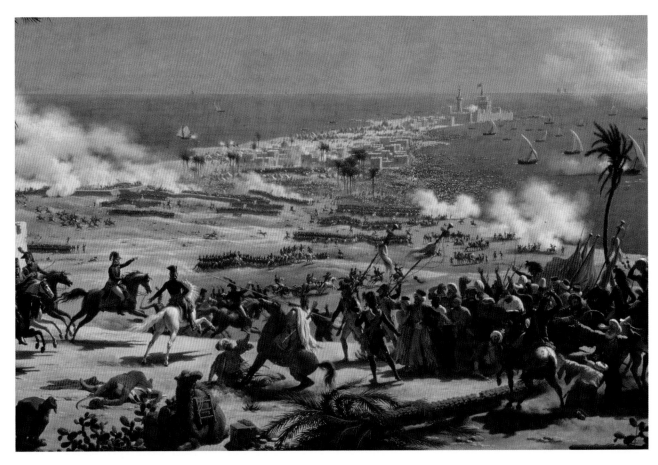

FIGURE 34 Louis-François Lejeune, *The Battle of Aboukir*, detail.

honored by a "row of spectators three deep" because of their commitment to representing the soldiers "in the order and in the positions they had at the moment of the combat."[67] The critic of the *Gazette de France* noted that instead of having to imagine what war looked like from written sources, Lejeune "could represent war as it happened and seize the combats at the perfect instant." This advantage of being both "actor and observer" meant that no other painter could "claim that his works excite the curiosity and the enthusiasm of the public" as much as Lejeune.[68]

Critics regularly deferred to the authority of soldiers to corroborate their own opinions on the disarmingly close-up encounter with warfare offered by Lejeune's battle paintings. While examining Lejeune's *Battle of Mont Thabor*, exhibited at the Salon of 1804, a critic "eavesdropped" on a soldier explaining the painting to a friend: "See there, said a soldier to his friend, see there, on the right, that mountain that rises like a cut-off cone? That's Mont Thabor. . . . I was there and it's there where I was wounded. . . . I'm no good at painting but this picture is true; so natural, the sites and the houses are so well imitated that I feel like I'm still there. My heart is beating like I've just heard a gun go off and I've just had the horror of getting wounded and it was not due to fear that it beat this way then."[69] This text stages an eyewitness experience in front of *The Battle of Mont Tabor* with great rhetorical effect. For this soldier, standing in front of Lejeune's painting is all too real: his rapidly beating heart is the product of a visceral reaction to the events depicted in the painting. In this way, critics relied on soldiers as rhetorical devices; they functioned as eyewitness experts capable of corroborating the authenticity of battle paintings beyond reproach. After overhearing the soldier's impassioned eyewitness testimony, the critic evaluates the episodes and concludes that "all of this is so truthful that there is nothing left to desire." He then attempts to move away from the painting and evaluate another one but finds that he is unable to do so. As he walks away from it, he discovers that "you cannot step away from this painting without turning around to look at it some more."[70] The responses of the critic and the soldier are thus both focused on the body's reaction to the painting before them. For the soldier, it is his beating heart; for the critic, it is his professional compulsion to look.

Despite their small scale, Lejeune's paintings were represented in contemporary criticism as eliciting physical, bodily responses, both from soldiers reliving the traumatic experience of war and jostling crowds gathered around the paintings, trying to get a better look. As forms of textual representation, contemporary critical accounts provided models for French audiences to forge corporeal, empathetic bonds with the conflicts being waged by the French army in far-flung locations. Whether soldiers actually experienced Lejeune's battles in this way, or whether the crowds were as populous as the contemporary critics make them out, is somewhat irrelevant for considering why this impassioned (and often corporeal) engagement figured so prominently in the reception of these battle paintings. Such responses to Lejeune's works, coupled with the constant affirmation of the paintings' capacity to re-create battles as they had actually appeared, suggest that audiences were looking for ways to negotiate and compensate for the physical and phenomenological disjunction between battle paintings and the expansive space of France's empire, whose borders were being reconfigured with every new military campaign. Perhaps more importantly, topographical battle imagery such as Lejeune's also worked to make the constantly expanding, contracting, and contingent French empire appear as stable space.[71]

THE HORROR OF THE DETAILS AND THE PERILS OF PROXIMITY

While topographical battle paintings such as Lejeune's and other visual material that has been discussed in this chapter proliferated in large part because of public interest in following the exploits of the French army, the question of how close audiences really wanted to come to these conflicts remains important. Contemporary commentators in France were simultaneously drawn to and repulsed by the prospect of up-close encounters with the horrors of war. In an extended discussion of the virtues of Lejeune's battle paintings, one critic described the thrill and danger of proximity to war: "There are storms more terrible that those of the ocean, still more deadly for humanity, more daunting for the arts and more dangerous especially for those who see it from up close; these are the disastrous scenes of war."[72] Denon contrasted war as an abstract, historical concept against the shock experience of viewing it up close: "O war, how you make for brilliant history! But seen from up close, how hideous you become, no longer able to hide the horror of your details!"[73] For Denon, the experience of getting too close to the battles of the Egyptian campaign stripped them of the epic grandeur with which an aesthete like Denon would have associated

them. Visual representations of French military intervention hinted at these horrors, yet enticed audiences through the allure of imaginative projection into the sites of French military intervention. Spectators could view hideous details yet be reassured that they were viewing them out of harm's way.

This situation changed radically between 1812 and 1813, with a series of devastating defeats for the Grande Armée in Russia and next in Prussia. These losses transformed the former thrill of distant territorial conquests into a horrendous site of trauma for soldiers and civilians alike. In the summer of 1812 the Grande Armée—a force of over 500,000 soldiers, by some estimations—gathered on the banks of the Niemen River. In September the French army arrived in Moscow, finding the city deserted and burning. The Russians had withdrawn to St. Petersburg, and the French army found itself poorly provisioned and far from its garrisons just as a harsh winter was setting in. The famous twenty-ninth *Bulletin de la Grande Armée* described the retreat of the Grande Armée from Russia in dire conditions: "the army without cavalry, feeble in munitions, horribly fatigued with fifty days' march, carrying along its sick and the wounded of so many combats." After describing the unimaginable misery visited upon the retreating soldiers, the bulletin incongruously concluded that "the health of the Emperor has never been better." Despite Napoleon's attempt to reassure French civilians that the Russian campaign did not portend a complete collapse of the French empire, the sheer distance between France and Russia had caused anxiety even before the terrible news of the twenty-ninth bulletin was published. Napoleon's losses in Russia precipitated another series of defeats that culminated in the arrival of the Allied army in Paris on March 31, 1814, the date of the official surrender of Paris.[74]

In her memoirs, Victorine de Chastenay, a Parisian aristocrat and occasional participant in the court life of Napoleon Bonaparte, recalled the horror of seeing maps of the march of the Grande Armée into Russia for sale in Paris: "Simple maps were published with color marks indicating the situation of our corps and the march of our army. This line, of a terrifying length, so thin and unsupported, made even the most confident tremble. It is said that the police prohibited the sale of this map." Chastenay's anecdote exposes the precariousness of territorial projection and of the "prospect" as an ideological and aesthetic condition of creating and sustaining empire. In reflecting on the

losses in Russia in 1812, the *Mercure de France* published a column that focused on the frustration of having to keep up with the constantly changing territorial conditions of military loss on a military map: "The reader, map in hand, following the order of the dates and the marches of the corps, must always with his pin, place the French headquarters a few leagues ahead of the place where the Russians crushed our army. This war therefore confounds all the ideas acquired up until now regarding the goal, the principles and results of military operations: the Russians having constantly and completely beaten the French on all points of attack."[75] This rare instance of despair in a French Napoleonic newspaper attests to the sense of disbelief on the part of readers and viewers as they attempted to keep pace with the retreat of the French army. The defeat of the army was signaled in spatial terms and could be represented as a literal retraction of pins on a map before one's very eyes. The impending redefinition of the borders of the French empire also provided a potent symbol for anti-Napoleonic caricatures: between 1813 and Napoleon's final defeat in 1815, maps became a form of symbolic currency to depict the foundering of France's campaigns of military conquest. In a caricature (fig. 35) that appeared after Napoleon's first abdication in 1814, *I Am on Pins and Needles*, a winged Napoleon looks at a series of posters, one of which announces "unexpected events." The caption reads: "I lose the map, I flap only one wing, I don't know which foot to dance on." Rolled-up maps of territories gained and then lost during the campaigns of 1812 and 1813 (losses that would become official at the Congress of Vienna in 1815) litter the ground: Holland, Switzerland, Italy, Spain. Only a fragment of the map of France remains in Bonaparte's hand as the rest falls to the ground. Here, the creative destruction of a map is used for very different political ends than in Monsaldy's *Triumph of the French Armies* of 1797, in which monumental maps of territory recently seized by the French army are torn asunder as a demonstration of military prowess.[76]

The language of abstract geographic notation of a map, as we have seen in this chapter, provided a form of distancing from the horrifying up-close particulars of a military campaign. The popularity of topographical military images also proposes that audiences were eager to come into visual contact with what Denon called the "horror" of details. Such horrible details were on full view for Paris audiences outside the spaces of Salon exhibitions and print seller windows when wounded French soldiers

Je suis sur les Epines.

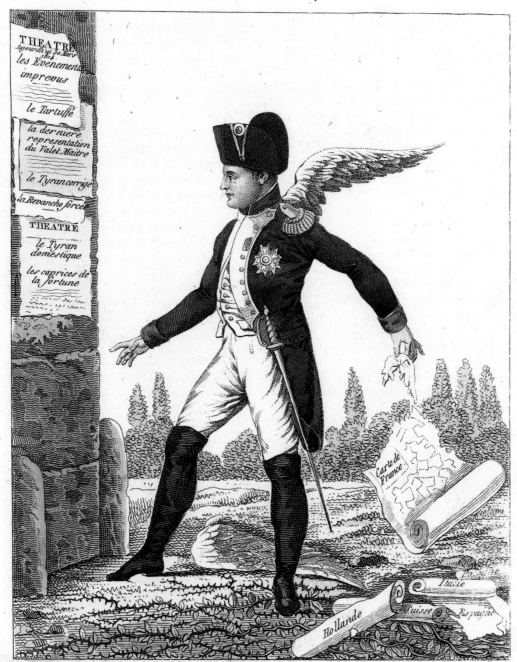

Je perds la Carte, je ne bats que d'uneaile,

Je ne sais sur quel pied danser.

FIGURE 35 Anonymous, *I Am on Pins and Needles*, 1814. Etching, 8¼ × 5⅞ in. (21 × 15 cm). University of Washington Library Special Collections, Napoleon Collection.

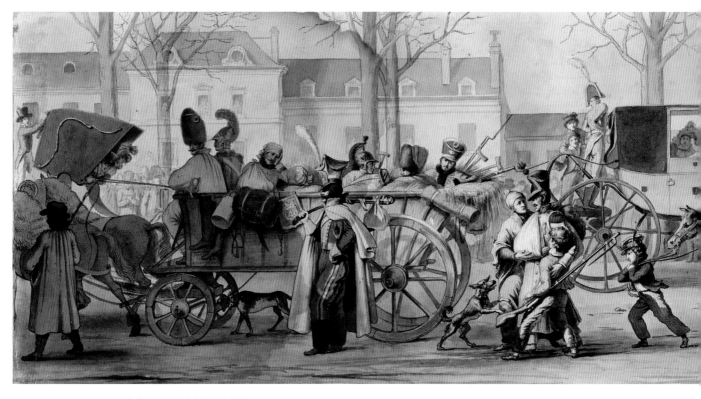

FIGURE 36 Etienne-Jean Delécluze, *Wounded French Soldiers Entering Paris after the Battle of Montmirail, 17 February 1814*, 1814. Watercolor, 13¾ × 40⅞ in. (35 × 104 cm). Musée National des Châteaux de Versailles et de Trianon.

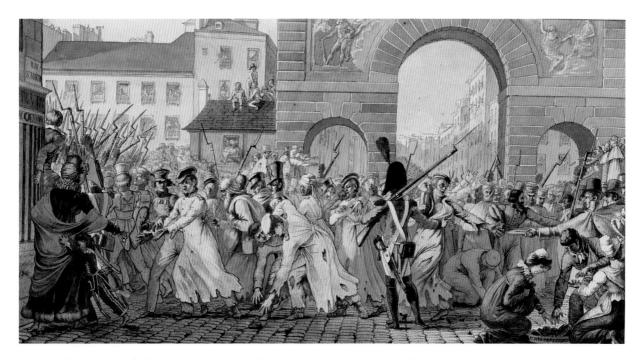

FIGURE 37 Etienne-Jean Delécluze, *Russian Prisoners Marching on the Boulevard Saint-Martin after the Battle of Montmirail, 17 February 1814*, 1814. Watercolor, 25⅝ × 13¾ in. (65 × 35 cm). Musée National des Châteaux de Versailles et de Trianon.

began to flood through the streets of Paris in 1814. A series of three drawings made by Etienne-Jean Delécluze, a former student of Jacques-Louis David, representing the events that marked the tumultuous end of the First Empire, speaks to the irresistible compulsion to look at war's horrible details up close. These drawings also speak to the challenge that contemporary military history posed to the traditional academic standards of artistic practice. Two of the drawings depict the return of wounded French (fig. 36) and Russian soldiers (fig. 37) after the battle of Montmirail in 1814. A third drawing (fig. 38) showed a scene from 1815: the encampment of allied soldiers who remained in Paris to assure the successful second return of the Bourbons following Napoleon's defeat and final abdication after Waterloo. All three of these drawings carry a notation in the bottom left-hand corner, *vidit*— in Latin, "things seen." The notation is significant, for it attests to Delécluze's own status as an eyewitness observer of these events and his compulsion to represent what was happening around him.

As a devoted student of David, Delécluze subscribed to the sets of beliefs and practices associated with grand manner history painting and was devoted to maintaining

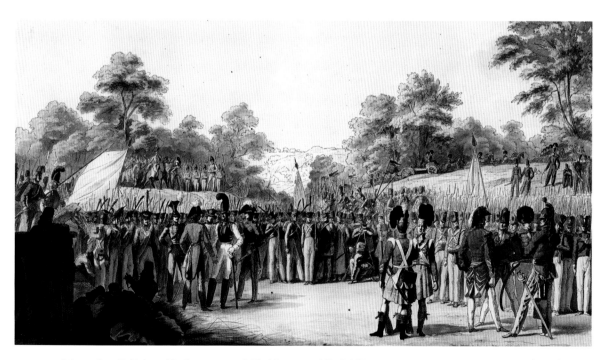

FIGURE 38 Etienne-Jean Delécluze, *The Encampment of Allied Russian and English Troops in Paris in 1815*, 1815. Watercolor, 25⅝ × 13¾ in. (65 × 35 cm). Musée National des Châteaux de Versailles et de Trianon.

its rigorous moralizing standards. In fact, when his peers welcomed commissions from Napoleon's government throughout the First Empire, Delécluze renounced painting altogether and refused to accept any state-sponsored commissions. For Delécluze, the classical tradition had compromised its rigorous system of values based on Greco-Roman traditions, abandoning them for the temporary favor of the government. Reflecting on the First Empire in his journal, Delécluze wrote that "the emperor and his regime fatigued me daily. The habits of adulation to which men of letters and artists had become accustomed were anathema to me. Little by little I lost courage, and I gave up the exercise of my art, painting."[77] In the absence of commissions from the government or other individuals, Delécluze occupied his time by copying the Marie de Medici cycle by Peter-Paul Rubens at the Luxembourg Gallery and began a successful career as an art and theater critic, about which more will be said in the chapters that follow. It was inconceivable that art could accommodate contemporary subject matter such as Napoleonic battles, which had in his opinion contributed to the ruinous state of history painting during the first part of the nineteenth century. In drawing what he *saw* and textually reminding his viewers of it in this series of three drawings, Delécluze effectively rebelled against his training and instead embraced a set of qualities more associated with lesser genres of war imagery. As we have seen, phrases such as *vidit, d'après nature,* and *peint sur les lieux* were routinely included in topographical battle imagery during the First Empire to make such representations appear as truthful eyewitness depictions.

Delécluze never publicly exhibited his three drawings or showed them in any Salons, nor were they reproduced in print form. They remained out of sight. Nevertheless, the drawings are unusually well documented, owing to a description that Delécluze gave to the curators at Versailles as part of the bequest to the museum at Versailles a year before his death in 1862.[78] Delécluze described the drawing of wounded French soldiers returning from the battle of Montmirail, one of the last battles before the emperor's first abdication in 1814:

> February 17, from two to three o'clock, the wounded of the French Imperial Guard, some of whom had participated in the Montmirail affair, made their entry in Paris along the boulevards, making their way to toward the Invalides hospital. . . . A mother supports her son, a soldier of the young guard, who is recognized by his dog. Behind, a young man, pulling a limping horse by the bridle upon which sits a grenadier whose head is wrapped in a bloody rag. . . . Beyond this sad and imposing procession, in the back of the picture, appear curious onlookers on foot and in carriages, moved by the spectacle so different from the gay and joyous one that they were used to seeing on the same day each year.

Delécluze's letter describing each scene reads like a description of a battle painting lifted out of a Salon catalogue. Though Delécluze emphasized the contemporaneity of his subject matter through the "vidit" notation in the bottom left-hand corner of the drawings, he attempted to impart hints of the antique to the procession, as befitted his aesthetic convictions. As an artistic subject, the procession recalls the iconography of Roman triumphal arches as well as friezes on ancient Greek temples. The horizontal orientation of the drawing, like an antique frieze, allowed Delécluze to imbue the line of French soldiers returning victorious from the battle of Montmirail with an air of solemn moral grandeur. Moreover, Delécluze even made reference to a famous episode from Homer's *Odyssey* in the middle of the drawing, where a dog runs up to a wounded soldier and wags his tail in recognition of his returned master. The incident recalls the moment where Ulysses, absent for twenty-eight years, is recognized only by his faithful dog Argos.[79]

Delécluze's recourse to a subdued form of classicism in all three of his drawings may have been an attempt to elevate what he probably perceived as an ill-advised subject for serious artistic practice. But even as he tried to redeem these contemporary military scenes, the appearance of the term *vidit* in all three of these drawings also provided a convenient hedge against the perceived lowliness of the subject. By asserting his position as a dispassionate observer of the events he depicted, Delécluze affirmed his drawings' status as mere historical documents and not as ambitious works of art, something that may have led him to donate them to the historical museum at Versailles and not to the great repository of fine art, the Louvre. In contrast to the works of art displayed at the Louvre or even at the Luxembourg (reserved for living French artists) during the Second Empire, Versailles was reserved for subjects

pertaining to French national history and was understood as a less artistically eminent collection.

Delécluze's notation of "vidit" on each drawing to designate a mode of representation distinct from the *beau idéal* reveals the profound problem that contemporary subjects posed to the aesthetic hierarchies of the classical tradition. Having bemoaned the slavish devotion of history painting to Bonaparte's political agenda under the First Empire, he thought the situation no better after the Bourbons assumed the throne in 1815: the willingness of painting to accommodate the subjects of contemporary political circumstance continued unabated. The former pupil of David thought that in taking on contemporary political subjects, painting had become "nothing more than a compliant art, ready to aid the new arrivals, just as it had served the one who had just fallen."[80] The only way for the Davidian tradition to renew itself would be through the representation of timeless, classical subjects. But as the unexhibited drawings make clear, the representation of contemporary events, especially military ones, during the period of prolonged peace after Waterloo allowed many artists to engage with a form of modern, lived experience that classicism forbade. In this way France's contemporary military endeavors had opened a floodgate for artists and audiences alike. French citizens became accustomed to viewing contemporary history as it happened. Even after peace finally came in 1815, the compulsion to look at war would remain more alluring than ever.

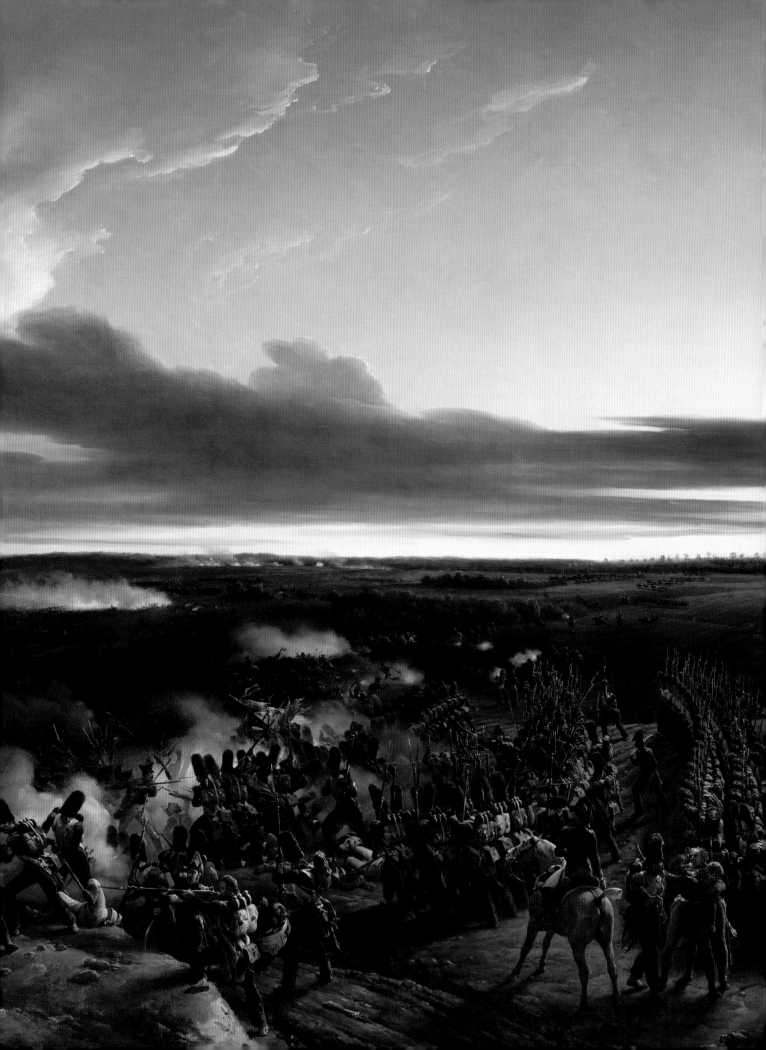

2 A Crowd Favorite

War Imagery and Politics by Other Means in the Restoration

At the Salon of 1817, the first held after the definitive return of the Bourbons to the French throne and while France was still occupied by allied forces, a small painting attracted so many spectators that it became one of the sensations of the exhibition. Exhibited anonymously under the title *View of the Monastery and the Ancient Bulls of Guisando, on the Banks of the Albergo, in Castilla,* the picture was far from the serene view of a Spanish mountain town suggested by its anodyne title (fig. 39). The Salon booklet offered a lengthy description of the painting, noting that "the author has transported into this landscape the event that happened to him on April 5, 1811, when he was attacked by eight hundred guerrillas of Don Juan Médico."[1] In addition to depicting the famous Neolithic bull sculptures and picturesque Spanish countryside referred to in the official title, the painting also featured an incident from the bitter guerilla war—famously depicted in Francisco Goya's *Disasters of War* series of prints—that eventually resulted in the retreat of the French army from Spain and helped to turn the tide against Napoleon in Europe. Viewers flocked to see the frenzied military encounter of Spanish guerillas and French Napoleonic soldiers. The crowds were so thick that fights reportedly broke out among those vying to view it, among them several critics who described having to wait: "When we perceived that the crowd around the *View of Guisando* was a little less large, we could approach it." In response to the scuffles breaking out in front of the painting, one newspaper was moved to plead with the administration, "We ask, in an effort to prevent such disagreeable scenes, that this difficult to see painting be placed higher on the wall."[2]

The cessation of major hostilities within Europe after 1815 only increased the public hunger for works of art that depicted contemporary warfare; these images provided an especially flexible area of visual culture through which ideas about the nation could be anchored, tested, and negotiated. No longer exclusively expected to perform as official propaganda or to keep pace with quickly changing military events, representations of war made during the Restoration responded to lingering questions that had percolated for decades about the organization, discipline, and agency of groups of individuals. In the face of the weakening of the French military and the reestablishment of noble privileges of birth within the Restoration-era French government, the reputation that the French army had earned during the Revolution and Empire as a meritocratic institution and as

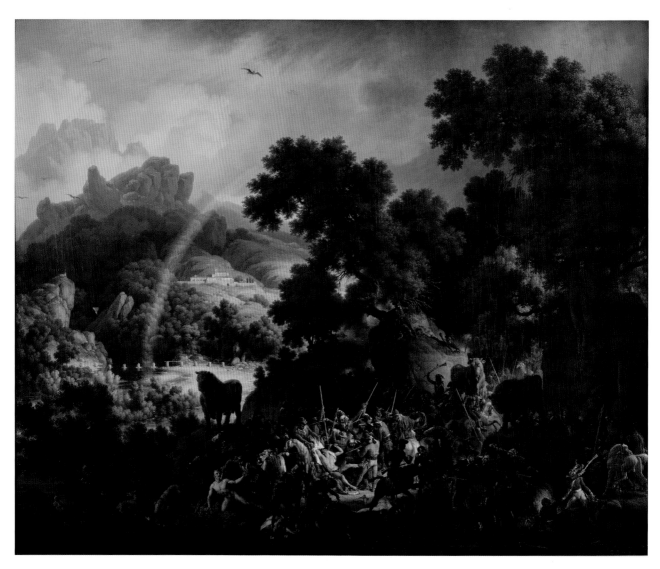

FIGURE 39 Louis-François Lejeune, *View of the Monastery and the Ancient Bulls of Guisando, on the Banks of the Albergo, in Castilla, 1817*, 1818–19. Oil on canvas, 82¾ × 102⅜ in. (210 × 260 cm). Musée National des Châteaux de Versailles et de Trianon.

an agent of social mobility contributed to a taste for imagery that recalled the revolutionary and Napoleonic period. The representation of the Restoration's own military campaigns, notably its brief expedition to Spain in 1823, proved less alluring to audiences.[3]

The chance to catch a glimpse of Napoleonic military history proved irresistible for viewers during the Restoration. This was because the Bourbons sought to erase most traces of Napoleonic military history, and specifically the figure of Bonaparte, from public spaces, including the Salon. In addition to promoting subjects favorable to the monarchy, the Bourbon government censored visual (and textual) representations that related to Napoleon Bonaparte and his armed encounters. These

policies, then called *oubli* and *mise-en-place*, promoted a compulsory forgetting of the past twenty-five years of revolution and empire. At the outset of the Restoration, the large-scale battle paintings that honored the military exploits of Napoleon Bonaparte and his generals were promptly rolled up and put into storage. The bronze statue of Napoleon atop the Vendôme column was replaced with a white Bourbon flag. Prints, coins, sculpture busts, songs, and plays that invoked the recent past were often targeted by the authorities. Despite these strong official political reactions against the representation of Napoleonic and revolutionary military subjects, however, censorship was unevenly applied, and these works continued to appear at Salon exhibitions, in

illustrated books, as luxurious reproductive engravings, and, perhaps most prominently, as prints. Even though France was no longer at war with its European neighbors, the depiction of military conflict not only endured but flourished. Artists who specialized in military imagery were ensured a steady stream of income and broad public recognition in the press.[4]

Just like the many critics who wrote about *Guisando*, the crowds that gathered around the anonymously exhibited battle painting at the Salon of 1817 recognized the artist as Louis-François Lejeune. Lejeune had likely taken the precaution of exhibiting anonymously because he feared—knowing that military subjects ran counter to the prevailing official taste in painting—that his painting would be rejected by the Salon jury. Though the painting contained the familiar hallmarks of his style of battle

painting, including topographic specificity and a proliferation of episodic actions, *Guisando* is unlike any of his previous works in its focus on individual, heroic action, notably that of the painting's author, who is pictured as a victim of the attack at center (fig. 40). An area of inexplicable light shines down on the focal point of the painting in the middle of the foreground: Lejeune, completely stripped of clothing, although a guerrilla's foot covers his genitals. Other nude figures appear throughout the painting: two lifeless nudes are splayed out in the foreground, and another nude, Lejeune's servant Williams, is pictured in the left middle ground, with a sword driven through his torso. The artist's nudity was explained in the *livret* as the result of having been attacked and robbed by the guerrillas, a fact corroborated in Lejeune's memoirs. Lejeune's decision to make himself the center of his first

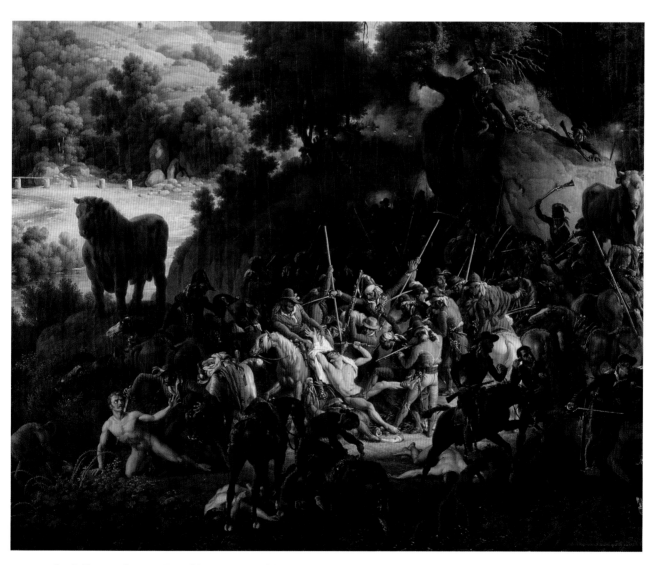

FIGURE 40 Louis-Francois Lejeune, *View of the Monastery and the Ancient Bulls of Guisando, on the Banks of the Albergo, in Castilla, 1817,* detail.

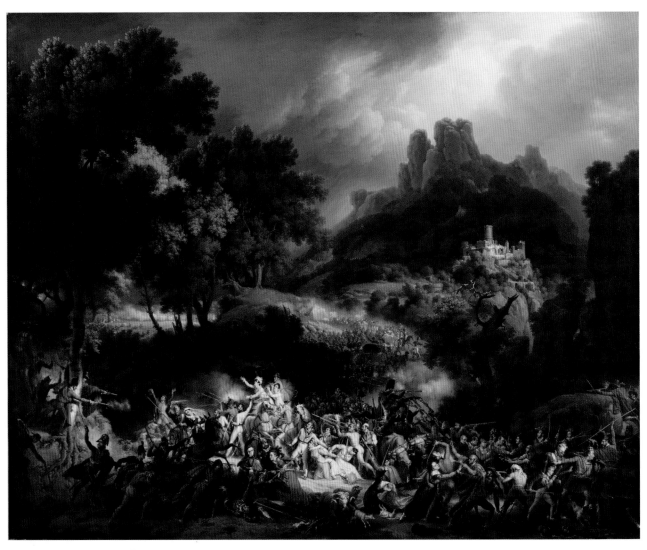

FIGURE 41 Louis-Francois Lejeune, *View of the Attack on the Grand Convoy, near Salinas*, 1818–19. Oil on canvas, 83⅞ × 104¼ in. (213 × 265 cm). Musée National des Châteaux de Versailles et de Trianon.

painting of Restoration is surely a reflection of the charged political atmosphere in which it was exhibited: in 1817, a personal drama likely played better with Bourbon censors than the depictions of famous French military encounters that Lejeune had regularly exhibited during the Empire. This attempt to obscure the painting's Napoleonic subject by showing it anonymously and not explicitly referring to war in its title, however, only made the work more alluring, since it enlisted the public's help in deciphering it as a Napoleonic battle painting made by one of the most recognizable officer-artists of the Napoleonic Wars. The painting spoke to its public in an easily understandable code: here were the illustrious military encounters of the recent past on full display, but only if you knew where to look.[5]

Lejeune followed suit with his 1819 Salon entry, *View of the Attack on the Grand Convoy, near Salinas,* which was exhibited under his name, and which many critics incorrectly inferred was also based on his personal experiences in the Spanish war (fig. 41). At the time of the incident, in late May 1812, Lejeune had already joined up with the Grande Armée, which was preparing for the invasion of Russia. The subject of the painting, which alluded to Napoleon Bonaparte's defeat in Spain, gave the artist an opportunity both to align himself with France as a defeated nation under the Bourbons and to continue to satisfy the public hunger for Napoleonic battle scenes. The painting depicted an infamous incident in which a French convoy of Spanish allies, English prisoners, and aristocratic women associated with the court of Joseph

FIGURE 42 Louis-Francois Lejeune, *View of the Attack on the Grand Convoy, near Salinas*, detail.

Bonaparte was attacked by Spanish rebel soldiers on its way to France. The subject was especially suited to official Bourbon tastes, since it represented the Napoleonic army in disarray and also showed English prisoners heroically fighting on behalf of the French against the rebels. In the context of the government's pursuit of peace with its former enemies and the departure of the allied occupying forces from French soil just a few months before the opening of the Salon of 1819, Lejeune's submission was particularly topical. The painting also valorized a demographic that had been key to the war effort at home and in the theater of war, but was practically invisible in previous Napoleonic battle paintings: French women. *Salinas* was unlike any of Lejeune's previous works, and indeed unlike any other previous Napoleonic battle painting, in its

depiction of hand-to-hand combat among men and women. In one of the most extraordinary instances, a *vivandière* (or sutler), named in the Salon *livret* as Catherine, is depicted as the most effective fighter among four wounded men, who are also shown defending themselves against the attack. She thrusts a bayonet at a Spanish attacker as she simultaneously shoulders a wounded dragoon (reportedly her husband) who, along with his other male soldiers, is visibly too wounded to fight (fig. 42). *Vivandières*—officially regulated businesswomen, whose job it was to sell food, alcohol, tobacco and other coveted items in short supply—were part of every regiment (other forms of female military participation included laundresses, who were understood to occupy a comparatively lowly status). They occasionally, like

Catherine, also got caught in the line of fire, though they were seldom rewarded for their bravery as the men were.[6] This exceptional inclusion of a woman in combat is accompanied by less surprising episodes that depict women in more conventional maternal roles; in particular, the woman in the middle of the foreground with her arms up, reacting to her child in danger, calls to mind the female figures in Jacques-Louis David's *Intervention of the Sabine Women.* Noblewomen, likely part of Joseph Bonaparte's fleeing court, are also depicted, such as those who remain in the carriage in the center of the painting. In his homage to aristocratic Frenchwomen caught in the crossfire and his depiction of the heroism of French female combatants, Lejeune portrayed women as key players in Napoleonic military history. Like Lejeune's other works at previous Salons, *Salinas* reportedly attracted crowds, this time so large that critics routinely complained about not being able to see the painting. While Salon criticism often assumes a bourgeois male to be the emblematic Salon viewer and rarely refers to the presence of female viewers in the space of the Salon, it is important to recall that women were most definitely on hand at the Salon of 1819 to witness their military participation in Lejeune's painting. When one of the many effusive commentaries warned would-be viewers, "You have to enter into combat to get up close to this painting," is it not hard to imagine that women were likely among those members of the public who entered into the polite fray, eager to see their contributions given the honors of being pictured by Lejeune's brush.

At the Salon of 1817, another group of Napoleonic military paintings also reportedly attracted big crowds: a series of small genre paintings by the young painter Horace Vernet. These works were listed in the catalogue under the generic title of "plusieurs tableaux, même numéro" ("several paintings, same number") and as "a battle" that most critics identified as the battle of Somosierra—or, in the careful words of the critic Landon, "the last war in Spain."[7] Other smaller-scale Napoleonic paintings included a portrait of a Napoleonic general, a *Halte*, a *Bivouac*, and an *Attaque d'avant-poste.* No artist would become more associated with the surge in enthusiasm for military subjects in art than Horace Vernet. Despite, or perhaps because of, the government prohibition against Napoleonic military subjects, Vernet's reputation skyrocketed during the Bourbon Restoration; he would remain the most important military painter up through the 1850s. The son of Carle Vernet and

grandson of the famed maritime painter Joseph Vernet, the younger Vernet excelled at cultivating a broad public across the political spectrum with his pictures of French military subjects. The artist's well-known liberal political sympathies and prolific production of Napoleonic imagery earned him a steady stream of patrons who were former Napoleonic officers and members of the liberal political elite. More surprising was Vernet's ability to build important relationships with Bourbon officials and members of the royal family, including Louis XVIII's heir to the throne, the duc de Berry, and Auguste de Forbin, the director general of royal museums, who is pictured prominently in the foreground of Vernet's portrait of his atelier on the rue des Martyrs (see fig. 87).[8] Vernet also benefited from several high-profile government commissions from the Bourbon government, including several large-scale paintings for the royal family immediately following his 1822 protest exhibition (*Louis-Antoine of Artois, Duke of* Angoulême [see fig. 77] and *Charles X Reviewing His Troops on the Champ de Mars,* commissioned in 1823 and 1824 respectively). Official honors soon followed, with the medal of the Légion d'Honneur awarded by King Charles X in 1825. The next year, he was elected by his peers to the Académie des Beaux-Arts.[9] In addition to producing works that were palatable to the Bourbons and becoming a member of France's most important art institution, Vernet managed to exhibit paintings with overt revolutionary and Napoleonic military subject matter at the Salon exhibitions of 1817, 1819, 1824, and 1827. The nascent medium of lithography, which came into social use in France after 1815, also made it possible for war imagery to reach a wider audience during the period; in addition to his painting practice, Horace Vernet was, for example, also a prolific lithographer.[10]

At the Salon of 1827, where Vernet's battle painting *The Crossing of the Arcole Bridge* (see fig. 59) appeared, an anonymous critic took comfort in the vogue for battle painting, so prominent during the Napoleonic period, was now definitively over: "One cannot deny that the *military century,* as it has been called, is thus closed and completed, that the vogue for battles in painting has passed, and that it requires a great deal of courage or a committed calling to deliver oneself now to this thankless and scorned genre."[11] The critic's pronouncement of the death of "the military century" was rhetorical–after rendering his opinion about the imminent demise of battle painting, this same critic reviewed three of the battle paintings on display. The seemingly paradoxical persistence of

military painting during a time of peace puzzled many contemporary commentators, who understood it as a genre that required a steady number of conflicts to remain relevant. This view was prevalent among more conservative critics who, feeling that under Napoleon battle painting had been little more than a political instrument in the service of a wartime government, welcomed its imminent demise.[12] These opinions nevertheless had to be squared against the astounding popularity of works like Lejeune and Vernet's. For critics writing about these paintings at a time when the subject of the Napoleonic Wars was widely regarded in official Bourbon circles as both unfashionable and politically suspect, the presence of the crowd provided a convenient rationale for reviewing them. The popularity of such work, moreover, allowed critics to distinguish their more educated taste from those of the abstract masses of spectators: "If it were necessary to evaluate the works in the Salon in the order of the curiosity they inspire, [Lejeune's *Guisando*] would be judged without question first. This . . . indicates less the perfection of a painting than the interest in its subject . . . [and] in the genre that produces strong impressions, and is able to charm the crowd."[13]

The hunger of audiences for military-themed works of art can be taken as a historical fact—it is likely that spectators crowded around these paintings at Restoration Salons, just as they reportedly did during the Salon exhibitions of the First Empire. While critical mention of crowds in Salon criticism was not unique to the Restoration, the repeated invocation of the crowd must also be interpreted in its particular historical context, as a feature of Salon criticism of a post-1815 historical moment, when Napoleonic battle paintings offered spectators the possibility of a retrospective reckoning with historical events whose meaning were hotly contested. What did it mean for audiences to be "charmed" by scenes of military violence at the time? In the wake of military defeat under Napoleon, war was viewed by many as an aberration, but for the crowds gathered around Lejeune and Vernet's battle paintings, war was something to be admired and celebrated. In demonstrating their preference for works of art with military subjects that went against official taste, these crowds point to an area of political sensibility within Restoration-era France. At a time when only property-owning male elites could vote and participate in official, institutional politics, the viewing of a picture of war emerged as an important means for audiences to stake out their relationship to political power, and

to devise opinions about the troubled past and the uncertain and divided present.

WAR IN THE GALLERY: BATTLE PAINTING AT SALON EXHIBITIONS DURING THE RESTORATION

After 1815, the Bourbons promoted their own version of battle painting by commissioning paintings of subjects that could construct a decidedly royalist military historical identity for France, instead of one rooted in Napoleonic military history. Two large-scale paintings that honored royal military achievements were exhibited at the Salon of 1817: Horace Vernet's *Battle of Tolosa* (fig. 43) and François Gérard's *Entry of Henri IV into Paris* (fig. 44). Gérard's *Entry of Henri IV* was commissioned to replace his 1810 painting of one of Napoleon's important victories, *The Battle of Austerlitz* (see fig. 23); the painting remained on display in the Conseil d'État in the Tuileries Palace (during the July Monarchy, King Louis-Philippe moved the painting into the Gallery of Battles at the Musée Historique at Versailles). Gérard was offered the opportunity to produce a new painting with the same monumental dimensions (16 feet 8 inches by 11 feet 6 inches) by the government and was paid handsomely for his efforts; he selected the subject himself.[14] In the *Entry*, Gérard replaced Napoleonic military heroes with the conciliatory figure of Henri IV, the first Bourbon monarch and the French king who brought the bloody wars of religion to an end at the end of the sixteenth century. The painting depicts the king's triumphant entry into Paris and the gratitude of the bourgeois of Paris, who gather on the city streets to greet him. Where a spatial void in the middle of *Austerlitz* between generals Rapp and Bonaparte establishes a temporality of anticipation about the news of the outcome of the battle that will soon be delivered, in the *Entry*, this void is filled by a triumphant Henri IV entering into Paris to establish peace. The dead and injured soldiers, struggling horses, and weapons that populate the foreground of *Austerlitz* are transformed into lavishly costumed princes and crowds of spectators who show their gratitude to the new French king for having forged peace. The strikingly similar compositions of *Austerlitz* and the *Entry*, which involve a series of spatial substitutions from one picture to the other, speak to the way that the thematics of war and peace informed the political agendas of successive postrevolutionary governments. Vernet's *Battle of Tolosa*, the artist's first large-scale history painting, represents a battle from the Crusades in which the kings of

FIGURE 43 Horace Vernet, *The Battle of Tolosa*, 1817. Oil on canvas, 59⅜ × 193¾ in.
(405 × 492 cm). Musée National des Châteaux de Versailles et de Trianon.

FIGURE 44 François Gérard. *The Entry of Henri IV into Paris,* 1817. Oil on canvas, 200¾ × 377¼ in. (510 × 958 cm). Musée National des Châteaux de Versailles et de Trianon.

Aragon, Navarre, and Castile outmaneuvered the Moors in Spain in 1212. Vernet represented the battle as a series of interlocking bodies in the heat of combat, with a clear formal debt to the figure arrangements of Napoleonic history paintings by Girodet and Gros. Bodies of horses and soldiers threaten to tumble out of the compressed space in which the action occurs. Despite critical consensus that the painting lacked clarity and unity of action, Bourbon authorities deemed it sufficiently important to be transferred to the Luxembourg Gallery, the official museum for contemporary French art, following its exhibition at the Salon of 1817. This turn to medieval history met with the approval of the critic for *La quotidienne,* relieved that he could gaze upon Vernet's "beautiful and vast composition of carnage . . . without the fear of recognizing among the dead a brother or a friend."[15]

The "beauty" that could be seen in Vernet's *Battle of Tolosa* could register as such because it occurred in a distant era. In contrast to more contemporary conflicts, medieval carnage was historical and could therefore be generalized, and with the exception of famous figures from the past, such as the king of Navarre on his white horse in Vernet's *Tolosa,* the violence committed might even be anonymous. The turn to a temporally distant idea of French military history in Gérard and Vernet's battle

paintings should be understood in dialogue with one of the main rallying points for anti-Napoleonic cultural commentators during the Restoration regarding the Napoleonic Wars, namely their brutality. In the words of one conservative, pro-Bourbon critic writing for *Le Conservateur* in 1819 and likely referring to Gros's *Battle of Eylau* (see fig. 22), even the most distinguished Napoleonic battle paintings during the Empire presented to French audiences "scenes of carnage, in their horrifying monotony." Front and center in these paintings was "their motherland's executioner, standing upon the corpses of their children and gaining life, so to speak, by exhaling death."[16] In his classic study *The Crowd in the French Revolution,* George Rudé concluded that the militarization of France effectively silenced the crowds of the revolutionary era: in this line of thinking, mass mobilization and the disciplinary culture of the military stymied popular uprisings and brought the uprisings of the French Revolution to a close. Napoleon's adept use of propaganda shifted focus away from his dictatorial policies and the sacrifices they demanded. National spectacles such as military parades, firework displays, and monumental history paintings of Napoleon's battlefield exploits served as distancing subterfuges. While scholars such as Alan Forrest have shown that dissent existed within the ranks of

Napoleon's armies, decades of uninterrupted warfare, economic disruptions, and other difficulties related to France's militarization also meant that Napoleonic soldiers (and civilians) who might have otherwise participated in popular uprisings were often preoccupied with merely staying alive.[17]

For many contemporary observers, Napoleonic battle painting represented atrocity, not glory; it was evidence of a troubling chapter of French history and signaled the decline of painting, misled under the aegis of a despot hungry for self-promotion at the expense of the French people. From this point of view, it might appear that the widespread interest in images related to Napoleon's reign constituted a symptom of collective amnesia, a willingness to forget the depravations endured, whether as civilians or soldiers, during the Napoleonic Empire. The crowds that surrounded Vernet's paintings of Napoleonic military subjects found something quite different than deplorable scenes of abject violence. If medieval war could be viewed as beautiful in Vernet's *Battle of Tolosa* because the actors were not one's contemporaries, it was precisely for the opposite reason that large crowds gathered around Vernet's other paintings of Napoleonic military subjects: in these paintings, viewers were invited to recognize their contemporaries and perhaps even themselves. While images of the recent military past would have necessarily recalled suffering, the constant references to crowds gathered around Napoleonic paintings suggest a willingness to look past these associations and see instead works of art that spoke to the participation of ordinary people in the great deeds of their own lifetimes.

At the Salon of 1817, Vernet's small-scale painting exhibited under the generic title of *Une Bataille* (*The Battle of Somosierra*, fig. 45) drew large crowds because of its legendary subject: the Polish light horse squadron, whose heroic charge against the last holdouts of the Spanish army gathered at the Somosierra Pass cleared a path for Bonaparte to advance toward Madrid, a city that ultimately capitulated to the French. The attack was one of desperation, since Bonaparte allegedly understood that the Polish soldiers would take heavy fire, but ordered it anyway.[18] Vernet represented the Polish squadron just after the charge, which resulted in devastating losses for the Poles: sixty out of sixty-eight men who participated in the charge died.[19] Two days later, the wounded were still left lingering on the battlefield. After the battle, the emperor immediately set off for Madrid: Vernet

represents this departure as a minuscule detail in the left background (fig. 46), where the *général-en-chef* rides past corpses that line his path. This very well could have been interpreted as a sign of Bonaparte's callous indifference to the suffering of his subordinates, which was a key part of Bourbon anti-Napoleonic propaganda at the time, though the focus remains decidedly on the Poles. The incident gave Vernet a way to invoke the idea of war's consequences and the emotional toll it took on survivors. In the painting, the bloody bodies of wounded and dying fill the foreground; those who escaped death embrace the fallen in visible outpourings of grief. Those still surviving embrace each other in recognition of the feat of escaping death. Vernet thus represents those who participated in the Napoleonic Wars as marked by (an exclusively masculine) collective trauma. Such a theme was in keeping with the Bourbon view of Napoleonic war in terms of its brutality, and helps to explain why this painting could have been exhibited in the Salon of 1817. Because of this, in conjunction with the fleeing figure of Napoleon in the background, the painting may have even given audiences license to decry the emperor's willingness to sacrifice his soldiers for victory.

While the Bourbons rejected Napoleonic military history as an acceptable subject for official art and sought to maintain peace within Europe, they were all too aware of the public's enthusiasm for it. In 1823, the Bourbons finally had an opportunity to try to position themselves as military leaders and focus the public's attention away from the devastating loss of 1815. In response to a liberal uprising in Spain, Louis XVIII mobilized the French army, which it called the "Hundred Thousand Sons of Saint Louis," led by the duc d'Angoulême, to restore King Ferdinand VII to the throne. The Bourbons viewed themselves as the rightful protectors of royal authority in Europe and relished the chance to win a war in a place where Napoleon had lost years earlier. The brief campaign resulted in a swift victory for the royalist army. Taking a cue from Napoleonic strategies of propaganda, the Bourbons sought to stir public excitement over the Spanish campaign in the form of festivals, monuments, and the commissioning of works of art. When the duc d'Angoulême returned victorious from Spain, he was honored with a triumphal entry and a national festival that featured distributions of wine and food to the working class. The war's seminal event, the capture of the Trocadero, was performed as part of the act at the Cirque Olympique, at the Franconi Brothers circus,

FIGURE 45 Horace Vernet, *The Battle of Somosierra*, 1816. Oil on canvas, 31⅞ × 39 in. (81 × 99 cm). National Museum, Warsaw.

and at Daguerre and Bouton's diorama, which King Charles X (Louis XVIII had recently died) came to view.[20]

The first painter tasked with making a large-scale painting of the capture of the Trocadero was Antoine-Jean Gros. The request for one of Napoleon's most important battle painters to execute the most notable painting of the campaign suggests that the Bourbons were eager to create their own image-based legacy of military achievement.[21] But after Gros failed to produce a painting by 1826, the government awarded the commission to one of his students, Paul Delaroche. Delaroche's *Capture of the Trocadero,* which appeared at the Salon of 1827, is now known through prints (fig. 47). Delaroche's depiction of the most dramatic event from the Bourbons' war in Spain employed the heroic dimensions of the official large-scale battle paintings pioneered by artists under Napoleon. Delaroche gave pride of place to the duc d'Angoulême and his generals in the foreground, who preside over the action, gazing into the distance, where the fighting occurs. A dead soldier slumped over the barrier just in front of the group of commanders serves as one of the few signs of the horrors of warfare in a painting that is short on clearly identifiable superlative action. The barrier itself, which takes up nearly a quarter of the composition, separates the painting into zones of action and zones of observation, placing the viewer in the space of the Bourbon commanders. It is an uncharacteristically detached viewpoint for a nineteenth-century battle painting. Literally kept at a distance from the chaos of warfare, the viewer is instead granted the privilege of proximity to Bourbon military power. Such distancing was in accord with the official Bourbon recrimination of what was perceived as the excessive violence of Napoleon's wars. This predilection for producing battle paintings that do not directly implicate the military commanders in war's violence may help to explain *Trocadero*'s lukewarm reception. Delécluze noted in his review in the *Journal des débats* that the painting attracted public attention, along with other large-scale history paintings. But Delaroche's work failed to attract the same degree of notoriety as the comparatively smaller (and less prominently placed) Napoleonic military paintings, with their much-discussed crowds, at Restoration Salons.[22]

The excitement over images of war during the Restoration was focused mainly on revolutionary and Napoleonic military history rather than on the Bourbons' royalist campaigns. The failure of the monarchy to generate public enthusiasm through works of art was powerfully apparent at the Salon of 1824, where paintings that represented the Spanish campaign were displayed alongside Napoleonic battle paintings, including most notably Horace Vernet's *Battle of Montmirail* and *Battle of Hanau* (figs. 48, 49), along with several smaller-scale works. The abundance of paintings by Vernet at the Salon of 1824 came just two years after the censorship of two of his Napoleonic paintings from the previous Salon. In reaction to this slight, Vernet withdrew (almost) entirely from the official Salon and held a private exhibition in his studio.[23] The publicity generated by this rebuke to the politics of censorship of Revolutionary and Napoleonic military history helped him to craft a public image as one of the bold new leaders of the generation of post-Davidian painters. The censored paintings, *The Battle of Jemappes* and *The Clichy Gate* (figs. 50, 51), represented the historical bookends of France's military adventures: Jemappes, in 1792, was the first important offensive victory for the armies of the First French Republic, and the defense of Paris at the Clichy gate, in 1814, represented the last stand of the French National Guard against Russian attack. Of over forty paintings of a range of subjects, including portraits, landscapes, and genre paintings, about half were somehow related to Napoleonic military history. For the following Salon, in 1824, Vernet was welcomed back into the official exhibition space by the authorities; he was allowed to show nearly two dozen works, including several of the paintings that had been on display in his 1822 studio exhibition, including the formerly rejected *Clichy Gate.* The presence of so many of Vernet's works related to France's Napoleonic military history overshadowed that of a half dozen paintings of subjects pertaining to the Bourbon campaign in Spain, including Vernet's own imposing, full-size equestrian portrait of the duc d'Angoulême, commissioned by the Bourbons in an effort to emphasize the military prowess of the leader of the Spanish campaign. Other paintings related to the Spanish campaign included Hippolyte Lecomte's *Avant-poste de l'armée française au bivouac, dans la Sierra Morena* (private collection) and Eugène Lamy's *Combat at the Miravete Gate* (now lost).[24]

The absence of important, compelling works was noted by the liberal critic Augustin Jal, who quipped that "the successes of our soldiers in Spain has not really inspired our painters."[25] On the other hand, critical excitement over the display of so many of Vernet's works from his 1822 studio exhibition in the official space of the Salon

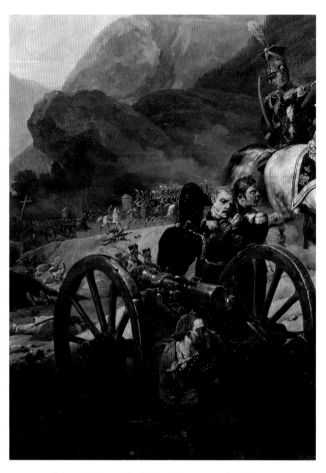

FIGURE 46 Horace Vernet, *The Battle of Somosierra*, detail.

was palpable. In his review of the Salon of 1824, Stendhal hailed Vernet's *Battle of Montmirail* as a "masterpiece" because of its ability to summon an idea of heroic Frenchness that was contemporary and accessible. Vernet had made *Montmirail* (along with *Hanau*, *Valmy*, and the censored *Jemappes*) for the liberal-leaning duc d'Orléans, one of Vernet's most reliable patrons for his military-themed works. In each of these four battle paintings, Vernet employed a similar formal strategy, combining an expansive topographical landscape with episodic actions scattered throughout. Vernet spared no detail, down to weapons, buttons on uniforms, and vegetation. Smaller in scale than the grand manner battle paintings that Gros and Gérard made under Napoleon, Vernet's four paintings for the duc d'Orléans also employed a completely different strategy of composition, in which action is spread across the entire expanse of the painting rather than focused on a single, transcendent military hero. In this sense Vernet's battle paintings have more in common with Lejeune's small-scale works and with the hunting and battle paintings made by his father, Carle Vernet. In Vernet's *Montmirail*, as in the other three paintings in the series, the principal actor is a military collective, not a

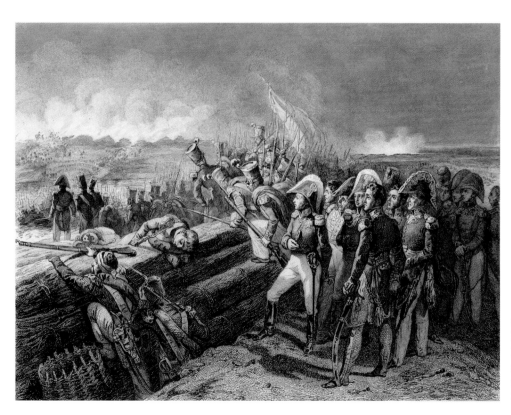

FIGURE 47 Achille Désiré Lefèvre, after Paul Delaroche, *The Capture of the Trocadero*, c. 1826–30. Engraving, 8¾ × 11¾ in. (22 × 30 cm). Yale University Art Gallery.

high-ranking collection of individuals who command or observe. Man-to-man fighting takes place throughout the painting, with pockets of relative calm, such as the lines of soldiers in the right half of the painting, contrasted to the direct, chaotic fighting of the left side; dead soldiers appear throughout the foreground (fig. 52). Vernet placed these scenes of direct combat in an expansive, swirling gray-and-blue landscape that imparts a further sense of drama to the scene. The horizontal orientation of the paintings, the proliferation of small, clear details, and the spread-out nature of the action compel close viewing. As with Lejeune's smaller-scale battle paintings, Vernet's use of this diminutive scale ensured that crowds would gather for a chance to catch a glimpse of the action. This is precisely how Stendhal famously understood the value of the painting, as an opportunity to view one's contemporaries in a historically significant encounter. Contrasting *Montmirail* with another famous battle painting, Jacques-Louis David's history painting of an event related to the founding of Rome, *Intervention of the Sabine Women* (1799; Musée du Louvre), Stendhal concluded, "What is *romantic* in painting is the *Battle of Montmirail*. . . . The *romantic* in all the arts is who represents the men of today, and not of these heroic times so far removed from us, and who probably never existed."[26]

Paintings like *The Battle of Montmirail* and other works that addressed Napoleonic and Revolutionary military history in an approachable, vernacular mode earned Vernet a moniker that would stay with him for the rest of his career: "national painter." By the 1830s and up through Vernet's death in 1863, this status would become a cliché of art criticism, and would earn Vernet the scorn of critics such as Charles Baudelaire, who consistently faulted him for a lack of imagination and a facile pandering to French national bravura. But during the Restoration, the act of calling Vernet a "national painter" was far from a cliché: it constituted a political act, designating military imagery of the recent past as a point of commonality for the abstract entity known as the "French nation," which was still reeling from its defeat, the continued occupation of its territory by allied forces, and divisions entrenched by decades of revolution and war. Étienne de Jouy, a liberal art critic writing at the time for *La minerve française*, was one of the first to use the term in 1819, when at the Salon that year, Vernet exhibited no less than twenty-two paintings, many of which represented Napoleonic

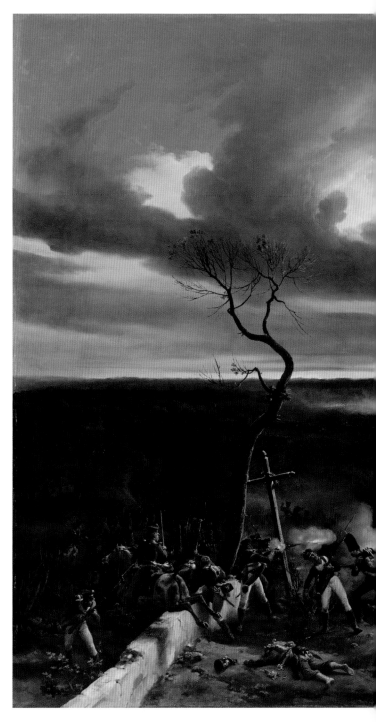

FIGURE 48 Horace Vernet, *The Battle of Montmirail*, 1822. Oil on canvas, 70⅛ × 114¼ in. (178 × 290 cm). Bequeathed by Sir John Murray Scott, 1914. National Gallery, London.

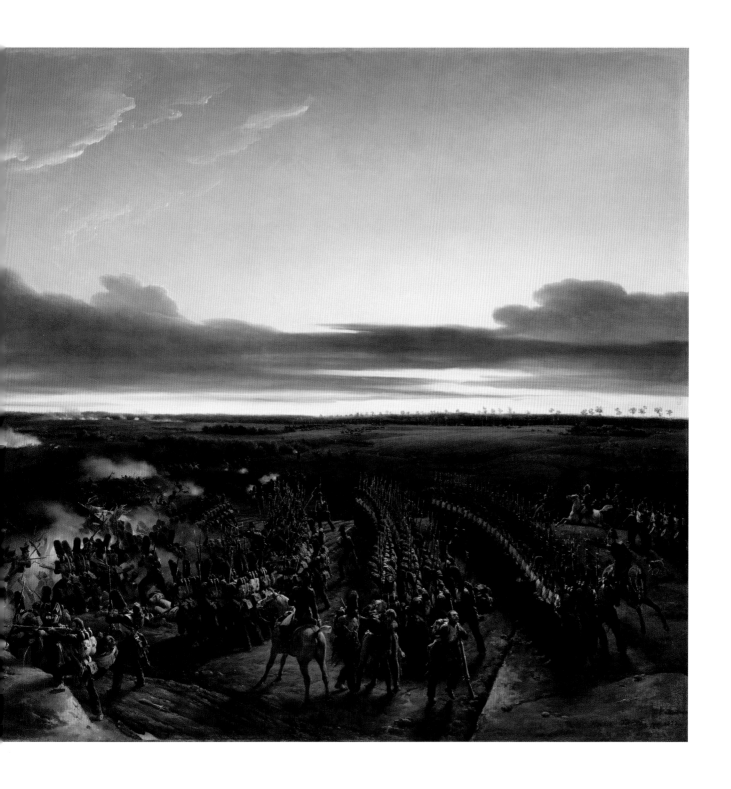

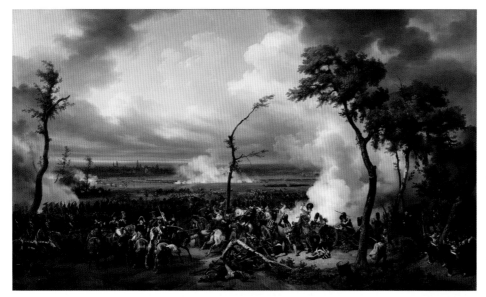

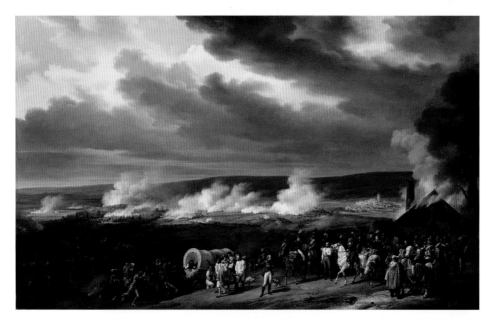

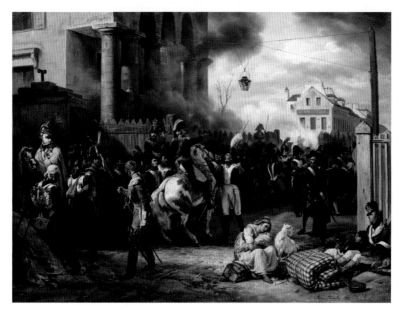

FIGURE 49 Horace Vernet, *The Battle of Hanau*, 1824. Oil on canvas, 68½ × 113¾ in. (174 × 289 cm). Bequeathed by Sir John Murray Scott, 1914. National Gallery, London.

FIGURE 50 Horace Vernet, *The Battle of Jemappes*, 1821. Oil on canvas, 69¾ × 113⅜ in. (177 × 288 cm). Bequeathed by Sir John Murray Scott, 1914. National Gallery, London.

FIGURE 51 Horace Vernet, *The Clichy Gate: The Defense of Paris, March 30, 1814*, 1820. Oil on canvas, 38⅜ × 51⅜ in. (97.5 × 130.5 cm). Musée du Louvre, Paris.

military subjects. The conservative critic writing for the *Conservateur* objected to Jouy's term; in his reasoning, a "national painter" could only be officially chosen by King Louis XVIII. In recognition of Vernet's startling facility across different genres of painting, the critic opted to call him "a surprising painter" instead.[27] This minor journalistic tussle between two critics on opposite sides of the political spectrum demonstrates that the status of Napoleonic imagery and its value as a potentially "national" form of art was very much up for debate during the Restoration: Who had the authority to determine the contents of a "national" form of painting? Was it up to an official government body or absolute authority of a monarch to confer this title, or did this duty fall to a more diffuse social body composed of Salon goers and liberal art critics? Though ostensibly focused on painting, these questions open up onto a much larger problem that is arguably the defining political issue of the postrevolutionary period; namely, who should have the power to make any kind of determination for French society—an immutable authority or a larger, and potentially unwieldy, social collective? In this sense, the critical reception of battle painting during the Restoration provided an area where ideas about social order and the balance of power could be aired.

Like the crowds described by Salon critics, Jouy's designation of Vernet as "national painter" points to a fissure in the fabric of Restoration artistic culture and recalls the oppositional late-eighteenth-century Salon publics that emerged in the years ahead of the French Revolution to challenge then dominant, official standards for art. As Tom Crow has argued with regard to the public reception of Jacques-Louis David's history paintings from the 1780s, these prerevolutionary Salon publics constituted a "force of disruption and recombination" that contested "the received categories of high culture." This unwieldy and ultimately unknowable social collective emerged as "the organizing principle of the dominant art of its time . . . via

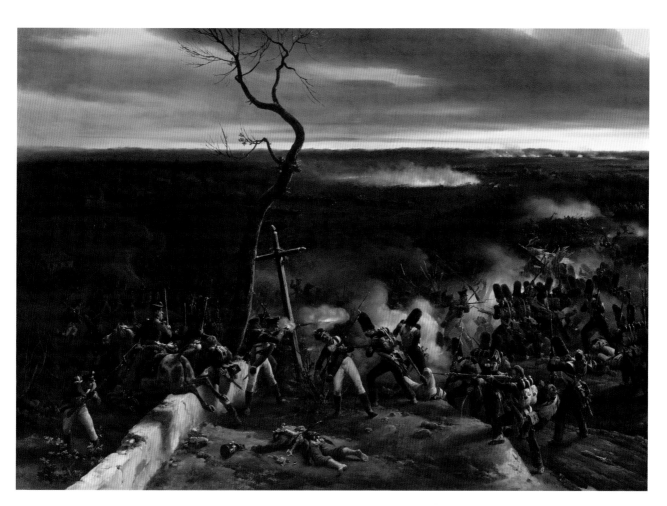

FIGURE 52 Horace Vernet, *The Battle of Montmirail*, detail.

its representation as an oppositional public." While the Napoleonic battle paintings of Lejeune and Vernet may not have been "dominant" in the way that Jacques-Louis David's history paintings were on the eve of the French Revolution, it is nevertheless important to acknowledge the crowds that gathered in front of these works as more than a symptom of their popularity. At a time when official participation in politics was the almost exclusive purview of a property-owning white male elite, any occasion where dissent against officialdom could be registered is significant. More than just a descriptive device within Salon criticism, the crowds gathered around Napoleonic battle paintings at Restoration Salons point to a site where official cultural standards might be contested, or in the terms of Jacques Rancière, where the "distribution of the sensible" was subject to rearrangement.[28]

PRINT CULTURES AND THE PICTURE OF WAR DURING THE RESTORATION

The ultimately unknowable collective of Salon goers who constituted the "crowd" in the writings of Salon critics circulated within a culture of newspaper (and pamphlet) print across Paris and the rest of France. In this sense, nineteenth-century newspaper culture enabled these crowds to exist beyond the official space of the Salon, and to enter into public discourse. The same could be said of the emergent medium of lithography, which became inextricably associated with the representation of military subjects and the publics who consumed them. Lithography was invented in Bavaria in 1798 by Aloys Senefelder, a musician who was looking for a way to reproduce sheet music cheaply. It came into social use in France after the collapse of the Napoleonic Empire. The earliest official reaction to the medium in France occurred in the academy's 1816 report on lithography, which betrays the early confusion over the status of the medium and a basic quandary over what the end result should be called. The academy referred to lithographs as "les gravures, ou plutôt les dessins"—"engravings, or more like drawings," somewhere in between original drawing and the familiar and established process of engraving. In contrast to laborious intaglio print methods such as burin engraving, lithography allowed artists to draw directly on a stone with a wax crayon, limiting the amount of labor required to make an image and providing an opportunity to translate original drawings into reproducible images. The close connection between drawing on the stone and the final print made the medium instantly

attractive to painters, who rushed to experiment with it. Despite the French academy's attempt to lay claim to lithography as an academic medium and early experimentation with the medium on the part of French history painters, it quickly became associated with more contemporary and popular subjects, and in particular with the representation of the Napoleonic military past. By 1818 this bond was so explicit that a conservative writer could describe his frustration at being inundated with "the lithographic profusion of great exploits that cover the stores of our print sellers."[29] He sarcastically referred to Napoleonic soldiers as "the heroes of lithography" and complained that the newly created Bourbon army did not receive the same honors of representation in the new medium.

In a series of lithographs that take as their subject the viewing of lithographs, the spectatorship of Napoleonic military imagery that is textually evoked by Salon critics takes visual form. The most prolific lithographer of Napoleonic military subjects and the plight of veterans during the Restoration, Nicolas-Toussaint Charlet, produced three lithographs that represented working-class viewers (including veterans of the Napoleonic Wars) looking at lithographs in outdoor spaces. In these images, absent is the commotion that Salon critics so often described around Napoleonic battle paintings in the official exhibition space. Instead, casual passersby pause in front of the print seller's stall. Charlet emphasized Napoleonic veterans as both spectators and subjects in these self-reflexive lithographs about the reception of lithography. All three show the outdoor stalls of lithograph vendors, rather than the upscale print shops where one might purchase more expensive reproductive engravings or more rarefied kinds of lithographs. The lithographs tacked up on the display boards, though unidentifiable, clearly represent martial themes: figures on horses in landscapes, for example, are visible in all three of Charlet's print stall lithographs. Charlet captured Napoleonic veterans in the act of reminiscing in front of lithographs that represented the very exploits in which they participated. In the *Merchant of Lithographic Drawings* (fig. 53), published by François Delpech, one of the most successful lithographic firms in Paris at the time, the lithograph seller slumbers as two men, one likely a veteran of the Napoleonic Wars, the other a young boy, gaze at the displayed images. The older man raises his finger in what is likely intended to be a didactic gesture involving the images on display, as he narrates his own personal

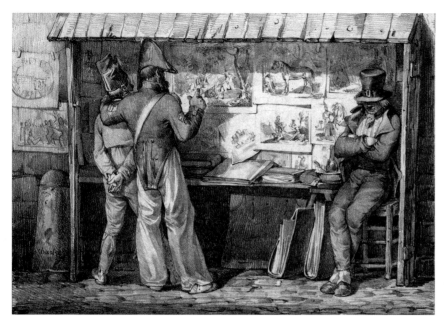

FIGURE 53 Nicolas-Toussaint Charlet, *Merchant of Lithographic Drawings*, c. 1819. Lithograph, 85⅜ × 122 in. (217 × 310 cm). Rijksmuseum, Amsterdam.

military experience. Here, the prints in the stall become visual aids in the boy's education. In another lithograph (fig. 54), Charlet depicts the display in front of a popular print shop, where a Napoleonic veteran, identifiable as a "Chasseur de la garde impériale," is in the process of showing off a cupid print to a woman; prints surrounding the cupid are easily discernable as military subjects. Another of Charlet's lithographs that depicts the viewing of lithographs specifically refers to Napoleonic military history in the caption: "You see Austerlitz when it trembled" (fig. 55). Here, a grenadier of the Royal Guard (a Napoleonic veteran, as evidenced by the two service stripes, emblems of fourteen years of service, on his left arm) gestures enthusiastically at a print that corroborates and illuminates his retelling of the intensity of Austerlitz; the caption also carefully avoids the mention of Napoleon's name, and refers to him instead as "the other" general present at the battle. The young boy, an *enfant de troupe*, listens attentively. His placid demeanor humorously contrasts with the veteran's enormous stature and emotional intensity. For the child, too young to have experienced these battles firsthand, the veteran's words in conjunction with the displayed image evoke events that are firmly, humorously, and melancholically (for the soldier, at least) in the past. Charlet often employed a veil of humor to acknowledge the discrepancy between France's recent military history and the conditions of life for Napoleonic veterans in the peaceful present. This comic element, a "distanced and sustained engagement with the world in its negativity,"

opened up the possibility of recognizing the contemporary consequences of history as an enduring part of everyday lived experience.[30]

Horace Vernet also distinguished himself during the Restoration as a prolific lithographer of Napoleonic subjects, taking up the medium along with his father Carle Vernet as soon as it came into use in France; it is largely through the proliferation of his works in print media that Vernet's reputation as a "national painter" would spread. Like Charlet, Vernet often relied on humor to approach the politically sensitive subject of Napoleonic veterans, as can be seen in a lithograph from 1818. In *In the Environs of a Ball* (fig. 56), a soldier plays with a child on his leg. The lighthearted scene is tempered by the recognition that this soldier sports a wooden leg—visual shorthand for military sacrifice during the Napoleonic wars. Like many of his contemporaries, Vernet used the medium as a creative spur to his practice as a painter and usually opted to produce original lithographs instead of using the medium to reproduce his paintings.[31] There are a few notable exceptions to this tendency, including the case of an image that the early-twentieth-century art historian Léon Rosenthal called "the most popular engraving of the [nineteenth] century," *The Death of Poniatowski*.[32] The painting (or paintings, for there were likely two made in 1816, for two different patrons) depicts the 1813 death of Josef Poniatowski at the battle of Leipzig at the moment when he plunged into the Elster River in an attempt to flee enemy fire.[33] Poniatowski, the nephew of the last king of

FIGURE 54 Nicolas-Toussaint Charlet, *Are You Serious?*, 1823. Lithograph, 10⅝ × 13¾ in. (27 × 35 cm). British Museum, London.

FIGURE 55 Nicolas-Toussaint Charlet, *Look at Austerlitz at the Moment When It Trembled!* 1827. Lithograph, 12⅝ × 9¾ in. (32 × 25 cm). British Museum, London.

FIGURE 56 Horace Vernet, *In the Environs of a Ball*, 1818. Lithograph, 11 × 14⅝ in. (28 × 37 cm). Anne S.K. Brown Military Collection, Brown University.

Poland, led the Polish army on behalf of the French after Poland became a French duchy in 1809. Vernet generated publicity for the painting (or paintings) by exhibiting them successively at the Salons of 1817 and 1819 (and at his private studio exhibition in 1822), but it was his adept promotion of the image as a print across a range of available media, including lithography, that ensured its popularity. Vernet produced a reproductive lithograph of the first version of the painting (fig. 57) that was published by Delpech shortly after the painting's completion; it was likely available for purchase at the same time that the painting was being exhibited at the Salon of 1817.[34] An aquatint of the painting by the prolific printmaker Philibert-Louis Debucourt was also on display at the Salon of 1817, ensuring the work's exposure across media and its reception by a large audience in potentially different venues such as the lithograph stalls depicted by Charlet and the windows of more upscale print shops.

Vernet's meteoric rise to prominence during the Restoration was aided by his ability to build bridges between his painting practice and the prints related to his work as a painter. As was the case with *Poniatowski*, some of his prints were based on his paintings (and were made by

his own hand or by a reproductive printmaker), and some were original prints, related to his paintings but distinct from them. As the descendent of a multigenerational dynasty of artists, Vernet was well positioned to understand the value of print media to bolstering his career and ensuring his legacy. His grandfather Joseph Vernet's *Ports de France* series of large-scale marine paintings commissioned by Louis XV, for example, also circulated as reproductive burin engravings and were regarded as masterpieces of the medium. Horace's father, Carle Vernet, worked fluidly between printmaking and painting throughout his career, and initiated young Horace into the illustration of fashion plates when he was still a teenager. In the early nineteenth century, reproductive burin engraving remained the most esteemed medium for painters to reproduce their works, but it was expensive and required time, potentially several years, to complete high-quality engravings. Vernet's solution to this problem was to utilize the comparatively quicker and less expensive print technique of aquatint to reproduce his paintings. In comparison with rarefied and expensive burin engravings, aquatint offered a more expedient and potentially democratic means to disseminate his oeuvre across different socioeconomic strata of society. Starting in the early years of the Restoration, Vernet initiated a lifelong collaboration with the reproductive printmaker Jean-Pierre-Marie Jazet, who was one of the most prolific specialists of aquatint working during the period.[35]

As was the case with *Poniatowski,* prints based on Vernet's paintings were produced quickly, their

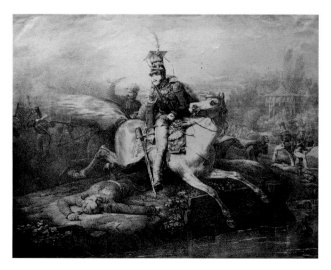

dissemination often timed to generate publicity between the Salon and the print market. This was a particularly effective strategy for Vernet in 1822, when he staged his private studio exhibition. Included within this selection of Napoleonic-themed works, many of which were painted for the duc d'Orléans and other liberal elite patrons, was a small genre painting that would prove to be one of the most popular of the private exhibition in terms of the amount of commentary it attracted: *Peace and War* (fig. 58). The painting represented a popular subject in post-Napoleonic France—the *soldat-laboureur,* or soldier-plowman—and associated Vernet with a thriving culture of liberal opposition to the Bourbon government. A part of the visual and literary economy of the 1820s, the iconography of the *soldat-laboureur* was not Vernet's invention: rather, it flourished within a climate of political opposition to the Bourbons' treatment of Napoleonic veterans after the disbanding of the Napoleonic army in 1815.[36] In *Peace and War* a decommissioned Napoleonic veteran-turned-farmer, grasping his Legion d'Honneur, tends to his land. Ruins in the background, a crumpled Napoleonic military uniform, and a helmet on the ground further underscore the mood

of somber reflection, which is also evident in the veteran's contemplative visage. Vernet exhibited the painting with a pendant, *Le soldat de Waterloo*, forming what the liberal critics Étienne de Jouy and Augustin Jal called "a veritable poem in two verses whose title could be 'The Life of the Citizen Soldier.' "[37] Despite Vernet's decision to show only one painting (*Joseph Vernet Attached Tied to a Mast during a Storm*) at the Salon of 1822, spectators at the official government exhibition were not completely deprived of his Napoleonic imagery. On display in the *gravure* section was a large-scale aquatint by Jean-Pierre-Marie Jazet of *Peace and War* whose dimensions exceeded the original painting.[38] Even in his self-imposed exile over the political impropriety of exhibiting Napoleonic paintings, Vernet's reputation as a "national painter" could continue to flourish in the same space from which he had ostensibly withdrawn.

HORACE VERNET'S *CROSSING OF THE ARCOLE BRIDGE*

The last Salon of the Restoration, in 1827, would feature yet another painting related to Napoleonic military history: a large-scale picture that reprised one of the most recognizable military events of the revolutionary wars, *The Crossing of the Arcole Bridge* (fig. 59). This painting, like *Peace and War*, *The Waterloo Soldier*, *The Clichy Gate* (all of which were also reproduced by Jazet), and *The Battle of Jemappes,* associated Vernet with liberal opposition to the Bourbons and earned him the adulation of liberal art critics. But Vernet's rapid rise within France's official art institutions suggests that by the mid-1820s, he had effectively learned how to maneuver between the polarized divisions that pervaded Restoration society, continuing to receive commissions from liberal elite patrons, including the duc d'Orléans and Gabriel Delessert, while simultaneously working for the Bourbons and within the dictates of France's official art world.[39] There is much to be gained by thinking about Vernet's Napoleonic oeuvre in terms of its ability to conceptualize new political orders during the Restoration. Vernet was not merely recycling well-known military events or tapping into themes that appealed to liberals: he inventively *worked* military subjects to produce visually seductive sites of political sensibility that invited audiences to take a stake in defining their relationship to contemporary politics. One of Vernet's most arresting (and least studied) paintings produced during the Bourbon Restoration, *The Crossing of the Arcole Bridge* makes this achievement especially apparent. In the painting, Vernet transmuted a well-known military event into an entertaining picture of the dynamic and

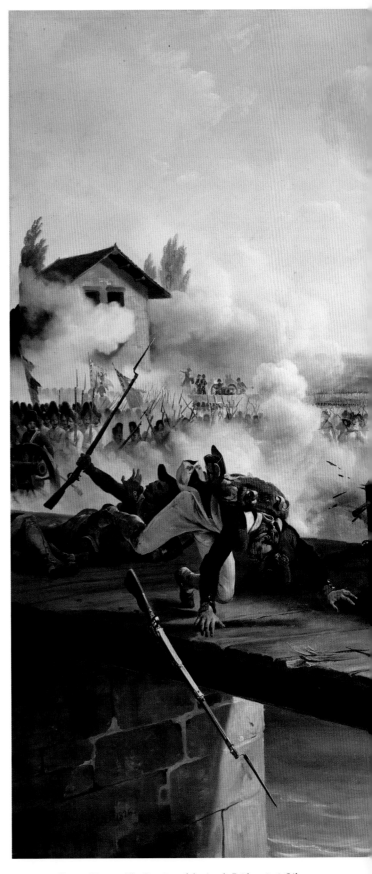

FIGURE 59 Horace Vernet, *The Crossing of the Arcole Bridge*, 1826. Oil on canvas, 102⅜ × 77⅞ in. (260 × 198 cm). Private collection.

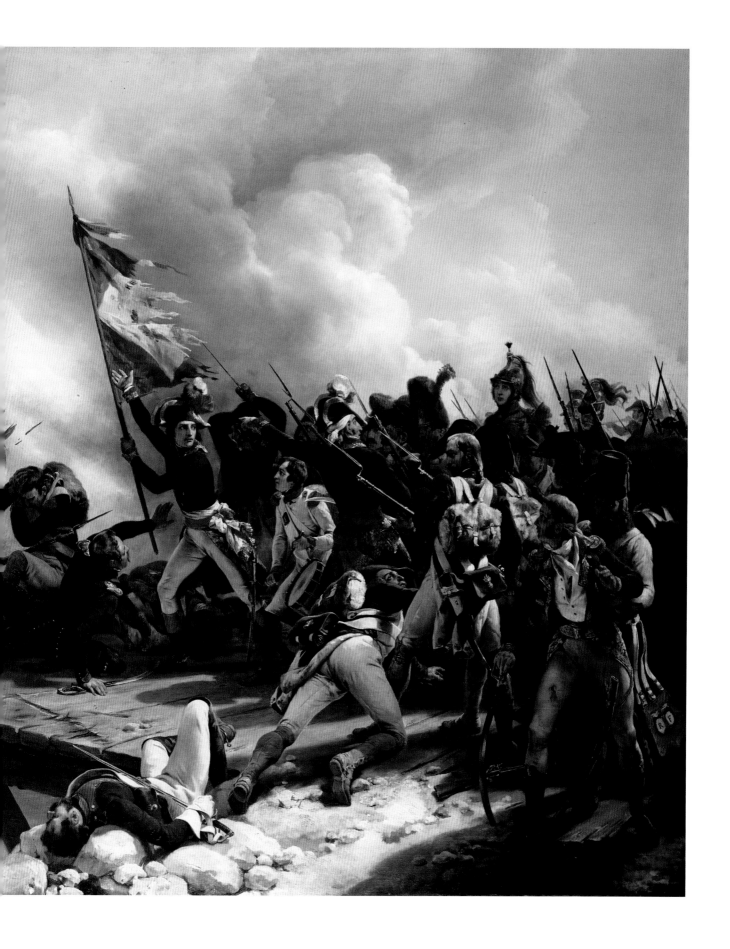

potentially disappointing process of producing group accord, representing power as an interdependent relationship between a figure of authority and a collective of individuals. In reinterpreting a revolutionary battle in which Napoleon Bonaparte's authority as a leader is shown to require the support of a larger social body composed of his soldiers, the painting spoke to a specific set of liberal political aspirations that were in the process of being articulated during the later years of the Restoration.

Throughout the Restoration, French liberals wrestled with the vexing question of how, as historian of liberalism Lucien Jaume has written, to "reconcile the emancipation of society and the individual with the prestige and legitimacy of the state."[40] In this sense, liberalism not only sought to challenge Bourbon authority but was also in search of the ideological basis for a "liberalism of government" to take hold of the reins of power and rule.[41] As such, this picture of war not only embodied a set of political values but played an active role in constituting them. Just as Vernet understood how to maneuver across political factions, his *Arcole* enacted the same form of delicate negotiation in the visual realm. Throughout the Restoration, Vernet benefited from the avid patronage of the elite intellectuals, politicians, and businessmen who were in search of a governing ideology capable of forging consensus, finally stabilizing France's government and bringing themselves securely into power. For this powerful set of French liberals, the stakes of the imaginative projection into and fascination with Napoleonic history on the part of French audiences would become powerfully apparent on the eve of and after the July Revolution of 1830.

The continuing renown of the crossing of the Arcole Bridge as a historical event over two hundred years after the battle is a function of the importance of Antoine-Jean Gros's 1796 portrait, *Bonaparte at the Bridge of Arcole* (fig. 60), which has been singled out for its precocious romanticism and innovative approach to fusing history painting with the genre of portraiture.[42] For viewers in the mid-nineteenth century, however, the bridge crossing would have also called to mind Horace Vernet's painting of the same subject—or one of the dozens of prints either directly or loosely based on the painting that circulated at the time. Upon Vernet's death in 1863, *Arcole* was regarded as among his most important works made during the Restoration.[43] When a maquette for Jean-Jacques Feuchère's relief sculpture (fig. 61) for the soon-to-be-completed Arc de Triomphe appeared at the Salon of 1834 during the July Monarchy,

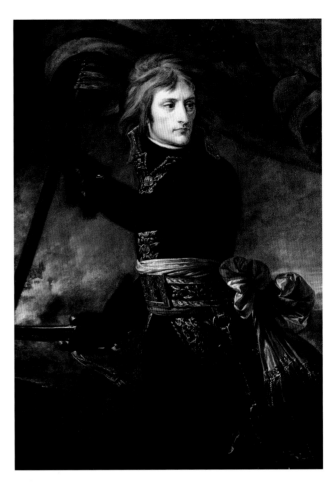

FIGURE 60 Antoine-Jean Gros, *Bonaparte at the Bridge of Arcole*, 1796. Oil on canvas, 102⅜ × 37 in. (130 × 94 cm). Musée National des Châteaux de Versailles et de Trianon.

critics saw it as having been directly inspired by Vernet's own version of the bridge crossing. It is not surprising that Vernet's image appeared on a public monument that strove to represent a collective idea of military grandeur for a government that believed its authority to derive from the consent of those it ruled over. The work's prominent place within the nineteenth-century French popular imaginary and its status as a generative image that gave rise to a host of visual reproductions was not merely a function of Vernet's immense popularity at the time; rather, the painting resonated with audiences because of the alluring model of the agency of the collective it depicted.[44]

Painted in 1826, eleven years into the Bourbon Restoration and thirty years after the battle of Arcole, Vernet depicted a subject that was securely in the past. This provided him and his audience with distance from the event, and licensed him to experiment with its formal and theatrical content to suit the demands of his present. One of the earliest questions that the Arcole bridge cross-

FIGURE 61 Jean-Jacques Feuchère, *The Crossing of the Arcole Bridge*, 1834. Chérence stone, 15⅞ × 335⅜ in. (396 × 852 cm). Arc de Triomphe de l'Étoile, Paris (upper relief, right panel).

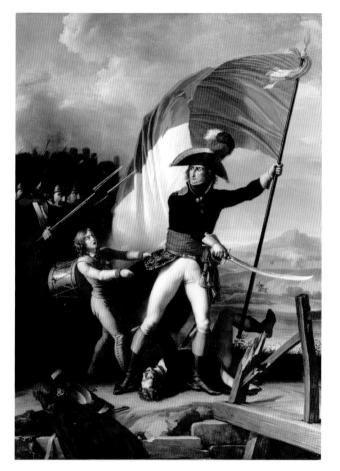

FIGURE 62 Charles Thévenin, *General Pierre Augereau at the Bridge of Arcole*, c. 1798. Oil on canvas, 142½ × 105½ in. (362 × 268 cm). Musée National des Châteaux de Versailles et de Trianon.

ing provoked involved the issue of who should be given credit for the battle's victorious outcome. In November 1796, as part of the Italian campaign, the First Coalition over the course of three days outflanked the Austrian army and forced them to retreat from their position in the small village of Arcole. Successive attempts to cross the bridge by French generals on November 16 and later, more daring attempts by generals Bonaparte and Augereau all ended in French retreat. On November 17, French forces finally captured the village by combining a surprise attack from the rear of the village with an assault across a pontoon bridge. Soon after the battle, in early 1797, the Council of Five Hundred accorded Generals Augereau and Bonaparte equal honors for the victory. This official recognition helped to focus attention on the bridge crossing as the most pivotal part of the three-day battle. Despite the early status of Arcole as a shared moment of triumph for Bonaparte and Augereau, the battle quickly became an integral part of Bonapartist mythology during and after Bonaparte's lifetime, aided importantly by its stirring representation by Gros, which helped Napoleon to cultivate an image of a self-sacrificing, courageous citizen-soldier. General Augereau's supporters attempted to counter the Bonapartist version of events by commissioning a portrait from Charles Thévenin that depicted General Augereau's crossing, but the comparatively stilted painting failed to have its intended effect (fig. 62). Both Gros's and Thévenin's paintings circulated as reproductive engravings, which speaks to the importance of these portraits for the ensuing public relations battle between the two generals. Vernet departed from the iconographic precedent of singular leadership that characterizes both of these early portraits by giving just as much visual priority to the behavior of the soldiers surrounding the general. The significance of Horace Vernet's *Crossing of the Arcole Bridge* lies in its bold redefinition of the event around the dynamic and potentially destabilizing relationship between a commanding general and the men in his charge. In prioritizing the interaction between the young general and the group of soldiers surrounding him, Vernet suggested that the battle was defined not by the heroism of one man, as it was in Gros' famous portrait, but by the dramatic stakes of participation on the part of a larger group that had to decide whether to follow its leader. Vernet's painting thus presented viewers with a temporal moment where the will of a group had yet to be determined.[45]

As with Vernet's other works, his *Arcole* painting cannot be easily separated out from his practice as a printmaker. While Vernet had previously experimented with lithography as a way to reproduce his paintings such as *The Death of Poniatowski*, in the case of *Arcole*, Vernet used lithography as a *productive* medium: the lithograph (fig. 63) preceded the painting and likely inspired the final form that it would

take.[46] Vernet produced his *Arcole* lithograph as early as 1822 for a large illustrated book entitled *La vie politique et militaire de Napoléon.* The book's author and editor was Antoine-Vincent Arnault, a playwright and close associate of Napoleon Bonaparte during his rise to power in the 1790s. Following Napoleon's death in 1821, the *Vie* was published between 1822 and 1826 through subscription as a folio. The text narrated the principal events of Napoleon's life, starting with his childhood and ending with his second and final exile on St. Helena. In his introduction, Arnault claimed that the book was intended to be an unbiased, politically neutral source of historical information about Bonaparte: "The events, scrupulously gathered together, are told with exactitude. . . . We offer the material for a judgment but not the judgment itself." The posturing of the book as a politically colorless historical work likely ensured the approval of the Bourbon censors. Though the book was available for sale in France, reviews in the press were censored, and sales were not brisk. The lack of publicity for the work may help to explain Vernet's later decision to use the lithograph of Arcole as the basis for a larger-scale battle painting. Vernet's lithographic contribution to the *Vie de Napoléon* gave the artist an opportunity to experiment with the formal dynamics of the negotiation between Bonaparte and his soldiers, something that would be dramatized even further in the painting.[47]

Vernet was an accomplished lithographer by the time he received the Arnault commission, but his lithographs generally consisted of stand-alone vignettes rather than full-fledged and compositionally complex battle scenes. *Arcole* presented Vernet with a new challenge: arranging a group of figures within the compressed compositional space of a small lithograph, relative to the larger-scale canvas that he normally used for his battle paintings. In the painting, Vernet could exploit the narrative potential of details formerly obscured by the generalized gray tones of the *Arcole* lithograph, which now took on a more pronounced role, allowing him to more fully explore the process through which the soldiers made their decision to cross the bridge. For example, in the lithograph a barely noticeable soldier falls off the bridge in the background, his weapon flailing out toward the viewer (fig. 64). The bridge dominates the composition, cutting all the way through it. Bonaparte, positioned in the middle of the bridge and at the center of the image, directs the soldiers to the other side, where Austrian troops would have been positioned. Just in front of Bonaparte, a fallen soldier reaches up in a futile attempt to stop the general, and toward the opposite end of the bridge, a figure lies facedown. In the face of these signs of the danger involved in the crossing, Bonaparte's outstretched sword reinforces and rallies the soldiers behind him. While some soldiers stand still, hesitant to traverse the bridge, a tide of participating soldiers dominates the print. Due to the bridge's compositional prominence in the lithograph, the crossing seems almost a fait accompli, as though it is already happening.

In the painting, by contrast, Vernet changed the placement of the bridge so that it does not stretch through the entire scene, and included a parcel of land to the right and in front of it—a choice that effectively transformed the bridge from a space of decisive action into a space of potential action. The majority of soldiers are clustered together, not yet committed to setting foot on the bridge. This reworking permitted Vernet to emphasize the contingency of their decision to follow their leader and forge ahead as a group. Two other changes in the painting—a line of enemy soldiers on the opposite embankment, weapons ready, and a regimental flag completely shredded by enemy fire—further dramatize the dangerous conditions. Moreover, while Bonaparte carries a sword in the lithograph, in the painting Vernet removed it from his hand. Without his weapon to rally his soldiers, he must appeal to them through a different means of persuasion.

The Crossing of the Arcole Bridge is a large painting, 8 feet 6 inches wide and 6 feet 6 inches tall, imposing enough to be considered a history painting. Though the Bourbons often censored public representations of Napoleon, Vernet's painting appeared at the Salon of 1827, where it reportedly attracted large crowds. And although the painting lacked a title in the official *livret,* viewers could not miss the overtly Napoleonic subject matter, given the man himself at the center of the composition, carrying a red, white, and blue regimental flag that would have recalled the tricolor.[48] The painting focuses on a series of episodic details and moments of suspended action that are only hinted at in the lithograph. These tour-de-force visual effects, which Marc Gotlieb has observed in Vernet's later paintings and has described as "heightened effects of instantaneity," do more than merely describe the specifics of the event; they suggest its presentness, that it is actually in the process of occurring.[49] The broken wood fence that appears in the lithograph is transformed in Vernet's painting into a moment of explosion, with splinters flying high in the air (fig. 65). A soldier

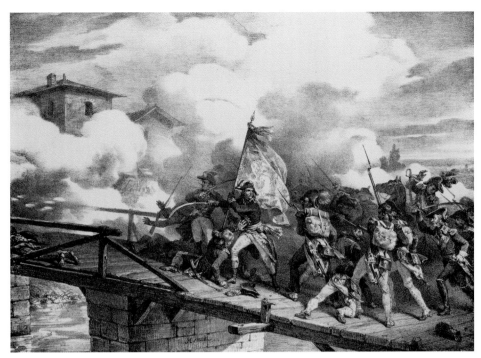

FIGURE 63 Horace Vernet, *The Crossing of the Arcole Bridge,* published in *Vie politique et militaire de Napoléon* (Paris: Émile Babeuf, 1822–26) Lithograph, 17¼ × 22⅜ inches (44 × 57 cm). McGill University Rare Books and Special Collections, Napoleon Collection, Montreal.

to the right of the shattered post covers himself against the debris, while the soldier just in front of it is caught in a moment of free fall, which was an obscure detail in the lithograph. Here, the man's gun flies into the foreground, toward the viewer's space, which is already threatened by a soldier whose wounded head protrudes forward. The group of soldiers who stand just behind Napoleon are caught in a moment just prior to action: the drummer boy, his drumsticks frozen between beats, looks up to Napoleon with one leg stepping forward and the other back, suggesting his ambivalence about crossing (fig. 66). The general behind Bonaparte gestures to the men near him, encouraging them to take part, while Napoleon looks back toward the group to see if they are following him.

This narrative mode, in which disparate and highly affective details play a major pictorial role in describing the dramatic stakes of the event, was one that Vernet often deployed in his battle paintings; it contrasts distinctly with the tradition of classical history painting, where such episodic details are subordinated to a single moment of narrative transcendence. Vernet's *Arcole* prioritizes the narrative role of flying objects, exploding wood, firing guns, and falling bodies, which become as pictorially important as the man who carries the tattered flag in the middle of the composition. All of these features, moreover, suggest a clamorous atmosphere around this bridge crossing that is a far cry from the measured stillness of the monumental history-cum-battle paintings

produced during the First Empire by Antoine-Jean Gros and his peers. Through a series of carefully selected episodes, Vernet's painting achieves the illusion of a highly particularized moment, implying a measured temporality that is very much of the present. These distinct and highly volatile narrative moments place viewers in a suspended instant, right after Bonaparte has decided that he will lead the charge but just before his men have decided to accompany him. In fixing this momentary gap between the action of an individual leader and the action of the group, Vernet provocatively opened this well-known episode of military history up to the prospect of an uncertain conclusion.

THE BATTLE OF ARCOLE'S NARRATIVE AMBIGUITY

Vernet's painting was made during a historical moment when the production of literature on Napoleon had reached a feverish pitch. Despite official attempts to suppress both textual and visual representations of Napoleon, written accounts of his life and his military campaigns proliferated during the 1820s, especially after the former emperor's death in exile on St. Helena in 1821. These publications, which included Emmanuel Las Cases's wildly successful *Mémorial de Sainte-Hélène* (1822–23), Walter Scott's *Life of Napoleon* (1827), and Adolphe Thiers's *Histoire de la révolution française* (1823–27), fueled the burgeoning post-Waterloo Napoleonic legend.[50] Arnault's *Vie politique et militaire de Napoléon,* in which Vernet's lithograph of the

battle of Arcole appeared, was part of this trend. Published just before the *Mémorial*, Arnault's *Vie* offered little in the way of clarifying details about Bonaparte's and Augereau's bridge crossings, save for the fact that both were unsuccessful: "In vain, the generals put themselves at the head of the columns; in vain, Augereau, a flag in his hand, carried it beyond the Arcole bridge; the soldiers did not follow him; they only followed at the moment when Bonaparte himself, holding the flag of Lodi, attempted to put them back on the road to victory. Taking the village from the front had to be abandoned."[51] While Vernet's lithograph depicted Bonaparte urging his soldiers to cross the bridge, the accompanying text focused only on the moment when Bonaparte grabs the flag. His gesture, whose goal is victory, is described as an attempt ("avait tenté") and not a fully realized action. The next line discloses that Bonaparte's attempt to rally his soldiers across the bridge was unsuccessful, but does not reveal why the village of Arcole could not be captured from the front. This abrupt transition amounts to a narrative covering-up of the course of events that led to the inability of the French army to cross the bridge; it also signals a larger representational problem that had plagued written and visual accounts of the battle of Arcole ever since the first eyewitness field reports were committed to paper in 1796: How to represent the temporal location between Bonaparte's decisive action and its ensuing failure? In most of the accounts of the battle published during the First Empire and the Bourbon Restoration, authors focused on the beginning of the charge across the bridge and on its outcome, but not on the course of events in between. Horace Vernet therefore located the most problematic moment within the narration of the battle and made it the focus of his lithograph and painting.

In Las Cases's *Mémorial de Sainte-Hélène*, a source that Vernet is likely to have consulted, Bonaparte's bridge crossing is represented as a failure but is redeemed by the sacrifices of the soldiers who rush to save their leader: "Napoleon personally tried one last time: he seized a flag, headed toward the bridge and placed it there. The column he led had crossed halfway, when the flank's fire caused the attack to fail. The grenadiers at the front of the column, abandoned by the back, hesitated: they had begun to flee, but they do not want to abandon their general; they take him by his arms, his hair, his clothing and flee with him in the midst of the dead, dying and smoke." Las Cases explained that enemy fire caused Bonaparte's charge to be

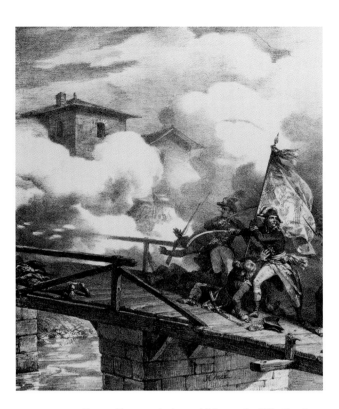

FIGURES 64–66 Horace Vernet, painting and lithograph of *The Crossing of the Arcole Bridge*, details.

abandoned, but not before his devoted soldiers rushed to his aid and brought the *général-en-chef* to safety after he fell into the swamp below the bridge. Though Las Cases alludes to the hesitation of the troops to follow their general, he does not linger on this potentially embarrassing detail: rather, the failed charge constitutes an opportunity for him to emphasize a moment emblematic of the soldiers' devotion to Bonaparte. This was very much in keeping with the overall honorific tone of the *Mémorial* and its efforts to depict the recently deceased former emperor as a man of the people. After recounting this episode of selfless military sacrifice, Las Cases assured readers that despite the charge's failure, "This day was crowned by important results."[52]

Four years later, Walter Scott's *Life of Napoleon* amplified the dramatic tone of the *Mémorial* and described Bonaparte's charge with similar stress on the devotion of the soldiers, who here too hesitate to follow Napoleon until they realize that his life is in danger. Scott relates that after grabbing the standard, Bonaparte rushed onto the bridge but quickly encountered enemy fire: "A murderous fire on their flank left their front without motion, and Bonaparte exposed to a shower of balls, and without support." The lack of support would seem to suggest that the

tail end of the column did not advance onto the bridge; Scott did not specify. In the end, Bonaparte is saved by a group of grenadiers who, in the midst of retreat, decide to come to the aid of their general; as in the *Mémorial*, Bonaparte's ineffective charge across the bridge is transformed into what Scott called "a scene of military martyrdom." While being rescued by his devoted soldiers, Bonaparte fell into the muddy swamp, "plunged to his waist." Similarly, in Adolphe Thiers's *Histoire de la révolution française*, the failure of Bonaparte's charge is explained by the barrage of enemy fire that caused the head of the column of soldiers to separate from the rear. While the generals follow him onto the bridge, Thiers claimed that some soldiers remained behind. But in the end, as in the other texts, the transgression of abandoning Napoleon on the bridge is assuaged by the soldiers' selfless devotion to their general, who they rescue from the swamp in the midst of being fired upon by the Austrians. These texts describe Napoleon's bridge crossing as an event structured by a beginning and an end with little attempt to account for Napoleon's vulnerable position, without support and under heavy enemy fire on the bridge and in the swamp. The events between these two narrative bookends could therefore be said to constitute the gray area of the event, the vaguest portions, which resist textual description. This helps to explain why these textual accounts focus on the heroic devotion of the soldiers as the battle's defining feature. Taking a different approach, Vernet's painting represented the scintillating moment just after Bonaparte commenced his charge, but before the scenes of soldierly devotion in a rush to save Bonaparte after he had fallen into the swamp.[53]

Vernet's decision to leave open the possibility that the soldiers were reluctant to follow their general corresponded to written accounts authored by high-ranking officers present at the battle on November 15, 1796; these were effectively struck from the official government reports of the battle under the Directory. Joseph Sulkowski, Bonaparte's aide-de-camp in Italy, described the bridge crossing in one of his unpublished letters as something much worse than a mere failed attack. After Bonaparte charged across the bridge, Sulkowski wrote, "The soldiers saw him, and none of them imitated him. I was present for this unprecedented cowardice, and I cannot understand it." In Sulkowski's account, after retreating, Bonaparte fell into the marsh. Instead of being rescued by devoted soldiers, the general was left to fend

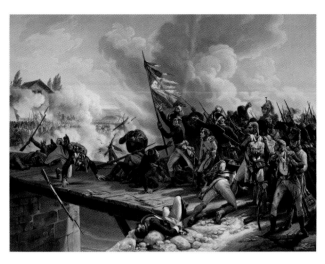

FIGURE 67 Pierre-Marie Jazet, after Horace Vernet, *The Crossing of the Arcole Bridge*, 1829–30. Aquatint, 22 × 25⅞ in. (56 × 66 cm). Bibliothèque Nationale de France, Paris.

for himself in the mud: "Without his *état-major*, he was drowning, as those who fled did not even think to lend him the slightest bit of help." In another unpublished letter composed by Napoleon's brother and aide-de-camp, Louis Bonaparte, just days after the battle, the assessment of what had happened on the bridge was even more damning: "Can you imagine . . . that they even abandoned their *général-en-chef* himself? He was ahead of them, all of the officers who were with him had fallen, and the cowards that were behind them were fleeing."[54] Louis Bonaparte's account, which highlighted the aberrant behavior of soldiers who acted in their own self-interest, struck at the core of one of the most important mythologies of the French revolutionary military: the idea of the devoted citizen-soldier who wages a selfless fight under the leadership of a commanding officer for the glory of the nation. Vernet not only depicted a moment when this founding tenet of modern French military conduct was cast into doubt but also went a step further, imbuing Bonaparte's authority with the specter of precariousness that is brought out in these letters and later suppressed in official government accounts of the battle.

PATRONAGE AND LIBERAL POLITICS

Vernet's painting redefined the battle of Arcole in terms of the dynamics of a motley group of soldiers and officers in the process of deciding whether or not to accompany General Bonaparte on his charge. Vernet's willingness to show that Bonaparte's authority as a leader required the

NAPOLÉON AU PONT D'ARCOLE.

FIGURE 68 Atelier Adrien
Dembour, *Napoleon on the Arcole
Bridge* c. 1844–47. Woodblock
print, 12¼ × 21⅛ in. (31 × 53.5 cm).
Département des Estampes et de
la Photographie, Bibliothèque
Nationale de France, Paris.

FIGURE 69 Advertising poster for the Toulouse-based lithographic
publisher Raynaud Frères, 1841, detail. Lithograph, 16⅛ × 22¾ in. (41 ×
57.8 cm). Metropolitan Museum of Art, New York.

support of those who are being led captured the public's
imagination, as is evidenced by the proliferation of print
reproductions that the painting spurred. In addition to a
reproductive aquatint that Vernet commissioned from
Jazet in 1829 (fig. 67), the painting also gave rise to a series
of popular lithographs and engravings, including an
Epinal-style print (fig. 68), an abundance of engravings

and lithographs that appear to be based on Jazet's aqua-
tint, and at least four copies inspired by the original litho-
graph in Arnault's *Vie de Napoleon.* Between the
mid-1820s and the Second Empire, Vernet's *Arcole* became
synonymous with the phenomenon of its own prolifera-
tion. A vignette-size lithographic reproduction of the
painting appeared, for example, on an advertising poster
for the Toulouse-based lithographic publisher Raynaud
Frères (fig. 69). In the 1836 *La Galerie des arts et de l'histoire,*
a visual and textual compendium of the life of Napoleon
illustrated with "the most remarkable paintings and
sculptures from European museums," it was Vernet's
painting of Arcole, and not Gros's portrait of Bonaparte,
that represented the battle. The explanatory text claimed
that Vernet "has rendered . . . this action of courage and
devotion in a new manner" and noted the painting's suc-
cess when it appeared at the Salon of 1827.[55] Though the
painting gained instant fame soon after it was exhibited
in 1827, its renown climaxed during the early years of July
Monarchy and continued well into the Second Empire.
The fact that Vernet's version of Arcole attributed
responsibility to a larger social body (and not just to an
exemplary leader) in determining the outcome of a major
historical event can help to explain its rapid rise to prom-
inence within nineteenth-century visual culture, and
after 1830 in particular.[56]

Horace Vernet's painting was purchased by one of the
major financial supporters of French liberal causes,
Jacques Laffitte. In 1826 Laffitte paid the princely sum of

10,000 francs for the painting, the same amount paid by the duc d'Orléans for each of the four battle paintings he commissioned from Vernet in the early 1820s. Laffitte, like Vernet, deftly negotiated across political factions, a strategy that ultimately worked to make him one of the richest men in France. One of the early innovators of investment banking, Laffitte served as Napoleon's banker, then helped the returning Bourbons to pay off France's war debts, lent Louis XVIII 5.7 million francs, and also lent the French government 2 million francs to pay the army in 1815. As if to cover all the possible political bases in Restoration France, he also loaned the duc d'Orléans (the future King Louis-Philippe) a generous 1.6 million francs. During the Restoration, Laffitte served as a liberal deputy and supported political causes such as retirement benefits for army veterans, Greek independence, and the freedom of the press. He used his wealth to finance the liberal, Orleanist newspaper *Le national,* which served as a valuable form of publicity during the three-day July Revolution in 1830, when Laffitte (along with Guizot and Thiers) played a leading role in the political maneuvering that resulted in the ascension of the duc d'Orléans to the throne and the establishment of the July Monarchy.[57]

The particular conception of political authority that Laffitte espoused and that helped bring the duc d'Orléans to power can be loosely described as "doctrinaire" or "conservative liberalism." Conservative liberalism preached the need for a strong constitutional monarchy to act as a buffer against the threat of social anarchy, for which the Terror stood as the most extreme and menacing precedent. To be this kind of liberal during the Bourbon Restoration would have meant favoring a constitutional monarchy and maintaining a suspicion of absolute power, the kind exercised by the ruling Bourbons during the period. However, this kind of liberal discourse was not hostile to governing power. On the contrary, it sought to ground the power to govern in strong institutions that buttressed the power of the state and, in turn, severely limited individual agency. The liberty of the state, idealistically and rhetorically constituted as a collective body, took precedence over the liberty of the individual. As Pierre Rosanvallon's work on French liberalism has shown, the doctrinaires recognized the importance of social elites for achieving a stable government; to do so, they "sought to create a new principle of social control and stability in the relationship between elites and masses." Conservative liberalism was in no way a progressive or radical political position but rather one that

was deeply suspicious of popular sovereignty and direct representative government in general. François Guizot, a future minister under King Louis-Philippe, a close associate of Laffitte, and one of the main theorists of this brand of liberalism, argued that power, properly channeled into the hands of those who truly deserved it, could be the ultimate guarantor of personal liberty. According to Guizot, power should be granted to "the bravest, the cleverest, the one who convinces us that he is the most capable of exercising it and of satisfying the common interest, of accomplishing everyone's thought." Thus, for conservative liberals like Guizot and his coterie of associates like Laffitte and the duc d'Orléans, those who govern do so through the accord of the people and act on their behalf to "accomplish everyone's thought."[58]

The presentness of the action in Vernet's *Arcole* invites the viewer to participate in witnessing these events unfold and moreover, to make a decision regarding who is the most fit to lead and, as Guizot put it, "accomplish everyone's thought." The multiple points of dangerous action dramatize the risks of this encounter: everywhere, soldiers are either dead or dying. Sharp objects fly through the air. Napoleon's decision to charge across the bridge, faced with all of these moments of physical violence depicted in the process of occurring, makes his leadership appear all the more heroic. Like these soldiers, the viewer beholds the action and is encouraged to come to the same conclusion as to who should cross first. Thus, *The Crossing of the Arcole Bridge* represents a moment when Bonaparte's status as a leader is suspended in time and space. Crucially, it is also a moment when the men standing behind him are deciding whether to follow or flee. Some within the group hesitate; others, such as the officer directly behind him, encourage the men to move across the bridge. This level of hesitation on the part of the soldiers was unprecedented in the visual representation of the battle of Arcole and in Napoleonic battles in general: in addition to forging new iconographic territory, Vernet's suggestion that Bonaparte's men might not follow him over the bridge underscores the precarity and complexity involved in the production of consensus around an exemplary leader. Although Bonaparte is the focal point of the painting, positioned in the middle of the composition, the group of soldiers dominates the right half; Vernet also depicted the soldiers and Bonaparte as being almost equal in height. Unlike the soldiers in Thévenin's painting of the bridge crossing,

Vernet's soldiers are not only more pictorially important but also highly individualized. The particularity of these men, the fact that they are not a generalized mass, heightens the stakes of the decision to cross. Bonaparte needs every one of these individuals to follow him as much they require a leader to bring them across the bridge. It is this aspect of the painting that stands out within the history of picturing war, since Vernet concentrated the drama of armed encounter on the questions and deliberations of subordinates as much as, if not more than, on the decisiveness of their leaders. The painting represents more than just a battle: in showing the relationship between those who lead and those who consent to being led as symbiotic, contingent, and not solely based upon a predetermined hierarchy, Vernet's *Arcole* should also be understood in terms of the power dynamics of nineteenth-century French revolutionary politics.

Judging from the proliferation of reproductions of Vernet's *Arcole*, the painting struck a particular chord in the wake of the July Revolution, when the French public's faith in its own ability to enact sudden and sweeping regime change would have run high. The compelling fiction represented in Vernet's *Arcole*, that the authority of those who rule is granted by a collective body, came to play an important ideological role in King Louis-Philippe's ascension to power. In an effort to differentiate the duke from the absolute authority of the restored Bourbons, his authority was figured as emanating from the people he sought to govern, a striking parallel to the power relations depicted in the painting. This was the message of a proclamation in favor of the duc d'Orléans' ascension to the French throne that was hastily written by none other than Laffitte (in consultation with Thiers) after King Charles X had fled Paris during the three-day July Revolution. Printed on the presses of the liberal newspaper financed by Laffitte, *Le national,* and distributed throughout Paris, the proclamation presented the heir apparent as a French revolutionary war hero who had already won the approbation of his adoring public. Its efforts to present the duc d'Orléans as a popularly supported alternative to the Bourbons underscores the high stakes of producing a compelling representation of group accord in a period of revolutionary upheaval: "The duc d'Orléans is a prince who is devoted to the cause of the revolution. The duc d'Orléans has never fought against us. The duc d'Orléans was at Jemappes. The duc d'Orléans carried the tricolor into battle, and only the duc d'Orleáns

can wear its colors now; we will not have any others. The duc d'Orléans has declared it: he accepts the Charter as we have always wanted and expected it. His crown will come from the French people." The authors of the text mobilized the symbolic power of the recent military past, epitomized by the invocation of the battle of Jemappes (painted by Horace Vernet for the duke and rejected from the Salon of 1822 by Bourbon censors) and of the tricolor, whose red, white, and blue colors feature prominently in Vernet's painting of the Arcole bridge crossing. This efficiently suggested the duke's devotion to *la patrie* without aligning him with any particular social group or any defined political agenda, other than a generalized anti-Bourbon one. In presenting the duke's rise to power as a *fait accompli,* the text took great care to insinuate that this was the result of the desire of the 'French people' whose authority needed to be conjured but not actually enacted in political life. This masterfully ambiguous piece of Orleanist propaganda elevates the promise of reciprocal and open exchange between Louis-Philippe and his subjects as the basis for a new governing regime in France. Just as in Horace Vernet's *Crossing of the Arcole Bridge,* the text affirms that governing authority is bestowed by the will of the people, a conception of political authority that was put in the service of legitimizing the constitutional monarchy of King Louis-Philippe.[59]

"MY NAME IS ARCOLE"
On July 28, 1830, the bloodiest day of the three-day July Revolution, a skirmish broke out in Paris on the pedestrian bridge known as the Pont de Grève, which separates the Hotel de Ville from the Île de la Cité. While this was one among many incidents of violent street fighting that took place throughout the city center, the event quickly distinguished itself as one of the most emblematic of the three-day revolution. It became a symbol of heroic devotion to the cause of defeating the Bourbon government and occasioned several popular prints and paintings, including one by Amédée Bourgeois that appeared at the Salon of 1830. With royalist troops defending the Hotel de Ville on the Right Bank, a group of students and workers from the Île de la Cité gathered on the bridge, just across the river from their heavily armed adversaries. As the legend went, the first man to attempt the crossing grabbed a tricolor flag, ran forward, and shouted back to his comrades, "If I die, my name is Arcole." This man, who may or may not have been called Arcole, quickly succumbed to enemy fire on the

FIGURE 70 Honoré Daumier, *Rue Transnonain, 15 April 1834*, published in *La Association mensuelle lithographique*, no. 24 (August–September 1834). Lithograph, 13¼ × 18¼ in. (33⅞ × 46.5 cm). Yale University Art Gallery.

bridge; an inscription was (unofficially) etched into one of the bridge's pillars on July 29, giving it a new name that was subsequently officially adopted: the Pont d'Arcole.[60]

Out of the temporal, spatial, and political confusion of urban insurrection, the 1830 bridge crossing quickly assimilated itself into a representational framework that made its importance already apparent. This incident of revolutionary insurrection (what one 1832 commentator called a conflict of "Frenchmen against other Frenchmen") and the battle from 1796 quickly came to refer to one another, a two-way street of signification that connected three decades of French history. Casimir Delavigne's *Une semaine de Paris*, published in the wake of the July Revolution, made this association explicit: "Who is this warrior suspended in the air?/ He still holds the flag / The tricolor blanket waves around him . . . / Great ghost of Napoleon! / It's up to you to engrave your name / On the pillar of the new Arcole Bridge." The July Revolution suddenly modified the cultural status of the Arcole Bridge crossing: more elastic and volatile, it could appeal across political factions to evoke both a shared military past under Bonaparte and a moment of contemporary euphoric revolution. More problematically for Louis-Philippe's July Monarchy, it could also refer to the threat of disunion and the potential of a social collective to upend governing authority. This proved to be the case two years later in an event popularly remembered as the "massacres of the Pont d'Arcole," which quickly cast into doubt the government's commitment to the republican ideals that had helped it come to power. On the second

anniversary of the July Revolution, a group of between 60 and 300 youths crossed the bridge singing "La Marseillaise"; an untold number were shot by municipal sergeants and thrown into the Seine, and the bridge washed to remove any traces of blood.[61]

While the July Monarchy attempted to position itself as a benevolent regime, its policies consistently emboldened the authority of the state at the expense of the liberty of the individual.[62] It is small wonder that during this period of intense political struggle, the popularity of Vernet's *Crossing of the Arcole Bridge* and the proliferation of prints that it inspired soared. This can be explained by its ability to satisfy multiple possible political readings, from the point of view of those dissatisfied with the new regime and of those who were more content with its version of liberalism.[63] This does not mean, however, that we should necessarily view Vernet as a cynical operator, trying to win favor wherever he might find it. Rather, the fact that the painting accommodated a host of readings reflects Vernet's sophisticated understanding of recent French military history as a flexible bearer of meaning across different audiences. The painting and its myriad reproductions imply that power is constituted through a wider social body, and not only by a singular figure of authority: this flattered the bourgeoisie's sense that it controlled its own destiny, and also offered an image of collective agency to publics who bristled against the repressive measures taken by Louis-Philippe's government. Vernet's particular achievement was to depict consensus and contestation at the same time, leaving open the possibility

of one outcome or the other. In contrast to Antoine-Jean Gros's singular young general who strides alone across the bridge, Horace Vernet recast the battle of Arcole as a motley drama of group accord, where resolutions hang contingently in the balance. Far from dwelling on the horror of violence, the painting depicts war as a heroic collective endeavor in a clear crisp facture brimming with the republican palette of reds, whites, and blues. As such, Vernet's *Crossing of the Arcole Bridge* served as an alluring, if illusory, counterpoint to what Baudelaire called "history, terrible and trivial reality."[64] Baudelaire wrote these words in response to Honoré Daumier's iconic lithograph of the 1834 massacre of men, women and children on the rue Transnonain. The massacre was part of a wider campaign to repress republican dissent against the July Monarchy government and was led by the same general, General Bugeaud, who would later orchestrate a scorched-earth campaign for the French army in Algeria. In terms of form and content, Daumier's unsparing depiction of the results of government-sponsored violence on innocent working-class bodies (fig. 70) could not be more different from Vernet's spectacular, bright celebration of soldiers and officers waging war in Italy. Daumier's lithograph, which appeared in Charles Philippon's *L'association mensuelle lithographique,* a publication that raised money for the legal fees of his other satirical lithography journals, shows the consequences and injustices of social difference and speaks to the deep internal divisions within French society. It could be argued that Vernet's painting represents an altogether different set of values that more directly served the interests of France's post-1830 ruling class. But there is also the possibility that Vernet's representation of a collective of soldiers who are shown in the process of deliberating could have served as a site of political sensibility for audiences who hungered for pictures showing the possibility of agency on the part of those who normally lack power. This would help to explain the enduring popularity of the image across a range of formats, notably those that were not otherwise regarded as luxurious.

In the wake of the July Revolution, Vernet continued to produce visually seductive and increasingly spectacular battle paintings for his most devoted patron, King Louis-Philippe. With the transformation of Vernet's most devoted patron from liberal-aristocratic agitator of the Bourbons to king of the French, the politics of Vernet's battle paintings also shifted. Under his regime, the picturing of France's revolutionary and Napoleonic military past became part of official arts policy, which once again aligned the government with the support for large-scale battle painting. While this was done out of a desire to publicize the king's commitment to French militarism and shore up public approval for the regime, the July Monarchy's support for the picturing of contemporary military events produced a series of unintended consequences. It created an atmosphere of unprecedented critical hostility toward battle painting, cast doubts upon king's legitimacy, and gave cultural commentators an efficient way to criticize the government's attempts at eliciting public support.

3 A Mighty Recasting

War Imagery during the July Monarchy

On June 10, 1837, the "citizen king" of the July Monarchy, Louis-Philippe, unveiled the newly completed Musée Historique de Versailles to a crowd composed of France's most elite citizens. Over 1,500 aristocrats, politicians, journalists, writers (including Victor Hugo, Alexis de Tocqueville, and Alexandre Dumas), members of the Institut de France, foreign dignitaries, artists, and military officers gathered for a lavish day-long royal fete whose magnificence, in the words of the writer for the *Revue des deux mondes,* "was so grand and complete that it would be impossible to describe in anything less than an entire book." This ambitious public art project had been personally overseen by the king. Just three years into his reign, King Louis-Philippe d'Orléans announced a project to renovate the dilapidated Château de Versailles into a massive French history museum to serve as a powerful political symbol of the recently established constitutional monarchy. Upon its completion, the museum boasted over 4,000 works of art, many of which had been commissioned especially for the newly renovated galleries. The important ideological role accorded to war imagery by the July Monarchy government was made clear by its prominence at the historical museum of Versailles. Various types of war pictures ranging from large-scale battle paintings to smaller-scale genre paintings, sculptures, and watercolors filled the galleries. Louis-Philippe requisitioned many of the previously made battle paintings by Antoine-Jean Gros, François Gérard, and Anne-Louis Trioson Girodet that had been languishing in storerooms during the Restoration. A large collection of watercolors made by the *ingénieurs-géographes* during the First Empire from the iconographic collection of the Dépôt de la Guerre formed the bulk of new museum's Galerie des Aquarelles. While Louis-Philippe had initially envisioned telling the story of French history entirely through these sorts of extant works, the project quickly grew to encompass the commissioning of new works for the museum, including dozens of new battle paintings from contemporary artists, including Horace Vernet, Ary Scheffer, and Jean-Charles Langlois, all of whom were present for the inauguration ceremonies.[1]

In the Musée Historique de Versailles, representations of war were cobbled together across different historically themed galleries, presenting a vision of French history in which military achievement was a common, illustrious thread. The July Monarchy's valorization of French military history was most prominently displayed in one of the

largest galleries in the museum, the Gallery of Battles. Twenty-nine new battle paintings were commissioned by the government for the space, where they were hung with paintings already in national collections, including Gérard's *Battle of Austerlitz* (see fig. 23). Of all the renovations at Versailles, the Gallery of Battles was the most extensive (fig. 71). An entire wing of the building measuring 120 meters long and 13 meters wide was reconfigured to make room for thirty-three large-scale battle paintings that covered a chronological span of two millennia, beginning with the battle of Tolbiac of 424 and ending with the battle of Wagram of 1809.[2] Napoleonic battles feature prominently, with five out of the thirty-three paintings dedicated to battles directed by Bonaparte. When Louis-Philippe arrived with his entourage at Versailles for the inauguration festivities, the Gallery of Battles was the first gallery that he visited. A genre painting by François Joseph Heim (fig. 72) represents the king greeting an assembled

corps of diplomats in the space on inauguration day. The monumental columns highlight the magnificence of the gallery and emphasize the dramatic scale of the assembled battle paintings, which are blurry approximations in Heim's painting. The fact that Louis-Philippe made the Gallery of Battles the first stop on his ceremonial tour of the museum, used the space to greet dignitaries, and had it represented in a genre painting underscores its importance. Heim's painting effectively shows that France's military annals were the symbolic centerpiece of the government's efforts to honor the history of France at its museum.

To many observers, however, Louis-Philippe's use of French military history for political benefit looked like an empty gesture. Several years before the inauguration of the Gallery of Battles, a caricature appeared in the satirical lithography newspaper *Le Charivari* that both anticipated and critiqued the king's increasing reliance on images of

FIGURE 71 Installation view of the Gallery of Battles, Musée National des Châteaux de Versailles et de Trianon.

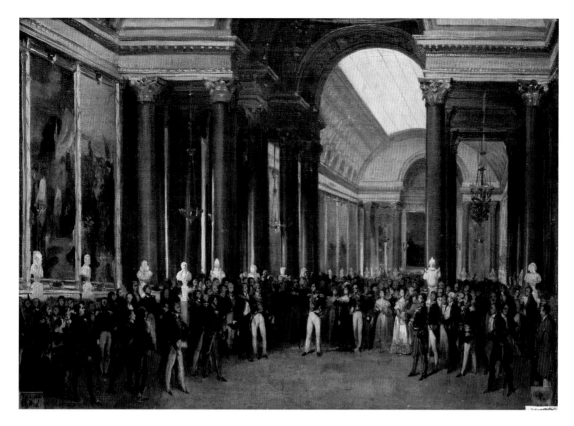

FIGURE 72 François Joseph Heim, *Louis-Philippe Inaugurates the Gallery of Battles, June 10, 1837*, 1837. Oil on canvas, 13¼ × 18¼ in. (33.5 × 46.5 cm). Musée National des Châteaux de Versailles et de Trianon.

French military achievement to bolster his standing with the public (fig. 73). In the lithograph, Louis-Philippe played the part of a magic-lantern guide who describes the images that he displays to curious passersby. The pictures inside the magic lantern illustrate two battles in which the king had participated in his youth: Valmy and Jemappes. These were also two battles that Horace Vernet had represented for the Louis-Philippe years earlier, during the Restoration. One of these battle paintings, *The Battle of Jemappes*, was displayed in Vernet's 1822 protest exhibition after the Bourbon authorities censored it (along with *The Clichy Gate*; see fig. 51) from the official Salon exhibition for its allegedly seditious content. This controversy and the subsequent publicity generated by Vernet's studio exhibition helped to launch the artist's reputation as France's premier battle painter and brought public attention to his cozy relationship with his patron. The print was published just two years before the passing of a set of restrictive press laws that barred the publication of any likeness of the king. The artist could thus draw a direct link between the king's person and his predilection for using war imagery to cajole and amuse the public. In this sense, the print presciently highlights the

instrumentality of Vernet's oeuvre in Louis-Philippe's reputation as a supporter of French military glory. Over the course of the July Monarchy, Vernet would become an increasingly close confidant of the king's, working assiduously to produce a steady stream of monumental battle paintings for his most dependable patron. The caricature represents the portly king describing the battle in a way that could have been taken directly out of a Salon guidebook ("You see General Dumouriez on your left . . ."); a crowd of men, women, and children, whose clothing marks them as distinctly working class, jockey to gaze upon the battles pictured inside the device. A (Napoleonic?) veteran with a peg leg is among the group of onlookers. The crowd gathered around the magic lantern could not be more different from the crowd assembled in Heim's painting of the inauguration of the Gallery of Battles, where battle painting served as the backdrop for some of France's most distinguished and wealthiest publics. In the street, a satirical king used magic-lantern battle images to entertain a public that enjoyed comparatively little official political power or prestige. This was nevertheless a public whose support was eagerly solicited by the powerful, who

FIGURE 73 Becquet, *Lanterne Magique. Bataille de Jemappes. Bataille de Valmy. Le montreur est Louis-Philippe qui commente pour les badauds: "Vous voyez à gauche le Général Dumouriez et son aide de camp,"* published in *Le Charivari*, no. 212 (December 8, 1833). Lithograph, 9⅛ × 11⅛ in (23.2 × 28.1 cm). Bibliothèque Nationale de France, Paris.

remained ever aware of the threat of revolutionary insurrection that had ushered the fragile July Monarchy government into power in 1830. The print effectively highlighted the display of war imagery as one of the channels of this solicitation. In Heim's painting, most, if not all of the assembled elites likely had the right to vote; the working-class public around the magic lantern did not possess the same right and would not earn it at any point during the eighteen years of Louis-Philippe's reign. In these two images of assembled publics, one in the street, one in an opulent gallery, war imagery is the common denominator, the tie that compels attention toward France's military achievements and the powerful rulers who display such pictures.[3]

In the sense that both Heim's painting and the lithograph portray the French government's attachment to war pictures as a way to court the favor of diverse publics, they exemplify one of the most fundamental governing philosophies of the coterie of doctrinaire liberals who had helped the regime come to power, namely the importance of bringing its citizens into contact with publicly oriented manifestations of governing authority.[4] For Louis-Philippe and his ministers, the king was only sovereign insofar as he maintained a level of consent to exercise his powers. François Guizot, whose well-developed theory of sovereignty informed the political operations of the July Monarchy, claimed that the expansion of government power depended upon seeking out and opening channels of communication with the public. In the *History of the Origins of Representative Government* (1821–22),

Guizot affirmed that "representative government does not attribute sovereignty as inherently residing in any one person—all its powers are directed to the discovery and faithful fulfillment of that rule which ought ever to govern their action; the right of sovereignty is only recognized on the condition that it should be continually justified."[5] Within the governing experiment that was July Monarchy liberalism, public expressions of government authority in the form of large-scale projects like the Musée Historique de Versailles opened up valuable channels of political communication between government power and the people; they were the motor that drove the people's recognition of government's right to rule. In the eighteen years of the July Monarchy, officially commissioned visual representations of war proliferated on an unprecedented scale, far outstripping their production during the First Empire, a time of continuous inter-European warfare. To give some sense of the magnitude of this effort, over 173 paintings of military subjects were shown at Salon exhibitions during the July Monarchy from 1836 to 1838, eclipsing in just three years the 143 paintings of war-related subjects exhibited over the entire ten-year course of the First Empire.[6]

In contrast to the battle paintings commissioned during the Revolution and First Empire, the July Monarchy's official embrace of military imagery occurred within a period of prolonged inter-European peace. One of the main imperatives of French foreign policy after 1815 was to maintain the delicately held peace within Europe and

prevent any large-scale conflicts between European allies from breaking out. In 1840 the recent age of France's military power gained symbolic closure with the return of Napoleon's ashes from the island of St. Helena, where he had died in exile in 1821. At the urging of Adolphe Thiers, Louis-Philippe's prime minister, a ship was dispatched to retrieve the emperor's remains, and upon the arrival of the ashes in Paris, an elaborate procession was staged. This political spectacle, while taking advantage of Napoleon's enduring popularity, also unwittingly represented the end of an era. The German writer Heinrich Heine, who lived in France during the 1830s, observed that with the return of the emperor's ashes "the last old fashioned kind of hero is extinguished." Ironically mocking the July Monarchy's government's politically calculated decision to bolster popular support by bringing back the ashes, Heine continued: "The new world of shopkeepers [épiciers] breathes easy, as though having been relieved of a brilliant nightmare. On the imperial tomb rises a new bourgeois and industrial era which admires an entirely different kind of hero, such as the virtuous Lafayette or James Watt, the cotton spinner."[7] In Heine's terms, the return of the emperor's ashes marked a moment of transformation in French society: if political convulsions of revolution and unrelenting warfare defined the beginning of the nineteenth century, the July Monarchy heralded the pursuit of profits, the *embourgeoisement* of French society, and a new set of distinctly unheroic preoccupations.

At home, the government sought a consensus-building politics: the *juste-milieu,* "middle way." It also pursued policies that expanded France's industrial economy, developing railroad network, ports, and other infrastructure critical for the production and circulation of goods and services. Louis Blanc, a French socialist and historian who would later be a member of the provisional government formed after the February Revolution of 1848 ousted Louis-Philippe, railed against the government's preservation of the peace within Europe. Echoing Heine's observations about the placidity of the petty bourgeoisie, he wrote, "The bourgeoisie was not at all tempted by the gleam of heroic adventures. Composed as they were mostly of bankers and industrial merchants, of men of independent means, of peace-loving and easily alarmed landlords . . . the grandeur of France, to them, meant war; and in war one only gets interruptions of commercial relations, the fall of whichever industry, lost opportunities, and bankruptcy."[8] Blanc, in his militarism, viewed the

Napoleonic past not in terms of the horrors of warfare but rather with reverential awe; like Heine, Blanc sensed that the present epoch could only experience military grandeur belatedly, as the product of a now-eclipsed recent past. To counter such claims, Louis-Philippe aggressively pursued the conquest of Algeria that had begun only two months before the fall of the Bourbon government, with the capture of Algiers. From the government's point of view, the colonization of Algeria offered a way to restore France's military legitimacy without endangering its internal stability. Vernet's monumental battle paintings of important battles from the campaign, including *The Capture of the Smalah* and the *Siege of Constantine,* were commissioned to heroicize these campaigns. Though these works were some of the artist's most impressive works to date and crowd favorites, they also drew unwanted attention to the mechanisms of state propaganda, providing a launching pad for a scathing critique of the emergent social values associated with industrialization and bourgeois liberalism.

During the July Monarchy, pictures of war were available to audiences in a wider array of unofficial spaces and contexts than ever before. The ever-increasing options for encountering such works continued a trend that had begun with the outbreak of war during the French Revolution, when a steady stream of images invited audiences to participate in an unofficial political discourse about the place of war in modern society and about the moral stakes of battle painting. New visual technologies, such as the battle panoramas of Jean-Charles Langlois and illustrated newspapers, offered viewers the chance to view images of war beyond Salon exhibitions and museum galleries, and often for a price. These for-profit forms of war imagery, blending entertainment, actuality, and fine art, interacted with the more traditional and official version of war imagery that was directly supported by the French government. This was a historical moment in which the distinctions between different domains of culture brought about by the rise of industrial capitalism became increasingly blurred. In his 1934 essay "The Author as Producer," Walter Benjamin refers to this as a "mighty recasting" and a process of "melting down" between cultural forms that have been understood as distinct from one another. This chapter will explore war imagery as one of sites of this "mighty recasting," where fine art, actuality, and entertainment blended in new and unexpected ways.[9]

FIGURE 74 Horace Vernet, *The Battle of Jena*, 1836. Oil on canvas, 183⅛ × 213¾ in. (465 × 543 cm). Musée National des Châteaux de Versailles et de Trianon.

BATTLE PAINTING FOR THE MUSÉE HISTORIQUE DE VERSAILLES

The vast majority of the battle paintings on view at the Salon exhibitions of the July Monarchy were commissioned by King Louis-Philippe to fill the galleries of the historical museum at Versailles. As Thomas Gaehtgens has shown, the archival evidence indicates that the choice of the battles kept changing throughout the four years of work on the gallery, with no clear iconographic or political agenda guiding the selection. Other studies of the historical museum at Versailles have focused on its uniqueness as a space for historicist illustration of national events of the French past. Michael Marrinan has argued

that the space enacted a "simulation of historical narration" and successfully disarmed any politically problematic aspects of France's tumultuous postrevolutionary history. Though the history museum at Versailles offered the regime an opportunity to use visual imagery to its own political advantage, the space's troubled public reception showed the political risks of this strategy. The quantity of battle paintings on view at Salon exhibitions prior to and just after the inauguration of the historical museum in 1837 gave material expression to the perception that France's best days were firmly located in the past. Just as problematic for the government, many contemporary observers saw the museum as a monument to a denatured,

FIGURE 75 Horace Vernet, *Battle of Friedland*, 1836. Oil on canvas, 183⅛ × 213¾ in. (465 × 543 cm). Musée National des Châteaux de Versailles et de Trianon.

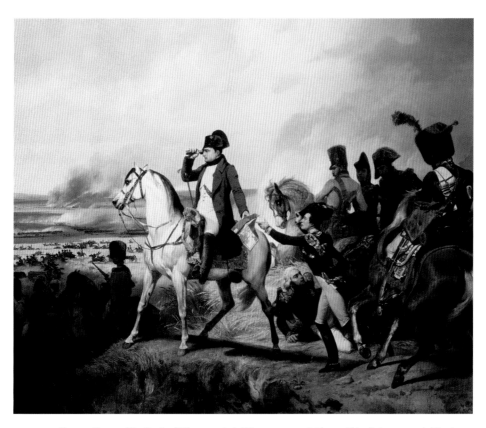

FIGURE 76 Horace Vernet, *The Battle of Wagram*, 1836. Oil on canvas, 183⅛ × 213¾ in. (465 × 543 cm). Musée National des Châteaux de Versailles et de Trianon.

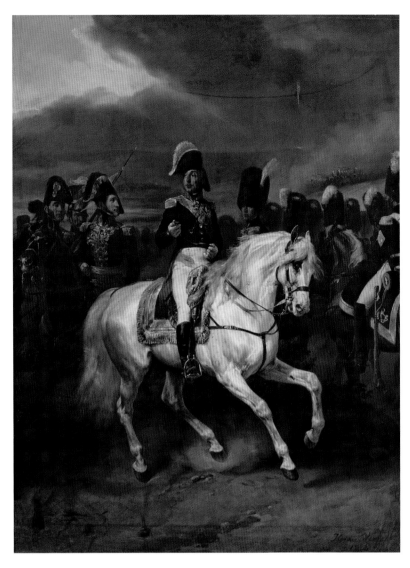

FIGURE 77 Horace Vernet, *Louis-Antoine of Artois, Duke of Angoulême*, 1823–24. Oil on canvas, 114¼ × 153½ in. (290 × 390 cm). Musée National du Château de Versailles et de Trianon.

anodyne form of official art. As Louis Véron put it in his *Mémoirs d'un bourgeois de Paris*, "The museum of Versailles can often provide, it is true, startling impressions and pleasant surprises for experts in bad painting."[10]

The Salon of 1836 featured three large-scale battle paintings commissioned from Vernet specifically for the Gallery of Battles. *The Battle of Jena, The Battle of Friedland,* and *The Battle of Wagram,* each measuring an imposing 4.65 by 5.43 meters, represented important battles from the Napoleonic Empire (figs. 74–76). After being exhibited at the Salon of 1836, these three canvases were transferred to the Gallery of Battles, where they were placed at the end of the gallery. This curatorial decision, which excluded the ongoing conflicts in Algeria from the gallery space, implied that France's illustrious military history had culminated with the Napoleonic Wars. Vernet's three paintings for the Gallery of Battles constituted a formal and thematic departure from the battle paintings that he had

represented for Louis-Philippe and other liberal patrons during the Restoration, helping to explain why many critics reacted so strongly against them. Vernet's Restoration paintings such as *The Crossing of the Arcole Bridge* and the *Battle of Montmirail* had established his reputation as the nation's most important battle painter and demonstrated his facility working in different pictorial modes. For the Gallery of Battles paintings, Vernet shifted into yet another visual mode: episodic incidents like the ones pictured on a small-scale in paintings like *Montmirail* and *Jemappes* are treated on a singular, monumental scale, resulting in works that strike a balance between history painting, historical portraiture, and topographical battle painting. Formally, the 1836 paintings are more closely related to the official equestrian portrait of the duc d'Angoulême (fig. 77) that Vernet painted for the Bourbons during the Restoration than to any of his previous battle paintings. This monumental historical portrait, exhibited

at the Salon of 1824, depicts the heir to the Bourbon throne commanding the French army in Spain. The duc d'Angoulême here stands apart from those around him, suggesting his effectiveness and singularity as a military commander. This painting, along with his *Portrait of King Charles X,* initiated Vernet into the practice of representing contemporary rulers on a monumental scale in a military setting, which he would reprise in the three Gallery of Battles paintings.

Though Louis-Philippe's public image as a figure of consensus benefited from his savvy invocation of the French military heroism that Bonaparte had come to stand for, he also understood the figure of Napoleon as a potentially radical and destabilizing political force that needed to be contained. Following the government's directives and working in close consultation with Louis-Philippe, Vernet inscribed Emperor Bonaparte into a historical narrative that represented him as a figure of authority who issues orders and presides at a remove over military action. As in his portrait of the duc d'Angoulême, Vernet chose not to represent Bonaparte engaged in any form of decisive, high-stakes activity, employing an iconography of unflappable officialdom and power from on high. In contrast to the contingent drama of General Bonaparte's bridge crossing in *Arcole,* Vernet's Emperor Bonaparte is shown to be secure in his position of power, insulated from danger and the threat of unsure outcomes.

The Battle of Jena is arguably the most visually interesting of the three paintings in form and narrative content. The painting depicts the 1807 battle under a stormy sky punctuated with rays of light that create luminous contrasts throughout the painting. The horses carrying Bonaparte and his aides are shown in dynamic motion as they move away from the foreground, a choice that invites the spectator into the picture's space. Bonaparte's horse is arrested in midstride as he stops to discipline an insubordinate young Imperial Guard soldier who had the nerve to yell "Charge!" in his presence, before the emperor could issue the command. In these otherwise stilted and subdued paintings, the interaction between Bonaparte and a lowly soldier is among the most scintillating episodes; the narrative drama in *The Battle of Friedland* and *The Battle of Wagram* is more muted.[11]

Critics did not take kindly to "the three *so-called* battle paintings of Iéna, Friedland and Wagram," as the critic for the *Journal des artistes* called them, affirming as others did

FIGURE 78 Auguste Raffet, *Bonaparte, Commander in Chief of the Army of Egypt,* 1835. Lithograph, 14¼ × 13⅝ in. (36 × 34.5 cm). Fitzwilliam Museum, University of Cambridge.

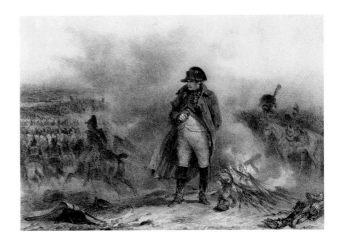

FIGURE 79 Auguste Raffet, *The Master's Eye,* 1833. Lithograph, 10½ × 13⅝ in. (26.7 × 34.7 cm). Anne S. K. Brown Military Library, Brown University.

that these were not battle paintings at all: "His three battles are in the *livret* but not on the canvas. I only see three groups where Napoleon appears with his horse and the rest is nothing, or very insignificant."[12] In his critique of the Salon of 1836, Gustave Planche blamed both the government and Vernet. The disappointing paintings, he contended, were the result of the government's selection of minor episodes from the battle and not the battle itself; Vernet was also culpable for not elevating his subjects above the incidental. Instead of giving Napoleon a grave and imposing expression in *The Battle of Jena,* Vernet made him look like a "horse groomer off for a morning stroll." In *The Battle of Wagram,* the emperor fared even worse, calling to mind "a conscript taking his first horse

riding lesson." For Planche, these paintings "civilized and disarmed history."[13] These critics faulted Vernet for deploying a seemingly unheroic visual language for Napoleonic military history, one that failed to satisfy their expectations, informed by academic tradition, that battle painting should offer a morally inspiring message. Instead, Vernet's paintings for the Gallery of Battles proposed a very different sort of war picture: monumental in scale, but without the grand message.

Despite the critical opprobrium, Vernet's paintings were the sensation of the Salon of 1836 and would later count among his most beloved and most reproduced paintings. The measure of popular success that they enjoyed in 1836 and thereafter suggests that Vernet's strategy of representing France's military annals through anecdotal, up-close encounters with Bonaparte on the margins of his military campaigns struck a chord with the public. This likely stemmed from the fact that in their distinctive style, the Gallery of Battles paintings were indebted to conventions drawn from lithographs and illustrated books on the life of Napoleon that, having circulated since the 1820s, had created one of the most recognizable cultural vernaculars of the nineteenth century. Along with the lithographers Nicolas-Toussaint Charlet and Auguste Raffet, Vernet, in prints and book illustrations such as those in Arnault's *Vie de Napoléon,* had helped to transform Bonaparte into an approachable figure of human proportions. Small-scale lithographs such as Raffet's *Bonaparte, Commander in Chief of the Army of Egypt* (fig. 78), published in a lithographic album in 1835, and *The Master's Eye* (fig. 79), published in an 1833 album, offered audiences up-close glimpses of Bonaparte's endeavors. While Raffet often depicted the heat of battle, he also showed less grandiose moments, such as the young Bonaparte hunched over rather unceremoniously on a camel, slogging through the desert with his army. Here was grand history on a minor scale that could be acquired for as little as a few francs. Vernet's large-scale paintings of Napoleonic battles seemed steeped more in this Napoleonic print culture than in the grand traditions of painting; thus, they spoke directly to the larger viewing public, who would have likely accepted the artist's invitation to look, identify, and enjoy. When the critic for the *Indépendant* newspaper accused Vernet of reducing events of "grand importance to the petty proportions of vignettes worthy of illustrating *The History of Napoleon* of Monsieur de Norvins," he was also intuiting the next major development in the spread of image-based Napoleonic military history. Just three years later, in 1839, the first illustrated edition of Jacques de Norvins's 1827 book was published, with hundreds of in-text woodblock illustrations by Raffet. The next year, Vernet illustrated Paul Mathieu Laurent de l'Ardèche's *Histoire de l'empereur Napoléon.* The ease with which Vernet moved between painting, printmaking, and book illustration may have troubled art critics, but this blurring of the boundaries between different visual forms was a thoroughly modern approach, which helped him to cultivate a broad public for his works.[14]

As the most prolific battle painter of the July Monarchy, Vernet received the lion's share of criticism for the state of battle painting in France. But it is important to note that critics were similarly scathing about other artists' battle paintings destined for Versailles. Scheffer's *Battle of Tolbiac* (fig. 80), the first painting in the gallery's succession of battles, and even Eugène Delacroix's *Battle of Taillebourg* (fig. 81), also destined for the Gallery of Battles, came under swift attack by several critics. While critics faulted Vernet's paintings for their banality, Delacroix's *Taillebourg,* whose swirling composition of men and horses coming to direct and violent blows recalled the Baroque tradition of battle painting as practiced by Peter Paul Rubens and Salvator Rosa, was mocked for its lack of clarity as "a sort of fricassee of men and horses." Beyond criticism of individual battle paintings, critics during the July Monarchy devoted entire sections of their articles to a very specific problem, namely the perceived overabundance of official battle paintings on display in official art galleries. This perception encouraged a critical discourse in which the intentions behind official propaganda were openly questioned, and the government's support of French militarism was derided as disingenuous. In this sense, the government-sponsored retrospective battle paintings on view at the Salon and displayed throughout the galleries at Versailles, far from reflecting the government's intentions, inadvertently generated a set of meanings that allowed critics to take issue with the political deliberations behind official patronage. Why, asked the critics, were there so many battle paintings at a time when the government sought to limit any conflicts with its European neighbors? In the words of one critic: "Ever since this European politics of peace, the fine arts have wanted to have their period of conquests and bloody victories. It's a flood that carries us away, and the painters are creating nothing more than

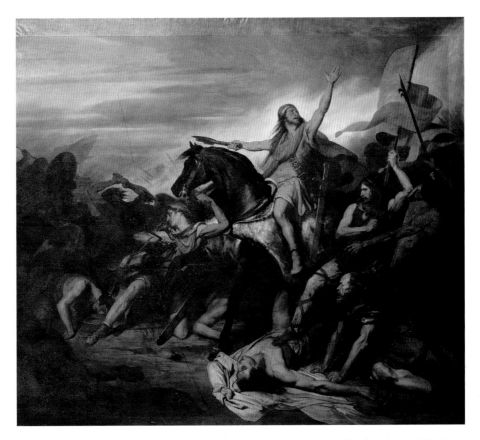

FIGURE 80 Ary Scheffer, *The Battle of Tolbiac*, 1837. Oil on canvas, 164.40 × 183⅛ in. (415 × 465 cm). Musée National des Châteaux de Versailles et de Trianon.

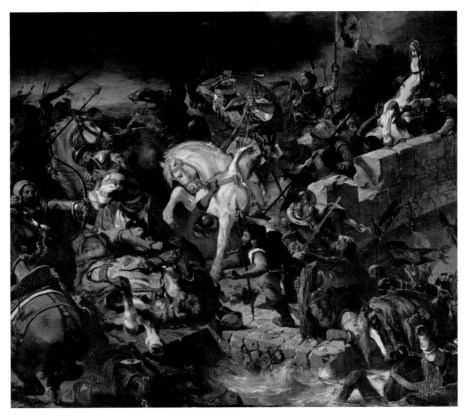

FIGURE 81 Eugène Delacroix, *The Battle of Taillebourg*, 1837. Oil on canvas, 192½ × 218⅛ in. (489 × 554 cm). Musée National des Châteaux de Versailles et de Trianon.

military wagons, cadavers and hole-ridden flags." Ulysse Tencé's complaint in the *Annuaire historique* that "it is certain that never have more war paintings appeared in such a peaceful time" became a reccurring motif of Salon criticism during the period. The critic for *L'Artiste* contended, "We no longer produce anything but battles in a time when we no longer fight." As another critic observed, the problem was one of historical distance and the difficulty of painting memories that had grown too lofty. Battle paintings commissioned under Napoleon were made during a time of war, when "the sound of success was on everybody's mouths, and wonder and admiration in every heart." Whereas early-nineteenth-century battle painters such as Gérard and Gros painted at a time when "victory shook all of Europe," artists of the July Monarchy painted belatedly. "All these triumphs have grown in the memory of the people. For them, Napoleon has the stature of a demi-god, and his battles are the combats of giants; and our artists seek with difficulty to idealize these figures and these memories. This is why the battles that will garnish the walls of the palace of Versailles are generally without interest." For this critic, and many others during the period, battle painting became an impossible endeavor when set against recent French history's "combats of giants."[15]

As a result of the government's patronage strategy, it appeared to many that France's most heroic days were firmly in the past. This perception compelled critics to examine France's contemporary military situation relative to what was perceived as a more illustrious, heroic period. "For years the Salon has been completely covered with battles," opined one critic. Completely ignoring the French conquest of Algeria, the critic contended that "for around twenty-four years we have done practically nothing in terms of war." This was a relatively common observation among art critics who viewed the surge of battle paintings during the July Monarchy as a symptom of the government's pursuit of peace with its European neighbors. In addition to representing a Eurocentric view of international politics that regarded colonialism in North Africa as a less illustrious form of military engagement, battle paintings offered "a substitute for horrible war" that arose out of "idleness" and the fact that French citizens no longer had to worry themselves over "the existence of an empire."[16] In this line of thinking, battle painting was a compensatory measure designed to perform France's military eminence in image only.

The impulse among critics during the July Monarchy to equate the explosion of official battle painting with a temporal and political condition that they called "peacetime" offered a way to define the present in negative opposition to the historical memory of the revolutionary and Napoleonic wars. For nearly all the critics writing about the overabundance of battle painting, "peacetime" was experienced mournfully and belatedly in relationship to Napoleonic wartime. In this sense, the meanings generated by government-sponsored Napoleonic battle paintings were a function of their perceived irrelevance relative to an absence of the kinds of large-scale international conflicts that had occurred before 1815. The troubling condition of military belatedness not only developed in relation to the contents of Salon exhibitions but was also exacerbated by the proliferation of Napoleonic and revolutionary war imagery circulating in the wider visual economy of the July Monarchy. Critics often discussed this "fatigue" as a part of a larger image-based problem, notably within print culture. In a review of the battle paintings on view at the Salon of 1836, a critic lamented the saturation of French visual culture with images of Napoleon and the wars he conducted, diagnosing this as an "unfortunate facility of reproduction." These images had become so endemic that "even the lowliest saddle boy can trace Napoleon on the wall with as much dexterity as the best of our painters."[17] For the chorus of critics who diagnosed the problem of battle painting's overabundance during the July Monarchy, these pictures depicted a muted, denatured history robbed of import. In this way, they acted not unlike the figure of the historian evoked by Walter Benjamin in a note for a draft of "On the Concept of History": "The happy message that the historian delivers with a flying pulse is uttered by a mouth that, perhaps already in the moment of opening itself, merely speaks into an emptiness."[18]

While it might strike twenty-first-century readers as a puzzling historical anachronism that critics should find "peacetime" a troubling, enervating condition, such misgivings do not necessarily mean that nineteenth-century art critics wished France to be plunged back into a state of protracted warfare. In accusing the government of overproducing battle paintings and using them as a feeble substitute for the heroic values of an eclipsed age, these critics were also launching a not so thinly veiled critique of Louis-Philippe's government for its embrace of profit, industry, and the market values of bourgeois liberalism,

values that were understood to flourish only in a time of peace. For many contemporary observers, including art critics, "peacetime" was equated with French military decline and the sense that the once great conquering nation no longer played any important role in determining international politics. This position was not necessarily a political critique of the July Monarchy government, but was employed to indict the values of an entire epoch by commentators across the political spectrum—even those within the elite circle of the July Monarchy's ruling class. Ximénès Doudan, for example, was a close advisor to the family of Louis-Philippe's powerful minister of public instruction, and later of foreign affairs, Victor de Broglie; he diagnosed a social and cultural malaise afflicting contemporary France in direct relation to "peacetime." For Doudan, the grand deeds and characters of the revolutionary and Napoleonic past created a contemporary stupor in French society: "How the shadows extend over everything so fast! . . . There is no more Revolution or Empire. There is no longer anyone who knew Mirabeau, had personally seen Bonaparte returning from Italy, given advice to the Emperor, and discussed with him all of these gigantic plans, of which there is nothing left but the Versailles museum. We have not done great things ourselves, but we have seen fall generations much stronger than us." Doudan sensed an acute lack of heroics in French contemporary life; the *grands hommes* of the Revolution and Empire were now either ailing or dead; Louis-Philippe's Versailles was like a mausoleum that had petrified France's storied past. He believed that war was anathema to the logic of progress and profits that ruled contemporary France. "The real canon does little to exalt the imagination," he wrote. Despite their hankering for the heroic endeavors of their fathers and grandfathers, "sensible landlords find themselves surprised by a profound melancholy when thinking about the cost of glory. This is not timidity before material danger, it is the horror of fortune, the fear that the teetering soup kettle might tip over, or that it may be disturbed." These comments suggest the complexities of mid-nineteenth-century French militarism and the role that battle painting played in relation to it: they echo the remarks made by art critics about battle painting in a time of "peace," with their unmistakable reverence for the recent military past, both wistful and tinged with regret. Doudan also recognized that this reverence toward and exaltation of war posed a threat to the economic security of land-owning French men (and

ostensibly himself), who sought to keep the "kettle" from tipping over. The exaltation of war and the fear of going to war were thus related phenomena during the July Monarchy, which helps to explain the lukewarm reception faced by battle painting destined for the Musée Historique de Versailles. Battle painting offered audiences opportunities to reflect upon past glories without compelling them to action; it also represented a set of experiences and values that were increasingly seen as incompatible with modern society.[19]

The most emblematic material expression of the values of the new industrial age was the railroad. Louis-Philippe ensured that his historical museum would be associated with these emergent values by linking his massive public arts project to Paris with not one but two separate railroad lines, built between 1836 and 1840 on each bank of the Seine. They became the most expedient way of traveling from Paris to see the historical museum and also gave the government an opportunity to connect its ambitious public arts project to a marvel of modern transport. The 1846 edition of *Galignani's New Paris Guide* advised tourists to take the south-bank rail line to Versailles and return on the north-bank line, "by which means two magnificent views of Paris and the neighboring country will have been obtained." But just as the official battle paintings destined for the historical museum attracted negative attention, so too did the railroads. Jérôme-Adolphe Blanqui, who held the chair of political economy at the Conservatoire des Arts et Métiers, derided the government's decision to construct two separate railroad lines. In an industrial economics textbook published in 1839, he wrote, "Do you understand? Two lines, between Paris and Versailles; not between an industrial city and a sea port, as with Liverpool and Manchester, but between a city of luxury and a city of curiosity; not for businessmen but for idle visitors." Like many commentators, Blanqui viewed the two lines that connected Paris and Versailles as a frivolity; instead of providing any instrumental benefit to France's industrial economy, the railroad connecting Paris and Versailles would be used by well-heeled tourists who possessed enough spare time and income to engage in the pursuit of leisure. Indeed, the railroad out to Versailles was hardly affordable for the entire French population; a round-trip ticket in second class cost 2 francs 50 centimes, almost an entire day's salary for a worker. Louis-Philippe's universalizing, historicist vision of French history was therefore only available to those who could afford to hire a carriage or purchase rail transport. The official

La Musique, la Peinture, la Sculpture

Par BERTALL.

Gravé par ROUGET.

FIGURE 82 Bertall, *Music, Painting, and Sculpture*, published in *Le Diable à Paris*, 1846. Dartmouth College Library.

guidebook for the museum, published just before the inauguration of the railroad, explained to readers that the voyage to Versailles from Paris would be reduced from two hours by carriage to a mere few minutes by rail "as if by enchantment."[20]

The French government's decision to construct two railroad lines between the historical museum and Paris implied the contemporaneity of Louis-Philippe's public arts project and linked it with the new era of industrialism made possible through "peace." It is therefore no surprise that Vernet, whose reputation during the July Monarchy was inextricably tied to the patronage of the bourgeois "citizen king" and to the display of his paintings at the historical museum, was often discussed at the time as an "industrial" artist. Though it was his prodigious output

that caused him to be associated with modern industry, the artist participated in a form of modern economic activity typical of men of his economic station during the July Monarchy: railroad speculation. Vernet's account books reveal that he was a shareholder in the newly constructed Versailles railroad, the same line that would have transported visitors to the historical museum. In 1837 and 1838 he made a tidy sum—3,084.75 francs—from his investments in the railroad.[21] While his personal ties to the railroad were not known to the public, critics during the July Monarchy associated his manner of working with industrial modes of production, including the railroad. In an allegorical caricature (fig. 82) of the arts in France entitled *Music, Painting, and Sculpture* that was published in the literary magazine *Le Diable à Paris* in 1846, the locomotive provided the caricaturist Bertall with a convenient way of characterizing Vernet: suspended from a railroad car as he executes a large battle painting. Ingres and Delacroix are pictured on the ground to Vernet's right, engaged in a debate on the merits of line versus color. In this humorous scenario, Vernet is spatially estranged from the heated intellectual debate of his contemporaries and is pictured instead in the process of producing. The print suggests that instead of being inspired by lofty aesthetic ideals like his contemporaries, Vernet works mechanically: in the image, it is the train that drives him, and not the other way around. His artistic identity is thus anchored in the material object world of modern industry and not in the loftier pursuits of fine art, represented here through his contemporaries Ingres and Delacroix. This line of critique was adopted earlier on by Gustave Planche, one of Vernet's most colorful detractors, who likened his prodigious output to that of a baron of industry. Commenting on the enormous scale of his works at the Salon of 1836, Planche wrote:

> If what they say is true, we should bend down on one knee before M. Horace Vernet and ask that he be given a patent; his name deserves to be inscribed next to James Watt in the history of European industry. It is permitted, without exaggeration, to see the brush of M. Horace Vernet as a machine with the force of 160 horses, and when his patent has expired, when, thanks to the fabulous fecundity of his methods, he will become the landlord of two or three regions in France, I hope that he will publish his secret and deign to train students. If it pleases M. Horace Vernet, and if the government,

enriched by peace, does not skimp, Paris will become the most beautiful city in the world; all the streets will be covered in painting, all the houses from the first to the third floor, will offer to the gazes of passersby the most glorious episodes of French history.[22]

Planche took aim at the proliferation of Vernet's battle paintings as well as the speed with which he made them, likening the artist's brush to a machine. Through hyperbole and sarcasm, Planche cast Vernet as a greedy landlord, taking over the landscape by covering entire facades of buildings. This humorous and prescient image of Vernet's own "museum without walls" is also an extremely pointed attack on the government's patronage strategies. Planche and Bertall's representations of Vernet correspond more generally to the ways that Salon critics discussed the overabundance of battle painting as Salon exhibitions—that is to say, in starkly material terms. "Nobody can ignore the manner in which battle painting is fabricated [se fabrique] today," wrote one critic in 1836. The use of the verb se fabriquer implied, according to the 1835 edition of the Dictionnaire de l'académie française, a mechanical mode of production that pertained specifically to industrial goods. Far from an elevated, higher mental calling, critics viewed the production of battle painting during the July Monarchy as an almost factory-based mode of production, devoid of artistic inspiration: "a group of officers, a hero who extends his arm and shakes his sword, one or two soldiers who die in beautiful poses; such is the summary of this genre that pleases the vulgar and consoles us through vision from this long peace that France enjoys despite herself."[23] Here, the production of battle paintings came to stand in for a nefarious form of material excess spurred by official patronage. While the government may have intended to use these works as a form of positive publicity for its policies and to neutralize the legend of Napoleon and the history of the wars he presided over, this strategy drew attention to machinations that the July Monarchy would have preferred to pass unnoticed. Instead of flattering government power, the production of official battle paintings for Versailles exposed the regime to charges that it was debasing art in the name of propaganda, producing vapid battle paintings without substance, and advancing a political agenda in which the values of material proliferation and the expansion of the industrial economy took precedence over the cultivation of military glory.

THE BATTLE PANORAMAS OF JEAN-CHARLES LANGLOIS

The critical backlash against the official retrospective battle painting on view at Versailles was directed as much at the paintings themselves as it was against a perceived cultural shift on the part of the ruling classes toward materialism, industry, and profit. In this sense, battle painting provided nineteenth-century art critics with a platform for launching more general critiques of French social and political developments seen as weakening French military prowess in "peacetime." With so many paintings on view at Salon exhibitions, a critical fatigue with the genre emerged as critics openly asked whether painters should just give up representing war entirely. In a series of comments on the dozens of battle paintings on view at the Salon of 1836, Victor de Nouvion called for artists to picture "this dreadful aspect that is inseparable from the idea of a combat." Battle painting should "be at least a combat, and the scene should be animated, imposing, majestic, and terrible." He concluded that "the painting of a battle is an impossible thing, and that one is forcibly restricted to choosing only the most brilliant episodes. If, instead of this, you represent a general chatting with his staff, or with some soldiers, one will have the right to laugh at you."[24] Taken in the context of the wave of critical invective against battle painting, Nouvion's remarks against the very possibility of representing a battle through the medium of painting might make it appear as though war as subject for visual representation had been exhausted.

In 1836, the secrétaire perpétuel of the Académie des Beaux-Arts, Antoine Quatremère de Quincy, admitted in his homage to the recently deceased Napoleonic battle painter Antoine-Jean Gros that the practice of modern battle painting had become incompatible with the modern scale of warfare, "with its limitless proportions of masses of troops and the dimension of the terrain they occupy." He contended that there was only one acceptable way to paint war on a modern scale: "Only the vast and special expanse of the panorama can suffice."[25] In contrast to government-sponsored battle painting, panoramas were viewed at the time as the one acceptable means of visually representing France's military history as "animated, imposing, majestic, and terrible," to use Nouvion's terms. Contemporary reviews of the battle panoramas of Jean-Charles Langlois, the nineteenth century's most important panoramist, reflect this idea. At the historical moment when critics were rejecting official battle painting's predictable clichés, Jean-Charles Langlois's panoramas

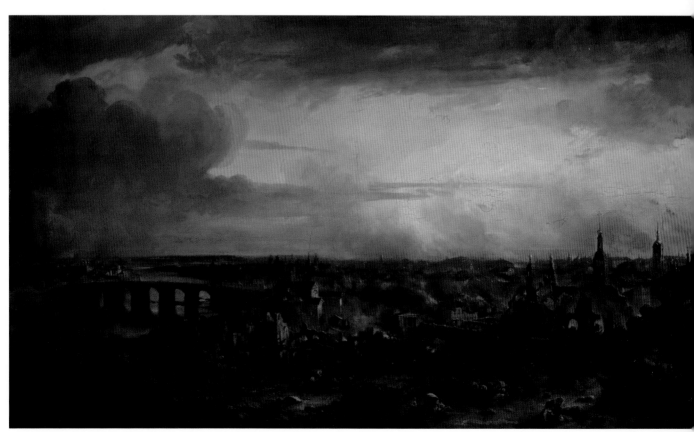

FIGURES 83–86 Jean-Charles Langlois, studies for *The Fire of Moscow*, 1843. Four paintings, each 29 × 52⅜ in. (76 × 133 cm). Musée des Beaux-Arts de Caen.

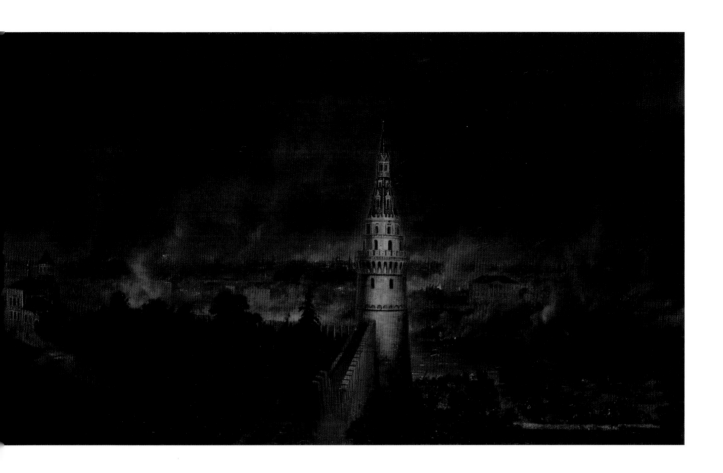

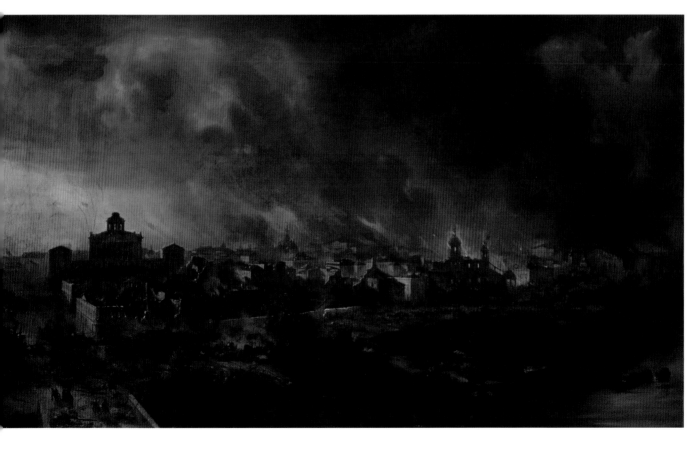

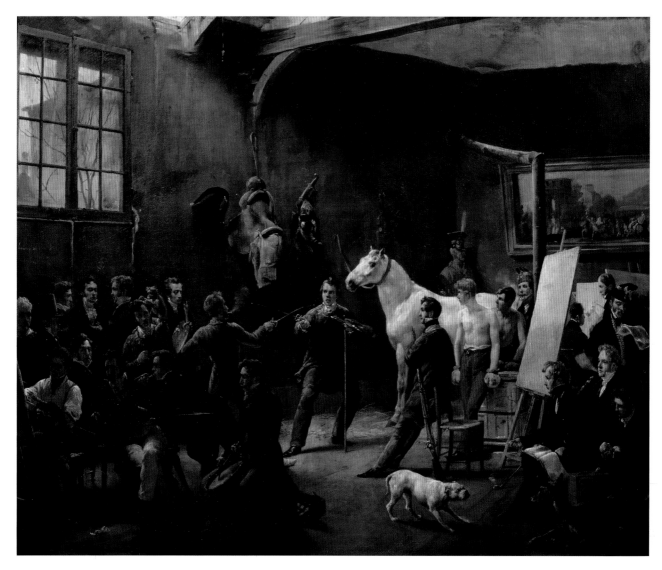

FIGURE 87 Horace Vernet, *The Atelier of Horace Vernet,* 1820–21. Oil on canvas, 21¾ × 25⅞ in. (55 × 66 cm). Collection Carnot, Paris.

occasioned a very different set of reactions. The art critic Etienne Huard, who normally reviewed Salon exhibitions for the *Journal des artistes,* marveled at the fiery debacle that unfolded before his eyes on a round monumental canvas approximately 125 feet in diameter. Though the panorama was completely destroyed in 1839 when the canvas was taken down, several large-scale preparatory studies remain (figs. 83–86):

> You enter through a dimly lit gallery, climb a winding staircase and then you see the light: finally, spectators, in less than a few seconds, find themselves on the Borisoff Tower, in the middle of the Kremlin, their surprised eyes contemplating the most beautiful and at the same time most hideous spectacle that could ever

be seen . . . because everything is on fire. . . . Right in front is the main event . . . the army, commanded by the Emperor, is ready to begin marching; two cavalry scouts are in the foreground, then come the group on horseback. . . . Farther away, everything burns. . . . One truly feels transported on this tower, and trembles [*frémir*] at these scenes, so varied, so rich and so especially truthful. It really does seem as though the fire reflects itself upon the spectators! . . . All of Paris will want to participate in the Moscow disaster.[26]

Langlois's representation in his third panorama of one of Napoleon Bonaparte's most devastating losses moved this critic and many others to describe what they viewed as a logical progression of events, actors, and topography,

a narrative description that would be a key feature of critical writing about all of Langlois's battle panoramas.

Langlois's successful career as a Salon battle painter and military panoramist extended and built upon the patterns of reception established by the artist-officers Louis-François Lejeune and Louis-Albert Guislain Bacler d'Albe, whose participation in the Napoleonic wars bolstered the credibility of their battle paintings in the public eye. Langlois had come of age during the Napoleonic Empire. At seventeen, he attended the prestigious École Polytechnique, began his military service in 1807, and was promoted to the rank of captain in 1812. Between 1807 and 1815, Langlois participated in eight military campaigns and was wounded at the Battle of Waterloo. In 1818 he was reintegrated in the army as an aide-de-camp to marshal of France Laurent Gouvion Saint-Cyr, and he remained an active member of the military throughout the rest of his life. After the fall of the empire and the disbanding of the Grande Armée, Langlois moved to Bourges, where he first took up painting; he soon relocated to Paris, where he studied briefly with Théodore Géricault, and then joined Vernet's studio, where he would hone his craft under the most accomplished battle painter of the period. Vernet's only claim to military experience was his participation in the defense of Paris at the Clichy Gate in 1814; welcoming veterans like Langlois into his studio during the Restoration allowed Vernet to burnish his reputation as a committed (and authentic) chronicler of France's military spirit. Langlois appears in Vernet's *Atelier of Horace Vernet* (fig. 87), where he is pictured on the far right, reading a newspaper in the jocular, homosocial atmosphere of the studio. Given Langlois's inclusion in this painting, which served as something of a manifesto and business card for Vernet, it would appear that the arrangement was mutually beneficial for both men.[27]

Langlois and Vernet remained close throughout their lives (they were the same age, both born in 1789). Langlois's wife, Zoe, wrote to Vernet's wife, Louise (née Pujol), two years before the opening of his first panorama, to tell her about her husband's project. In the letter, Zoe described how the panorama might offer a way to overcome the bounded limitations of battle painting. "My husband," she wrote, "has devised a project for a naval panorama that will be 120 feet in diameter. From the vantage point of a life-size ship, the viewer can consider all of the details and at the same time view the ensemble of a naval combat." She called the project "a speculation, into which we are putting a part

of our fortune."[28] Langlois thus staked his financial future on the prospect that French audiences would be willing to pay for the privilege of experiencing a more totalizing representation of contemporary war than traditional framed battle painting was thought capable of providing. His calculations proved correct: critics routinely asserted that Langlois's panoramas were capable of immersing viewers in not just an image of a battle but an experience that might impart knowledge of what war *felt* like. At 2 francs 50 centimes, the cost of tickets for Langlois's first panorama in 1831 would have excluded most working-class patrons; like Louis-Philippe's Musée Historique de Versailles, battle panoramas were classed spaces. Extant large-scale studies for Langlois's panoramas can only partially recapture the embodied experience described by critics; panoramas were ephemeral attractions, meant to be taken down and discarded (or painted over) after they closed to the public. Battle panoramas, for those who could afford the entry fee, were immensely popular in France from the Directory up through World War I. The panorama was originally invented by the Englishman Robert Barker in 1787 and quickly gained popularity all over the European continent. Most of these early panoramas represented topographical cityscapes of distant lands. Langlois departed from this tradition to specialize in contemporary French military history, a subject to which he was uniquely suited because of his military experience, which he would continue to gain throughout his lengthy lifetime career in the French army. As François Robichon has noted, he was the first panoramist to take on the challenge of integrating figures into his monumental compositions, a formal innovation likely encouraged by his training as a battle painter in Vernet's studio. Langlois also introduced several other innovations to his panoramas: using frosted glass for the rotunda roof to create a more even distribution of light and extending the illusionism of the circular painting into three-dimensional space with false terrain and other props. He oversaw the production of no less than eight panoramas between 1831 and 1863, none of which survive today.[29]

The panorama's importance as one of the constitutive sites of modern spectacular scopic regimes has been widely discussed by scholars of visual culture. Echoing the prominent place accorded to the panorama by Walter Benjamin in his *Arcades Project,* Jonathan Crary has noted that it is "one of the places in the nineteenth century where a modernization of perceptual experience occurs." Scholars have likewise been interested in the panorama's status as a

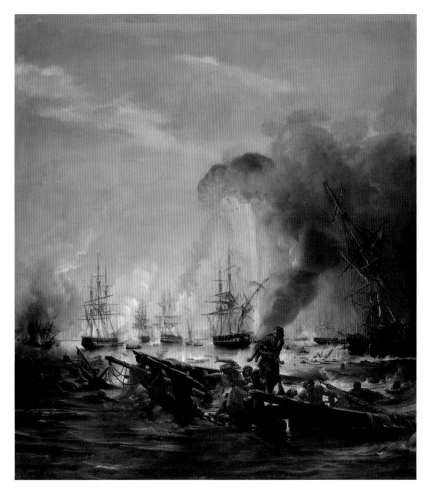

FIGURE 88 Friedrich Bouterwerk, after Jean-Charles Langlois, *Episode of the Battle of Navarino, October 20, 1827*, 1837. Oil on canvas, 66⅞ × 59¾ in. (170 × 152 cm). Musée National des Châteaux de Versailles et de Trianon.

forerunner of cinema and as an early form of mass culture. Vanessa Schwartz has, for example, emphasized the panorama's status as a technology of entertainment in relationship to the development of early cinema and other late-nineteenth-century visual spectacles, such as the wax museum. In Maurice Samuels' terms, the panorama is also the site of a new mode of realist historical representation that accompanied a new tide of historians and authors who increasingly turned to image-based modes of narrative descriptions to make the past appear more vivid and engaging. Though the panorama has been firmly established as a mode of popular spectacle within studies of nineteenth-century visual culture, it occupies a somewhat more marginal position within most art-historical accounts of the nineteenth century. In his 1889 *Histoire de la peinture militaire en France,* Arsène Alexandre explained, "We do not consider the panoramas to be art at all . . . we simply ask which museum has conserved the ones that are no longer in use."[30] Though panoramas and official battle painting were two very different modes of visual production and were viewed in completely different exhibitionary contexts, they were nevertheless often understood by nineteenth-century commentators in relationship to one another. Langlois helped cultivate this impression by frequently exhibiting works related to the subjects of his panoramas in the Salon. With the openings and closings of his different panoramas in mind, he often used the Salon as a publicity tool to prime the public. At the Salon of 1831, for example, he exhibited a painting entitled *Episode of the Battle of Navarino* right after the opening of his first panorama of the same battle (fig. 88). Auguste Jal praised the painting, specifically its fidelity to the depicted events (he claimed that naval officers who had participated in the battle spoke to him of its accuracy), and then described it as a "prelude" to the panorama in which "the spectator becomes witness and actor in the combat." This was hardly an isolated

incident: Langlois maintained a presence as a Salon battle painter throughout his lengthy career in relationship to his panoramas; he also obtained several commissions for battle paintings for the historical museum at Versailles, all the while serving as an active member of the French military. Langlois's panoramas not only acted as benchmarks for evaluating government-sponsored battle painting but also provided a new standard for picturing war that shaped the look and ambition of nineteenth-century battle painting to come. There is therefore much to be learned by placing these two visual forms back into dialogue with one another as they would have been in the nineteenth century.[31]

Though the status of Langlois' panoramas as temporary, for-profit attractions that worked through a series of carefully calibrated visual and mechanical illusions divided them from the rarefied cultural domain of large-scale official battle painting, critics nevertheless frequently referred to them as works of art, often in direct negative comparison with official battle painting. Like Salon painting, Langlois's panoramas were reviewed by art critics for newspapers, so writers brought to these reviews a vocabulary that was already informed by the language of art criticism. Echoing an oft-repeated sentiment, the critic for the *Gazette des Salons* argued that Langlois had expanded the "limits of art" with his panoramas.[32] Paul Mantz, writing in 1853, contended that

Langlois had elevated the panorama from "a sort of toy for large children, a pure curiosity" into a "work of art."[33] Mantz then advocated for the establishment of a panorama museum whose mission would be to educate the French public and transform these temporary spectacles into enduring monuments to French military history. Mantz's plea underscores the fact that the boundaries between painting, education, and entertainment were being continuously recast under the guise of emergent visual technologies such as the panorama. Within the context of a typical complaint about the abundance and lackluster quality of the battle paintings at the Salon of 1837 destined for Versailles, Alexandre Lenoir (founder of the Musée des Monuments Français, turned art critic) lamented the fact that Langlois's *Fire of Moscow* panorama could not be transported to the Salon. In comparison to the usual clichés of official battle painting on view, Lenoir deemed Langlois's panorama to be "the most surprising battle painting ever made."[34]

Etienne-Jean Delécluze, writing in 1831 in reaction to Langlois's first panorama, *The Battle of Navarino*, a decisive 1827 battle from the Greek War of Independence, worried that the panorama's marvelous illusionism might threaten the very existence of traditional painting. If Langlois continued to produce panoramas, he wrote, "what will become of flat, framed painting? God only knows."

FIGURE 89 Jean-Charles Langlois, *Rotunda of the Panorama of the Battle of Navarino*, 1831. Pencil and ink wash on paper, 11 × 12⅞ in. (28 × 33 cm). Musée Carnavalet, Paris.

Though Delécluze was impressed by the effect of *Navarino,* he accused the panoramist of carrying the illusion too far, to the point of "disorienting the public." He criticized the fact that Langlois had combined a painted panorama with what he called "reality, which will become confused with painting."[35] Delécluze's discomfort with painting intermingling with other forms of visual illusionism was in response to Langlois's use of a series of three-dimensional features apart from the painting of the naval battle. Langlois made a life-size model of one of the ships, the *Scipion,* that had participated in the battle of Navarino, and equipped it with seventy-four decommissioned cannons provided by the French navy (fig. 89). The choice to include a replica of the *Scipion,* which many reviewers took to be the real ship, was crucial to the veracity of the illusion of entering into a space of war. This rather effusive commentary can be taken as typical of the vast majority of newspaper accounts: "There has never been a more original use of panorama painting than the one offered at this moment by the panorama of Navarino. . . . Spectators climb the successive levels of the vessel. At first, you find yourself near a battery, where one sees a part of the crew busy putting out a fire caused by a burning enemy ship. Then, one climbs a staircase to the storeroom. There, you can ACTUALLY go through the sleeping quarters of the commanding officer as well as a small gallery armed with cannons. Finally, a third staircase goes all the way up to the rear deck, from which you discover the entire deck of the ship; and from there and all sides, the naval combat and the mountains that surround the bay of Navarino." The "crew" putting out the fire that the writer mentioned was actually an elaborately constructed diorama of wax figures placed in the lower deck, inside the ship, along with other three-dimensional objects, including navigation manuals, maps, compasses, and barometers. Two bloody wax bodies of injured sailors also greeted visitors on their way up to the painted canvas. The captain's uneaten dinner was displayed in his quarters.[36]

To help visitors make sense of the expansive painting that surrounded them above deck, Langlois produced a printed brochure that described the topographical and episodic details of the combat and landscape represented on the canvas. But to ensure that the narrative of the battle be clearly understood and recounted in a logical progression for the audience on the viewing platform, Langlois made use of what one critic called "living debris" of the French army.[37] As he would at many of his future panoramas,

Langlois hired veterans, some of whose bodies bore the marks of their military service, to act as official guides. The guide of Langlois's *Battle of Navarino* was described by one reviewer as "a civilized Provençal who chews tobacco because he's a sailor, but does so with propriety." His arm was "carried off in 1805 at the Battle of Trafalgar."[38] The guide would have stood out from the Parisian bourgeois crowd because of his missing appendage and, more importantly, his status as a working-class sailor from the countryside. In the context of Langlois's battle panoramas, the maimed veteran guide constituted a living, breathing testament to the physical violence wrought by armed combat and would have further obscured the boundaries between representation and reality, between telling and showing upon which contemporary accounts of battle panoramas placed such a high value.

The enthusiastic reception of Langlois's battle panoramas was premised upon their deployment of multiple registers of illusion: inanimate objects in dioramas, the viewing platform itself, the monumental circular painting, the fake debris in front of the painting, and the "living debris" that was the guide. Langlois asked his paying customers to navigate a series of different visual experiences in which the transition from material objects to painted canvas was carefully calibrated to be as seamless as possible. The art critic Auguste Jal, who wrote a lengthy review of the panorama of Navarino, described the belowdecks illusions: "You did not even perceive the diorama, because the transition from the real to the represented is so well considered."[39] Unlike Delécluze, who objected to Langlois's "disorientation" of his public, Jal, like most other reviewers, welcomed the confusion between levels of illusion and took pleasure in the challenge of deciphering them. This process of immersing oneself in an environment of sensual confusion elicited an active form of spectatorial engagement with contemporary military history, or with what one critic called its "horrifying truth."[40] Critics routinely argued that Langlois's panoramas allowed viewers to participate in the experience of the event that they portrayed. The truth value of the panoramas was thus premised upon a form of historical knowledge steeped in lived experience. Assertions such as this one were typical: "There is no inhabitant of Paris, as peaceful and home-loving as they might be, that would not be tempted to say in leaving the rotunda, 'Me too, I was there with the Emperor on the terrible campaign of 1812!' "[41]

Though it might be tempting to attribute these reactions entirely to the immersive environment of war

Langlois constructed, and to the sophistication of its illusions, it is also important to note that his battle panoramas satisfied a set of viewing expectations associated with military imagery that been in place since the French Revolutionary Wars. The claim that the panoramas represented battle as truthfully and transparently as possible, and that they permitted viewers to *experience* a battle, harkens back to critical writing on topographical war imagery starting in the 1790s: during a period of protracted warfare and national upheaval, these works were praised as participatory images. Small-scale battle paintings and prints were discussed in these terms and were valued for their ability to transform viewers into eyewitnesses. Though very different in scale and embodied experience from Langlois's panoramas, the topographical war imagery produced in the wake of the French Revolution also featured decentered compositions bereft of a singular, culminating focus. The proliferation of detailed episodes that unfolded within Lejeune's battle paintings, for example, enabled the illusion that the depicted events were structured not by narrative conventions but by careful, direct observation; because of this, they earned praise as faithful transcriptions of military events that provided a surrogate visual experience of war. Critical affirmations regarding the transparency of Langlois's panoramas—of their ability to impart to viewers the experience of a historical battle through the act of viewing and embodied encounter—therefore have a rich history that depended on the willingness of viewers to *forget* that they were looking at a series of illusions and not at a battle itself. It goes without saying that viewers and critics did not actually abandon their ability to discern between the visual representation of a battle and battle itself. Rather, they eagerly affirmed that they had lost their ability to discern. Thus, quite paradoxically, one's ability to know what war looked like—to claim that one was experiencing the thing itself and not an image of it—was premised upon a condition of epistemological confusion, a voluntary abandonment of knowing the difference between representation and reality. Maurice Samuels has argued that French audiences' desire to view historical spectacles such as the panorama as *real* stemmed from the social and political upheavals of the first half of the nineteenth century, which accelerated historical change and introduced the trauma of rupture into everyday life. The ability to experience these events through visual representation "materialized the past, depriving it of its mysterious otherness" and made it available for visual consumption.

When it came to the consumption of recent military history, French audiences were especially eager to use images as a means of transforming geopolitical events into personal, lived experiences.[42]

The paradoxical form of historical knowledge that might be gained through navigating the different levels of illusion in one of Langlois's panorama rotundas stood in stark contrast to the predictability and formulaic nature of contemporary battle painting commissioned by the French government. As I have suggested, it was in the government's interest to neutralize the recent military past, especially when it came to the historical memory of Napoleon Bonaparte, who continued to be a volatile political symbol throughout the period. It is not surprising that the July Monarchy, in its quest to stabilize France after decades of turmoil and ensure the longevity of its grasp on power, deployed a patronage strategy for monumental painting of Napoleonic military history that kept viewers historically grounded, without demanding that they temporarily abandon their ability to discern between representation and reality. This strategy changed dramatically when it came to the series of battle paintings that the government commissioned from Vernet to commemorate contemporary French military victories in Algeria. For these, a new mode of battle painting would be required to summon the enthusiasm of audiences for France's ongoing military conquest of Algeria, and for official battle painting as a genre of artistic production.

HORACE VERNET AND THE PAINTING OF ACTUALITY

Soon after the inauguration of Louis-Philippe's historical museum at Versailles, the French government awarded Vernet with a series of important commissions for battle paintings that were exceptional within the artist's oeuvre for their monumentality. Depicting France's contemporary conquest of Algeria, these works would be the largest battle paintings that he ever executed. For an artist who continuously reinvented the genre of battle painting over the course of his lengthy career, they constitute yet another reinvention of the genre, this time in the service of valorizing a contemporary colonial war for the benefit of a reigning monarch. King Louis-Philippe personally oversaw the production of these paintings, helping to ensure Vernet's safe travel in war-ravaged Algeria, securing Vernet studio space at Versailles (and visiting him there as he worked on the paintings), and conducting an ongoing dialogue with the artist about the subjects they

FIGURE 90 Installation shot. Horace Vernet, *The Siege of Constantine*, 1839. Oil on canvas, 204 × 816 inches (512 × 2072 cm). Musée National des Châteaux de Versailles et de Trianon.

FIGURE 91 Installation shot, Horace Vernet, *Capture of the Smalah of Abd-el-Kader by the Duc d'Aumale at Taguin, 16 May 1843,* 1845. Oil on canvas, 192 × 841 feet (489 × 2139 cm). Musée National des Châteaux de Versailles et de Trianon.

represented. Of several official large-scale paintings Vernet produced depicting the Algerian campaign, the two most important were *The Siege of Constantine* (fig. 90), a triptych that measured 68 by 17 feet, and *The Capture of the Smalah of Abd el-Kader by the Duc d'Aumale at Taguin, 16 May 1843* (fig. 91), which measured 70 by 16 feet. When he was asked in 1837 to paint the capture of Constantine, Vernet had already spent time in Algeria: in May 1833, as director of the French Academy in Rome, he had been transported to Algeria on a warship and given the protection of the French army upon arrival, proof of his close connection to official government power and to the person of Louis-Philippe in particular. During this first voyage, Vernet participated directly in the process of conquest by purchasing land from the French colonial authorities, against the wishes of his wife.[43]

Vernet was hardly the only artist to travel to Algeria: he followed in the footsteps of others, including his former student Jean-Charles Langlois, who volunteered for the naval expedition of June 1830 (paying his own way) for the express purpose of making studies for his *Panorama of the Capture of Algiers.* In 1832 Langlois returned to make more studies of the city and its inhabitants for this panorama, which opened in Paris in 1833, the year of Vernet's first visit to Algeria. Langlois's panorama depicted Algiers's topography from the heights of the Dey's fortress, which served as the French forces' *quartier-general* after its capture early in the invasion. Instead of representing a particular armed conflict as he had in his *Panorama of the Battle of Navarino,* Langlois offered his Parisian viewers the illusion of a foreign cityscape that was suddenly under French military control. This shift from military action to urban landscape was not due to a lack of suitable subjects: among other combats, Langlois reportedly witnessed the battle of Sidi-Ferruch–which he painted in 1834 for Louis-Philippe's historical museum; it is now badly damaged)—during the campaign. His decision to revert to the more traditional subject of a cityscape for his panorama did not, however, draw crowds: the panorama of Algiers closed after a relatively short run of one and a half years, in comparison with three years for most of his other panoramas.[44] Langlois did not return to the Algerian campaign in any of the six panoramas that he executed before his death in 1871; avoiding the conflict altogether, he instead decided to go back in time to subjects that were reliable crowd pleasers, especially Napoleonic battles. *The Battle of the Pyramids,* for

example, was drawn from Bonaparte's Egyptian campaign, a conflict that was safely in the past and represented a different phase in France's evolving imperialist aspirations, not predicated on settler colonialism as Algeria was during the July Monarchy and thereafter. As Jennifer Sessions has argued, the "Bonapartist idiom" also provided an illustrious predecessor on which to model France's contemporary military ambitions in Algeria. Langlois looked to Napoleonic military history as a way to represent France's new colonial war without depicting the bloody and ignoble French campaign there, which was infamous for its brutality against the indigenous populations of Algeria.[45] Langlois continued to focus on battles from the Napoleonic period throughout the July Monarchy; he did not return to contemporary armed encounters until the very end of his career, with Napoleon III's victories in Crimea and Italy. Thus, it was neither contemporary warfare nor past French military intervention in North Africa that posed a problem for Langlois, but the current campaign in Algeria in particular. This is not to say that Algeria was an undesirable subject for artists, more broadly speaking: the patronage of the July Monarchy government guaranteed a steady stream of painted representations of the French military campaign in Algeria, many of them destined for the historical museum at Versailles. Unofficial albums of lithographs by artists such as Auguste Raffet also abounded, not to mention a proliferation of popular woodblock prints and engravings. But for Langlois the panoramist, whose livelihood depended on ticket sales, the French government's conquest of Algeria failed to fit the bill.[46]

When he came into power in July 1830, Louis-Philippe decided to continue the French effort to colonize Algeria that the Bourbons had begun two months prior; the new king viewed Algeria as a means of demonstrating his support of France's military glory without provoking wars within Europe. In a personal display of commitment to establishing France's new colony, all four of Louis-Philippe's sons received military commissions to join the effort there: the duc de Nemours participated in the second, successful capture of Constantine, and the duc d'Aumale, in the capture of Abd el-Kader's *smalah;* both sons appear in Vernet's paintings of each event. Soon after the French established a military presence in Algiers in 1830, an active Algerian resistance thwarted the government's efforts to hold Algeria as a colonial possession, making the country less amenable to Langlois's

spectacularizing panoramas, but also making Vernet's monumental paintings of the campaign all the more important in legitimizing it. The French countered the Algerian resistance with ruthless tactics against combatants and noncombatants alike, including the *razzia*, a scorched-earth raid that had become a standard practice in the French army by the early 1840s. Between 1830 and 1845, the numbers of soldiers engaged in the conflict ballooned from 30,000 to 95,000, an expansion that reflected the government's increasing determination to bring Algeria under its control by penetrating deeper into Algerian territory and seizing more land for France. The French military struggled not only with several active resistance movements but also with its own logistical problems with waging colonial war in the desert, just as it had decades earlier in Egypt. Disease and desertion were endemic; officers found it difficult to discipline their soldiers. The conquest also faced lukewarm support among certain sectors of the French public; the republican and Bonapartist opposition regarded it as merely "a box at the Opera," less illustrious than Napoleon's wars of European conquest. For many of Louis-Philippe's political opponents, the war in Algeria spectacularly displayed the government's incompetence and weakness.[47]

Even after a French victory at Constantine in 1837 (the subject of Vernet's 1839 painting), the colonization of Algeria continued to be a difficult undertaking for the French military and politically risky for King Louis-Philippe. To make matters worse, in 1840 England and Russia made important diplomatic decisions regarding the sovereignty of Turkey and Egypt without consulting France. The republican opposition, which had been advocating for war against these same European powers since France's defeat in 1815, considered this move to constitute an act of war on the part of England and Russia; much to the opposition's disdain, however, Louis-Philippe's cabinet maintained their policy of nonintervention within Europe.[48] Widely chronicled by the press, this humiliation led to a series of very public attacks on the legitimacy of the July Monarchy. The most vehement came from the historian Edgar Quinet, who published an incendiary political pamphlet with the evocative title *1815 and 1840* (anticipating Marx's *Eighteenth Brumaire*). He pointed to France's diplomatic and military weaknesses and argued that the conquest of Algeria was little more than a futile attempt to compete with other European nations: "I see Russia marching to conquer the Bosphorus, England to

conquer Upper Asia, France, in Algeria, to conquer the desert. Isn't there something about this that makes you think?"[49] Despite the violence and scope of the conquest of Algeria and the firestorm of opinions like Quinet's, writers continued to refer to France as a peaceful nation. This compulsion to dismiss France's conquest of Algeria as unimportant underscores the high degree of ambivalence and uncertainty that greeted the colonial project during the July Monarchy; it also exposes the racist attitudes that came to dominate understandings of the conquest, specifically related to Algeria's unworthiness as a site of colonial ambition. Official battle paintings of the conquest were therefore tasked with convincing the French public that Algeria was a desirable object of French conquest within a climate that many commentators lamented as "peaceful."

The massive scale of Vernet's paintings of the Algerian campaign can be understood as a potential means of countering opinions like Quinet's, affirming through bombastic proportion the grandeur and epic quality of French military action in Algeria. *The Siege of Constantine* and *Capture of the Smalah* were commissioned for rooms (designed by Vernet and financed at the king's personal expense) in the historical museum at Versailles. The resulting

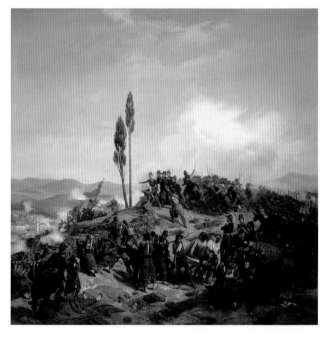

FIGURE 92 Horace Vernet, *The Siege of Constantine: The Enemy Pushed Back from the Top of Coudiat-Ati, October 10, 1837*, 1838. Oil on canvas, 201 ⅝ × 203⅞ in. (512 × 518 cm). Musée National des Châteaux de Versailles et de Trianon.

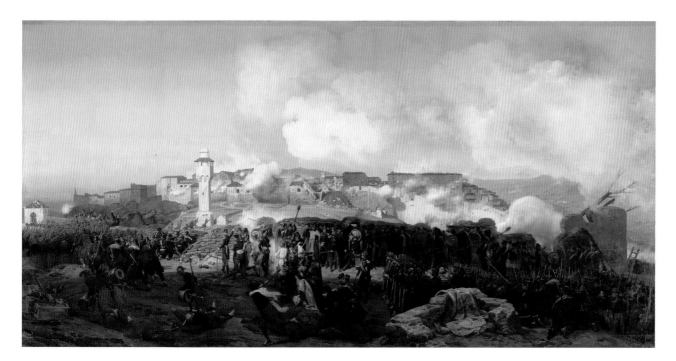

FIGURE 93 Horace Vernet, *The Siege of Constantine: The Columns Begin Their Movement, October 13, 1837*, 1839. Oil on canvas, 201⅝ × 409⅛ in. (512 × 1039 cm). Musée National des Châteaux de Versailles et de Trianon.

galleries—the Salle de Constantine, inaugurated in 1842, and the Salle de la Smalah, inaugurated in 1845—were devoted to the representation of colonial victories mostly related to Algeria.[50] Before being permanently installed in these galleries, both works were exhibited to great public acclaim at the Salons of 1839 and 1845. Although the reception of these works was mostly positive, a deep suspicion of their scale, subject matter, and style nevertheless permeated it. Critics expressed a concern that Vernet's battle paintings were not art at all; in their seeming overreliance on the rhetoric of journalistic reportage, they appeared to present the conquest of Algeria as nothing more than a minor news event, an ephemeral "bulletin" whose relevance would soon expire. Such reactions demonstrate the pitfalls of using monumental battle painting to elicit public support; they also attest to the ongoing transformation of battle painting's interaction with emergent nineteenth-century media, including the newspaper and panorama.

Louis-Philippe viewed the capture of the forbidding walled city of Constantine in October 1837 as the kind of event that could shore up support for his constitutional monarchy and convince the French public of the illustriousness of the military campaign in Algeria. Just one year

earlier, the poorly provisioned French army had been forced to retreat at Constantine in the face of stiff local resistance, a humiliating defeat widely chronicled in the press, which created the impression that the conquest was foundering and demonstrated the strength of the Algerian resistance to French rule.[51] The 1837 victory, by contrast, was trumpeted as a potential turning point in France's struggle to establish a permanent colony. As a way of registering enthusiasm for the victory, the French public turned to boulevard theater productions of the siege of Constantine, popular prints, and monumental painted war imagery. As one newspaper related, the capture of Constantine had reawakened "sympathies for the military glory of France and provide[d] a new interest in works of art dedicated to perpetuating the memories of the great armed events that immortalize the Empire." This was reflected by "an affluence of curious visitors at the *Panorama of the Battle of Moscova*."[52] The subject matter of the panorama, a devastating battle from the First Empire, mattered less than the connotations of the panorama itself, as surrogate for the experience of modern warfare. It is therefore not surprising that in an effort to revive a genre of painting under increasing attack for its inability to produce an acceptably grandiose and stirring image of war,

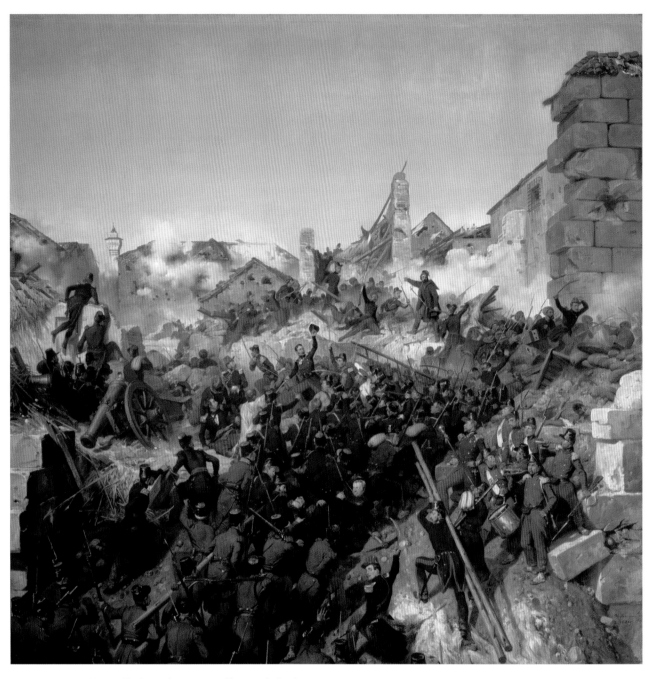

FIGURE 94 Horace Vernet, *The Siege of Constantine: The Assault, October 13, 1837,* 1839. Oil on canvas, 205⅝ × 203⅞ in. (512 × 518 cm). Musée National des Châteaux de Versailles et de Trianon.

Vernet employed a series of visual devices that would have recalled to contemporary audiences the experience of visiting one of Langlois's panoramas.

The Siege of Constantine takes the form of a triptych; it features three separate, yet related, episodes from the battle at the walled city. In chronological order, from right to left, they are *The Enemy Pushed Back from the Top of Coudiat-Ati, October 10, 1837* (fig. 92), *The Columns Begin Their Movement, October 13, 1837* (fig. 93), and the *Assault,*

October 13, 1837 (fig. 94). The middle painting is the largest of the three, though it represents a moment between two decidedly more dramatic episodes; on its own it measures a staggering seventeen by thirty-four feet. When the *Constantine* triptych was first exhibited in the Salon Carré of the Louvre at the Salon of 1839, the three paintings were unified within a single frame.[53] In its permanent home at Versailles, each of the three paintings occupied its own separate frame. Faced with three monumental paintings at

the Salon whose scale made it impossible to apprehend the work in a single glance, viewers could have followed along with the narrative printed in the Salon guidebook, which corresponded to the arrangement of the three canvases from right to left.[54] But this proscribed reading would have been just one possibility of apprehending the work, since the paintings provide multiple points of entry for viewers through subtle pictorial devices. In typical Vernet fashion, seemingly mundane details help to bolster the verisimilitude of the painting. Vernet's habit of placing "reality effects" at key strategic points in the paintings recalls the devices Langlois employed in his panoramas to focus viewers on authenticating details, securing the impression of a truthful recounting of a battle. In the middle painting, *The Columns Begin Their Movement*, for example, a destroyed wall in the middle of the foreground has become a makeshift tomb that opens out to reveal a dead French soldier (fig. 95). At first glance the corpse in the foreground does not stand out; painted in muted browns and grays, it looks more like a pile of rubbish than a human form. Upon closer inspection, the soldier can be seen to lie underneath a tent, his feet protruding into the foreground; the gold buttons are visible on his navy-blue uniform. Even though the action depicted in this section

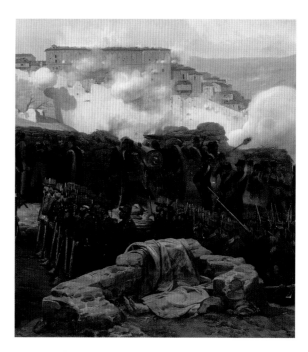

FIGURE 95 Horace Vernet, *The Columns Prepare for the Assault*, detail.

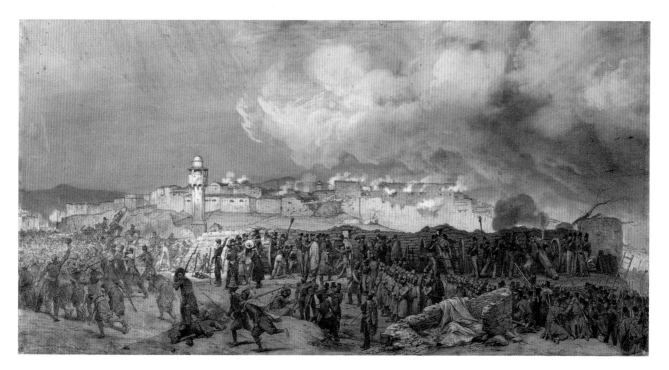

FIGURE 96 Horace Vernet, study for *The Columns Prepare for the Assault*, c. 1838. Pencil and ink on paper, 20½ × 37 in. (52 × 94 cm). Musée National des Châteaux de Versailles et de Trianon.

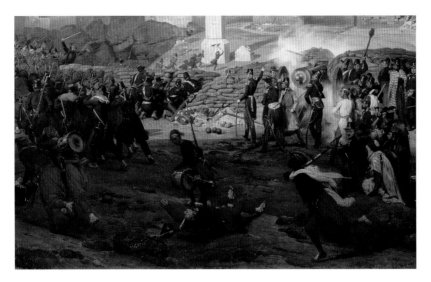

FIGURE 97 Horace Vernet, *The Columns Prepare for the Assault*, detail.

of the triptych occurred moments before the major assault, the presence of the body instructs the viewer that danger is very present. In a study for the composition (fig. 96), Vernet included the tomb but made it much narrower, and obscured the body behind the tall, narrow wall.

In the final painting, Vernet took advantage of the tomb as a marker of an elapsed temporality, to show that the battle had been taking place over the course of several days before the moment represented in the painting. As we have seen in earlier battle paintings such as *The Crossing of the Arcole Bridge* (see fig. 59), Vernet had a penchant for representing temporal immediacy; his approach sharply differed from the transcendent form of epic time that was the standard in the paintings of classically trained Napoleonic-era battle painters such as Antoine-Jean Gros and François Gérard. In *Constantine*, these markers of immediacy occur on an unprecedented scale and extend across all three canvases; the effect is such that the "here-and-nowness" links his three canvases together and anchors the visual experience of them. In the middle ground of the painting, the duc de Nemours raises his hand to signal the beginning of the attack: to his left and toward the foreground, a trumpet player is depicted in the act of falling backward into the foreground (fig. 97); he spreads his hands outward, and his head displays a fresh wound, evidence of the violent battle that has already started even before the real assault. The soldier to his immediate left looks at him, as though he too has been taken by surprise by the fall. He is running, as are the drummers in front of him. The episodes of violence occur

throughout the painting, not set into any sort of visual hierarchy: they all vie for visual attention, and because they lack an ordering logic, they appear to be random, even artless. While this representational strategy frequently earned Vernet the ire of critics, it tapped into long-standing conventions of topographical battle painting that were present in Lejeune's Napoleonic battle paintings and helped to ensure that they could be understood as authentic eyewitness images of war. Vernet had not witnessed the capture of Constantine, but his paintings made it appear as though he had. To look at *Constantine* is to constantly be in competition with the limits of one's own vision. In this sense, Vernet's monumental Algerian campaign picture shares much with Langlois's battle panoramas: impossible to seize the action in a single look, or *coup d'œil*.

In the third painting of *Constantine*, the *Assault*, the preparations that took place in the previous scene are put into action. In the previous painting, soldiers in the foreground fire cannonballs at the walled fortress in the distant background. In the *Assault*, Vernet moved the walled city into the foreground, providing an up-close view of the formerly distant target. In doing so, the artist located an efficient way of connecting these two paintings as a logical narrative through time and space. The narrative of the battle is also told through physical marks of violence. In the right middle ground, an entire chunk of the brown wall has been torn off (fig. 98); a gray hole in the wall with a cannonball inside attests to the barrage that was fired at the walled city in the previous painting. The hole in the wall is painted

FIGURE 98 Horace Vernet, *The Assault*, detail.

with such a rich depth of color and tonal contrast that the destructive impact of the cannonball finds a material correspondence in paint, one of many tour de force visual effects that Vernet strategically placed in the composition. The *Assault* is a vertically oriented painting, in contrast with the wide horizontality of the *Preparation*. This verticality is emphasized by the narrative situation of the painting: the army must literally scale the mountain to capture the walled city. Thus there is a material, physical equivalence between the task at hand and the format of the painting. Vernet also fills his composition with the tools needed to scale a wall: ladders. The ladder that protrudes out of the right side of the painting provides a visual bridge between the climbing soldiers and the engaged viewer (fig. 99). As they climb up the hill, the ladder invites the viewer to do the same. Visual bridges abound. A *chef de bataillon* in the middle foreground, next to the man with the ladder, turns around, stares toward the viewer, and raises his sword, in yet another invitation to participate visually in the climb up the hill.

Certain passages of *Constantine* mobilize the illusionistic qualities of paint, which masquerades as material such as dirt and crumbling rock. As we have already seen, this confusion between registers of illusion was an important part of the verisimilitude of Langlois's battle panoramas. For example, contemporary reviews mention that in the belowdecks portion of Langlois's *Battle of Navarino*, the artist used red paint to double as the blood of a wounded sailor, whose wax body spectators would have encountered as they climbed up to the viewing platform. In this sense, Langlois's battle panoramas accorded mundane objects an important role in narrating the story of battle.

FIGURE 99 Horace Vernet, *The Assault*, detail.

FIGURE 100 Horace Vernet, *The Assault*, detail.

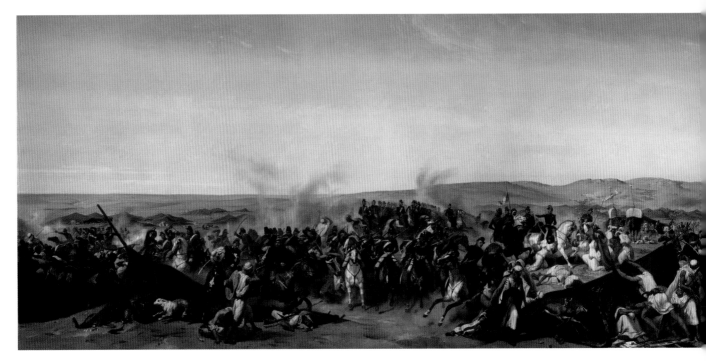

FIGURE 101 Horace Vernet, *Capture of the Smalah of Abd-el-Kader by the Duc d'Aumale at Taguin, 16 May 1843*, 1845. Oil on canvas, 193 × 842 feet in. (489 × 2139 cm). Musée National des Châteaux de Versailles et de Trianon.

In *Constantine*, Vernet used the mimetic qualities of paint in a similar fashion. The boots of a soldier are covered with a grimy, chalky, light-brown paint that serves as a material index of contact between the bodies of the soldiers and the crumbling vertical cliffs of the walled city (fig. 100). These brown, scratchy spots do not read as a smooth continuation of the soldier's boots but rather as a separate layer, a substance deposited there by contact with the cliffs. Such "dirt"-covered boots abound within these paintings. Another similar passage appears in the *Assault*, which depicts the army's climb up the rocky hill. To represent the rock, Vernet relied on a thick, swirling impasto of brown, white, and ocher paint to provide a material analogue to the rock. While he did not have recourse to the three-dimensional false terrain that Langlois employed in his panoramas, he made use of a visual vocabulary that sought to heighten the objectness of depicted objects and bolster the illusion of warfare's materiality. Both Langlois's battle panoramas and Vernet's monumental battle paintings relied on a wide distribution of dramatic narrative elements to tell the story of the battle, yet without the stable narrative hierarchy found in a classical history painting. In the words of one critic who reviewed the Salon of 1839 for the artistic journal *L'Artiste*, Vernet's

Constantine "let us touch victory with our gaze and transported us into the melee." This critic, and many more, praised *Constantine* for making the battle seem to be actually in the midst of occurring. Such language recalls the way that critics discussed the illusionistic effects of Langlois's battle panoramas.[55]

Vernet's other monumental battle painting of the Algerian campaign, *Capture of the Smalah*, debuted at the Salon of 1845 (fig. 101). Like his 1839 *Siege of Constantine*, Vernet's *Smalah* spread dozens of different yet interrelated groups of figures across a horizontal expanse, placed them and their actions within a precise moment in time: the key difference is that in the *Smalah*, all of the action takes places within a single painting, not three. The work's unusual and unprecedented format—a staggering sixty-six feet wide by sixteen feet tall—provoked an immediate sensation in the press. "In front of the infinite canvas of M. Horace Vernet," wrote one critic, "everything else is erased, everything disappears. . . . You are seized on your approach by a group of cavalry who stop you. Impossible to escape them! M. Vernet thrusts them, at a gallop, upon you, and there you are, captured."[56] The *Smalah* reportedly attracted huge crowds, causing another critic to note that "no painting has ever been the object of such

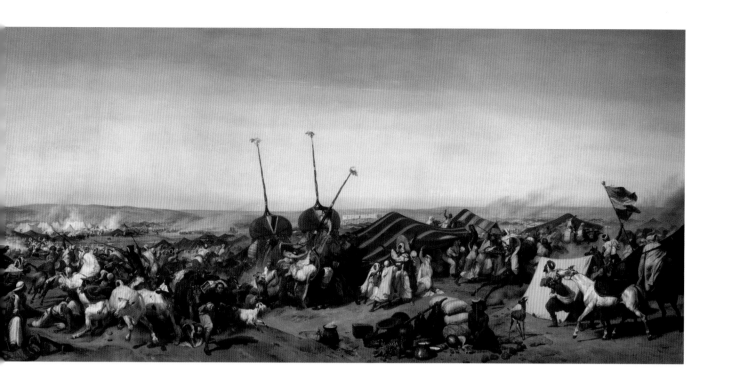

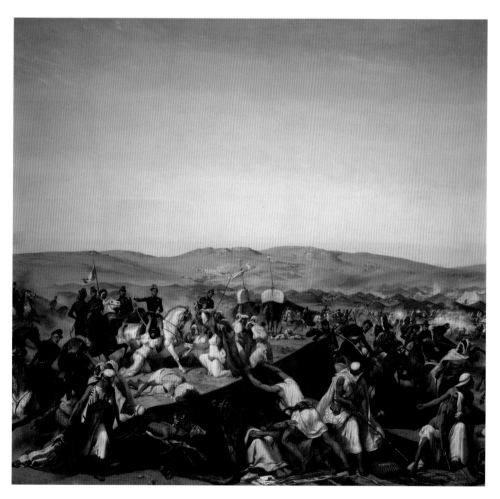

FIGURE 102 Horace Vernet, *Capture of the Smalah,* detail.

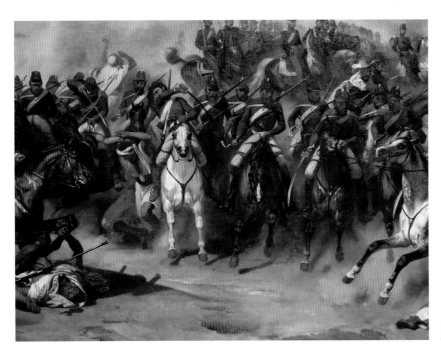

FIGURE 103 Horace Vernet, *Capture of the Smalah*, detail.

FIGURE 104 Horace Vernet, *Capture of the Smalah*, detail.

FIGURE 105 Horace Vernet, *Capture of the Smalah*, detail.

enthusiasm."[57] The painting represented an armed encounter that had taken place in the Algerian desert in May 1843: the capture of the itinerant military encampment, or *smalah*, of the Algerian commander Abd el-Kader, the spiritual and military leader of the resistance against France's military. Newspaper accounts at the time celebrated the proliferation of objects captured by the French military: "four flags, one canon, two gun carriages, [Abd el-Kader's] correspondence, the family members of his most important lieutenants, an immense booty: such are the trophies of this memorable day."[58] Conspicuously absent from this list was Abd el-Kader himself, who had fled to Morocco during the scuffle with the French army and would not be captured until 1847.

The title of the work, *Capture of the Smalah*, is somewhat misleading, since it does not actually represent the capture of the itinerant 15,000-person encampment but rather the flight of its inhabitants right after the French army commenced its brutal surprise attack, or *razzia*. In keeping with the political imperative of honoring the military service of Louis-Philippe's sons in Algeria, the duc d'Aumale, who led the attack, is pictured on a white horse, granting clemency to the besieged (fig. 102). The left part of the painting features the arrival of the French army, and the right side depicts the reaction of the men, women, children, and animals within the camp. The entire background consists of a continuous desert landscape, punctuated by hills, rocks, and patches of translucent smoke. The

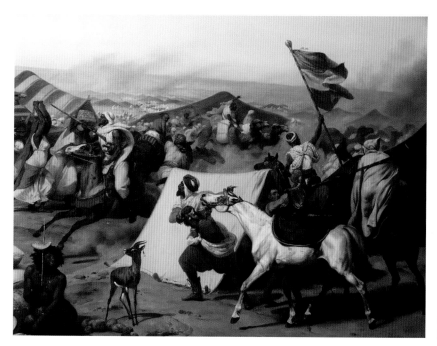

<mark>FIGURE 106</mark> Horace Vernet, *Capture of the Smalah*, detail.

viewer is positioned within the encampment, in the middle of the chaos, effectively with inhabitants of the *smalah* as they flee from the charging French army. Across the majority of the composition, they run out toward the space of the viewer; some of Abd el-Kader's soldiers hold their ground to fire at the French cavalry, who are depicted by Vernet in midgallop (fig. 103), the horses with nostrils flared, advancing toward the foreground. A group of charging oxen (fig. 104) in the middle-right foreground similarly threatens to run out of the picture; a baby tumbles out of a mother's arms as she falls to the ground. Steam wafts off a bowl of couscous (fig. 105), registering the unexpected nature of the attack. The painting is replete with violent, racist caricatures; an especially virulent one represents a nude Sub-Saharan African woman (likely a slave), squatting and eating a slice of watermelon as everyone else around her flees for their life (fig. 106). Another shows a man—who nineteenth-century audiences would have identified as Jewish—in the middle of the painting, clinching a bag of money as he retreats. Racial stereotypes such as these reduced the victims of colonialism to exotic others and helped to popularize the ideologies of French cultural and racial superiority upon which public support for the conquest of Algeria depended. The painting also sexualized and objectified the women who are shown fleeing: Vernet opted to partially expose the breasts and buttocks of the wives of Ben Kharoubi, Abd el-Kader's prime minister, who are

depicted toward the middle of the painting falling out of a palanquin, which has tipped over in the chaos. As Jennifer Olmsted has argued, Vernet's decision to eroticize the female victims of the surprise attack constituted "an act of sexual and political violence."[59]

Several critics remarked upon the similarities between the expansive horizontal format of *Capture of the Smalah* and the compositional strategies of the panorama. Delécluze, whose ambivalence toward Horace Vernet had begun during the Bourbon Restoration and continued throughout the July Monarchy, could hardly contain his enthusiasm when he reviewed Vernet's *Smalah* at the Salon of 1845, where it was displayed prominently in the Salon Carré. According to Delécluze, Vernet had managed to achieve a unified whole, despite the fact that "the ensemble of this vast scene submits to many points of view as in a panorama." He marveled at the fact that Vernet's lack of a singular focal point enabled a flexible mode of viewing: the painting could be apprehended from left to right or the other way around without "destroy[ing] the clarity or the unity of the subject. One only goes from the cause to the effects, or one can go from the effects to the cause, and in both cases, the talent of the artist makes you go on this voyage with great pleasure for the eyes as well as the intellect."[60] Delécluze's enthusiasm for Vernet's *Smalah* and approval of his use of a panoramic mode of composition is all the more remarkable in light of the critic's skepticism, voiced in 1831 in reaction to Langlois's

battle panorama of *Navarino*, regarding the panorama's ability to "disorient" the public and challenge the illusionistic limits of what he called "flat painting." The *Smalah* prompted Delécluze to revise his opinion on the panorama's relationship to more traditional forms of painting to the point where the critic contended that Vernet's borrowings from the panorama produced a novel way to achieve "unity of the subject" in a monumental battle painting. Coming from a former student of Jacques-Louis David and a proponent of the classical tradition of French painting, which prized pictorial unity above all else, this was high praise indeed. Implicit in Delécluze's writing is the sense that Vernet's *Smalah* was a successful history painting because of its use of a panoramic format, not in spite of it. Thus the emergent visual mode of the panorama had the surprising effect of elevating Vernet's painting from the mundane reproduction of a military event (one of Delécluze's long-standing complaints about Vernet's battle paintings) to a work of art that spoke to "the eyes as much as to the intellect."[61]

Other critics were less enthused, notably Charles Baudelaire, who accused Vernet of using cheap visual tricks to keep viewers interested, a view that recalls Honoré de Balzac's pronouncement in 1831 that Langlois's panorama of *Navarino* constituted "mechanical charlatanism": "Zero unity; a crowd of small, interesting anecdotes. . . . Thanks to this method of a serial novelist, the memory of the viewer finds its bearings. To note: a large camel, some deer, a tent."[62] Baudelaire's scathing critique implied that Vernet's "cabaret panorama" was a distinctively lowbrow form of painting whose composition was designed to compel visual attention through almost mechanical means. The accusation that the painting's elongated format represented a proliferation of *things*—akin to an inventory—more than an inspiring work of art was widespread.

As with the *Smalah*, the *Siege of Constantine* was also criticized in terms of its association with the panorama. The ephemerality and disposability of Langlois's panoramas provided Charles Blanc with an efficient way to accuse Vernet's *Constantine* of representing an event whose significance would wither with time. Blanc advised Vernet to abandon battle painting altogether and "do what M. Langlois has done with his panorama. . . . Posterity will not have a guidebook to recall this date in the month of October: she will think that this is an episode from the wars with Russia." The accusation that the *Smalah* and

Constantine dwelled on the "incidental physiognomy" of warfare and not on its higher meaning was widespread. The cavalry charge in the *Smalah*, in this reading, suggested not an important encounter in the dessert but a minor skirmish, implying that "this war is nothing more than the *little war*."[63] Other critics called attention to the disproportionately large French military force compared to the enemy in the *Smalah*, which "diminishes the merit of the victory" and "results in an involuntary pity for these poor Arabs."[64] This rather extraordinary evocation of sympathy for the victims of French colonial intervention, like the charge that Vernet had not sufficiently elevated his subjects, underscores the instability of the paintings' intended propagandistic function in support of the colonization of Algeria. Beyond the possibility that Vernet had depicted the fleeing inhabitants of the *smalah* as innocent victims, or that he focused too much attention on the mundane details of uniforms, for example, many critics perceived a troubling incongruity between the subjects of these paintings and their gigantic proportions. Why, asked one critic, did Vernet use such a large canvas "for an armed encounter that certainly does not rival the battles of Alexander, of Caesar, of Charlemagne or Napoleon?" He then sardonically remarked that the canvas could be rolled up and taken back to North Africa "to make a good tent."[65]

Horace Vernet had long been accused of painting in a descriptive mode, without elevating or idealizing his subjects. This particular criticism, which had been routinely leveled at his battle paintings since the Bourbon Restoration, was largely due to the fact that his works rejected the aggrandizing rhetoric associated with French classical tradition of history painting. As we have seen, critics often voiced objections to Vernet's battle paintings by comparing them to emergent nineteenth-century forms, such as Baudelaire's invocation of the panorama and what he deemed to be the "method of a *feuilletoniste*," or serial novelist, whose works were disseminated piecemeal in the bottom section of nineteenth-century newspaper pages. Perhaps more than that of any other artist of the period, Vernet's practice as a painter was explicitly aligned with early mass cultural forms, especially and not coincidentally with the newspaper—an information commodity whose circulation and readership grew exponentially during the July Monarchy. As Richard Terdiman has argued, during the nineteenth century the newspaper became a "characteristic metonym for modern life itself"; it "almost seems to have been devised to represent the pattern of variation

without change, the repetitiveness, autonomization and commodification."[66] When critics questioned the loftiness and importance of Vernet's monumental Algerian paintings and contended that despite their scale they would be easily forgotten with time, they were also objecting to a perceived alliance between the practice of history painting and its seeming devotion to representing events whose importance seemed minor and fleeting.

Though previous generations of history painters produced contemporary battle paintings for Napoleon Bonaparte, they relied on narrative devices, such as a focus on a singular, culminating figure or action, to assimilate the contemporariness of newsworthy military events into the formal parameters of grand manner history painting. This, along with a culture of censorship that prevented critics from openly complaining about official works of painted propaganda, helped to insulate contemporary Napoleonic battle paintings from charges that they depicted insignificant current events that would soon be forgotten. By the time of the July Monarchy, the relationship between history painting and the representation of contemporary events had become so intertwined that an art critic could argue, reviewing paintings of the Algerian campaign, "It is surely the duty of painting to bend itself to the thousand metamorphoses of this chameleon of the present time, of occasion and success, that we call *actuality*."[67] Rather than containing and transcending the "thousand metamorphoses" of an uncertain present that this critic called "actuality" (a word that had come into wide usage during the July Monarchy), contemporary history painting was now being asked to play catch-up. Because the newspaper had assumed the status of a prolific and culturally visible commodity, it became an effective means of questioning the value of Vernet's monumental Algerian campaign paintings and casting doubt on the government's ambitions in Algeria.

In his review of Vernet's *Smalah,* Théophile Gautier contended that the painting did nothing more than reproduce images and ideas already circulating in newspapers: "Everybody knows ahead of time what [Vernet] wants to say. The text of his compositions is spread by the thousands by one hundred newspapers. Everybody has seen the African *chasseurs* and the *Zouaves.* . . . People who know little of painting can attest to the exactitude of a reproduction . . . and as they find these things faithfully reproduced, with a certain sense of trompe-l'oeil, in the

battles of their favorite artist, they see this as the last word in art."[68] In his critique, Gautier equated newspaper reports with Vernet's painting but did so by inverting and confusing the status of each form: Vernet's painting is a reproductive "text" that has already been "seen" in one hundred newspapers. In these terms, the *Smalah* reproduced an already reproductive form. What, asked Gautier, was the difference between the event's appearance in newspapers and its representation by Vernet? Gautier's critique implicated more than rhetorical grandstanding or an equivalence between text and image: the possibility that news could be a picture and a monumental painting could be a newspaper text was not outside the realm of possibility when Vernet's painting was exhibited at the Salon of 1845. Between the exhibition of Vernet's *Constantine* in 1839 and of *Smalah* in 1845, a new form of image-based newspaper commodity, the illustrated newspaper, came into circulation. In 1842, the *Illustrated London News* in England became the first newspaper of its kind to feature articles accompanied by woodblock engravings. *L'Illustration*, which followed it the next year in France, was not the first illustrated periodical in France, but it was the first to market itself explicitly as *journal d'actualité*, rather than a more general and popular educational magazine in the vein of the *Magasin des familles* or *Magasin pittoresque*, both founded in 1833 with the aim of enlightening a working-class readership.[69]

The first issue of *L'Illustration* appeared in February 1843, thirteen years after the French campaign in Algeria had commenced. A series of articles, under the title of "Revue Algérienne," were published to catch readers up with these past events. On June 17, 1843, *L'Illustration* introduced the contemporary events of the campaign to readers with a lengthy description of the capture of the *smalah*, accompanied by a large illustration. In contrast to the bright clarity of Vernet's painting, the black-and-white newspaper image of the raid depicts French and Algerian forces charging in multiple directions within a landscape that is almost completely obscured by clouds of smoke (fig. 107). This illustration was not based on visual reportage but likely on the official dispatches of the event. Though the schematic character of the image prevents a focus on any individual soldier, their uniforms clearly distinguish Algerian and French forces. A separate image, located below this central image of the capture of the *smalah*, provides readers with an image of a dramatic hand-to-hand combat lacking in the central image: in this

case, the image's caption states, it portrays the death of Mustapha Ben Ismaïl, an Arab chieftain who fought for the French army. The column of text informs readers that Ben Ismaïl's tragic end occurred one day after the capture of the *smalah.* To the right, the smallest image on the page appears: the seal of Abd el-Kader, ostensibly seized during the capture of the *smalah.* Spread out asymmetrically over the newspaper page, these three images offer different perspectives on the event—an overview, a close-up detail of combat, and a glimpse of the material culture of the encampment. As a group, they depict the event as a series of shifting temporal and spatial perspectives, making readers aware of the expansiveness of the campaign and the allure of some of its details.

Two years later, in the pages of the March 15, 1845, edition of *L'Illustration* devoted to the Salon of 1845, a reproduction of Vernet's *Smalah* appeared (fig. 108). While it had become routine by 1845 for the newspaper to publish reproductions of works of art that were on view at Salon exhibitions, the publication of this particular reproduction constituted a formal intervention, expanding across the entire space of two pages as no image in the newspaper's two-year history had before. Making no mention of these unprecedented honors of horizontality, the paper claimed that the image appeared "to satisfy the curiosity of readers" who were eager to glimpse the year's most discussed work. After marveling at the size of the painting and describing its manifold episodes, *L'Illustration*'s art critic took Vernet to task for "exciting and satisfying curiosity" without "stirring the soul." At the very end of the section devoted to Vernet, the critic launched into a more severe, and exceptional, critique, which revolved around the problem of illustration: "With these exaggerated proportions, painting is threatened by being no more than picturesque and animated topography; battle painters transform into illustrated bulletin authors, and Versailles, if this should continue, will cease to be a museum in order to become an annex of the [French] War Depot." Illustration, claimed this critic, was best left for the newspapers: this was not the domain of history painting, which was still expected to elevate its subjects above the here and now. This critic, along with others such as Gautier and Baudelaire, recognized that Vernet's *Smalah* problematically blurred the boundaries between oil painting and the production of visual actuality by the illustrated press. Such defensiveness against emergent reproductive media suggests that by the mid-nineteenth

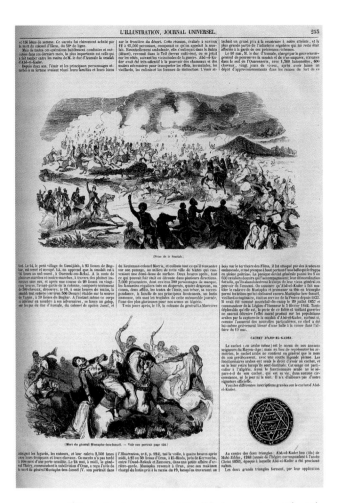

FIGURE 107 *L'Illustration,* June 17, 1843. Woodblock engraving, 14⅜ × 9¾ in. (36.5 × 25 cm). Dartmouth College Library.

century, war imagery had become one of the most significant cultural sites where mass culture and traditional visual forms might intermingle to produce new, thoroughly modern forms of art.[70]

As a monumental battle painting, Vernet's *Smalah* was criticized as ineffective because it appeared to employ a visual language that too closely resembled the nominative rhetoric of newspaper reportage. Its appearance as a woodblock engraving in the pages of *L'Illustration* literalized these critical complaints by transforming the painting into an illustration of an article devoted to the Salon of 1845. But far from confirming any critical misgivings about painting masquerading as illustration, in its reproductive form in an illustrated newspaper Vernet's *Smalah* was subject to a different set of formal and physical conditions. The image appears on the top portion of two pages, interrupted by the center fold, which cleaves the image into two discrete halves. This has the effect of focusing

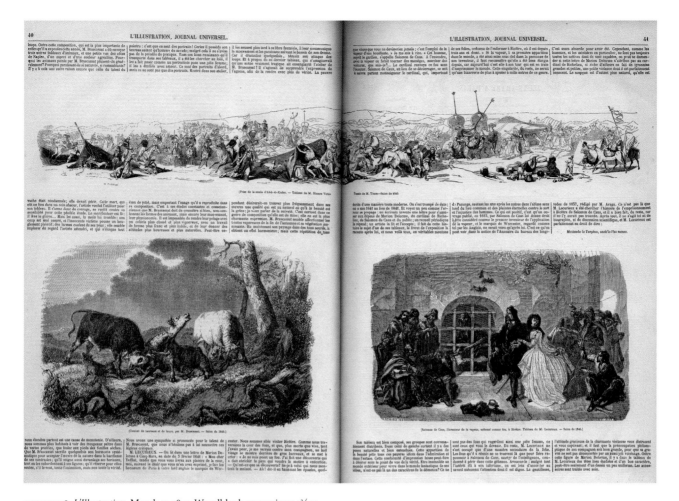

FIGURE 108 *L'Illustration,* March 15, 1845. Woodblock engraving 14⅜ × 19¾ in. (36.5 × 50 cm). Dartmouth College Library.

attention upon the center of the image in a way that the painting, with its sprawling horizontality and lack of a single narrative focus, did not. The dramatic imposition of a central focus also created a rupture in the frieze-like horizontal flow of the image and proposed an alternative mode of apprehending it: from the center out toward the edges of the page. The material conjunction between the center of the newspaper page and the center of the composition bestowed upon *Smalah* what many critics felt it had lacked as a large-scale oil painting: a heroic center of focus, the most important and traditional criterion for grand manner history painting. Quite paradoxically, the emergent visual form of the illustrated newspaper and the exigencies of page layout bestowed upon Vernet's *Smalah* what many critics thought it lacked as a history painting.

This striking interaction between the illustrated newspaper page, woodblock engraving, and oil painting

portended a new frontier of cultural leveling between media at a time when the identity of nascent mass cultural forms like the illustrated newspaper were still very much up for negotiation. Human perception, as Walter Benjamin argued, is "conditioned not only by nature but by history."[71] The fact that the illustrated newspaper could disrupt and readjust the visual codes of history painting, and at the same time generate its own particular systems for representing contemporary actuality, is one example of the ways in which the "medium" of mid-nineteenth century perception was undergoing constant redefinition through the circulation of new visual forms. As we will see, this trend became more pronounced during the next major war to break out on European soil, the Crimean War. Fought between 1854 and 1856, this was the first time that photography and the illustrated mass press played major roles in representing a major armed conflict.

4 The Promise of Something More

The Crimean War and "New Media" of the Nineteenth Century

In Stendhal's 1839 novel *The Charterhouse of Parma*, the protagonist, Fabrice del Dongo, finds himself in the middle of the battle of Waterloo, where he struggles to make sense of the swirling chaos. Fabrice is unable to decipher the events going on around him because they do not align with what he thinks a battle should look like—as we learn early on in the novel, Fabrice's childhood home was filled with "prints of the battles won by Napoleon." Whether they were reproductions of battle paintings by history painters or topographical prints, these images would have trained Fabrice to expect that his vision would be unburdened by gunpowder, that he would see clear demarcations between soldiers and officers, and between enemy armies. Fabrice's on-the-ground experience at Waterloo is more destabilizing because it fails to correspond to the visual conventions that he had come to know in his childhood during the First Empire. On the battlefield, Fabrice hears the guns and knows that the battle must be near, but does not see it amid the plumes of white smoke; he cannot even tell if the decorated officer who rushed by him on horseback is really his hero, Marshal Ney. He is thus compelled to ask a French sergeant: "This is the first battle that I've ever been in. But is this a real battle?"[1] Stendhal's evocation of modern warfare's unrepresentability is premised upon temporal, spatial, and sensory dislocation, and a refusal to disclose its larger meaning as a definable historical event. This literary representation of war as intractable confusion and illegibility, which ran counter to the tendency to value battle paintings and battle panoramas as sources of knowledge about what war looked like to those who experienced it firsthand, was published in the same year in which Jacques-Mandé Daguerre announced the invention of the daguerreotype.

Though it came into social use in France during the July Monarchy, photography did not play an important role in the representation of armed conflict until more than fifteen years after Daguerre's announcement, when the Crimean War broke out between 1854 and 1856. As the first large-scale multinational conflict to occur in Europe since the Napoleonic Wars at the beginning of the nineteenth century, the Crimean War was fought in the industrial age: the steamship, railroad, and telegraph all played major roles in warfare for the first time. The use of these new technologies of transport and communication was mirrored by a new configuration of nascent modes of visual reproduction, including photography and the illustrated mass press that provided image makers with a dazzling proliferation of

visual forms with which to represent a major contemporary armed engagement. After an extended period of critical fatigue with large-scale battle painting during the 1830s and 1840s, a new set of representational strategies emerged during the 1850s that would transform the representation of contemporary war in the age of high industrial capitalism and alter battle painting's status in French visual culture. While the definition of what constituted a complete and successful battle painting had been hotly debated since the First Empire, the question was renewed under the political exigency of depicting the first "great power" conflict of the modern industrial age.

Photography has been rightfully understood as a groundbreaking transformation in the history of visual representation, but the emergent medium did not radically or suddenly transform the representation of warfare or lead to the obsolescence of battle painting. The early history of military photography, as we will see, took shape in relationship to an earlier set of discourses about the visual representation of war in nonphotographic media. In touting military photography's potential to represent war more truthfully than ever before, commentators in the 1850s formed their opinions in dialogue with a set of expectations that shaped the reception of earlier kinds of military imagery, such as topographical battle prints during the First Empire, and battle panoramas and Horace Vernet's monumental battle paintings during the July Monarchy. These forms of visual production were all prized for their seemingly faithful representation of war and were understood to provide a privileged form of witnessing; such values are now widely ascribed to photography. In *Regarding the Pain of Others*, Susan Sontag's ethical account of beholding images of war and atrocity, special status is accorded to photography's capacity to transform viewers into witnesses. "Something becomes real," she writes, "to those who are elsewhere, following it as news, by being photographed." Sontag contends that "photographs are a species of alchemy for all that they are prized as a transparent account of reality." These statements, as this book has argued, could have very well been made about nonphotographic media used to represent war.[2]

Despite Sontag's belief in photographic exceptionalism, she admits that because of technological limitations and the political pressure governments exerted on photographers to sanitize the grisly appearance of the theater of war, early photographs of military conflicts failed to provide viewers with veristic representations of the horrors of warfare that might compel an ethical reaction. She deems the English photographer Roger Fenton's photographs of the Crimean War, in their inability to display the full scale of atrocity, to be "benign documentation" and "anodyne." For Sontag, only when it first represented dead bodies could photography assume its status as a technology of witnessing, as it did in photographs of the American Civil War. Though the photographs taken during the Crimean War by French photographers may not compel revulsion by disclosing the horrors of war, they are significant in other ways, especially when they are put back into dialogue with other forms of visual media used to represent contemporary armed conflicts.[3]

Through an unprecedented intermingling of nascent and established media, a predominantly middle-class public wary of armed conflict between European nations was provided with a compelling set of reasons to engage with the war, apart from merely nationalistic or propagandistic ones: the proliferation of war imagery was discussed at the time as a marvelous phenomenon that confirmed the productive powers of France's fledgling industrial economy. Photography, along with illustrated newspaper reportage and other modes of visual reproduction, affirmed the representability of the conflict through strategies of material proliferation: that is, by sheer volume and accumulation of visual information, distant military events could be presented to viewers as coherent objects of knowledge. The Crimean War provided the first sustained opportunity for image makers to depict warfare with a new set of technologies of visual reproduction whose use and meaning developed in relationship to more traditional media, such as oil painting and reproductive engraving. These emergent reproductive technologies were especially suited to depicting the Crimean War, which was more drawn-out than previous wars of similar scale, lacking the decisive military events that were the traditional subject matter of battle painting. The use of photography and illustrated reportage to represent this war also exposed a pictorial tension already well-established in modern battle painting, between the endless constitutive parts of a military event and its totalizing whole. Nineteenth-century audiences had long grown accustomed to the entertaining solicitations of the fragmented and seemingly improvised episodes depicted in the battle paintings of Louis-François Lejeune and Horace Vernet; this mode of picturing contemporary warfare had emerged as an alternative to the grand manner battle

paintings of Antoine-Jean Gros and François Gérard during the Napoleonic period, with their more traditional focus on a central heroic figure. While photography and newspaper illustration disrupted the traditional notions of pictorial unity that were defining narrative elements of the battle paintings made by Jacques-Louis David's students, this was not completely uncharted territory for the depiction of nineteenth-century warfare. Set in relation to the pictorial strategies of Lejeune and Vernet, the tendency of photographs and newspaper illustrations to focus on isolated details of larger military events should be viewed as part of a tradition of narrative fragmentation begun at the beginning of the nineteenth century, well before the introduction of these technologies.[4]

In comparison to the 1830 and 1840s, the Crimean War took place within a transformed media environment, when the illustrated mass press and photography were viable technologies for representing a contemporary armed engagement. The political situation had also changed. In February 1848, growing discontent with the July Monarchy over its treatment of the nation's poor, its aggressive press censorship, and an economic downturn resulted in a revolution that ousted Louis-Philippe's government from power. The February Revolution, as it was called, was soon followed by the June Revolution when the working class's demands for universal suffrage and more humane working conditions went unmet by the newly formed Second Republic government. The government's violent suppression of this second 1848 revolution led to the massacre of thousands of people across France. When, soon after, the nephew of Napoleon Bonaparte, Louis-Napoleon, was elected *président de la république* in a landslide victory, mindful of the bloody revolutions that had ushered him into power and a continued weariness with militarism within France and the rest of Europe, he was quick to associate himself with peacetime prosperity. Just before Napoleon III, as he would be called, seized absolute power in a *coup d'état* in 1851, declaring the establishment of the Second Empire, he proclaimed his peaceful intentions in a famous speech given in Bordeaux, couched in the rhetoric of peace and economic prosperity: "There is nevertheless a fear that I must respond to. In the spirit of defiance, certain people say: the Empire means war. I say: the Empire means peace! It means peace because France wants it, and when France is satisfied the world is tranquil. War is not made for pleasure, it is made out of necessity . . . I admit nevertheless that as Emperor I will have

quite some conquests to make. . . . We have immense uncultivated territories to clear, roads to open, ports to dig, rivers to make navigable, canals to finish, our network of railroads to complete . . . Everywhere, we have ruins to rebuild, false gods to bring down and truths to conquer."[5]

In Karl Marx's terms, France had substituted "the nephew for the uncle" and proved that the images and symbols of the past could be made to look new again.[6] Louis-Napoleon assured the public that whereas his illustrious uncle had conquered countries, his conquests would be of the economic variety. Indeed, as he promised in his speech, and thanks to state subsidies, the 1850s would be a watershed decade for industrial development in France, accompanied by a growth in the centralization of state power. The projects that Louis-Napoleon referred to in his speech would make the land fit for industrial development and aid the process of accumulating and processing materials essential for the production of goods and the enrichment of national coffers. This promised increase in France's productivity rhetorically justified the need for the greater ruling power that Louis-Napoleon would seize, as his uncle had at the beginning of the century. Like his forebears, Louis-Napoleon's rise to absolute power was accompanied by the rise of a police state and new powers given over to institutions of government surveillance. Dissent was viciously crushed throughout the Second Empire, with over 26,000 arrests made in the 1850s alone. Those who disagreed with the regime, such as Victor Hugo, were often targeted by police and forced into exile; speeches Hugo gave while in exile burn with vociferous condemnation of the regime.[6]

Louis-Napoleon's dedication to peace and prosperity did not prevent him from instigating a war with Russia. This would lead to France entering the Crimean War—begun in 1853 as a conflict between Ottoman and Russian armed forces—in 1854, when, in a bid to shore up Catholic support after his *coup d'état*, Louis-Napoleon sought to have France control Christian sites in the Holy Land, which the Ottomans had allowed the Russian Orthodox church to control since the fifteenth century. Having obtained authority from the Ottomans to guard these sites on behalf of the Roman Catholic Church, Louis-Napoleon sent a ninety-gun steamship called the *Charlemagne* through the Dardanelles to back up his claim with a show of force.[7] The Russians experienced the agreement between the crumbling Ottoman Empire and France, and their loss of control of these important religious sites, as

an international humiliation. In 1853, a series of escalating actions occurred: Russia sent warships to Constantinople and France sent its own fleet of ships in response, plunging Europe once again into diplomatic and military conflict. As the conflict intensified, France secured valuable alliances with Turkey and England.

Unlike the wars of the First Empire or the Algerian campaign, which had been wars of conquest, the Crimean War can best be characterized as a war over strategic influence. In the words of the French historian Alain Gouttman, "The Crimean War was, in fact, an abstract war." That is, the objectives of the Crimean war were not to conquer the port cities in Crimea but rather to prevent Russia from assuming too powerful a sphere of influence over the Ottoman Empire; economic interests also played a role in terms of protecting the shipping routes upon which English and French trade depended. The war would last until 1856, far longer than initially hoped. Approximately three-quarters of a million people were killed during the conflict, the vast majority of them Russian.[8] The outbreak of the Crimean War was widely understood as anachronistic to the steady march of industrial progress in Western Europe. It thus also threatened Louis-Napoleon's assertion that the Empire meant peace. As one of the government's regional procurers in Bordeaux noted in an 1854 report, the long war was starting "to cause a certain weariness to appear in one part of the population. . . . It is neither the agricultural nor laboring classes which seem to feel it so much. It is rather the business and leisure classes which are troubled by it in their transactions and speculations and which hope most devoutly for a return of peace as a vital factor in their prosperity."[9] These "business and leisure classes" were crucial for maintaining the stability of Louis-Napoleon's regime. They were the same parts of the French population which had profited under Louis-Philippe's reign and did not want a war to interfere with the economy. France and England officially entered the war in March 1854, with French public opinion on the matter sharply divided.

ILLUSTRATED NEWSPAPER REPORTAGE AND THE CRIMEAN WAR

In an 1861 letter to Jean-Gilbert Fialin, duc de Persigny, a personal friend of Louis-Napoleon, Charles Baudelaire attempted to secure a pension for his friend Constantin Guys, an illustrator who had worked for the *Illustrated London News* during the Crimean War. Guys had trouble finding steady work after the end of the Crimean War but could still count on an occasional assignment from the *Illustrated London News* thanks to the generosity of its founder, Herbert Ingram. But after Ingram drowned in Lake Michigan in 1860 while touring the United States, Guys's prospects for employment with the newspaper ended.[10] Two years after his appeal, Baudelaire published his seminal essay "The Painter of Modern Life" in the French daily newspaper *Le Figaro*, identifying Constantin Guys as the artist who most adeptly captured the transitory essence of modernity. In the 1861 letter Baudelaire counted Guys's talent for representing war as one of the accomplishments that entitled the artist to French government support: "I have seen the *entire* Crimean campaign drawn by him, from one day until the next, when he followed the expedition after the English army, all of his drawings accompanied by the most curious of notes." Baudelaire was referring to a series of sketches that Constantin Guys had made while he worked as a correspondent in Crimea for the *Illustrated London News*. Baudelaire's encounter with Guys's original ink wash sketches (likely owned by Nadar), rather than their reproductions, was a privileged one, allowing him to bypass their mode of mass diffusion. Baudelaire's disdain for the newspaper is well known, although he could not have pursued a literary career in the mid-nineteenth century had newspapers not published his work. As he wrote in *Mon coeur mis à nu*, "It is this disgusting aperitif that civilized man takes with breakfast every morning. . . . I do not understand how a pure hand could touch a newspaper without a convulsion of disgust." In the section of the "Painter of Modern Life" entitled "The Annals of War," he wrote about these sketches (and not their woodblock reproductions): "I can affirm that no newspaper, no written account, no book can better express the grand epic of the Crimean War in all of its painful details and sinister scope." As we shall see, Baudelaire's focus on the tension between the representation of the war's plentiful details and its overarching ensemble is at the heart of the visual culture of the Crimean War.[11]

Baudelaire interpreted the sketches as series of eyewitness encounters with war: their facture, in quick, autographic lines, seemed to indicate their authenticity as works produced in the heat of battle. From Baudelaire's point of view, such marks of improvisation were a world apart from the predictable battle paintings of Horace Vernet, with their careful attention to military costume

FIGURE 109 Constantin Guys, *The Charge of the Light Brigade,* 1855. Pencil, ink, wash, and watercolor on paper, 12 ⅝ × 15 ⅝ in. (32 × 39.6 cm). Private collection.

and other denotative details. Even though Guys worked as an actual newspaper illustrator, it is Vernet who Baudelaire described in *the Painter of Modern Life,* in a surprising inversion of the categories of fine art and journalism, as a "veritable journalist [*gazetier*], more than a real painter."[12] This identification of a history painter as a journalist and a newspaper illustrator as the visual poet of actuality confused different forms of cultural production. It also signaled the rhetorical tightrope that Baudelaire had to walk to distinguish Guys's "living *tableaux,* traced from life itself" from Vernet's work, which he famously called in 1846, "a lively and frequent masturbation, an irritation on the French epidermis." It is therefore no wonder that Baudelaire's reading of Guys's

Crimean War imagery would reserve his praise for the autographic marks of the originals rather than for their woodblock translations.[13]

Guys's sketch of the charge of the light brigade, the military disaster later made famous by Lord Alfred Tennyson's 1864 poem of the same name, was made first hand (fig. 109). The episode caused a firestorm of negative public opinion in England after newspaper reports exposed the incompetent English generals who led the doomed cavalry charge against blankets of Russian artillery fire. In Guys's drawing, a flurry of ink at the top of the composition depicts the barrage of artillery fire and smoke. Below, small flecks of ink represent soldiers charging toward their certain deaths. "Stains and tears show . . .

the trouble and tumult in the middle of which the artist laid down his memories of the day," Baudelaire wrote of Guys's drawings, with their unevenly covered surface riddled with hastily made brushstrokes. The weathered appearance of the original drawings served as an index of the privations the artist faced on the warfront and materially demonstrated their status as eyewitness transcriptions of war. Baudelaire also focused on the novelty of their transport from Crimea to the offices of the *Illustrated London News:* "Toward the evening, the mail carried off toward London the notes and drawings of M.G., who often entrusted to the post more than ten sketches improvised on thin paper that the engravers and the newspaper's subscribers impatiently awaited." The immediacy of experience of war that Baudelaire identified in Guys's drawings depended on their status as eyewitness images, something that illustrated newspapers learned to exploit during the Crimean War to sell the news.[14]

While engravings and battle paintings produced "on the spot" (*sur les lieux*) during the revolutionary and Napoleonic wars commercialized eyewitness experience for viewers on the home front, they did so as isolated, one-at-a-time images. Illustrated newspapers, by contrast, disseminated a continuous and interrelated stream of eyewitness images that kept readers "impatient," to echo Baudelaire's words. For their coverage of the Crimean War, both *L'Illustration* and the *Illustrated London News* sent correspondents to the front and printed weekly text and image dispatches that had been sent back from Crimea. The enterprising editors of these illustrated newspapers thus took advantage of emergent communication and transport technologies including telegraphy, steamships, and railroads to produce a new kind of news commodity that marketed the illusion of making the *entire* war representable through a series of episodic occurrences. Though illustrated newspapers were invented during the July Monarchy, their circulation grew rapidly during the Crimean War. The historian Jean-Noel Marchandiau has estimated that by 1854, the year in which France officially entered the Crimean War, *L'Illustration* had over 14,000 subscribers. By 1855 that number had risen to 24,000, which suggests that coverage of the Crimean War was an economically lucrative undertaking.[15]

Far from an objective reporting of eyewitness information from war front to home front, the modern discourse of reportage, or what Urich Keller has called "the mythology of reportage," can be more accurately described as a construction by a reader based on a set of claims promoted by the press for commercial gain.[16] The imperative of the illustrated mass press during the Crimean War was to convince readers that they were, in effect, privy to a totalizing, comprehensive account based on truthful information not available anywhere else. *L'Illustration* frequently laid bare the questionable veracity of their own eyewitness sources to alert readers to more authoritative drawings or written accounts that would appear in the next issue. While such an editorial strategy would seem to contradict the paper's claim to authoritative objectivity, it actually worked to ensure that readers would consult the next edition, where the new information appeared. In the summer of 1855, which coincided with the Exposition Universelle in Paris, Jean-Baptiste Alexandre Paulin, editor in chief of *L'Illustration,* expressed his exasperation with the lack of spectacular, definitive battles in the text of his own paper: "The news from Crimea is more worthless than ever. This grave calm that preoccupies everybody resembles the tranquil weight of the atmosphere and of the elements just before a dreadful new world storm."[17] Despite the frequent protests from editors at the lack of dynamic military events between 1854 and 1856, the Crimean War enabled the nascent illustrated mass press to transform a slow war into a sellable news event.

With no shortage of other newspapers available in France during the Crimean War, the editors of *L'Illustration* had to demonstrate that their news was the most accurate and informed. This was often accomplished by lamenting the problematic accuracy of the telegraphic dispatches, at the time the dominant technology for supplying up-to-the-minute news, upon which *L'Illustration* and its rival papers relied for the most recent news from the front. For *L'Illustration,* this was a savvy tactic, allowing the paper to assert that eyewitness visual reports, though slower to reach the Paris offices, were more reliable than the telegraph. This increased the value of the eyewitness visual sources unique to the illustrated press, setting such papers apart from their unillustrated rivals. Early in the war, *L'Illustration* and other newspapers such as the *Journal des débats* voiced doubts over the veracity of telegraphic dispatches from Vienna, owing to Austria's neutrality in the Crimean War. The country's refusal to take sides was understood at the time to undermine the authority of information sent to France and England, since its veracity was thought to depend upon the national allegiances of the telegraph operator. As the war

progressed, the accuracy of updates received via telegraph was increasingly cast into doubt. In January 1855 *L'Illustration* published an excerpt from a rival paper, the *Journal des débats,* regarding a series of newspaper reports that Russians had crossed the Danube and that French and English forces had begun to attack Sebastopol. These telegraphed reports, according to the *Journal des débats,* were erroneous, and their consequences were multiplied by the unscrupulous editors of newspapers that chose to publish them. *L'Illustration* included the excerpt in its lead article: "We already tried many times to protect the public against the dangers that can result from the use of the electric telegraph. . . . In the past, the telegraphic dispatch had an official character; today it only has as much worth as the intelligence of the person who sent it. . . . In the end, interest in circumstances excites a very legitimate curiosity, but this singularly facilitates the propagation of error; to this end, we call upon the shrewdness and prudence of the reader." While the telegraph promised to deliver the news quickly, this very speed created the possibility of multiplying false information across the European continent. In printing this apology for the telegraph in its pages, *L'Illustration* affirmed the dependability of its eyewitness sources against what the editors saw as the unscrupulous financial motivations of other international press outlets. Whereas the telegraph conveyed unfamiliar and technologically figured information, woodblock engravings translated from original drawings made on the spot asserted the presence of a witnessing artist with which readers would have been more familiar in both epistemological and material terms.[18]

L'Illustration sought to distinguish itself in the Crimean War news market through its use of special eyewitness correspondents, chief among them its visual reporter, Henri Durand-Brager (1814–1879). Like Louis-François Lejeune and Louis-Albert Guislain Bacler d'Albe before him, Durand-Brager's authority as an eyewitness observer was bolstered by his status as military insider and by his proximity to France's military and ruling elites. A marine painter by training (he was a student of Théodore Gudin and Eugène Isabey), Durand-Brager also served at various points in his life on French naval expeditions and was awarded the Legion d'Honneur in 1844 for his service. In 1840 he worked as an official draftsman for the general staff of Louis-Philippe's son, the prince de Joinville, on board the ship charged with returning Napoleon's ashes from St. Helena, the *Belle Poule.* He later participated in

naval campaigns in Tunisia, Morocco, and Argentina, during which he was charged with topographical reconnaissance work and produced several lithographic albums that depicted his travels at sea. The timing could not have been better for him: his experience as an artist-officer had prepared him for a career as visual wartime correspondent in the nascent age of the illustrated newspaper. Just as Lejeune's status as an officer often featured in descriptions of his battle paintings and in the official Salon guidebooks, *L'Illustration* frequently touted Durand-Brager's military credentials in its pages. This not only legitimized the authenticity of his drawings for the reading and viewing public but also became part of their value in the crowded marketplace for news about the war. For example, on a brief hiatus in Paris from covering the war, Durand-Brager was granted a private audience with Napoleon III and Eugénie to present original drawings that he had made during the siege of Sebastopol. *L'Illustration* took full advantage of the meeting and ran a news story explaining that Durand-Brager's "careful and true drawings, produced under the heat of enemy fire" had won the approval of the ruling family. Their prized correspondent had received "encouragement and support to continue his long and perilous job" and was now back on his way to the theater of war to continue covering it for their readers.[19]

In addition to drawings by Durand-Brager, *L'Illustration* often supplemented its pages with official, government-supplied dispatches written by military officers. On May 5, 1855, at a particularly low point in the war, when hopes of taking the Russian fort of Sebastopol had been dashed yet again, *L'Illustration* confided in its readers that "the details published up until now on the operations of the siege are, like all the rest, far from having an authentic character." The text assured readers that by contrast, "the rapport of General Canrobert, published in this edition, gives the exact state of things for the date of April 16." The general's official communiqué was superior to the telegraphic dispatches in whose "contradictions one can begin to see the game of speculators who have dictated to it everything that adheres to the interests of the stock exchanges of Vienna, Frankfurt, Paris and London."[20] General Canrobet's report appeared in the newspaper as a thin horizontal band of text set between two larger engravings based on drawings sent from the front by Durand-Brager (fig. 110). On the page, images based on Durand-Brager's sketches compliment and corroborate the general's official text. Together, the text and

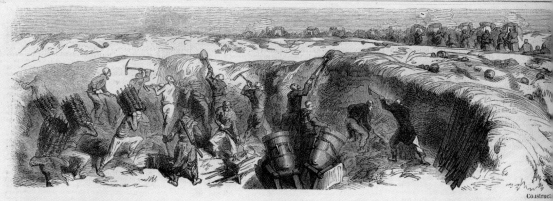

Co.struct...

Rapport du général Canrobert

Sur les opérations du siége, en date du 16 avril (*Moniteur* du 3 mai).

« Monsieur le maréchal, j'ai l'honneur de vous rendre compte de la succession de nos opérations devant la place.

« Après un feu soutenu pendant le jour avec une supériorité marquée sur celui de l'ennemi, nous avons avancé nos cheminements, pendant les nuits du 9 au 12, dans la direction du bastion du Mât, tout en luttant avec succès contre les postes soutenus par de fortes réserves que l'ennemi tient dans ses embuscades.

« Dans la nuit du 13 au 14, le général Pélissier a pris des dispositions efficaces pour nous assurer la possession du terrain sur lequel le génie devait cheminer vers le bastion central. L'opération se divisait en deux parties : celle de droite, *en avant du T*, dirigée par le général Rivet; celle de gauche, vers le cimetière, dirigée par

le général Breton. A la première, les embuscades ennemies ont été enlevées avec une grande vigueur par quatre compagnies du 46e, aux ordres du chef de bataillon Juhen, et une compagnie du 5e de chasseurs (lieutenant Copri). La résistance de l'ennemi a été des plus vives, et ses réserves ont fait plusieurs retours offensifs qui n'ont pu triompher de la résolution de nos compagnies engagées. Soutenues par un détachement de la légion étrangère (capitaine Robert), deux compagnies du 42e (capitaine Beauregard), une compagnie du 14e (lieutenant Sauve), elles se sont vaillamment maintenues sur le terrain. Les embuscades, malgré la solidité de leur construction, ont été rasées. A la gauche et en arrière, le travail du génie était protégé par trois compagnies du 26e aux ordres du capitaine Michel, qui avait pris d'excellentes dispositions et qui a été blessé à la tête de sa troupe.

« Pendant que ces événements se passaient, le général Br... faisait enlever vers la gauche, avec la même énergie et le m... succès, toutes les embuscades russes du cimetière par six co... gnies du 98e, commandées par le chef de bataillon Grémion. compagnies, renforcées pendant l'action par deux autres du 9... taillon de chasseurs, ont fait preuve de l'élan et de la solidit... plus remarquables. Le 98e (23e léger) a eu là un brillant début. ... nemi a plié après un feu très-vif qui n'a pas fait reculer un ins... les nôtres. Ces embuscades ont été occupées et rasées comme c... de droite.

« Protégé par cette double opération vigoureusement cond... le génie a pu accomplir son tracé et pousser ses travaux avec ... vité. Une nouvelle parallèle a été formée ; nous nous propo... d'en tirer un très-bon parti.

« Nous avons eu, dans cette affaire de nuit, qui a été très-vi...

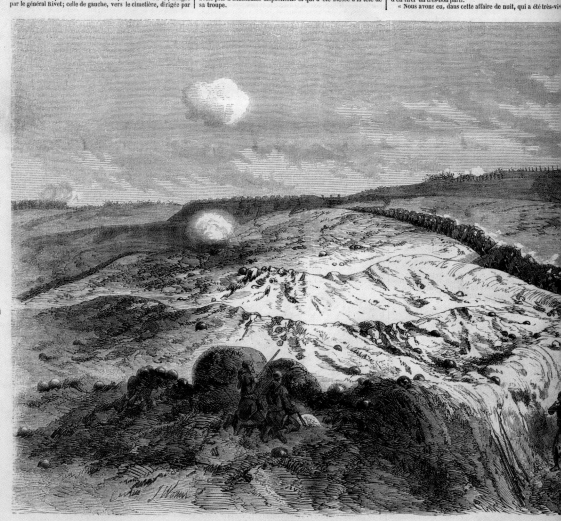

Cheminement d'un boyau de tranchée d...

FIGURE 110 *L'Illustration,* May 5, 1855. Woodblock engraving after original drawings by Henri Durand-Brager, 19¾ × 14¼ in. (50 × 36 cm). Dartmouth College Library.

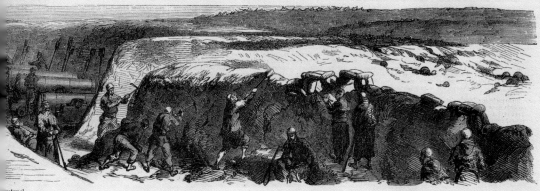

...astopol.

...plus grand honneur à nos troupes, 40 hommes tués, dont ...et 117 blessés.

...à nos cheminements sur le bastion du Mât, les effets de ...ennemie agissant à très-petite distance, les rendaient à ...mpossibles, ou, du moins, ils n'étaient praticables qu'à ...n de se résigner à des pertes continuelles. Dans cette si- ...us avons cherché à former une tranchée à demi-distance ...e troisième parallèle et le saillant du bastion, à l'aide de ...eaux de mine qui avaient été convenablement disposés ...bjet. Le feu a été donné dans la soirée du 15. L'opération ...a réussi. Les officiers et les sapeurs du génie ont trouvé ...se loger dans un immense fossé de 4 mètres de profon- ...oyenne, fossé dont l'ennemi ne nous a pas disputé la ...n. Ses troupes ont bordé la fortification et ont commencé ...-vif de mousqueterie et de canon.

« Nos mortiers, à leur tour, ont fait pleuvoir les bombes sur ces troupes agglomérées, et je suis informé par un sous-officier déser- teur que la garnison a fait là des pertes sensibles. Nos travailleurs, bien que dans une position difficile, ont activement opéré toute la nuit dans ce terrain tourmenté, pour compléter, autant que possi- ble, le couronnement des entonnoirs et relier la nouvelle tranchée avec la 3e parallèle. Cette nuit, les troupes ont continué ce travail avec ardeur. Cent hommes d'élite, du 74e, occupent aujourd'hui, pendant le jour, cette quatrième parallèle.

« Au milieu de ces combats et de ces travaux pénibles, les troupes ont toujours montré l'attitude la plus ferme et le meilleur esprit. Le général Pélissier, qui commande à la gauche, en est on ne peut plus satisfait.

« A la droite, du côté de la tour Malakoff, la supériorité de notre artillerie s'est également maintenue, mais sans parvenir à éteindre

celle de l'assiégé, sauf pourtant dans les deux ouvrages de contre- approche du Carénage, qui ne tirent plus depuis deux jours. Dans cette partie de notre attaque, comme dans l'autre, nous avançons avec lenteur, perfectionnant nos tranchées existantes et ne donnant rien au hasard. Une nouvelle batterie, établie devant l'ouvrage de contre-approche, dit du *Mamelon vert*, dont le feu a commencé hier matin, produit de bons effets.

« Au rapport des déserteurs, la garnison a fait des pertes considé- rables, et ses canonniers de marine, qui en forment la partie la plus vitale et celle qui montre le plus de moral, ont particulièrement souffert. Les bastions central et du Mât sont gravement endomma- gés. Leur armement a été souvent mis hors de service; mais les ressources presque inépuisables de la place en artillerie ne lui font pas encore défaut, et chaque nuit des milliers de travailleurs pro- cèdent aux réparations les plus pressées. »

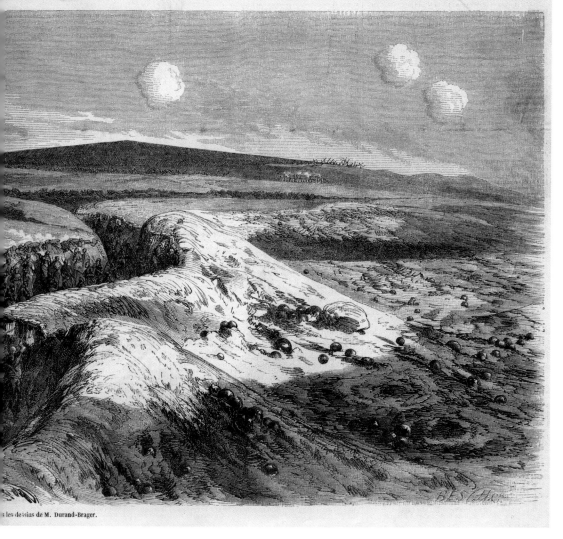

...s les dessins de M. Durand-Brager.

image formed what the newspaper claimed was the most authoritative version of the war's events for that particular day, based on sources touted by the newspaper as beyond reproach. The top image represents French soldiers building one of the hundreds of trenches used during the war. It places the viewer within the trench, at ground level, sufficiently close to make out the details of the soldiers' endeavor: barrels, sandbags, and the installation of cannons. At the same time, viewers are distanced enough from the soldiers to prevent them lingering on individual physiognomy, so that they may read the image as a schematic overview of the trench's topography. The bottom image, in contrast, provides a broad overview of the trenches from a bird's-eye perspective set at a comfortable distance above the trenches. This slightly hovering vantage point makes us privy to an expansive landscape that extends into a seemingly boundless battlefield beyond. Cannonballs cover the landscape, and puffs of smoke appear in the skyline, indicating that the conflict is ongoing. The duality here, between the top image's focus on up-close details and the bottom image's emphasis on a much larger parcel of strategic land, is emblematic of one of the most fundamental problems in the visual representation of war: the tension between a battle's plentiful details and its overarching ensemble.

Wartime coverage consisted of an unending succession of better and more complete news to come, a perpetual future of news about the war. The fragmentary nature of news production provided a convenient marketing ploy: readers had to purchase these weekly news "fragments" continuously, in an ongoing process of accumulating a more complete story of the war as it unfolded. On May 13, 1854, just after the bombing of Odessa, the newspaper claimed that it had received several reports, ranging from ones published in German and Belgian newspapers to an official report written by a French naval officer, Admiral Ferdinand-Alphonse Hamelin, that had appeared in the French government newspaper *Le Moniteur universel.* The editors of *L'Illustration* evaluated these written accounts relative to each other and then relative to a series of drawings they had received with Hamelin's report, which differed somewhat from his written accounts. They concluded that this difference posed no problem: "It must be recognized that the point of the view of the draftsman, and the moment when he captured a scene as mobile as this one, sufficiently accounts for this difference. Whatever the case, we did not want to deprive our readers of these sketches, received on

Wednesday, copied on wood, engraved, and put to press Thursday, at the moment when we received other drawings of the same kind, more detailed, and by consequence more complete. The official report of Hamelin will supply what is lacking in these engravings."[21] The visual accounts were taken as primary in their authority over the multiple written accounts. Readers were assured that the information in that day's paper was as accurate and as recent as possible. The process of transforming the drawings into engravings demanded a great deal of labor by the engravers, who worked around the clock to produce several engravings for each issue. The speed with which engravings were produced ensured the newspaper's value as a superlative source of up-to-date information. But in a move to spur readers' curiosity, the editor disclosed that brand-new, and *better,* drawings had been received at press time, which could not be included in the current issue. What other choice did an inquisitive reader have than to purchase the next issue? Leaving the news open-ended and inconclusive encouraged readers to keep reading the newspaper, and implied that participation in the narrative of war it relayed was under the reader's control. *L'Illustration* set the terms of this participatory game through a mix of editorial savvy and technological affect. The fragmentary nature of news production provided a convenient marketing ploy: readers had to purchase these weekly news "fragments" continuously to follow the war, and the more they read, the more complete the narrative would become. In addition to selling newspapers, aspirations toward completeness also structured the discourse surrounding war photography and shaped the production and reception of battle paintings related to the Crimean War. The same inclination toward an unending stream of visual and textual information lies at the heart of the discourse on the military uses of photography in the same period.

MISSION IMPOSSIBLE: THE EARLY ASPIRATIONS OF MILITARY PHOTOGRAPHY

Though not the first war to be photographed, the Crimean War was the first international conflict to be photographed on a relatively wide scale. There were at least five separate photographic expeditions to the Crimea during and immediately after the war, resulting in hundreds of photographs that were sold as albums and publicly exhibited in London, Paris, and elsewhere. When the war broke out in 1854, French photography periodicals immediately began to discuss the potential uses of photography. The mechanical

nature of the medium gave these early commentators license to imagine the possibility of achieving a totalizing photographic representation of armed combat through a potentially infinite proliferation of images. In April 1854, the journal of the Société Française de Photographie, *La Lumière,* published an excerpt from the English *Journal of the Society of Arts* announcing that the English government had decided to send an official photographer to the front. After the article, a French editor commented that the French government was also planning to send a photographer to the war, something that never materialized. The author let his imagination run wild with the ways that photography would revolutionize the pictorial representation of war: "A dispatch, accompanied by photographic views, will give much more precise information than a simple written document, however voluminous and detailed it may be. One can, with a lens, instantaneously reproduce promontories, coasts, forts, dispositions of fleets, armies, military positions. . . . Nothing could be compared to the results that will be obtained."[22] Photography promised to represent and disseminate military information instantly and with greater precision than ever before. The author envisioned a new era of technological progress where war would be represented far more efficiently with photographic images than with antiquated and imprecise words.

In 1861, five years after the Crimean War ended in victory for France and England, an important article appeared in the military periodical *Le Spectateur militaire.* Titled "On the Usage of Photography in the Army," the article outlined the potential importance of photography for the French military. Eugène Disdéri, the famous portrait photographer and one of the most successful men in the business of photography in France, had just had a proposal accepted by the minister of war to integrate the technology of photography into the "corps of troops" of the French military. The author of the article, Ferdinand de Lacombe, proposed that the new medium would produce a more complete representation of war than had ever been possible: "The photographers [will be] numerous, always present everywhere, distributed over the entire line of battle or siege, constantly ready to collect everything that interests them in the spectacles that strike their gazes." The idea was to blanket the entire field of combat with photographers, thus covering all aspects of a campaign. This unending flow of photographs, taken by an unending flow of photographers, would finally produce the perfect picture of war, as the sum of all of its multifarious and potentially infinite details. In contrast to

the laborious process of sketching the battlefield by hand with the aid of perspectival devices, photography would allow the military to represent territory quickly and without burden. The medium's utility for war was likened to a weapon: "Nothing would have escaped the speed of photographic methods, not even the appearance of the countries traveled through, of which the artist could assure the reproduction with the same kind of liberty and ease that comes with artillery fire. . . . Military photography can trace its own annals."[23] The author implied that the camera would be as easy to manipulate as a rifle, a reference that would not have been lost on the readers of this military periodical. But beyond photography's speed, the author also inferred that the medium could function without human labor as a self-acting mechanical tool. As Steve Edwards has argued with regard to English photography in the Victorian era, photography's autogenic potential was frequently touted as its greatest quality: the dream of autogenesis "unleashes the possibility of a frenzy of making," while substituting the agency of the mechanical device for human labor in the production process. This is precisely what occurs in these texts: the authors envisioned a constantly expanding set of visual images of war made possible by the camera. Photographs would accomplish what no soldiers or army engineers could: a military event in all of its parts as well as its glorious "ensemble." The photographic archive envisioned by war photography's early commentators was above all an imaginative site of longing that could never be realized materially. This fantasy of a summary image of war composed of an exhaustive collection of eyewitness accounts was precisely what the photography historian John Tagg has identified as the "phantasy of something more."[24]

Early theories of military photography contended that the new medium would picture war in its elusive totality by collecting and compiling exhaustive visual archives. Such aspirations contrasted sharply with photographic practice in the Crimean War, during which, despite the excitement about integrating photographers into the ranks of the army, no official French government photographers were sent to the front.

Unlike the English photographers Roger Fenton, who was sent to Crimea by the Manchester publisher Thomas Agnew and Sons, and encouraged by the government, the two French photographers there were on private expeditions unaffiliated with the government. Jean-Baptiste Henri Durand-Brager, the correspondent for *L'Illustration,*

and Jean-Charles Langlois, the panorama painter, both led photographic expeditions during the last months of the Crimean War. Neither had been trained in photography, and both likely decided to take photographs well after arriving at the war front, where they had originally come to paint. Both hired assistants to take photographs for them. That Langlois's photographs have received less attention than Fenton's, and those of Durand-Brager less still, is partly due to their failure to achieve any notable commercial or artistic success, and to their relatively late date—they were mostly taken in 1856, after the major hostilities had ceased. But a more critical factor in their comparatively lowly historiographical status was the fact that both artists used their photographs as source material for paintings. This not only diminished their role as authors, but relegated their work to the category of preparatory material for altogether different final products.[25]

Durand-Brager's photographic expedition to the front with his assistant was accompanied by an advertising scheme. In May 1856, an article written by Durand-Brager's partner Pierre Lassimonne—of whom very little is known other than his role on this expedition—appeared in the *Revue photographique,* one of many new journals dedicated to photography, titled "French Photography Expedition in the Crimea" and published, according to the editors, in its entirety. The archival documentation of the expedition consists of this article, thirty photographs, and a few comments in letters written by other artists working there at the time. The nature of the collaboration remains a mystery, but it is probable that Lassimonne supplied the technical knowledge and Durand-Brager dictated the point from which the views were taken, having already spent years in the area reporting on the war for *L'Illustration.* Like any enterprising photographer working at the time, Lassimonne often announced his discovery of various chemical solutions and emulsions in photographic journals; the mention of his name in connection with these innovations in the burgeoning photographic press is, apart from the images themselves, the only archival trace that remains of his role in nineteenth-century photography.[26]

Roger Fenton's photographic expedition to the warfront received a great deal of attention at the time in the English and French photographic press, and his album was displayed at the Exposition Universelle of 1855. On his return from the war, he famously published an account of his time there, in which he took great pains to detail the obstacles he encountered at just about every point in his journey. After a series of painstaking and laborious preparations, Fenton finally began to make photographs. The difficulty of the endeavor was almost too overwhelming to describe: "I need not speak of the physical exhaustion which I experienced in work in my van at this period. . . . As soon as the door was closed to commence the preparation of a plate, perspiration started from every pore. . . . I should not forget to state that it was at this time that the plague of flies commenced."[27] Here, hardship functions as a badge of honor. The difficulties faced by the photographer serve to make his work all the more impressive. Fenton's account, published widely in France, reaffirmed his status as illustrious author, with its implication that the resulting photographs were made possible through the toil of their author and not merely through mechanical processes.

Lassimonne published his own account four months later in the *Revue photographique* as a direct response to Fenton's. He began by admonishing the journal, in which the translation of Fenton's account appeared, for frightening aspiring photographers with tales of such hardship: "Fearing that you have terrified the photography *amateurs* subscribing to your journal by the account of the things that Mr. Fenton had to resort to during his time in the Crimea to avoid being condemned to a grievous immobility, we would like to invite them to be reassured by giving them the details of our winter expedition in the same place." Lassimonne described the relative ease with which the two men carried out their expedition: "We departed, M. Durand-Brager and myself, only carrying one very small bag that could rest on the back of a man during our excursions. We did not have a tent, nor a mobile laboratory; we found corners and shelters everywhere where we could prepare our plates away from light. Failing that, the dry-plate collodion would relieve us this difficulty." In contrast to Fenton's notoriously immobile laboratory and heavy equipment, Lassimonne touted the ease with which he and his partner prepared the plates, with very little equipment and practically no shelter. He explained that during the expedition, they lacked distilled water, "an agent considered by a great number of photographers to be completely indispensable," but were still able to prepare wet collodion glass-plate negatives.[28] Lassimonne's focus on overcoming the material deprivations he and Durand-Brager faced during the expedition allowed him to draw a powerful contrast between their ingenuity and Fenton's

lack thereof: while Fenton suffered under harsh conditions, the Frenchmen flourished.

The rivalry evident in Lassimonne's text can be partly explained by the broader historical rivalry between England and France. Even before the more recent defeat at Waterloo and subsequent occupation of Paris by English and other allied troops, the two countries had a fractious history stretching back centuries; the Crimean War represented the first time in modern history that the two nations were allies. But mistrust on both sides still ran high. Anti-English sentiment remained in the French press, despite Queen Victoria's visit to Paris in 1855 and Louis-Napoleon's to England during the course of the war, the first such state visits in over four hundred years. This national rivalry, which grew out of competition for economic dominance, extended into nearly every domain of industry, including photography. But Lassimonne's published account in the *Revue photographique* was also a thinly veiled attempt to garner advance publicity for his photographs. At the end of his text, he announced that "in a few days our collection will be delivered to the public, and everyone will see that in spite of not having traveled with the huge bazaar of Mr. Fenton, we have been able to gather an ample and beautiful harvest."[29] There is no evidence that the photographs were taken with the support of the state, and every indication that they were taken purely for commercial profit.

Much to the disappointment of these early war photographers, photographs of the Crimean War were anything but profitable, largely because the market quickly became saturated. Though Roger Fenton's photographs were some of the first of the war to be publicly exhibited, they were by no means the only ones available after 1855, nor did they achieve much success commercially. After returning from the war in the summer of 1855, Fenton received audiences with the Queen as well as with Louis-Napoleon, both of whom were said to delight in his photographs. Fenton exhibited his Crimean War photographs in the English photography section (considered a branch of industry) at the Exposition Universelle of 1855 and in three separate exhibitions in England, yet despite all this publicity, they still failed to sell, and at the end of 1856 his negatives were auctioned off. The negatives of the other English photographer who undertook an expedition on the Crimean Peninsula, James Robertson, were sold at auction after being exhibited across England in 1855 and 1856.[30]

While information on Durand-Brager and Lassimonne's photographic expedition is scant, the purpose of Jean-Charles Langlois's photographic expedition was much clearer. He was there to prepare studies for his panorama of Sebastopol, which opened in 1860 in a new rotunda built with funds supplied by the French government. Langlois treated his preparatory photographs as valuable property, retaining them for exclusive use in the construction of his panorama (figs. 111–13); the set of fourteen plates (four of which are illustrated here) that represent the view taken from the Malakoff Tower, for instance, served as the basis for his painted panorama that depicts the French army storming the tower. His assistant Léon Méhédin, who like Lassimonne supplied his partner with valuable photographic expertise, hoped to sell many of the photographs that he took, and entered into an agreement with Langlois to separate the instrumental, documentary views from the "picturesque" views, of which Méhédin would be the sole proprietor.[31] Their relationship deteriorated over the course of the expedition, and ended with Méhédin's abrupt departure. Writing to his wife just after he and Méhédin had parted ways, Langlois portrayed his former assistant as a greedy schemer: "His nature is so abrupt, so outside of even the most common upbringing, that I do not even want to do a minor publication with him, neither for gold nor money. He has, I think, an inextinguishable thirst for riches."[32] Langlois proceeded to threaten legal action against Méhédin if he dared to publish any photograph that was to be used for the panorama. The famed panorama entrepreneur understood his photographs as a unique source of information to which other artists were not privy; as the building blocks of his panorama's landscape, akin to preparatory drawings, they needed to be protected from careless dissemination by unscrupulous photographers like Méhédin. Any publication, he believed, would limit the public's interest in his panorama. Langlois's use of a medium that was inherently reproductive for the purpose of producing "studies" only bolstered his defensiveness over keeping them private.

In the running correspondence between Langlois and his wife while he was on his expedition, Mme Langlois warned her husband of the pitiful market for photographs in Paris. She was well informed about the status of the market because she frequented photographic supply stores in Paris, where she purchased materials to send to

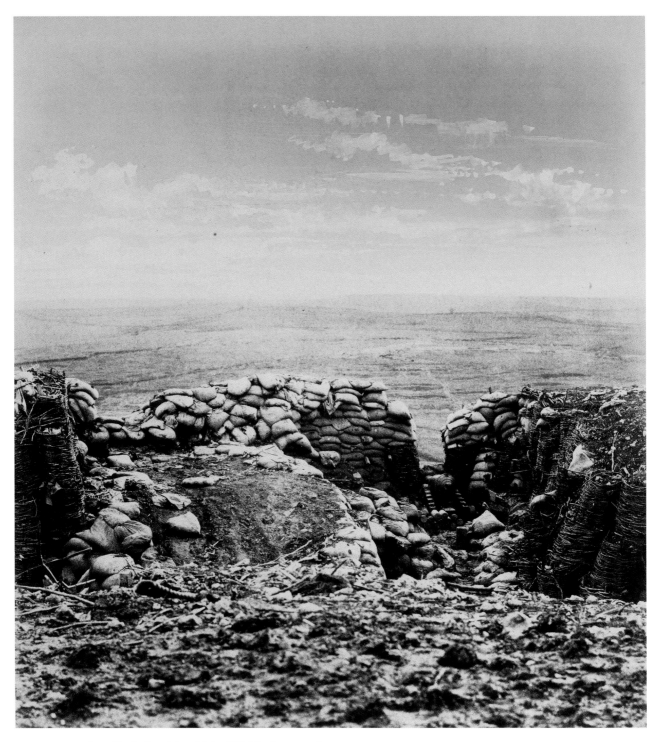

FIGURES 111–113 Jean-Charles Langlois and Léon Méhédin, *Panorama of
Sebastopol, Taken from the Malakoff Tower*, 1855. Albumen salted paper prints,
13¾ × 12⅜ in. (35 × 31.5 cm) each. Musée d'Orsay, Paris.

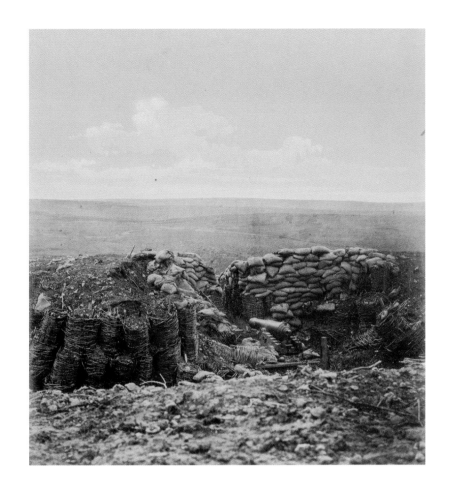

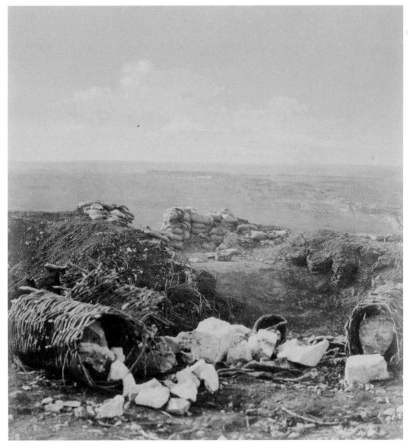

her husband in Crimea. According to Mme Langlois, photographs by Roger Fenton cost from 12 to 25 francs at Bisson Frères and at Goupil, prices unaffordable for the vast majority of the public: to put this figure in perspective, the average worker's daily wage hovered between 3 and 5 francs during the Second Empire.[33] In a revealing letter, Mme Langlois observed that the market for photographs of the Crimean War was completely glutted, warning her husband that all of the "delightful views" of the war have "already been explored and reproduced by many artists." In the course of making inquiries into the state of the market, she was told by the publishers MM. Rittner and Goupil "that they were inundated with views of this country. . . . You will also remember that Englishman [presumably Fenton] who, it was said, presented the most curious things to the Emperor and found little success. Others have since come in, and in my last letter I told you about having seen the marvelous photographs of Robertson of Sebastopol and of Malakoff. He had sent them as samples to see if they could be put into circulation [*jeter dans le commerce*] with the hope of selling them, and the response was nearly negative."[32] Mme Langlois informed her husband, who was thousands of miles away from Paris, that he had little hope of selling his photographs even if he wanted to.

It is worth pausing here to consider the contrast between this evocation of the oversaturated Crimean War photograph market and the idealized notion of endless proliferation promoted by war photography's early supporters. Photography was supposed to enable a complete and exact representation of war through an accumulation of photographic images, but this accumulation could only exist outside of the material conditions of market capitalism. From the theorists' point of view, this limitless photographic archive of war would serve the interests of the state, and required no buyers; the photographers who actually photographed the Crimean War, however, were subject to the pressures of the marketplace.

Another factor in the reception of Crimean War photographs was their inability to provide the illusion of a complete picture of war that dominated expectations for other war imagery, such as battle paintings and panoramas. Whereas in monumental battle paintings such as Vernet's *Smalah* (1845) and Langlois's panoramas, conventions had been established that enabled the artist, through the depiction of significant episodes, to create the illusion of a comprehensive summary of action, photographs of

the Crimean War could only show isolated and inanimate details of the war, or at best views of the battlefield or strategically important parcels of land. Despite their authors' best efforts, they were fragmentary. As we have already seen, early commentators on military photography imagined that an accumulation of photographic details would add up to an ensemble of the entire conflict, but neglected the very real problem of how all of these photographic fragments could achieve this effect. Crimean War photographers often engaged with this representational problem. A series of three photographs taken by Durand-Brager and Lassimonne, depicting Fort Nicolas before, during, and after its destruction (figs. 114–16), speaks to the difficulty, if not impossibility, of representing historical events with this nascent medium. The fort, which appears as a long white building in the images' background, was a naval fortress held by the Turks since the early days of the war. At the end of the war, when Durand-Brager and Lassimonne were taking the photographs, the French ordered the fort destroyed so that Russians could not use it. Like many other photographs of the Crimean war, such as those taken by Langlois and Robertson, the Fort Nicolas series represents an after-event of war. The first photograph establishes a temporal baseline, depicting the fort as it stood during the war. It sets up a sequence through which the passage of time and the impact of an explosion can be tracked. Puffs of white smoke set the second photograph apart from the preceding establishing shot, bearing witness to the explosion that is in the process of occurring. Absent the white smoke, the second image is no different from the first. The third image, taken after the explosion, helps it to signify more fully as an event. Placed between before and after images, the explosion is given a temporal location, a place in a narration of events, giving the destruction of the fort a sense of having *happened*. In the absence of other visual indices of war, the white smoke functioned as a powerful reminder that this was not just a picture of ruins but rather a site of explosive conflict, the closest that the camera could get to representing events.

The use of white smoke to signify a dramatic event in Durand-Brager's photographs contrasted to his experience making drawings as a war correspondent for *L'Illustration* (fig. 117). In the January 13, 1855, edition of *L'Illustration,* he reasoned that the inclusion of white smoke would only serve to obscure the scene he wanted to represent: "I have excused myself from placing cannon

smoke here for the reason that it can be done easily enough but hides details. Those of your readers who value these details will want to pay special attention that, on drawings done like this, one must manage the space well and leave it all for details."[35] According to this logic, within the context of an illustrated newspaper woodblock engraving, puffs of smoke would prevent readers from fully grasping the events depicted in the landscape. Durand-Brager took care to signal to his editors that topographical accuracy should be prioritized over any other consideration and admonished them to publish the drawings exactly as he had made them: "I strongly recommend the view of the camps; it is very exact and must be copied exactly. Believe me, do not try to shorten it; publish it as it as is, one band over the other. You have no idea how many army officers have begged me to do this work so that their families can understand the place where they are."[36] Durand-Brager objected to the inclusion of white smoke because he worried that it would hide important details, compromising the image's ability to picture a unified ensemble. His experience with the banal element of white smoke in newspaper illustration and in the medium of photography demonstrates how he adapted his representational strategies to suit the particularities of the media he used to depict the Crimean War. Durand-Brager would continue this flexibility of approach when it came to the ambitious series of paintings of the Crimean War that he exhibited at the Salon of 1857.

HENRI DURAND-BRAGER: DETAILS AND ENSEMBLES

Despite Durand-Brager's nearly complete effacement from art history, his practice as a photographer, newspaper illustrator, and painter provides an unparalleled opportunity to examine the new relationships between media that emerged during the 1850s. His work in the emergent reproductive media of his day not only gave Durand-Brager a practical understanding of the problem of the relationship between an imagined whole and its constituent parts, but also permitted him to approach battle painting with a fresh perspective, unparalleled by other battle painters of the time. His submission to the Salon exhibition of 1857, *The Siege of Sebastopol,* consisted of twenty-one individual rectilinear canvases. This expansive work transformed representational problems from photography and the illustrated newspaper into pictorial solutions for the painted representation of a

contemporary military event. At least one of Durand-Brager's photographs made its way into one of these paintings: *View of Kamiesch Taken from the Port* corresponds almost exactly to a photograph entitled *Kamiesch: Panorama of the City and of the Port* (figs. 118, 119). One curious set of details was transferred from the photograph to the painting: two people standing on a dock and a small hut a little distance to the right of them (figs. 120, 121). Durand-Brager's direct formal borrowing from the photograph demonstrates the ease with which he moved between media.

The siege depicted in these twenty-one canvases was the most important and drawn-out event of the Crimean War. While no documentation exists for how the canvases were displayed at the Salon of 1857, they were probably organized in one long horizontal band to emphasize their panoramic aspect. Two large canvases—at 2 by 9 feet, about three times the length of the other nineteen—anchored the series, providing a broad topographical overview of the port of Sebastopol and the entire set of French fortifications along the coast (figs. 122, 123). The rest of the paintings represent various locations of strategic importance, which register as barely visible details in the broad synoptic view of the two large paintings. These two lateral paintings are so expansively rendered that far-ranging topography takes precedence over the historical specificity of siege. As we will see, their lack of discernable military events produced the effect of a calm detachment, which was crucial for containing the disquieting effects of modern artillery warfare depicted in many of the other small paintings.

The smaller paintings provide a "zoom-in" effect vis-à-vis the panoramic topographical paintings and bring the viewer closer to the details of the siege. Many, including *The Clock Tower,* depict strategic locations not otherwise visible in the two large canvases (fig. 124). The clock tower was the location of a field hospital during the first few months of the siege, but was later relocated since it was within the range of Russian guns.[37] In the painting, some soldiers are carrying away the dead on stretchers, while two others, in the far-right corner, run for cover (fig. 125). Durand-Brager thus dramatizes the relationship between the dead soldiers being carried out of the hospital and those who run for their lives. This unsentimental image of danger and death reminds the viewer of the human drama unfolding within the otherwise picturesque larger panoramic landscapes of Sebastopol. Illustrated newspapers

and photographs might excel at representing and multiplying details, but they were materially incapable of producing the kind of summary image that battle painting might still aspire to provide. In painting his *Siege of Sebastopol*, Durand-Brager carved out a way to represent war through both a synoptic singular view (the two large paintings) and its fragmented details (the nineteen small paintings), thus acknowledging the importance of the ensemble as well as the details that comprised it. This innovative solution effectively resolved a long-standing formal conundrum for battle painters—the need to choose between episodic details and broader overviews: Durand-Brager accommodated both modes into his series of paintings. The artist's engagement with this problem of historical—rather than optical—vision coincided with the rise of new modes of visual production put into the service of producing war imagery during the Crimean War by none other than the artist himself.

Two lengthy and important articles appeared in the press in the months before Durand-Brager's *Sebastopol* was shown at the Salon of 1857: Théophile Gautier's in *L'Artiste*, one month before the opening of the Salon, and Cléon Galoppe d'Onquaire's in the March issue of *Revue des beaux-arts*. This advance publicity not only foreshadowed *Sebastopol*'s critical reception but also speaks more generally to the public interest in paintings of the Crimean War. In the absence of other documentation, these texts provide insight into how Durand-Brager's twenty-one paintings may have been viewed as a group. Galoppe examined the paintings in Durand-Brager's studio, well before their completion. Although he noted the presence of only one large panoramic painting, not two, the mode he proposed of viewing the series nevertheless corresponded to Durand-Brager's paradoxical attempt to represent the siege as a combination of disparate parts and a totalizing whole: "On a large canvas, the artist painted an

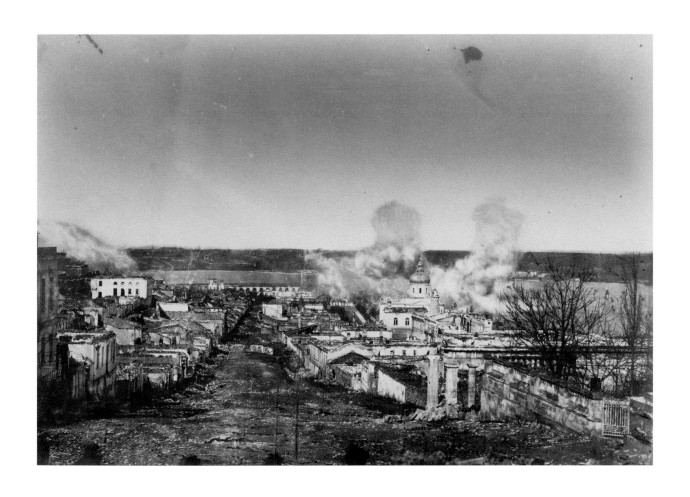

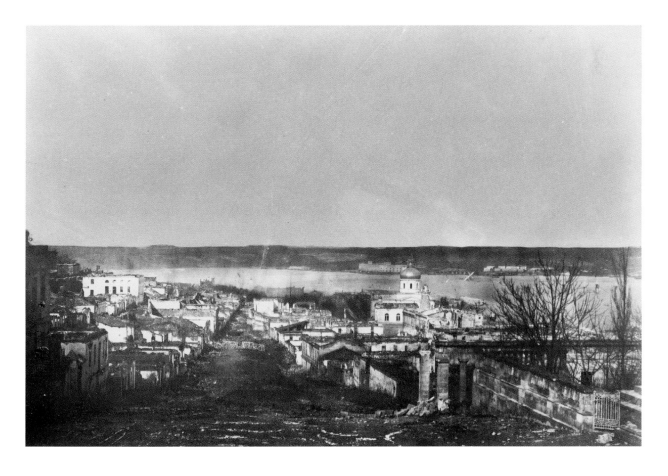

FIGURE 117 *L'Illustration*, January 13, 1855. Woodblock engraving after original drawings by Henri Durand-Brager. Dartmouth College Library.

immense panorama of the Sebastopol harbor. It is the entire left side attack seen in its ensemble from headquarters; it's a sort of synoptic painting, of the general map of the siege and of the lines of defense. But one understands that in a work so spread out, the eye cannot seize upon the thousand individual details of the coast; thus the painter, in dividing his *mother panorama*, has made a series of paintings where each point of view is repeated in larger format."[38] The writer's recourse to the term "mother panorama" assumed a logic of reproduction, whereby the smaller paintings were generated by, or contained within, the larger "mother" canvas. Each of the "thousand individual details" barely visible in the "mother panorama" was reproduced in the small individual paintings. The writer directly addressed the recurring problem of war imagery during the period; that is, the tension between the proliferation of individual details and a visible, totalizing

ensemble. He also claimed that no fewer than 130 paintings "will form the ensemble of this gigantic work," thereby invoking the seductive power of an abundance of episodic details to secure the truth value of the ensemble. This positive valuation of material accumulation was at the heart of image production of the Crimean War and, as we have seen, was not limited to one medium in particular. It was a concept that cuts laterally across discourses, audiences, and media from the period.

Théophile Gautier, who must have seen the work close to its completed state, understood the two large canvases as anchors, which "started his campaign." These "long transversal canvases fit together and continue: the form and the elevation of the hills, the position of the forts, the look of the town and the harbor . . . each white mark indicates a house, a fort, a bastion . . . and yet, if you had not been warned, you would believe that you had in front of

FIGURE 118 Henri Durand-Brager, *View of Kamiesch Taken from the Port*, 1856–57. Oil on canvas, 66⅞ × 68⅛ in. (170 × 173 cm). Musée National des Châteaux de Versailles et de Trianon,.

FIGURE 119 Henri Durand-Brager and Lassimonne, *Kamiesch: Panorama of the City and of the Port*, 1855–56. Albumen print after two glass negatives, 8⅞ × 22¼ in. (22.8 × 56.4 cm). Bibliothèque Nationale de France, Paris.

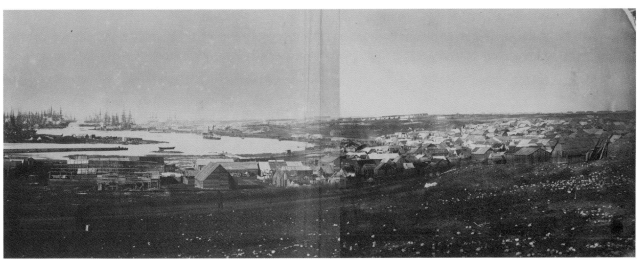

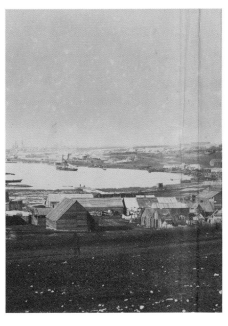

FIGURE 120 Henri Durand-Brager, *View of Kamiesch Taken from the Port*, detail.

FIGURE 121 Henri Durand-Brager and Lassimonne, *Kamiesch: Panorama of the City and of the Port*, detail.

FIGURE 122 Henri Durand-Brager, *Siege of Sebastopol: Panorama of the Left Attacks Seen from the Observatory of Marshal Canrobert*, 1856–57. Oil on canvas, 22 × 106¼ in. (56 × 270 cm). Musée National des Châteaux de Versailles et de Trianon.

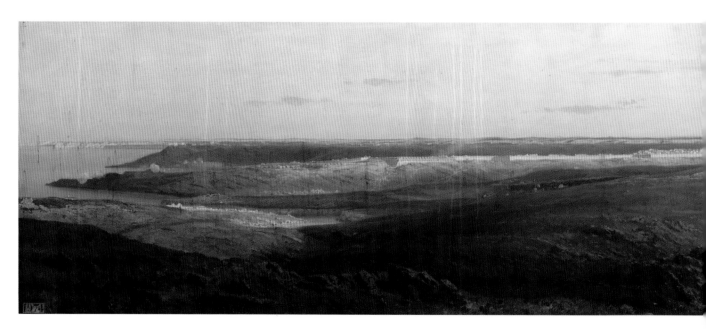

FIGURE 123 Henri Durand-Brager, *Siege of Sebastopol: Panorama of the Left Attacks Seen from the Extreme Left*, 1856–57. Oil on canvas, 22 × 106¼ in. (56 × 270 cm). Musée National des Châteaux de Versailles et de Trianon.

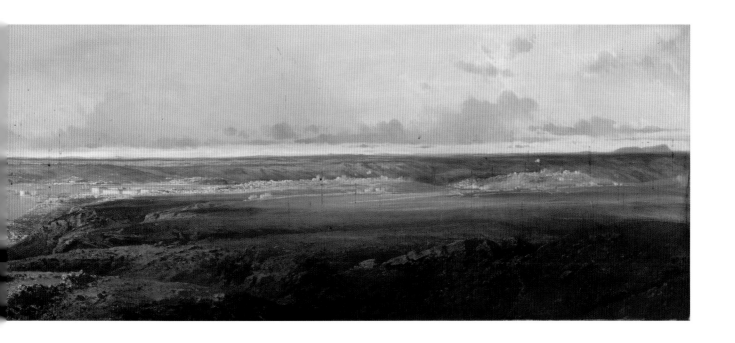

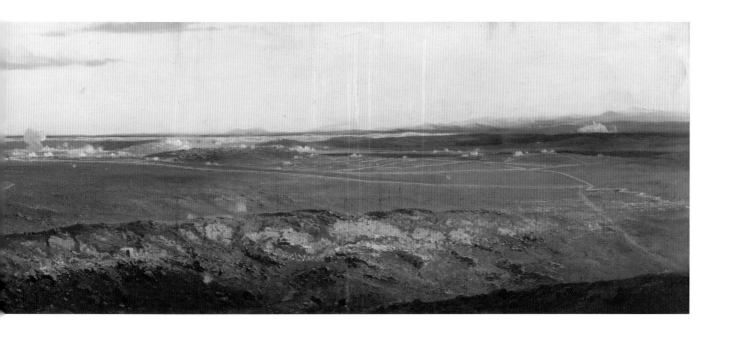

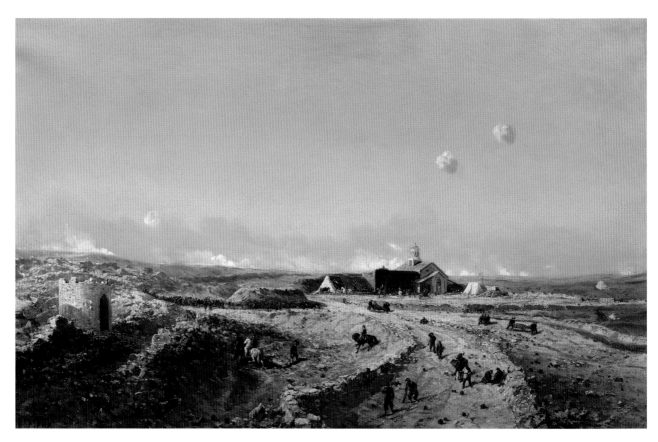

FIGURE 124 Henri Durand-Brager, *The Clock Tower*, 1856–57. Oil on canvas, 22 × 34⅝ in. (56 × 88 cm). Musée National des Châteaux de Versailles et de Trianon.

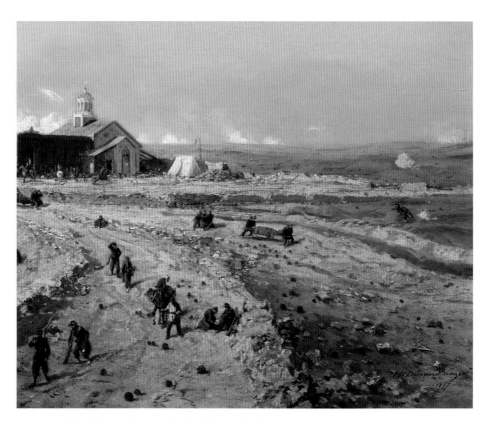

FIGURE 125 Henri Durand-Brager, *The Clock Tower*, detail.

you a simple picturesque view."[39] As Gautier pointed out, the large canvases depicted the land so broadly that they had the effect of dispersing one's vision. In *Panorama of the Left Attacks Seen from the Observatory of Marshal Canrobert*, a hovering, bird's-eye view represents the peninsula from the strategic position of the French command, which gives the impression of spatial mastery across and into the space. The contours of the harbor of Sebastopol are delineated with water and wisps of smoke are barely perceptible, hinting gently at the subject at hand. In their ambiguity, these large landscapes resemble the panoramic landscape photographs taken by Lassimonne and Durand-Brager: without the captions, it is impossible to tell that here a bloody armed conflict took place. The nineteen smaller paintings, however, make it clear that the subject matter has little to do with picturesque landscapes.

Durand-Brager's paintings exemplified the character of modern warfare as it became evident during the Crimean War, the first conflict in which industrial advances in artillery and small arms played a decisive, and deadly, role. While the Russians used outdated smooth-bore muskets, the French and the English were equipped with state-of-the-art Minié rifles with a range of up to 1,200 meters and greater precision.[40] The war was also the first in which both sides used large numbers of rockets. Large guns positioned in batteries fired artillery at unprecedented rates. According to a French government report, the French fired over 1.1 million canon shots and used over 3 million kilograms of gunpowder. Both nineteenth-century and contemporary commentators have noted that the Crimean War differed from wars of the past, and the siege of Sebastopol was the defining event of this new war. Unlike a military charge or a conventional battle between armies, the siege became a long, drawn-out series of events, with both sides firing blankets of long-range artillery at one another. The siege set an ominous precedent for future wars of attrition and "tactical stagnation," including World War I. As we shall see, the consequences for visual representation were just as notable.[41]

The Russians dug into the city of Sebastopol and concentrated their defenses at the Malakoff Tower. The siege lasted one year, from September 1854 through September 1855, and resulted in heavy losses for all sides. This agonizingly slow military event posed new problems in terms of its representability: how to represent a historical event with no particular center of action, neither temporal nor

spatial. The problem was noted by one critic at the Salon of 1857, who doubted whether such an event could ever be painted: "Is this a battle? Yes, says the historian, and the strategist sees in it a conflict of the first order. The attacker lost 9,000 men. Yes, this supreme effort is truly a battle. . . . But, for the painter, where is this battle? From where will it be taken? At Tchorgoun? At Traktir? These are episodes, bridge crossings, outpost affairs. It is really just a matter of artillery . . . so show me an artillery event on the canvas."[42] Just as Durand-Brager's paintings represented war as a series of scattered episodes, mimicking the visual idiom of illustrated newspaper reportage and photography's fragmentary but plentiful details, the new character of warfare lacked a definable center of action. The critic challenged his audience to tell him how to represent in a battle painting a series of gunpowder explosions volleyed from a distant location. *The Siege of Sebastopol* contends with this new kind of artillery war. The artist, having personally experienced such barrages during the two years he spent working as a naval officer and correspondent for *L'Illustration*, understood that the shortage of definable heroic events required a new kind of representational strategy.

Théophile Gautier believed that Durand-Brager's series of paintings was the first to represent these new conditions of warfare: "A hero nowadays is made up of 2,500 men and is called the 24th line or the 32nd demi-brigade, and seen on the battlefield, from the top of the hill where the general stands, spyglass in hand, produces the effect of small red and blue stripes. Death, managed through scientific means, happens to the soldier from afar, anonymous like him, through the haze [*flocons*] of smoke."[43] Gautier emphasized the decentralized aspect of artillery war, with the general directing action from afar. The "scientific" character of the operations, which Gautier understood to be related to the advances of modern weapons technology, produced a new social relationship between war and individual soldiers that revolved around anonymity and detachment. Modern warfare alienated the soldier from the process of war; it disconnected him from direct combat with his enemy. Many of the smaller paintings that purported to represent the fragmentary details of the siege are unprecedented within the history of war imagery in the nineteenth century. Gautier wrote of the terrifying character of artillery warfare that he saw in these smaller paintings: "Tree limbs twisted on the ground like vegetal cadavers, mutilated,

minced, turned over, stripped, reduced to a skeletal state . . . bullets, debris, bomb explosions blanket the broken earth.—Those who spent heroic blood to take this ashen mound, this heap of pallid gypsum, one thinks of them and can only tremble. . . . The interior of an erupting volcano furnishes a good enough idea of the crater sketched by Durand-Brager; it's a chaos of rocks, boulders, of clumps that jump, explode, fly in the air amidst the smoke and the flames."[44]

In contrast to the heroic charging armies in Horace Vernet's battle paintings such as the *Siege of Constantine* (1839), or in most battle paintings from the First Empire, Durand-Brager's paintings are devoid of displays of heroic unity, battlefield bravura, or even identifiable individuals. Instead of depicting encounters between men, these paintings describe the physical properties of specific areas of land and depict the impact on it of artillery-fueled trench warfare. Durand-Brager included human figures in many of these war-torn landscapes, but they are minuscule in comparison to the land they inhabit. In the words of Gautier, Durand-Brager "has placed man on the scale of the landscape and the soldier in proportion with war."[45] Gautier thus approved of the diminution of the soldier's scale and narrative importance in Durand-Brager's *Sebastopol* because it forced viewers to contend with the new terms of industrialized warfare, which he viewed in spatial terms. Gautier's remarks on Durand-Brager's series imply a sense of foreboding about what this sort of war might portend, namely a lack of agency on the part of soldiers and an anonymity in the theater of war. While this had arguably been the case in earlier wars, Durand-Brager's panorama offered something truly new: it made the insignificance of the individual soldier relative to modern weapons' destructive power a subject for visual representation. Gautier's remarks about the diminution of the human subject should also be understood in relation to the series' format. The twenty-one separate canvases (some smaller than others) meant that the attention of viewers would have been quite literally dispersed among them, making a totalizing view of the entire series impossible. The actions visible within them, moreover, would seem all the more minuscule to someone viewing all of them at the same time. This all-encompassing, landscape-dominant point of view of the theater of war thus came at the expense of human actors, on the level of what was pictured as well as of the experience of viewing the series. This helps to explain Gautier's focus on the metaphorical

character of landscape in relationship to the scale of human actions at Sebastopol. His conclusion about modern industrial war as an alienating condition could have perhaps only been reached after having viewed a series such as Durand-Brager's.

In a painting entitled *Craters in Front of the Bastion du Mat* (fig. 126), the land has been transformed into a black, craggy wasteland. This painting is unique within the *Panorama of the Siege of Sebastopol* insofar as it represents a specific event that took place at the height of the siege on April 15, 1855, when French troops, operating under heavy enemy fire, constructed a much-needed additional trench in front of one of their bastions. The Salon *livret* described the event in great detail; this differed from its descriptions for the other paintings, which were mainly concerned with describing topographical particulars and events that had taken place there. In the May 5, 1855, edition of *L'Illustration* (see fig. 110), Durand-Brager represented the same event during daylight hours, alongside a narrative description by General Canrobert. The newspaper engraving, which depicted a group of soldiers in the process of digging the trench, plunged viewers down toward the ground, making them visually privy to the labor of these men. In his painting, Durand-Brager departed from the visual idiom of his trade as a war reporter; taking advantage of the medium of oil paint to depict the chromatic effects of enemy fire in the darkness, he produced a haunting image that conveys a condition of extreme destruction. Every sign of undisturbed nature is obliterated; the horizon line of the newspaper image has become a line of yellow fire and twisted lumps of destroyed earth. This is hardly a zone capable of supporting human life, and yet yellow explosions signal that the fight is not yet over.

The scorched-earth landscape of *Craters* recalls the corpus of works done by artists who served in World War I, often understood as the first trench war—and in fact, the two wars had much in common. At the time of their fighting, each was understood to be a distinctly modern kind of war waged with new tactics and weapons. George Leroux's *Hell* (fig. 127) and Otto Dix's *Shell Holes Illuminated by Flares near Dontrien* (fig. 128), with its landscape destroyed by a barrage of artillery, are more akin to Durand-Brager's *Craters* than to any other image from the nineteenth century. All three of these works announce man's destruction of earth's surface with the help of modern weapons technology; moreover, all were made by artists who served in the conflicts represented. Their visual

FIGURE 126 Henri Durand-Brager, *Craters in Front of the Bastion du Mat,*
1856–57. Oil on canvas, 22 × 34⅝ in. (56 × 88 cm). Musée National des
Châteaux de Versailles et de Trianon.

impact comes from a metonymic use of the ravaged land-
scape to stand in for the human cost of war; the images are
too dark and scorched to decipher the presence of human
bodies. While it is impossible to see bodies in *Craters,*
some of the smaller *Sebastopol* paintings do depict the
human cost of war. In *View of the Central Bastion* (fig. 129)
and *Right View of the Bastion du Mat* (fig. 130), the small
figures represented are either dead, running from danger,
or trudging through impossible terrain, a far cry from the
heroic masses of French soldiers that audiences had come
to expect from battle paintings. The landscape, decimated
like the people who occupy it by modern weaponry, pro-
vides an appropriate setting for this dim human drama. In
Right View of the Bastion du Mat, dead tree roots mingle
with small cannonballs, the debris of the combat that
occurred at that site. Durand-Brager discovered a picto-
rial economy based on the color brown, using its various
shades to render the landscape as a devastated, washed-
out ruin. Durand-Brager's destroyed landscapes limit our
ability to view the destruction of human subjects, which in
turn denies a sense of scale and prevents viewers from

negotiating their spatial layout. All that remains in these
paintings are torn mounds and horizons of destroyed
earth, often illuminated by explosions. In contrast to the
broad overview in the larger landscapes, these bleak
smaller canvases plunge the viewer into a ground-level
view of the horrors of modern warfare.

Durand-Brager's paintings were exceptional for their
time because they insisted upon war as an event absent a
heroic center. In so doing, they foreshadowed the chal-
lenges that future twentieth-century wars would pose for
artists relative to more traditional modes of battle paint-
ing as practiced by Horace Vernet and others during the
nineteenth century. In his *L'Art pendant la guerre, 1914–1918,*
the art historian Robert de la Sizeranne's description of
the difficulties of creating battle paintings of World War I
could just as easily apply to Durand-Brager's *Sebastopol*:
"Even on the battlefield, we find hardly any visible ruins,
unless it's some ruins of plant matter. The shell has made a
tabula rasa. After several days of bombardment, there is
nothing left. It is upon this 'nothing' that the modern
painter must display the action of his combatants."[46] Given

FIGURE 127 Georges Leroux, *Hell*, 1921 Oil on canvas, 44⅞ × 63¾ in. (114 × 162 cm). Imperial War Museum, London.

FIGURE 128 Otto Dix, *Shell Holes Illuminated by Flares near Dontrien*, 1924. Aquatint, 7⅝ × 9⅞ in. (19.3 × 25.1 cm). Museum of Modern Art, New York.

how horrifying these painting are in their evocation of modern warfare, it is interesting that the critical reaction to Durand-Brager's *Siege of Sebastopol* was overwhelmingly positive. The idiom of reproduction pervaded much of the discourse, with the metaphor of photography used to invoke the paintings' capacity to reproduce the real: Victor Fournel likened them to "intelligent photographs."[47] But by far the most pervasive current within the criticism of *Sebastopol* was the idea that the series constituted a complete representation of the siege. Etienne-Jean Delécluze, noting that Durand-Brager's series was one of the most popular works of art on view, emphasized its depiction of the siege in its entirety: "One of the parts of the exhibition that has particularly attracted the attention of the public is the one where the twenty [sic] panoramas and paintings represent the views of Sebastopol, taken from every side and every accident of its siege."[48] Lacking a center of decisive action, Durand-Brager's *Siege of Sebastopol* stood firmly outside the tradition of nineteenth-century battle painting. This was a new manner of battle painting for an unprecedented form of artillery-fueled siege warfare, which did not rely on direct clashes between armies. As a correspondent for *L'Illustration* and as an amateur photographer of conflict, Durand-Brager made use of modes of visual production that held out a new kind of technologically figured promise: that a totalizing picture of contemporary war could be arrived at through a potentially endless proliferation of parts. His engagement with this possibility through the medium of painting resulted in a form of battle painting that hinted at

the difficulty, if not the impossibility, of representing the Crimean War as a large-scale singular image of two clashing armies.

Despite the distinct lack of conventional military encounters in Durand-Brager's paintings, Louis-Napoleon purchased the entire series; starting in 1859, it enjoyed an afterlife in a room especially devoted to the Crimean War in the historical museum at Versailles, the so-called Salle de Crimée. This room was Napoleon III's continuation of Louis-Philippe's didactic museum project; the new space made use of the unfinished Salle de Maroc that Vernet had been at work on when Louis-Philippe abdicated in 1848. Reproductive engravings made by the same firm, Lemercier, that had published Durand-Brager and Lassimonne's photographs were published to coincide with the unveiling of the new Salle de Crimée in 1860. Significantly, the three most somber small paintings were not among those reproduced. Lemercier decided instead to publish the more picturesque reproductions; Durand-Brager's depressing war-torn images, it seemed, were not good for business.[49]

LARGE-SCALE BATTLE PAINTING AND THE PROBLEM OF REPRODUCIBILITY

Gautier was one of at least three critics to suggest that Durand-Brager's series be turned into a large-scale, immersive panorama in the vein of those made by Jean-Charles Langlois.[50] Like earlier critics such as Quatremère de Quincy and Delécluze, Gautier asserted the panorama's unique capacity to represent an armed encounter as

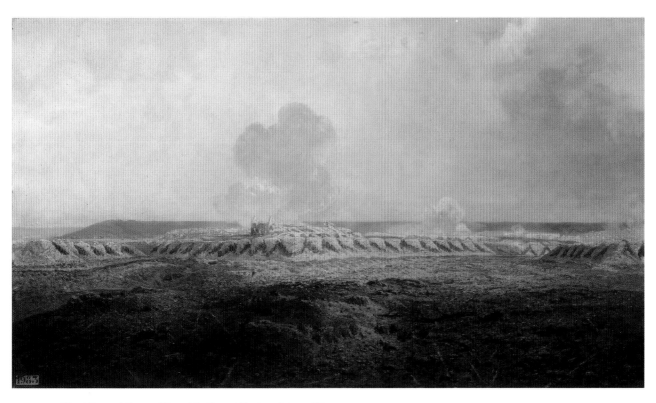

FIGURE 129 Henri Durand-Brager, *View of the Central Bastion*, 1856–57. Oil on canvas, 22 × 34⅝ in. (56 × 88 cm). Musée National des Châteaux de Versailles et de Trianon.

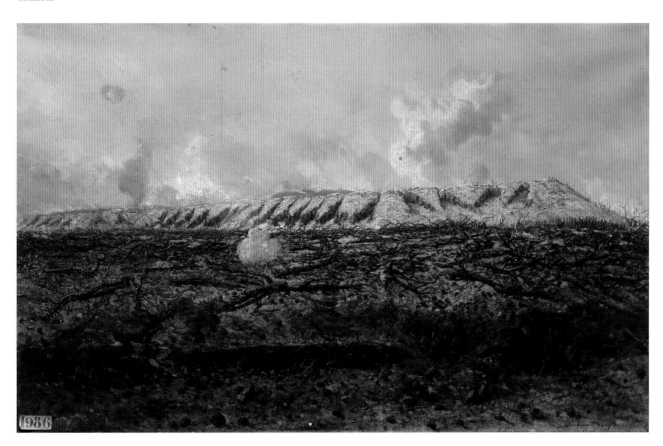

FIGURE 130 Henri Durand-Brager, *Right View of the Bastion du Mat*, 1856–57. Oil on canvas, 22 × 34⅝ in. (56 × 88 cm). Musée National des Châteaux de Versailles et de Trianon.

completely as possible, and doubted the ability of traditional battle painting to provide anything but an isolated fragment of a larger whole. Gautier's discussion of the merits of the battle panorama differed from his predecessors', however, in its focus on the relationship between the panorama and emergent technologies, specifically that of locomotion. His comments came at a time when steamships and trains both played a major role in the operations of the Crimean War, radically altering the way that human beings experienced the land; over the course of the Second Empire, France's rail network rapidly expanded. Gautier argued that these new ways of moving human bodies impacted visual perception to the point that a new visual form, the panorama, would become the only appropriate form for representing a landscape: "When rapid and perfected locomotion will permit us to visit all of the corners of the planet, do you think that a frog pond by the woods at Bas-Bréau, a tree near a country hut with a pigeon on the roof, a chicken incidentally perched upon a pile of manure will still be interesting? The public will demand grand points of view, immense horizons, bird's eye views of an entire country, of an entire mountain chain . . . and the landscape will take the form of the panorama."[51] This invocation of the marvels of modern transport in relationship to the form of the panorama is now a familiar part of the scholarly literature. According to Gautier, who was an avid travel writer, the panorama was destined to become the form par excellence of a scopic regime characterized by a new demand to see *more*—to picture wider vistas, vaster horizons, and greater expanses of land. Inspired by Durand-Brager's *Siege of Sebastopol,* and in opposition to the realist forms of landscape painting then current in France, Gautier called for a new kind of battle picture, one that spoke to evolving technologies of travel and vision.

Gautier's certainty that the Crimean War could only be represented in the form of the panorama was affirmed by none other than Langlois, who was there to take photographs and make sketches for his Crimean War panorama. The panorama, which was partially funded by the government and based on photographs that Langlois took of ravaged sites after the war was over, would open in 1860; it represented the most important and definitive battle of the war, the capture of the Malakoff Tower. This event marked the end of the drawn-out siege of Sebastopol and signaled to the French public that the war would soon be over. In contrast to the siege of Sebastopol, which was short on definitive events and man-to-man combat, the

capture of the Malakoff Tower allowed artists to focus on a heroic center of action. Louis-Napoleon anticipated the event's attractiveness for visual representation, ordering that the tower be stormed to produce a spectacular military event "worthy of his uncle" and end the war.[52] In a letter to his wife, Langlois asked: "What is a battle painting if not a condensed panorama in the proportions of a single painting?" Even the best battle paintings could only produce "a very small, totally incomplete part of an immense whole, with less illusion and more shocking discrepancies."[53] Langlois's remarks were made in direct response to what he viewed as the futile efforts of an up-and-coming battle painter, Adolphe Yvon, who had been sent to Crimea to make studies for a monumental battle painting of the same seminal event, and who, Langlois contended, would be unable to keep his painting from devolving into a series of unrelated incidental details. In deriding the younger painter as a dilettante who knew nothing about war, Langlois was speaking from a doubly authoritative position; as not only a panorama painter but also a colonel in the army, he possessed a wealth of knowledge about the waging and painting of war. To add insult to injury, Yvon had chosen exactly the same point of view—from the center of the Malakoff Tower—as Langlois had for his composition. In Yvon's painting, General MacMahon is pictured on the summit of the tower (fig. 131). Langlois's panorama positioned the viewer at this same point, looking out over the entire 360-degree panorama and emulating the authoritative gaze of the general.

Langlois, who had exhibited several battle paintings at Salons during the Bourbon Restoration and the July Monarchy, recognized a crucial divide between battle painting and panorama painting. From his point of view, the two demanded separate subjects and points of view and completely different compositional approaches. As a panoramist, his objective was to produce an illusion of a battle in its totality, aided by the physical enclosure of a large, round canvas. It is therefore not surprising that he would have taken issue with the conventions of battle painting and Yvon's apparent pretension in depicting a summary representation of the capture of the Malakoff Tower in a comparatively limited physical format. More significantly, the gap between Yvon's painting's constitutive parts and its status as a coherent whole was also taken up by Salon critics, who viewed the painting at the Salon of 1857—the first exhibition to be held after the cessation of hostilities. The exhibition featured dozens of battle

paintings of the Crimean War, the most ambitious of which was Yvon's monumental 19-by-27-foot *Capture of the Malakoff Tower*. It attracted the ire of critics who focused upon its failed attempt to produce the illusion of panoramic totality and contended that an excessive amount of detail and an overreliance on violent episodes made for a confused and decentered picture. Yet, as we shall see, Yvon's work did achieve a measure of success, apart from the criteria used to determine the aesthetic merit of a painting exhibited at the Salon: it enjoyed an afterlife as a graphic and photographic reproduction across a staggering array of emergent and established media. The values invested in these reproductions recall those discussed in relationship to the boundless photographic archive of the Crimean War that photography's early commentators had hoped for: this handmade painting became the site of a potentially limitless form of photomechanical accumulation.

In Yvon's *Malakoff*, several groups of figures are distributed around the foreground and middle ground of the Malakoff Tower, in the throes of direct combat. Whereas the top half of the painting features a deep horizon and a few soldiers standing on top of the fort, an abundance of figures in the bottom half creates a crowded foreground and makes the painting spatially uneven. A trench that diagonally cuts across the hill from the foreground to the middle ground is filled with a proliferation of small, almost indistinguishable heads. This signals the presence of a large mass of men without showing their entire bodies, an effect that augments the painting's sense of compression. General MacMahon stands on the summit of the Malakoff Tower, ostensibly directing the action unfolding below. To his left, a Zouave holds a tattered French flag—an important element, since it emphasized the contribution of soldiers to the tower's successful capture. The entire foreground is dominated by direct combat between French and Russian soldiers.

Following the display of *The Capture of the Malakoff* at the Salon of 1857, Yvon was commissioned to paint two other large canvases for the Salon of 1859 that served as pendants to it. *The Malakoff Gorge* and *The Malakoff Courtine* (figs. 132, 133), represented other actions related to the capture of the fort from different points of view. The government's commission of the two pendants to the *Capture* directly (and unwittingly) validated Langlois's earlier critique of Yvon and the limitations of more traditional "flat" battle painting in providing a summary image

of any conflict. All three paintings were eventually exhibited together at the historical museum at Versailles in the Salle de Crimée, in a triptych format mimicking that of Vernet's earlier *Constantine* series, which was also composed of three separate, monumental battle paintings. The use of multiple canvases by Crimean War battle painters such as Yvon and Durand-Brager suggests that battle painters had come to see Vernet's material and narrative strategy of dispersing his battle painting across multiple frames as a viable response to the challenges posed by the panorama's claims for totality. The practice of battle painting thus gradually refashioned itself in dialogue with a popular visual spectacle that had not previously been understood as having a strong claim to the category of fine art.[54]

Critical comments about Yvon's painting were particularly attuned to problems of the fragment and the detail. Many focused upon its failed attempt to produce the illusion of panoramic totality and the artist's lack of selectivity in the episodes he included. At a historical moment when new modes of visual production such as photography and the illustrated newspaper produced decentered and potentially limitless pictures of war, critics craved the illusion of totality more than ever when it came to the more traditional mode of history painting. "The melee has retreated and the panorama has been put up on the canvas," wrote one critic; "Yvon's painting hardly speaks to the imagination. This pell-mell does not capture any reality; this large machine lacks unity, and is without any real grandeur."[55] The accusation that the painting had failed to achieve the ineffable quality of "grandeur" referred to the set of timeless universal values associated with the genre of history painting as well as the complex ideological operation through which a bloody battle between opposing armies over a small parcel of land could be interpreted as a noble and virtuous event of national importance. The failure of Yvon's battle painting to produce either of these related ideas was widely noted. For many critics, the meaning of the painting, which was ostensibly to represent France's military prowess, buckled under the saturation of episodic detail. As Edmond About wrote, "When one's eyes are cast upon the large canvas of M. Yvon, one is tempted to go over to the reverse side [of the canvas] to look there for France's glory. . . . You will find a little bit of everything in Yvon's painting, but this everything is not enough, and one desires something else."[56] The critic charged that Yvon's *Malakoff* substituted a proliferation of incidents for a heroic center, whose

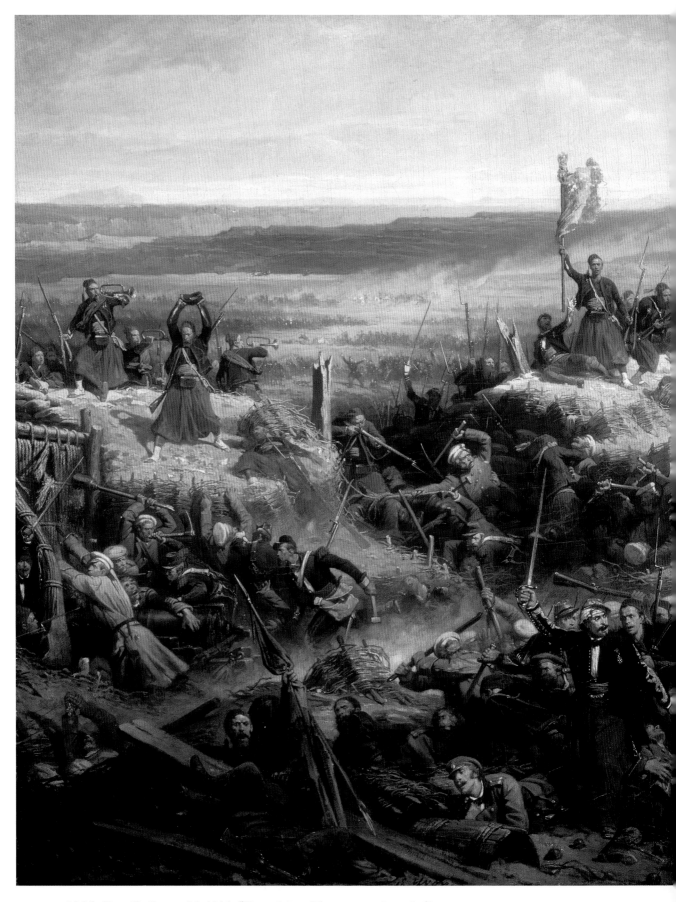

FIGURE 131 Adolphe Yvon, *The Capture of the Malakoff Tower,* 1856–57. Oil on canvas, 236 × 354 in. (600 × 900 cm). Musée National des Châteaux de Versailles et de Trianon.

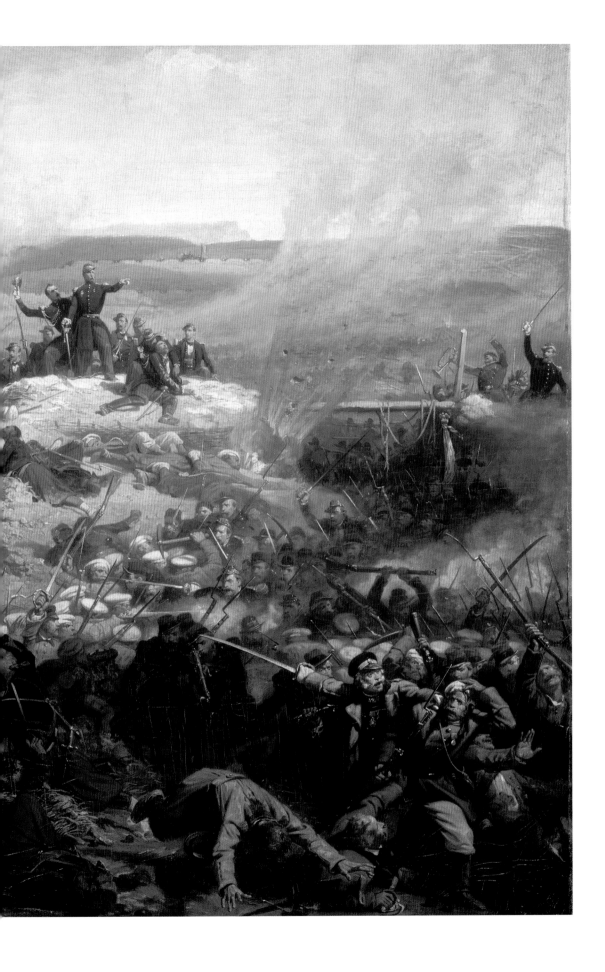

FIGURE 132 Adolphe Yvon, *The Malakoff Gorge*, 1859. Oil on canvas, 197 × 295 in. (500 × 750 cm). Musée National des Châteaux de Versailles et de Trianon.

FIGURE 133 Adolphe Yvon, *The Malakoff Courtine*, 1859. Oil on canvas, 197 × 295 in. (500 × 750 cm). Musée National des Châteaux de Versailles et de Trianon.

epic quality was sorely missed: "I want to see the grand figure of the army personified in a mass of men, and I do not find it. . . . A single spirit, a single heart, a single courage incarnated in the thousands of beings who sacrifice themselves for peace within Europe: that is Malakoff. A collection of good enough portraits and intelligent episodes: that is Yvon's painting."[57] More problematically for the painting's reception, critics interpreted many of the episodes as excessively violent, only adding to the impression of the painting's disconnect from the larger, universalizing meaning it was expected to produce. "No primordial thoughts enhance this painting," wrote one, "though none of these episodes can the public see anything other than a horrid melee of victors and vanquished!"[58] The episode that most critics focused on was in the foreground, and featured a

group of three French soldiers firing upon a fleeing Russian soldier (fig. 134). They face the viewer with their weapons still pointed in firing position, while the Russian falls out toward the space of the viewer, head down, in midair. A bloody spot on his back marks the impact of the bullet. A group of Russian soldiers to the right of their fallen comrade try to flee, knowing that the battle is already lost, but a Russian officer holds them back to continue fighting. In the words of Charles Perrier, "If the attackers only had to fight against fleeing men, what sort of glory could we ever collect from victory?"[59] Yvon appeared to have overstepped the bounds of decorum by including an episode that reeked of too much French pride. For the majority of critics, Yvon had made a painting of particulars that did not coalesce into any form of higher meaning. *Malakoff* thus hinted at a discrepancy between the widely received notion of French military heroism that had been encouraged by visual images of armed combat over the course of the nineteenth century and the painterly conventions used to represent it.

Many of these comments recall the criticism directed at Horace Vernet throughout his lengthy career and betray a long-standing critical skepticism over battle painting's popularity with the public. By the Salon of 1857, Horace Vernet was sixty-eight years old. His reputation, which had always polarized critics, had begun to suffer as a result of a series of poorly received battle paintings made after 1851.[60] In an 1852 letter to his son-in-law Paul Delaroche following critical hostility over his *Siege of Rome*, Vernet mentioned that the time would soon come to "close up shop."[61] Following the Exposition Universelle of 1855, in which he was given a retrospective exhibition along with Alexandre-Gabriel Decamps, Jean-Auguste-Dominique Ingres, and Eugène Delacroix, a very public feud erupted between Vernet and Théophile Silvestre, in which Vernet appeared as a publicity-hungry sycophant. Despite these setbacks, in 1856 the French government gave Vernet the commission to paint the capture of the Malakoff Tower. But upon hearing that Yvon had also been asked to paint the same subject, he promptly withdrew and left the task to the up-and-coming painter instead. His waning reputation as a battle painter notwithstanding, Vernet had arguably done more than any nineteenth-century artist to advance public expectations about the mass availability of battle painting through a proliferation of reproductions. While this ensured his renown, his eagerness to reproduce his works and their abundance across media was viewed with suspicion during his lifetime and thereafter.

FIGURE 134 Adolphe Yvon, *The Capture of the Malakoff Tower*, detail.

More than any other battle painting that preceded it, Yvon's *Capture of the Malakoff* became synonymous with its circulation as a graphic and photographic reproduction at the time that it was made. For this reason, the painting's proliferation as a series of reproduced images offers a particularly rich opportunity to examine the history of interactions between new technologies of visual reproduction and more traditional forms of picture making. In addition to being reproduced as a lithograph, a woodblock print, and a small-engraving, Yvon's *Malakoff* was reproduced photomechanically by three different photographers. The painting's circulation as a reproduction provoked an important set of discussions related to contemporary understandings of and hopes for France's emerging industrial economy.[62] Reproductions of Yvon's monumental

battle painting in a variety of emergent and established media were understood by commentators as demonstrating the strength of France's productive (and reproductive) powers. These claims countered concerns expressed before the outbreak of the Crimean War that armed conflict with France's neighbors would harm economic expansion. If anything, the war itself and the energy invested in depicting it were evidence that war and a strong capitalist economy went hand in hand.[63] As Henri Lefebvre has argued in *The Production of Space*, war played a formative role in the historical development of capitalism: "under the dominion of capitalism and of the world market, [war] assumed an economic role in the accumulation process . . . We are confronted by the paradoxical fact that the centuries-old space of wars, instead of shrinking

into social oblivion, became the rich and thickly populated space that incubated capitalism."[64] While Lefebvre directly implicated the role of war in the process of primitive accumulation and the opening of channels of trade, he was more broadly concerned with the spatial and material consequences of the close relationship between warfare and the acceleration of the productive capacities of European economies. Though the subject of Yvon's painting was a decisive battle from the Crimean War, its circulation in a variety of different reproductive forms took on its own form of meaning beyond the painting itself as an analogy for the value of the dazzling proliferation promised by industrialized modes of image production.

In the years immediately following *The Capture of the Malakoff*'s debut at the Salon of 1857, three different prints were made: an etching published in the periodical *L'Artiste* as the featured reproduction for the September 5, 1858, issue, a carte-de-visite-size etching, and one extraordinarily large-scale lithograph (figs. 135–37). These three different modes of graphic reproduction disseminated Yvon's painting to potentially diverse publics. The etching's publication in *L'Artiste* would come under the gazes of an informed, bourgeois readership interested in the promotion of the fine arts within French culture. The luxurious lithograph made by the distinguished reproductive lithographer Louis-Emmanuel Soulange-Teissier was a very different kind of print, intended for collectors. Its rarefied status was reflected in the second-class medal that it won at the Salon of 1859, and the degree of its refinement and the bombast of its scale attracted the interest of the press when Lemercier published it in 1859. The *Revue des beaux-arts* claimed that it was the largest lithograph ever to have been produced; another newspaper even commented upon the transport of the lithographic stone used to print it.[65] Unlike the smaller-scale etching that would have accompanied one's subscription to *L'Artiste*, the reproductive lithograph was monumental, at 35 by 24 inches. Whereas the etching is dominated by hazy gray tones and a general lack of contrast, the lithograph represents Yvon's *Malakoff* in astounding tonal and graphic detail. The woodblock print, by the virtually unknown Marthe, is very small and lacks detail, akin to a line engraving. In contrast to the lithograph and even the etching, Marthe's etching would have been sold cheaply, ensuring a wide base of diffusion. Despite its lack of aesthetic refinement, one critic argued that Marthe's etching was all the more of an achievement because it reduced

"the colossal butchery of Yvon's painting," with its dozens of figures, into a diminutive format that still managed to accommodate the monumental original: "With heads no larger than the head of a pin, [. . .]its simple format, its minimal price and above all else, the talent with which it is made will guarantee this print lasting popularity."[66] Marthe's print reduced Yvon's overcrowded painting into manageable proportions, transforming it into an inexpensive, portable print that was paradoxically in keeping with the values of availability associated with contemporary large-scale battle painting.

Unlike any battle painting that had come before it, Yvon's *Malakoff* was available as three different photomechanical reproductions soon after it was shown at the Salon of 1857. These included a Salon installation view by Pierre-Ambroise Richebourg (fig. 138), a reproductive photograph by Robert Jefferson Bingham (fig. 139) that was sold in two different formats (a 11-by-16½-inch print as well as a carte-de-visite), and finally a photogravure by Charles Nègre, based on Bingham's photograph (fig. 140). Richebourg's installation view was one of a series of photographs taken of the Salon of 1857 and speaks to the evolving technical progress of photographing works of art. It contextualizes Yvon's *Malakoff* by capturing its enormous scale, but obscures its details in the generalized gray of the photographic image. Out of the many reproductions of Yvon's *Malakoff*, Robert Jefferson Bingham's reproductive photograph received the most critical attention. Along with Jean-Baptiste Gustave Le Gray, Bingham was one of the most prominent practitioners of photographic reproduction of art, and one of the few to have achieved a measure of commercial success at it in France. Several critics who reviewed Yvon's painting at the Salon of 1857 mentioned Bingham's photograph, confirming that it was in circulation during the Salon exhibition. The photograph sold at Bingham's shop for the high price of twenty francs, with a special five-franc discount for members of the military.[67]

A woodblock engraving that appeared in the pages of the magazine *Musée des familles* reveled in the conjunction between Yvon's battle painting and photomechanical reproducibility (fig. 141). The caption printed underneath the image, which illustrated a fictional short story about the war and a brief account of Yvon's *Malakoff*, informed readers that it was a reproduction not of Yvon's painting but of Bingham's photograph. The writer paused to consider the implications of the photographic dissemination

FIGURE 135 Ferdinand Lefman, *The Capture of the Malakoff Tower,* after Adolphe Yvon, published in *L'Artiste,* 1857. Etching. New York Public Library.

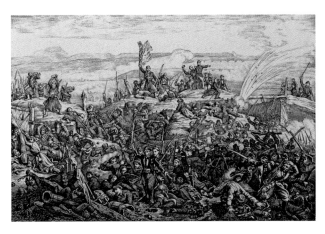

FIGURE 136 Marthe, *The Capture of the Malakoff Tower,* after Adolphe Yvon, c. 1857. Etching, 3⅜ × 4⅛ in. (8.5 × 5.4 cm). Bibliothèque Nationale de France, Paris.

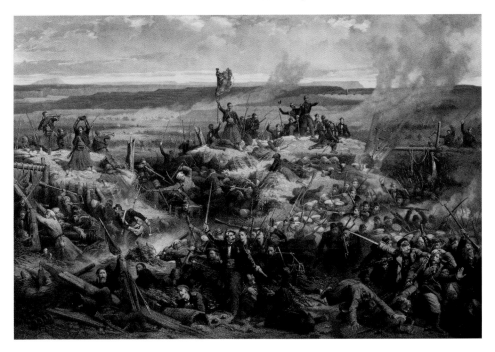

FIGURE 137 Louis-Emmanuel Soulange-Teissier, *The Capture of the Malakoff Tower,* after Adolphe Yvon, c. 1858. Lithograph, 24 × 35½ in. (61 × 90.3 cm). Bibliothèque Nationale de France, Paris.

of *The Capture of the Malakoff Tower:* "One guesses that photography has taken possession of M. Yvon's work. M. Bingham has finely rendered its ensemble and the finesse of its details, which assures the popularity of this national page. One hundred thousand copies will be printed by the sun, and this living bulletin of Malakoff will spread itself throughout the workshops and the country huts."[68] The working class, rural peasants, and, by extension, all reaches of French society, are imagined as the beneficiaries of the "spread" of what was in actuality a prohibitively expensive photograph. The invocation of

France's poor was therefore a rhetorical device that represented, through class-based language of inclusivity, a visual form that would have appealed to a class of consumers capable of buying Bingham's prohibitively priced reproduction. The exaggerated figure of 100,000 copies of the photograph printed "by the sun," and therefore without human labor, emphasized the positive valuation of material proliferation and the wondrousness of producing images in fantastical excess.

In addition to giving rise to the woodblock engraving that appeared in *Musée des familles,* Bingham's photograph

FIGURE 138 Pierre-Ambroise Richebourg, *View of a Room at the Salon of 1857*, 1857. Albumen print, 8¾ × 12¾ in. (22 × 32.5 cm). Musée d'Orsay, Paris.

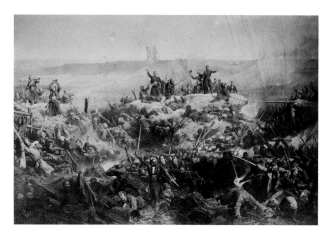

FIGURE 139 Robert Jefferson Bingham, *The Capture of the Malakoff Tower*, after Adolphe Yvon, 1857. Albumen print, 10⅞ × 16½ in. (27.8 × 42 cm). Musée Français de la Photographie, Essonne.

FIGURE 140 Charles Nègre, after Adolphe Yvon, *The Capture of the Malakoff Tower*, c. 1857. Photogravure, 11¼ × 16½ in. (28.6 × 41.8 cm). Musée Français de la Photographie, Essonne.

also served as the basis for another form of photomechanical reproduction as a photogravure by the photographer Charles Nègre. This process, invented by Nicéphore Niépce and later perfected by Nègre, produced intaglio plates obtained from photographic images and printed them with ink rather than photosensitive materials, which at this point in photography's technical development were susceptible to fading. In 1856 Nègre received a patent for his process of transforming "printed photographic images into engraved plates." Shortly after receiving his patent, Nègre wrote to Bingham to arrange for the use of his *Malakoff* photograph. By early October the two men had come to an agreement to share in the profits generated by the photogravure, demonstrating that they both understood the representation of the Crimean War to be a financially lucrative enterprise. The photographic press celebrated Nègre's photogravure process as a technical achievement, a commercially viable way to produce photographs that did not fade. At least 1,500 copies were printed, a large number especially if we consider the saturated market for photographs of the Crimean War. These numbers suggest that Bingham's and Nègre's photomechanical reproductions of Crimean War subjects were more profitable and desirable to larger audiences than the photographic albums of the Crimean War taken in the theater of war by Roger Fenton, Langlois, and James Robertson. At this early phase in the development of photography, well before it assumed its hegemonic status as the preeminent medium for picturing war, the photomechanical reproduction of battle paintings was an early component of what would later become known as war photography, and helped to ensure that painted representations of war would flourish for decades to come.[69]

Nègre's photogravure of Bingham's photograph was the result of a remarkable wellspring of images based on a single battle painting, which seemed to contemporary observers to generate themselves. But this was not the last in the line of images generated photomechanically from Yvon's *Malakoff*. In 1858, Charles Nègre used his photogravure of the battle painting as the subject for an extraordinary photograph (fig. 142). The image depicts a man, whom the title identifies as an apprentice of Charles Nègre, gazing down at a print in the courtyard of Nègre's studio in the heart of Paris. His rolled-up sleeves and apron suggest his status as a worker. The camera captures this anonymous figure as he takes a break from his endeavors, stepping outside to admire the object of his

FIGURE 141 "Fragment du tableau d'Adolphe Yvon, dessin de J. Duvaux d'après la photographie de Bingham," published in *Musée des familles*, October 9, 1857. Woodblock engraving. Bibliothèque Nationale de France, Paris.

labor (fig. 143). He turns to the side in an awkward pose, one leg crossed behind the other, and angles the print toward the camera, where it comes into remarkable focus. The worker's rapt gaze at the product of his labors models our own at Nègre's photograph and sets up a mise-en-abyme–like chain of viewing encounters that fall back on one another. We, the viewers, behold another viewer, who is the worker, beholding the object of his labor, the *Malakoff* print, which is itself a multilayered, intermedial entity. Here, the problem of reproducibility is figured as a chain of obliquely ordered signs, what could be deemed an allegory of the relationship between spectatorship and visual production during the industrial age.[70]

It is no coincidence that Nègre opted to use a reproduction of a battle painting, and not any of the other dozens of photogravures that he would have produced in his

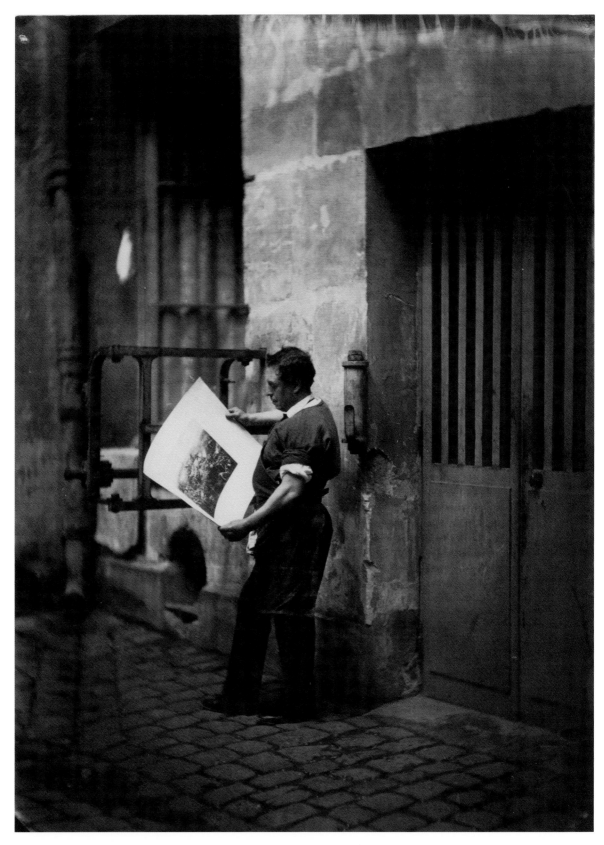

FIGURE 142 Charles Nègre, *An Assistant of Charles Nègre Examining a Proof in the Courtyard of the Studio*, c. 1857. Albumen print, 6¼ × 4⅝ in. (16 × 11.8 cm). Musée Français de la Photographie, Essonne.

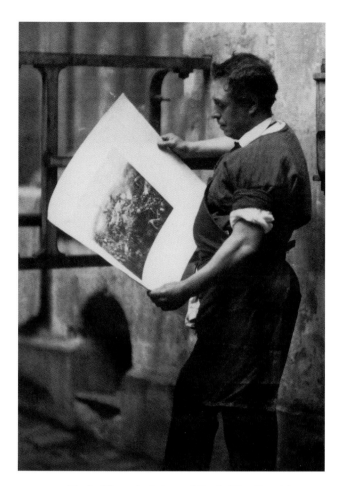

FIGURE 143 Charles Nègre, *An Assistant of Charles Nègre Examining a Proof in the Courtyard of the Studio*, detail.

studio during the same period, to create this self-reflexive image. The tension between the part and the whole of battle painting, which was exacerbated by the rise in new visual technologies that produced endless streams of fragments, is crystallized into a single image. Through the mediating presence of a picture of war, Nègre's photograph represents the dramatic and potentially destabilizing looking-glass effect of spectatorship in the age of early industrial capitalism. This mesmerizing photograph is therefore an affirmation not only of Nègre's own prowess as a producer of photomechanical images but just as much of the "dream-state of technology" with which the picturing of war had become intertwined during the Crimean War. Nègre's photograph is thus a harbinger of an image-world to come, one in which photomechanical reproduction would transform the function of art and create the conditions necessary for images to circulate in interminable numbers. In the 1850s, battle painting's efficacy as an enduring artistic practice thus depended on a set of expectations related to abundance and proliferation; this foreshadows our own contemporary expectations that war should be available to those who do not fight first and foremost as an image.[71]

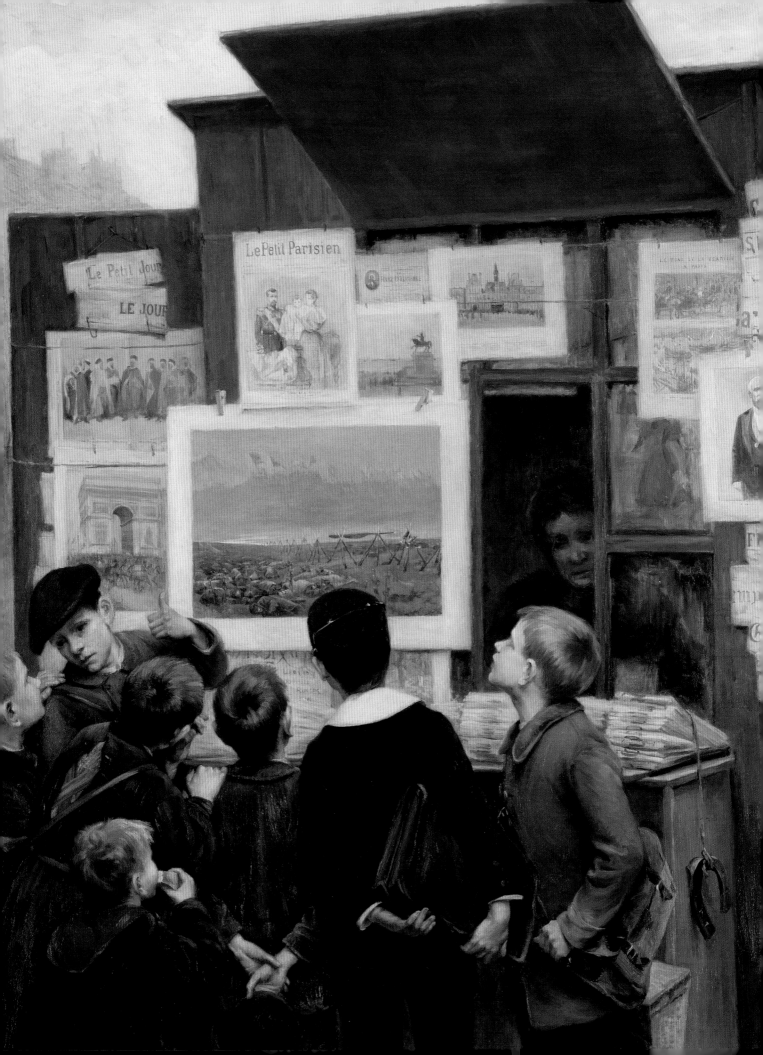

Conclusion

The Crimean War might seem a curious place to end this book, given the fact that Napoleon III's campaigns in Italy and the disastrous Franco-Prussian War of 1870 also generated a proliferation of works across traditional and emergent media. If anything, the ubiquity and importance of war imagery only increased in the later part of the nineteenth century, especially after France's defeat in the Franco-Prussian War and the emergence of a politics of revanchism thereafter.[1] While the history of the visual representation of warfare in the latter part of the nineteenth century and up through World War I remains to be written, such a history would be rooted in developments that I have examined in the preceding pages, including, most notably, an intensification of the blurring of boundaries between traditionally prestigious visual forms like battle painting and more commercial modes of visual reproduction like newspaper and magazine illustration. In my account, the 1850s stand as a watershed moment in the history of war imagery as it related to the commercialization of photography, the growth of the illustrated press, and the overall availability of images; and yet this was still a moment in which traditional battle painting played a crucial, even leading role in generating these images. In the latter part of the nineteenth century, a new generation of military painters, including Ernest Meissonier, Alphonse de Neuville and Édouard Detaille, represented a series of subjects related to Napoleonic military history, the military campaigns of the Second Empire, and the defeat of 1870.[2] De Neuville and Detaille also earned reputations for depicting the feats of individual, often anonymous soldiers at a time when France instituted increasingly universal military service laws (for men) over the course of the Third Republic.[3] Just like the military artists who came before them, the new generation made works with mechanical reproduction in mind. Rising literacy rates, falling prices, and new reproductive technologies like the halftone ensured an expanded readership for newspapers and magazines that were richly illustrated with reproductions of original photographs and battle paintings that had first debuted at the Salon. Military panoramas continued to be produced by battle painters, including Detaille and de Neuville, who like Jean-Charles Langlois before him also exhibited works at the Salon.

One of the most well-known and oft-reproduced paintings of French military subjects to emerge out of the latter part of the nineteenth century was Édouard Detaille's *The*

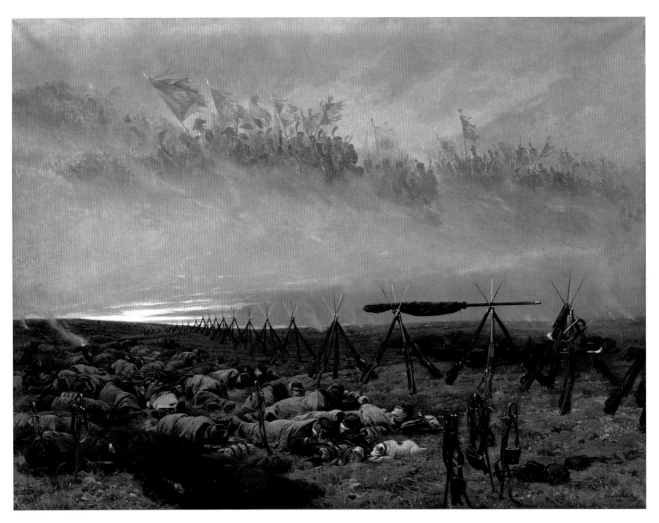

FIGURE 144 Édouard Detaille, *The Dream*, 1888. Oil on canvas, 118 × 158 in. (300 × 400 cm). Musée d'Orsay, Paris.

Dream, exhibited at the Salon of 1888 (fig. 144). France's defeat underpinned the personal commitment of this later generation of battle painters and gave their works a political resonance that recalls the ways in which audiences reacted to Horace Vernet and Francois Lejeune's Napoleonic battle paintings during the Restoration. The afterlife of Detaille's painting demonstrates how the conditions of war pictures described in this book underwent a process of amplification in the latter years of the nineteenth century and up through World War I. *The Dream* entered the public imaginary through such a dizzying array of visual forms that it makes the proliferation of reproductions of Adolphe Yvon's *Capture of the Malakoff Tower* appear almost quaint by comparison.[4] Detaille, who was a veteran of the Franco-Prussian War, pictured a bivouacked unit of soldiers sleeping in a field next to their weapons;

above them, dead French soldiers of yore parade in a hazy, pastel fog. Detaille's large-scale (3 by 4 meters) painting included soldiers from the revolutionary and Napoleonic wars, the Bourbon campaign in Spain in the 1820s, the soldiers of July Monarchy Algeria and Second Empire Italy, and finally, those who fought in the Franco-Prussian War. After being exhibited to great acclaim at the Salon of 1888, Detaille's emblematic image of French military ambition in the wake of defeat was also shown at the Exposition Universelle in 1889, where it became explicitly associated with republican politics. It then entered the Luxembourg Museum and remained there until Detaille's death in 1912. In 1894 the naturalist painter Paul Legrand used it as the basis for his painting of children and one peg-legged veteran gathered in front of a reproduction of *Le Rêve* at a print kiosk (fig. 145). Legrand's painting harkens back to the

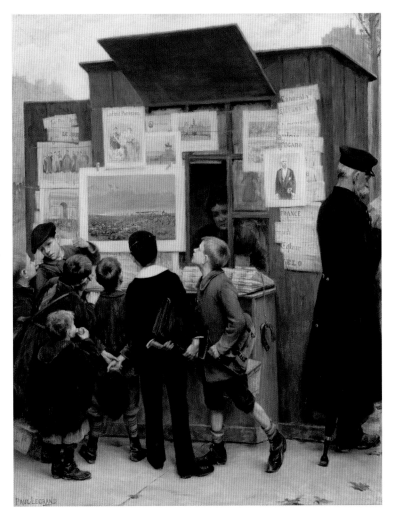

FIGURE 145 Paul Legrand, *In Front of* Le Rêve *of Detaille*, 1897. Oil on canvas, 52¾ × 41¼ in. (134 × 105 cm). Musée des Beaux-Arts, Nantes.

lithographs of Nicolas-Toussaint Charlet, produced more than half a century earlier, of groups of veterans looking at lithographs related to the Napoleonic Wars. *The Dream* would endure as a potent political image up through the end of World War I, when it was often reproduced on postcards, which could legally circulate through the French postal system after 1873.[5] In this highly mobile and inexpensive format, Detaille's painting provided a rallying cry for a nation at war and likely served as an unofficial recruitment tool. This was certainly the case when it appeared as a striking postcard photomontage (fig. 146), with a photograph of a model dressed as Marianne superimposed over a reproduction of Detaille's painting, along with the caption "Expiation" (Atonement). In spite of this late-nineteenth-century flourishing of military painting, this was to be its last gasp. Along with the decline of practices and

institutions associated with the production of academic art in France, battle painting ceased to play a major role in French artistic life in the early twentieth century.

MODERNISM, WAR IMAGERY, AND VALUE JUDGMENTS

In an appraisal of Vernet just after the artist's death in 1863, the print connoisseur Henri Delaborde contended that while his contemporaries reserved their best work for reproduction, Vernet was not as selective. Delaborde framed Vernet's penchant for reproducing his works in decidedly negative terms: "The minor compositions of the painter of the *Smalah*, reproduced as best as they could be as soon as they came out of his studio, proceeded to spread the fame of this extravagant talent or rather constantly maintained a reputation that had long since become familiar in country huts as well as palaces."

FIGURE 146 Anonymous, "Atonement," after Édouard Detaille, *The Dream*, c. 1915. Photomontage postcard, 3½ × 5½ in. (9 × 14 cm). Private collection.

In the words of the nineteenth-century print historian Henri Béraldi, "Vernet was reproduced only by approximate engravings" of low quality. For Béraldi and Delaborde, whose positions can be qualified as academic and connoisseurial, Vernet's rejection of burin engraving in favor of less prestigious and more expedient methods of reproduction, such as aquatint, reflected his penchant for quantity over quality and seemed to indicate a lack of aesthetic discernment; his works were "familiar" to the point of banality. In their suspicion of the availability and popularity of Vernet's oeuvre, these nineteenth-century value judgments correspond to Clement Greenberg's twentieth-century denigration of denatured, inauthentic culture, or "kitsch." Greenberg opposed this negative definition of culture with what he viewed as the only authentic and autonomous outpost of "living culture" capable of distancing itself (though not completely separating itself from) capitalist relations of production and the stultifying effects of mass culture and official, academic art: the heroic avant-garde. Within Greenberg's conception of artistic modernism, the avant-garde's steady march toward painterly autonomy and self-referentiality began in the 1850s with the emergence of artists and writers such as Gustave Courbet and Charles Baudelaire, both of whom positioned their practices in opposition to dominant, bourgeois culture.[6]

As T. J. Clark has argued, Courbet addressed his art not to the Parisian bourgeoisie or connoisseurs "but to a different, hidden public," the people. It was partly through adopting the conventions associated with popular print culture that Courbet was able (albeit briefly and fleetingly) to speak to his target audience in a language that resonated with their experience of the visual.[7] Within art history, the path staked out by Courbet remains noble, visionary, and worthy of emulation. Vernet's embrace of officialdom and cultivation of a broad public through inexpensive reproductions of his works (which decorated the walls of brothels, students' hovels and village cottages, according to Baudelaire) would seem to have no place within this kind narrative, if for the obvious reasons that Vernet did not share Courbet's committed politics or his insurgent approach to the (theoretical and formal) practice of painting.[8] But given the proliferation of Vernet's prints and his status as a "national artist," is it not possible that the publics for both artists may have, on occasion, also overlapped? In his "Notes on Deconstructing 'the Popular,'" cultural theorist and sociologist of popular culture Stuart Hall argued against the possibility of making clear distinctions between dominant, commercial-bourgeois culture, epitomized by someone like Vernet, and more oppositional, insurrectionary, and popular modes, such as Courbet's. "The danger," Hall warned, "arises

because we tend to think of cultural forms as whole and coherent: either wholly corrupt or wholly authentic." He argued that "tensions and oppositions" determine what belongs to one category or another, in a process that he likened to a "cultural escalator" of continuous reorganization.[9] In this book, I have attempted to articulate how such a process played out for a domain of imagery that operated on a shifting terrain of cultural prestige, located at various moments between official, commercial, and "popular" culture. What would it mean for art history to take into account the set of overlaps between what have been viewed as diametrically different publics, as one of the conditions of nineteenth-century visual experience and modernity more generally? Rather than placing different nineteenth-century practices in a hierarchy, where one is a "living art" (to invoke Courbet's own terms) and the other a degraded, official, or "dead" art, it is more productive to think of them as two crucial elements of what Abigail Solomon-Godeau has called the "active dialectical process" that modernism required to form its identity.[10]

While Vernet's oeuvre and most of the art that I have examined in this book constitutes the low term in modernist accounts, its status as a reproducible art is more easily accommodated within the idea of visual modernity as articulated by Walter Benjamin in "The Work of Art in the Ages of Its Technological Reproducibility." For Benjamin, lithography, photography, and film led to a withering of the "aura" of the original work of art, which in turn produced the conditions for the destruction of aesthetic traditions and hierarchies premised upon reverence for original art objects. Vernet became one of the most reviled and celebrated artists of the nineteenth century because he harnessed available technologies of visual reproduction to redefine the standards of battle painting. He set an important precedent for future developments in the production and circulation of military images in terms of their availability to the public as inexpensive, accessible, and reproducible objects. But Benjamin's argument extended beyond identifying the importance of mechanical reproduction as the new condition of artistic production and as a leveler of aesthetic hierarchies. Benjamin, a German Jew writing in exile from the Nazis, understood firsthand the dangerous effects of mass media in the hands of modern dictators, which he sought to counter with his own redemptive and progressive theory of reproducibility. Far from a polemic for or against photomechanical images, Benjamin's essay famously argued

that industrialized image production would result in new conditions of politicized spectatorship ("a different kind of participation," he wrote) that held the dialectical promise of emancipation as well as fascism.[11]

The kinds of war pictures produced by Vernet and his contemporaries fit awkwardly, if at all, within Benjamin's paradigm of a radical politics for works of art and its publics. I have hoped to show here that these images did not carry with them a stable set of politics, but instead offered viewers an invitation to stake out their position to politics by coming into contact with and relating to images of war. Viewers for war pictures may remain stubbornly abstract for the historian, but they are a far cry from the "masses" represented in Walter Benjamin's theories of mechanical reproducibility, who he likened to "a matrix," and who are formed (and arguably flattened) as political subjects by mass culture, even if they are also potentially emancipated by it. Audiences evaluated these pictures in ways that they saw fit and according to their own desires, hopes, and experiences, even though works like Vernet's could be labeled as propaganda in support of state power and of French nationalism more generally. Neither state patronage nor popular adoration implied a stable set of political commitments. The political effects of war pictures were not monolithic: they suggest the possibility of a more contingent set of "politics" for this body of work, not necessarily determined by the desires of government authority. War pictures were available across a range of different areas of cultural production, which provided a variety of opportunities for viewing in different contexts, whether in the space of the Salon exhibition, on the newspaper page, or in the window of a print shop, to name just a few. The popularity of war imagery might be best understood as evidence of a desire, on the part of a broad French public, to participate in a form of unofficial political discourse related to the exercise of state power. In this sense, it is best to think of war pictures as a proving ground from which politics might emerge. The consistently reliable feature of nineteenth-century war imagery was neither its political message (if it can even be said to have one), nor its relative veracity, but rather its desirability for viewers, who encountered it in a diverse array of spaces that were sometimes outside of direct government control. The pages of illustrated newspapers, the viewing platforms of panoramas, and the domestic space of the home are a few examples of these kinds of locales. Artists also adopted formal strategies to cater to audiences who were attracted

to war pictures as a form of knowledge about how modern warfare operated; hence battle painters developed a predilection for including seemingly random, mundane details within their works, which were often absent the clear center of action found in a classically composed history painting. Such a strategy on the part of an artist such as Louis-François Lejeune, for example, opened up new kinds of viewing experiences in which identifying the authenticity of the depicted scene was understood as a conduit for experience by proxy and initiated a dialogue with the knowing, informed viewer.

A corollary to this idea is that the subject matter and relative abundance of war imagery also expanded opportunities to participate in the practices associated with knowing and viewing works of art. By boldly declaring Vernet the "absolute antithesis of an artist" in his "Salon of 1846," and labeling his battle paintings prosaic, facile, and made for the masses, Baudelaire proposed that such works risked not being art at all. Indeed, in the same piece of criticism, Baudelaire launched his assault on Vernet's *Victory of Isly* by cataloging the list of mundane objects of war that the artist had taken pains to represent in great, oppressive detail: the copper on a weapon, the correct number of buttons on a uniform, the wear and tear on a soldier's shoe. Baudelaire intended this list of objects to indict Vernet's lack of imagination and denounce his art as a mindless replication of the real. Yet this description also has the effect of positioning Vernet's battle painting and the objects within it as articles of "ordinary life," a term that Jacques Rancière has used to describe the mundane objects that might be contained in a nineteenth-century curiosity shop, the sort of shop that could have inhabited one of Walter Benjamin's decaying arcades. A seemingly uninteresting object that is not given the honors of being immediately understood as art may in fact hold the promise of becoming "a poetic object, a fabric of hieroglyphs, ciphering a history." In these "showrooms of Romanticism . . . the prose of everyday life becomes a huge fantastic poem." Rancière thus laid out the terms through which unremarkable commodities could

nevertheless produce an "aesthetic experience" for viewers. In his focus on out-of-fashion cultural objects as relics of the past, with a poetic-historical value in inverse proportion to their use value, Rancière celebrated the lowliest forms of nineteenth-century visual and material culture. Indeed, for nineteenth-century viewers the "aesthetic experience" of a battle painting such as Vernet's, Yvon's, or Langlois's often revolved around the picturing of precisely these types of mundane materials of everyday (military) life and the multiplication of these paintings into still more common, prosaic reproductions. While this book has attempted to point out the prominence of war pictures in the nineteenth century, it has not been my aim to argue that they were necessarily exceptional. War pictures were one of the most common forms of imagery of the period, in perpetual circulation across an abundance of visual forms. Despite the fact that Salon criticism of battle paintings and reviews of Langlois's panoramas may have made it appear that pictures of war were extraordinary visual forms, in terms of circulation and relative abundance, they were everywhere, endemic even. These battle panoramas were not preserved because they were a common (bourgeois) form of nineteenth-century experience characterized by ephemerality and novelty, not the sort of material that normally comprises museum collections. Looking back from the vantage point of the early twenty-first century, nineteenth-century war imagery (especially in reproduction) risks appearing as a curious historical relic, something that would have fit right on the shelves of Rancière's curiosity shop, or lined the walls of an outmoded petit-bourgeois interior in one of Atget's photographs. The goal of this book has not been to rehabilitate the careers of art-historically marginal figures such as Louis-François Lejeune, Horace Vernet, Jean-Charles Langlois, and Henri Durand-Brager. Rather, it has been my intention to show that art history has much to gain by examining parts of visual culture that most accounts of the development of modern art may have deemed below the threshold for investigation.[12]

Notes

INTRODUCTION

1. "Le passage des objets réels du premier plan aux objets peints sur la toile circulaire est vraiment inappréciable, même aux yeux les plus attentifs et les plus prévenus." Théophile Gautier, "Le Panorama des Champs-Élysées," *La Presse*, 29 June 1843, 2. For more on *The Panorama of the Battle of Eylau*, see Musée des Beaux-Arts de Caen, *Jean-Charles Langlois, 1789–1870: Le Spectacle de l'histoire* (Paris: Somogy, 2005), 109–118. For more on Langlois's illusionism see Maurice Samuels, *The Spectacular Past: Popular History and the Novel in Nineteenth-Century France* (Ithaca, N.Y.: Cornell University Press, 2004), 51–55.

2. The definition of mass culture is notoriously ambiguous. Vanessa Schwartz has characterized it as "mass production by industrial techniques and consumption by most people, most of the time." See Schwartz, *Spectacular Realities: Early Mass Culture in Fin-de-Siècle Paris* (Berkeley: University of California Press, 1997), 7–8. Scholars of French cultural history, including Schwartz, have pointed to the 1890s as the period of mass culture's emergence through industrialized technologies of visual reproduction, such as the halftone and the penny press. In *La Culture de masse en France* (Paris: Éditions la Découverte, 2001), Dominique Kalifa also sees the 1890s as a watershed decade for mass-cultural forms.

3. Jurgen Osterhammel uses the term "communicative spaces" to describe the sociability engendered by newspapers; he argues that newspapers allowed for a "new level of society's reflection of itself." See Osterhammel, *The Transformation of the World: A Global History of the Nineteenth Century* (Princeton, N.J.: Princeton University Press, 2014), 29, 30. I take the term "community" from Benedict Anderson, who emphasizes the importance of forms of culture in producing the set of beliefs upon which nationalism takes shape. See Anderson, *Imagined Communities* (London: Verso, 2002).

4. Stephen Bann has defined visual economy as the "sum total of all the means of visual reproduction available at the time, taking into account not only the specific processes of production, their cost, and their duration, but also the available means of publication and dissemination." See Bann, *Distinguished Images: Prints in the Visual Economy in Nineteenth-Century France* (New Haven: Yale University Press, 2013), 19.

5. Previous studies of nineteenth-century representations of war have emphasized the production of canonical works of art, most notably the large-scale history paintings made by Jacques-Louis David and his students under the patronage of Napoleon Bonaparte. Christopher Prendergast's examination of Napoleonic painting, *Napoleon and History Painting: Antoine-Jean Gros's La Bataille d'Eylau* (Oxford, England: Clarendon, 1997), is an example of this tendency. The majority of inquiries focus on individual artists or on specific conflicts. See David O'Brien, *After the Revolution: Antoine-Jean Gros, Painting and Propaganda under Napoleon* (University Park: Pennsylvania State University Press, 2006); Nina Anathanassoglou-Kallmyer, *French Images from the Greek War of Independence, 1821–1830: Art and Politics under the Restoration* (New Haven: Yale University Press, 1989); Hollis Clayson's study of Paris during the Franco-Prussian War, *Paris in Despair: Art and Everyday Life under Siege,* *1870–71* (Chicago: University of Chicago Press, 2002); and Ulrich Keller's *Ultimate Spectacle: A Visual History of the Crimean War* (New York: Routledge, 2001).

6. "Aussi, quel immense public et quelle joie! Autant de publics qu'il faut de métiers différents pour fabriquer des habits, des shakos, des sabres, des fusils et des canons ! Et toutes ces corporations réunies devant un Horace Vernet par l'amour commun de la gloire! Quel spectacle!" Charles Baudelaire, *Curiosités esthétiques: L'Art romantique et autres oeuvres critiques* (Paris: Garnier Frères, 1962), 166.

7. Guy Debord, *The Society of the Spectacle,* trans. Donald Nicholson-Smith (New York: Zone, 1995); Theodor Adorno and Max Horkheimer, "The Concept of Enlightenment" and "The Culture Industry: Enlightenment as Mass Deception," in *Dialectic of Enlightenment* (London: Verso, 1997), 3–42.

8. Jacques Rancière, *The Politics of Aesthetics: The Distribution of the Sensible,* trans. Gabriel Rockhill (London: Continuum, 2004), 13.

9. Ibid., 12–19. See also Yves Citton, "Political Agency and the Ambivalence of the Sensible," in *Jacques Rancière: History, Politics, Aesthetics,* ed. Gabriel Rockhill and Philip Watts (Durham, N.C.: Duke University Press, 2009), 123.

10. Rancière, *Politics of Aesthetics,* 21. Jonathan Crary has also argued against the isolation of visual forms from each other. See Crary, *Techniques of the Observer: On Vision and Modernity in the Nineteenth Century* (Cambridge, Mass.: MIT Press, 1990), 23. My study also follows the path set by Stephen Bann in his groundbreaking *Parallel Lines,* in which an entire chapter is devoted to the intermedial "troc" of early

nineteenth-century French war imagery. See Bann, *Parallel Lines: Printmakers, Painters, and Photographers in Nineteenth-Century France* (New Haven: Yale University Press, 2001), 43–87, 211. Lynn Hunt has suggested that studying the proliferation of prints is one way to interrogate the ways in which society "became increasingly visible as an object as the gap grew between customary social experience and new political expectations."

11. See Hunt, "The Experience of Revolution," *French Historical Studies* 32, no. 4 (Fall 2009): 677.

CHAPTER 1. VISUAL PARTICIPATION BY PROXY IN THE REVOLUTIONARY AND NAPOLEONIC WARS

1. The maps pictured in Monsaldy's print are likely the *Carte de la France divisée en 103 départements et les pays conquis en-déca du Rhin* and the *Carte politique de l'Europe.* See *Journal général de la littérature de France,* Fructidor an VII (1799), 285.

2. Lucien Febvre, "Frontière: The Word and the Concept," in *A New Kind of History: From the Writings of Febvre,* ed. Peter Burke, trans. K. Folca (London: Routledge and Kegan Paul, 1973), 212.

3. Chenxi Tang, *The Geographic Imagination of Modernity: Geography, Literature, and Philosophy in German Romanticism* (Stanford, Calif.: Stanford University Press, 2008), 139.

4. Molly Nesbit, "Photography and History: Eugène Atget," in *A New History of Photography,* ed. Michel Frizot (Cologne: Könemann, 1998), 402–403; Molly Nesbit, *Atget's Seven Albums* (New Haven: Yale University Press, 1992), 16–18. My understanding of Nesbit's arguments has been shaped by Steve Edwards's work on nineteenth-century British photography. See Edwards, *The Making of English Photography: Allegories* (University Park: Pennsylvania State University Press, 2006), 59–62.

5. Carl von Clausewitz, *On War,* trans. Michael Howard and Peter Paret (Princeton, N.J.: Princeton University Press, 1976), 591–592.

6. François Furet, *Revolutionary France, 1770–1880,* trans. Antonia Nevill (Oxford, England: Blackwell, 1992), 102–103.

7. Susan Siegfried, "Naked History: The Rhetoric of Military Painting in Postrevolutionary France," *Art Bulletin* 75, no. 2 (1993): 235.

8. Keith Michael Baker, *The Old Regime and the French Revolution,* ed. John W. Boyer, Keith Michael Baker, and Julius Kirshner, University of Chicago Readings in Western Civilization (Chicago: University of Chicago Press, 1987), 340–341.

9. For background on the French revolutionary army, see S. P. MacKenzie, *Revolutionary Armies in the Modern Era: A Revisionist Approach* (London: Routledge, 1997), 34–49; and Paddy Griffith, *The Art of War of Revolutionary France, 1789–1802* (London: Greenhill, 1998), 39–62. For a rich account of the problem of desertion during the period, see Alan Forrest, *Conscripts and Deserters: The Army and French Society during the Revolution and Empire* (New York: Oxford University Press, 1989).

10. David Bell, *The First Total War: Napoleon's Europe and the Birth of Warfare as We Know It* (New York: Houghton Mifflin, 2007), 191.

11. Christy Pichichero, "Moralizing War: Military Enlightenment in Eighteenth-Century France," in *France and Its Spaces of War: Experience, Memory, Image,* ed. Patricia M. E. Lorcin and Daniel Brewer (New York: Palgrave Macmillan, 2009), 13–18.

12. André Félibien, *Conférences de l'Académie royale de peinture et sculpture* (London: David Mortier, 1705), 16. There is debate among military historians over whether the eighteenth century really did constitute an "era of limited warfare." In his global history of early modern warfare *European Warfare in a Global Context, 1660–1815* (New York: Routledge, 2007), Jeremy Black called this idea a "cliché" (65). David Bell, on the other hand, advances the thesis of limited warfare in the eighteenth century, which he contrasts with the "era of total warfare" of the French Revolution and Napoleonic Wars. See Bell, *First Total War,* 32–51. See also Aaron Wile, *Watteau's Soldiers: Scenes of Military Life in Eighteenth-Century France* (New York: D. Giles and The Frick, 2016).

13. There were some notable exceptions to this tendency, such as Jean-Antoine Watteau's paintings of military retreats and soldiers. See Julie Anne Plax, "Gloire Surrenders: Watteau's Military Paintings," in *Conflicting Visions: War and Visual Culture in Britain and France, c. 1700–1830,* ed. John Bonehill and Geoff Quilley (London: Ashgate, 2005), 15–40.

14. Julie-Anne Plax, "Battling for Representation: Ideology and Military Images," *Quaderno* 6 (September 2015): 207–208.

15. Robert Wellington has argued that the mapping technology of chorography appears in many of Van der Meulen's battle paintings. See Wellington, "The Cartographic Origins of Adam Frans van der Meulen's Marly Cycle," *Print Quarterly* 27 (June 2011): 142–154.

16. Frédéric Lacaille, "Les Grands: La Peinture et la guerre, galeries et grands ensembles consacrés à la représentation de la guerre en France aux xviie et xviie siècles," in *L'Art de la guerre: La Vision des peintres aux xviie et xviiie siècles* (Paris: Centre d'Etudes d'Histoire de la Défense, 1997), 108–112. For more on Van der Meulen, see Isabelle Richefort, *Adam-François van der Meulen, 1632–1690: Peintre flamand au service de Louis XIV* (Rennes, France: Presses Universitaires, 2004).

17. William Olander, "Pour transmettre à la postérité: French Painting and Revolution, 1774–1795" (PhD diss., New York University, 1983), 90.

18. "Aujourd'hui a été remportée la première victoire, en bataille rangée, par les soldats de la liberté. Le souverain, le peuple, doit à l'instant même être instruit de ce succès." *Moniteur universel,* 11 November 1792; reproduced in *Réimpression de l'ancien moniteur* 14, no. 316 (Brussels: Librairie Belge-Française, 1840), 438.

19. "Toutes trois ont l'autorisation des généraux et des principaux officiers de l'armée Il serait peut-être publié d'autres plans de cette célèbre journée, mais ils ne peuvent [pas] avoir le même degré d'authenticité. Les jeunes artistes dont ceux-ci sont l'ouvrage se sont efforcés de mettre dans leur dessin la chaleur dont ils furent animés sur le champ de bataille, jointe à la plus exacte vérité." "Arts: Gravures," *Gazette nationale ou le moniteur universel,* 20 January 1793, 224.

20. Mary Sponberg Pedley, "The Commerce of Maps," in *Atlas militaires manuscrits européens, XVIe–XVIIIe siècles: Forme, contenu, contexte de réalisation et vocations; Actes des 4es journées d'étude du Musée des plans-reliefs,* ed. Isabelle Warmoes, Emilie d'Orgeix, and Charles van den Heuvel (Paris: Musée des Plans et Reliefs, 2003), 23.

21. Matthew Edny, *"Mapping an Empire: The Geographical Construction of British India, 1765–1843* (Chicago: University of Chicago Press, 1997), 52.

22. Lorraine Daston, "Objectivity and the Escape from Perspective," *Social Studies of Science* 22 (November 1992): 599–600. See also Edwards, *Making of English Photography,* 44–46.

23. Rory Muir, *Tactics and the Experience of Battle in the Age of Napoleon* (New Haven: Yale University Press, 1998), 24–25.

24. Roland Barthes, "The Reality Effect," in *The Rustle of Language,* trans. Richard Howard (New York: Hill and Wang, 1986), 148.

25. *Encyclopédie, ou dictionnaire universel raisonné des connoissances humaines* (1774), ed. Denis Diderot, Fortunato Bartolomeo De

Felice, and Jean Le Rond d'Alembert, s.v. "Témoin."

26. "Le but des éditeurs est de transporter pour ainsi dire le lecteur sur les lieux même, et de le rendre témoin oculaire des événements." *Journal typographique et bibliographique*, 30 Brumaire, An 11 (21 November 1802), 64.

27. "Lettre sur les géographes gobes-mouches," *Journal de l'empire*, 3 August 1812. For an in-depth discussion of Boilly's painting, see Alfred Boime, "Louis Boilly's Reading of the XIth and XIIth Bulletins of the Grande Armée," *Zeitschrift fur Kunstgeschicte* 59 (1991): 374–387.

28. Conrad Malte-Brun, "Variétés: Carte de la méditerranée et de la mer noire par M. Lapie, capitaine ingénieur-géographe," *Journal de l'Empire*, 7 January 1809, 3.

29. *Journal général de la littérature de France, ou Répertoire méthodique*, no. 2 (1806): 299. With the average salary for a worker around 9 francs per month, even inexpensive maps such as this one would have been an unaffordable luxury. See Claire-Elisabeth-Jeanne Gravier de Vergennes Rémusat, "Le Coût de la vie sous le premier Empire," in *Mémoires de Mme de Rémusat*, ed. Charles Kunstler (Paris: Hachette, 1957), 359.

30. Susan Sontag, *Regarding the Pain of Others* (New York: Farrar, Straus and Giroux, 2003), 21.

31. Lloyd A. Brown, *The Story of Maps* (Mineola, N.Y.: Dover, 1979), 255.

32. It was then guarded as a state secret, transferred to the Dépôt de la Guerre, and not published until 1815. See William Ravenhill, "The Honourable Robert Edward Clifford, 1767–1817: A Cartographer's Response to Napoleon," *Geographical Journal* 160, no. 2 (July 1994): 162–163.

33. I use the French *vue* to characterize this particular form of battlefield landscape, which was prevalent during the First Empire. The English *view* lacks the specificity connoted by the French term. The *ingénieurs-géographes* were created under Louis XIV 1696, but were not part of the military until 1769. In 1791 their ranks were dissolved, but they were reinstated in 1793 without military rank, under the pressure of war and the need to produce maps. In 1809 Bonaparte passed an official decree that once again made the *ingénieurs-géographes* part of the army.

34. Anne Godlewska, "Napoleon's Geographers, 1797–1815: Imperialists and Soldiers of Modernity," in *Geography and Empire* (Oxford, England: Blackwell, 1994), 32. Godlewska's important article argues that the *ingénieurs-géographes* were instrumental

in the development of France as a modern, nationalized state. The connection between surveying and state power has also been made with respect to eighteenth-century French imperialism. See Jennifer Palmer, "Atlantic Crossings: Race, Gender, and the Construction of Families in Eighteenth-Century La Rochelle" (PhD diss., University of Michigan, 2008), 32–75.

35. John Lynn, "Nations in Arms, 1763–1815," in *Cambridge History of Warfare*, ed. Geoffrey Parker (Cambridge: Cambridge University Press, 2005), 200–202. Godlewska, "Napoleon's Geographers," 34–35.

36. "J'apprends avec plaisir que vous avez trouvé un nombre tres considérable de graveurs de paysages. Je n'oppose formellement à ce que vous preniez des graveurs de cartes, pour les livrer à un autre genre. Il nous faut d'abord les cartes, les paysages n'étant qu'accessoire. Je vous répète, mon cher Muriel, accaparés tous les graveurs que vous pouvez, bons et médiocres. . . . Voila ce qui donnera de la représentation au Dépôt de la guerre, par l'utilité qu'en retira le gouvernement ainsi que les militaires. Sur tout point de luxe dans la gravure, et que l'on fasse vite, afin qu'on en puisse jouir le plutôt." Nicolas Sanson, general director of the Dépôt de la Guerre, to Colonel Muriel, adjoint director, 1807, *Correspondance de M. le colonel Muriel, directeur adjoint du dépôt de la guerre*, 3M 247, Service Historique de l'Armée de Terre, Vincennes, France.

37. Josef Konvitz, *Cartography in France, 1660–1848: Science, Engineering, and Statecraft* (Chicago: University of Chicago Press, 1987), 99–101. As a further obstacle to wide public dissemination of maps, many were considered confidential state secrets. Such was the case with the cartographic survey of Egypt undertaken during Napoleon's ill-fated invasion of the country but not published until the 1830s. For more on the cartographic survey of Egypt, see Anne Godlewska, *The Napoleonic Survey of Egypt: A Masterpiece of Cartographic Compilation and Early Nineteenth-Century Fieldwork* (Toronto: University of Toronto Press, 1988).

38. For a discussion of the early years of the panorama, see Bernard Comment, *The Panorama*, trans. Anne-Marie Glasheen (London: Reaktion, 1999), 7–22. For the early history of panoramas in France, see Stephan Oettermann, *The Panorama: History of a Mass Medium* (New York: Zone, 1997), 5–48; and François Robichon, "Les Panoramas en France au XIXe siècle" (diss., Université de Paris X, 1982).

39. See, for example, *L'Abeille du nord*, 27

October 1807.

40. Robert Lefebvre, "Étude sur le cabinet topographique de l'empereur Napoléon Ier," *Le Spectateur militaire* 6, no. 33 (November 1853): 239–242. Bacler d'Albe, in a letter to Général Sanson, demanded the original hand-drawn reconnaissance maps, noting that the emperor "conçoit parfaitement que la mesure de tout copier est fort bonne en temps de paix ; mas la rapidité des ses marches ne lui pas permet d'attendre" ("understands perfectly that the task of copying everything is fine and well in peacetime, but that the rapid pace of his marches does not permit him to wait"). See also Anne Godlewska, "The Troubled History of the Survey of Italy," in *An Atlas of Napoleonic Cartography in Italy*, http://www.geog.queensu.ca/napoleonatlas/main_page.htm; and Colonel Berthaut, *Les Ingénieurs-géographes militaires, 1624–1831: Etude historique* (Paris: Imprimerie du Service Géographique, 1902), 2:246–247.

41. "Cette estampe est gravée avec beaucoup de soin, et a un grand effet; le tableau original joint le mérite assez rare d'une exactitude précieuse de style et de détail, à celui d'une composition riche et savante. Dessiné sur le champ de bataille même, par un homme à la fois artiste et militaire, on y voit partout la touche d'un témoin oculaire." "Gravures," *Journal général de la littérature étrangère*, no. 9, Fructidor, An VIII (1800): 287.

42. Richard Shiff, "Phototropism (Figuring the Proper)," in *Retaining the Original: Multiple Originals, Copies, and Reproductions*, Studies in the History of Art 20 (Washington, D.C.: National Gallery of Art, 1989), 161.

43. As Susan Siegfried has argued, the Battle of Nazareth competition set a precedent in terms of awkwardly merging two different genres of French academic painting that traditionally been understood as separate from one another. See Siegfried, "Naked History," 146–151.

44. O'Brien, *After the Revolution*, 54.

45. Ibid., 68.

46. Siegfried, "Naked History," 243.

47. Pierre-Henri de Valenciennes, *Élémens de perspective pratique: À l'usage des artistes* (Paris: Duprat, 1800), 515.

48. See the letters written by Louis-François Lejeune to Alexandre Berthier, 2 Pluviôse, An 8 (1800), and 3 Frimaire, An 9 (1801), Dossier Lejeune, Service Historique de l'Armée de Terre, Vincennes, France, 8YD1417. For more on Lejeune's life and career, see Valérie Bajou, ed., *Les Guerres de Napoléon: Louis-François Lejeune, général et peintre* (Paris: Hazan, 2012).

49. *Arlequin au Muséum; ou, Critique en vaude-ville des tableaux exposés au Salon* (Paris: Brasseur Aîné, 1806), 23; Pierre Jean-Baptiste Chaussard, *Le Pausanias français; ou, Description du Salon de 1806* (Paris: Demonville, 1806), 215.

50. Antoine Quatremère de Quincy, *Essai sur la nature, le but et les moyens de l'imitation dans les beaux-arts* (Paris: Treuttel & Wurtz, 1823), 220.

51. Prendergast, *Napoleon and History Painting*, 69–71.

52. "Lors donc que le peintre d'*histoire*, ainsi appelé, par distinction de celui que l'on nomme de *genre*, prétend aujourd'hui nous représenter une bataille; comme c'est moins son action physique, que son résultat définitif, qu'il lui est possible d'exprimer, il doit avoir recours à quelqu'un de ces moyens métaphoriques, ou de *transposition*, qui ne parlent aux yeux, qu'afin de transmettre par eux à l'esprit du spectateur le résultat de l'action, au lieu de l'image impossible de sa réalité." Antoine Quatremère de Quincy, "Notice historique sur la vie et les ouvrages de M. Gros," in *Recueil des notices historiques lues dans les séances de l'Académie royale des beaux-arts à l'Institut* (Paris: A. Leclerc, 1837), 161.

53. "Salon de 1806, 1e article," *Mercure de France,* 27 September 1806, 600.

54. Ibid.

55. F. C., "Lettre sur le Salon de 1806," *Archives littéraires de l'Europe ou mélanges de littérature* 12 (1806): 115. For more on Hennequin and the problem of violence, see Lela Graybill, "The Display of Violence in Philippe-Auguste Hennequin's *The Remorse of Orestes,*" *Art History* 37 (November 2014): 940–959.

56. "Sont moins des compositions pittoresques que la representation exacte de faits d'armes, tels qu'ils sont passes." *Journal de l'Empire,* October 10, 1806.

57. "Il est aisé de reconnaître qu'il a eu les camps pour atelier et les champs de bataille pour modèles." "Le salon de peinture de 1804," Collection Deloynes, Département des Estampes, Bibliothèque Nationale, Paris, vol. 32, no. 900.

58. Michaud, "Louis-François Lejeune," in *Biographie universelle ancienne et moderne* (Paris: Delagrave, 1843), 43. Lejeune's personnel dossier, conserved at the Service Historique de l'Armée de Terre, clearly indicates that Lejeune did not serve in Egypt. Dossier Lejeune, 8Yd1417.

59. Darcy Grigsby, *Extremities: Painting Empire in Postrevolutionary France* (New Haven: Yale University Press, 2002), 81. Grigsby's

emphasis on the fragility and contingency of Bonaparte's authority within Gros's *Jaffa* is part of a recent turn in the scholarship on Napoleonic history painting. Susan Siegfried and Todd Porterfield have advanced a similar line of argument for two important Napoleonic paintings, Ingres's *Napoleon Enthroned* and David's *Le Sacre,* both of which were produced around Bonaparte's coronation in 1804. See Porterfield and Siegfried, *Staging Empire: Napoleon, Ingres, and David* (University Park: Pennsylvania State University Press, 2006).

60. "Heureux citadins pourront jouir du spectacle d'une bataille sans en courir le danger, ou plutôt des enfants, des familles s'enflammeront à la vue des actions de leurs pères et de leurs proches. Ils suivront de l'oeil, pour ainsi dire, tous les pas. . . . Tout y est juste, tout y est vrai ; on assiste à l'Action." Chaussard, *Pausanias français,* 215–216.

61. "C'est ici la représentation exacte de l'objet, c'est à dire la vérité, l'histoire, dont nous devenons alors témoins oculaires." Ibid., 596.

62. "Pour obtenir plus d'espace, l'Artiste a pris son point de vue de fort haut, de manière que d'un regard on embrasse tout l'ensemble: il ne lui échappe pas un Épisode, pas un Détail; tout s'y trouve, et s'y trouve sans confusion ; le Peintre habile s'est rendu un compte exact de tout ; il a parfaitement calculé ses Lignes, ses plans, son Ordonnance, sa composition ; et par-tout une netteté admirable." Ibid., 217.

63. See Linda Nochlin, "The Imaginary Orient," in *The Politics of Vision: Essays on Nineteenth-Century Art and Society* (Oxford, England: Westview, 1989), 33–60; and Edward Said, *Orientalism* (New York: Random House, 1979). As Anne Godlewska points out, "The atlas was based on field surveys carried out through the duration of the expedition wherever and whenever the troops were available to defend the surveyors from the hostility of the Egyptians." Godlewska, *Napoleonic Survey of Egypt,* 3–8. See also Black, *European Warfare,* 200.

64. W. J. T. Mitchell, "Imperial Landscape," in *Landscape and Power* (Chicago: University of Chicago Press, 1994), 17. For more on French orientalist attitudes and their relationship to visual production, see Grigsby, *Extremities;* Todd Porterfield, *The Allure of Empire: Art in the Service of French Imperialism, 1798–1836* (Princeton, N.J.: Princeton University Press, 1998).

65. "Si vous aimez les batailles, vous tâcherez, si vous pouvez, de percer la foule pour voir de plus près et pour ajourer celles de Lodi, du

Mont Thabor, et d'Aboukir par Lejeune." "Exposition au Salon du Louvre, 1804," Collection Deloynes, vol. 36, no. 982.

66. "Quoique cette composition soit d'un genre moins relevé que les deux précédentes, et que par la petitesse des dimensions elle appartienne plutôt au paysage qu'à l'histoire, elle est toujours assiégée d'un grand nombre de spectateurs, qui aiment à contempler à l'abri du danger, un spectacle fait pour frapper toutes les imaginations." C., "Salon de 1806, 1er article," 602.

67. Delasalle, "Suite de l'examen des tableaux," Collection Deloynes, vol. 40, no. 1058, 109–110.

68. "Salon de 1808, No. XI," *Gazette de France,* 1 December 1808, 1334.

69. "Vois-tu, disant un militaire à son camarade, vois-tu à droite cette montagne qui s'élève dans les vues comme un cône tronqué ? C'est le mont tabor . . .; j'y étais, j'y fus blessé, je m'y conduisis bien, Buonaparte le sut et je suis de la légion d'honneur. . . . Je ne me connais pas en peinture mais ce tableau est vrai ; si naturel, les lieux, les maisons sont si bien imitées, qu'il me semble y être encore. Tiens, mon coeur bat comme lorsque j'entendis sonner la charge, et que j'ai eu l'honneur d'être blessé et ce n'était pas de peur qu'il battait alors." "Lettre adressée à Messieurs les rédacteurs du journal des sciences, de littérature, et des arts," Collection Deloynes, vol. 32, no. 888, 385–386.

70. Ibid.

71. Mary Favret has argued that Romantic British poetry written during the Napoleonic Wars served a similar function for English audiences. See Favret, *War at a Distance: Romanticism and the Making of Modern Wartime* (Princeton, N.J.: Princeton University Press, 2009).

72. "Il est des tempêtes non moins terribles que celles de l'Océan, plus funestes encore à l'humanité, plus redoutables pour les arts, et plus dangereuses sur tout pour celui qui les voit de près ; ce sont les scènes désastreuses de la guerre." "Salon de 1808, No. XI."

73. "O guerre, que tu es brillante dans l'histoire! Mais vue de près, que tu deviens hideuse, lorsqu'elle ne cache plus l'horreur des détails." Vivant Denon, *Voyage dans la basse et la haute Egypte, pendant les campagnes du général Bonaparte* (London: M. Peltier, 1802), 157.

74. "29e bulletin de la Grande-Armée," *Mercure de France,* 19 December 1812, 570–573.

75. "On avait publié de simples cartes où des traits en couleur indiquaient la situation de nos corps et la marche de notre armée.

Cette ligne, d'une si effrayante longueur, si mince et si peu appuyée, faisais frémir les plus confiants. On prétendit que la police avait arrêté la vente de cette carte." Victorine de Chastenay, *Deux révolutions pour une seule vie: Mémoires, 1771–1855* (Paris: Bibliothèque d'Evelyne Lever, 2009), 248. "Le lecteur, la carte à la main, suivant l'ordre des dates et les marches des corps, soit toujours obligé, avec son épingle, de placer le quartier-général français quelques lieues en avant de la place où les Russes ont écrasé notre armée. Cette guerre confond ainsi toutes les notions acquises jusqu'à ce jour sur le but, les principes et les résultats des combinaisons militaires: les Russes ayant constamment est complètement battu les Français sur tous les points d'attaque." "Politique," *Mercure de France,* 19 September, 1812, 568–569.

76. *"Journal de Paris,* 11 May 1814, 3. The print was publicized in newspapers during Bonaparte's first exile.

77. "L'empereur et le régime impérial me fatiguaient journellement. Les habitudes d'adulation que les gens de lettres et les artistes avaient contractées m'étaient antipathiques. Peu à peu je perdis courage, et je renonçai en quelque sorte à l'exercice de mon art, la peinture." Etienne-Jean Delécluze, *Journal de Delécluze, 1824–1828,* ed. Robert Baschet (Paris: Éditions Bernard Grasset, 1948), 373, 374. "Dans l'idée de réformer mes études qui avaient été dirigées vers l'antiquité, pour leur donner un vernis plus moderne."

78. Xavier Salmon, *Trésors cachés, chefs-d'oeuvre du cabinet d'arts graphiques du chateau de Versailles* (Paris: Somogy, 2001), 116–117.

79. "Le 17 février, de deux à trois heures, les blessés de la garde impériale française, dont une partie avait pris part à l'affaire de Montmirail, firent leur entrée à Paris et suivirent les boulevards, se dirigeant vers l'hôtel des Invalides. . . . Une mère soutient son fils, soldat de la jeune garde, qui est reconnu par son chien. Derrière, un jeune garçon, tirant par la bride un cheval boiteux sur lequel est un grenadier à cheval, dont la tête est enveloppée d'un linge ensanglanté… Au-delà de ce triste et imposant cortège, au fond du tableau, sont des curieux à pied et en voiture, émus par un spectacle si différent de celui gai et joyeux qu'on avait coutume de voir chaque année à pareil jour." Salmon, *Trésors cachés,* 117. For the incident of the faithful dog, see Homer, *The Odyssey,* trans. George Herbert Palmer (New York: Houghton Mifflin, 1921), 266–267.

80. "La peinture n'était plus qu'un art complaisant, prêt à aider les nouveaux venus, comme il avait servi à soutenir celui qui venait de tomber." Delécluze, *Journal,* 374.

CHAPTER 2. A CROWD FAVORITE

1. "L'auteur a transporté dans ce paysage, l'événement qui lui est arrivé le 5 avril 1811, lorsqu'il fut attaqué par huit cents hommes des Guérillas de don Juan Médico." *Les Catalogues des Salons des Beaux-Arts I, 1801–1819,* ed. Pierre Sanchez and Xavier Seydoux (Paris: Échelle de Jacob, 1999), 288.

2. "Nous nous aperçûmes que la foule un peu moins grande, autour du *Monastère de Guisando,* nous permettait d'en approcher." Étienne Jouy, "Beaux-arts," *Mercure de France,* 17 May 1817, 354. "Hier au salon, d'assez vives querelles se sont élevées parmi les curieux qui se pressent pour voir le tableau de M. le général Lejeune, représentant une scène de guérillas. Il serait à désirer que pour prévenir le retour le ces scènes désagréables, le tableau dont on n'approche que difficilement fut placé plus haut." *Le Constitutionnel,* 6 May 1817, 2.

3. For an account of the representation of official Bourbon military subjects in Paris theaters, see Olivier Bara, "Dramaturgies de la souveraineté: Entrées royales et pièces de circonstance sous la Restauration," in *Imaginaire et représentations des entrées royales au XIXe siècle: Une Sémiologie du pouvoir politique,* ed. Corinne Perrin-Saminadayar and Eric Perrin-Saminadayar (Saint-Étienne, France: Université de Saint-Étienne, 2006), 41–60.

4. Sheryl Kroen, *Politics and Theater: The Crisis of Legitimacy in Restoration France, 1815–1830* (Berkeley: University of California Press, 2000), 57. As Kroen argues, this policy was "effacement not only from the public landscape but from the very memory of the population of any alternatives to legitimate monarchy." Sudhir Hazareesingh's study of police archives in Restoration-era France has shown that censorship was especially active during the first years of Bourbon rule. See Hazareesingh, *The Legend of Napoleon* (London: Granta, 2004), 72–98. Despite the high profile of Napoleonic military imagery during the Restoration, the tendency in art history has been to view the period in terms of a decline of these representations in French visual culture. As Léon Rosenthal asserted in his classic study of the period, *Du Romantisme au réalisme : Essai sur l'évolution de la peinture en France de 1830 à 1848* (Paris: Macula, 1987), "The Restoration did not nourish military painting and more or less eliminated subjects pertaining to

national contemporary history" (79). For the uneven censorship of Napoleonic military subjects, see Robert Justin Goldstein, *Censorship of Political Caricature in Nineteenth-Century France* (Kent, Ohio: Kent State University Press, 1989); George McKee, "La Surveillance officielle de l'estampe entre 1810 et 1830: Le Dépôt légal, la *Bibliographie de la France,* le projet *Image of France* et leurs statistiques," *Nouvelles de l'estampe* 188 (May–June 2003): 22–35. Despite official prohibitions, Nicolas-Toussaint Charlet earned a reputation for his lithographs of Napoleonic military subjects during the Restoration. For more on Charlet, see *The Hero at Home in France: Lithographs by Nicolas-Toussaint Charlet, 1792–1845,* ed. Tom Gretton (London: University College, London, 2004). For more on lithographs of Napoleonic veterans during the Bourbon Restoration, see Nina Athanassaglou-Kallmyer, "Sad Cincinnatus: Le *Soldat-Laboureur* as an Image of the Napoleonic Veteran after the Empire," *Arts Magazine,* May 1986, 65–75. See also Barbara Ann Day-Hickman, *Napoleonic Art: Nationalism and the Spirit of Rebellion in France, 1815–1848* (Newark: University of Delaware Press, 1999).

5. Toussaint-Bernard Émeric-David, "Beaux-arts, Salon, Sixième Article," *Le Moniteur universel,* 6 June 1817, 619–620; Valérie Bajou, "Captivités," in *Les Guerres de Napoléon,* 172; Louis-François Lejeune, *Souvenirs d'un officier de l'Empire* (Toulouse: Typographie Viguier, 1851), 187–196.

6. Delécluze devoted several pages to Lejeune's *Salinas* in his review of the Salon of 1819 and was one of many critics who incorrectly assumed that the artist had witnessed the attack. Etienne-Jean Delécluze, "Beaux-arts, onzième lettre," *Lycée français ou mélanges de littérature et de critique* 3 (1820): 134; *Louis-François Lejeune: Memoirs of Baron Lejeune Aide-de-Camp to Marshals Berthier, Davout, and Oudinot* (New York: Longmans, Green, 1897), 2:146. On 26 May 1812, the day after the Salinas convoy attack took place, Lejeune arrived in Posen, Poland; "Premier aperçu sur le Salon de 1819," *Le Constitutionnel,* 27 August 1819, 4; Auguste Jal, *L'Ombre de Diderot et le bossu du Marais: Dialogue critique sur le Salon de 1819* (Paris: Corréard, 1819), 169. For more on the role of *vivandières* in the French military, see Thomas Cardoza, " 'Habits Appropriate to Her Sex': The Female Military Experience in France during the Age of Revolution," in *Gender, War and Politics: Transatlantic Perspectives, 1775–1830,* ed. Karen Hagemann,

Gisela Mettele, and Jane Rendall (New York: Palgrave Macmillan, 2010), 188–205.

7. C. P. Landon, *Annales du musée et de l'école moderne des beaux-arts* (Paris: Imprimerie de Chaignieau, 1817), 85.

8. For more on Vernet's close ties to Forbin, see Marie-Claude Chaudonneret, "Horace Vernet and the Conquest of Public Opinion," in *Horace Vernet and the Thresholds of Nineteenth-Century Visual Culture*, ed. Daniel Harkett and Katie Hornstein (Hanover, N.H.: University Press of New England, 2017), 46–51.

9. On 26 June 1826, Vernet was elected to the Académie des Beaux-Arts on the third *tour de scrutin*. On 15 July, King Charles X approved his election. See Jean-Michel Leniaud, Béatrice Bouvier, and François Fossier, eds., *Procès-verbaux de l'Académie des beaux-arts*, vol. 3 (Paris: École des Chartes, 2005), 31–32.

10. Some of these paintings included *The Death of Poniatowski* (1817), *A French Grenadier on the Battlefield* (1819), *The Battle of Montmirail* (1824), *Peace and War* (fig. 58), *The Crossing of the Arcole Bridge* (fig. 59), and *Portrait of General Foy* (1827). See Sanchez and Seydoux, *Catalogues des salons des beaux-arts*; Claudine Renaudeau, "Horace Vernet, 1789–1863: Catalogue raisonné de l'oeuvre peint" (PhD diss., Université de Paris IV, 1999).

11. "Peintres de batailles," *Journal des artistes*, 1827, 196.

12. See, for example, "Sur quelques tableaux du Salon," *L'ami de la religion et du roi, journal ecclésiastique, politique, et littéraire*, 10 November 1819, 415.

13. "S'il eût fallu rendre compte des ouvrages du Salon dans l'ordre de la curiosité qu'ils excitent, celui-là eût été jugé sans contredit le premier. Toutefois, ce concours renaissant de spectateurs indique moins la perfection d'une peinture que l'intérêt de son sujet. Cet intérêt est ici du genre qui produit les impressions fortes, et est en possession de charmer la foule." "Salon de 1817," *Le Constitutionnel*, 13 May 1817, 4.

14. Marie-Claude Chaudonneret and Sébastian Allard, *Le Suicide de Gros: Les Peintres de l'Empire et la génération romantique* (Montreuil, France: Gourcuff Gradenigo, 2010), 44–46.

15. "C'est une belle et vaste composition du carnage; mais du moins on peut regarder celle-là sans avoir la crainte d'y reconnaitre parmi les morts, un frère ou un ami." "Salon de 1817, 3e article," *La Quotidienne*, 17 May 1817, 2. For a negative judgment of Vernet's *Tolosa*, see Jal, *Ombre de Diderot*, 63.

16. "Ces scènes de carnage, qui, dans leur effrayante monotonie, présentoient constamment aux regards des Français le bourreau de leur patrie debout sur les cadavres de leurs enfants, et respirant, pour ainsi dire, sa vie dans les exhalaisons de la mort!" Le Comte O'Mahony, "Réflexions préliminaires sur l'exposition des tableaux au Louvre: Exposition des tableaux," *Le Conservateur* 4, no. 51 (1819): 563.

17. George Rudé, *The Crowd in the French Revolution* (Oxford, England: Clarendon, 1959), 177. One such example of this strategy of visual subterfuge is Jacques-Louis David's 1807 *Le Sacre de Napoléon* (Musée du Louvre). As Todd Porterfield has argued, the painting provided viewers with "illusory access" to the spectacle of Napoleon's coronation through a dazzling display of visual details. See Siegfried and Porterfield, *Staging Empire*, 115–171; and Forrest, *Conscripts and Deserters*.

18. Guy C. Dempsey Jr., *Napoleon's Mercenaries: Foreign Units in the French Army under the Consulate and Empire, 1799–1814* (London: Greenhill, 2002), 27–28, 80–83.

19. Charles Esdaile, *Peninsular Eyewitnesses: The Experience of War in Spain and Portugal, 1808–1813* (Barnesley, South Yorkshire: Pen & Sword, 2009), 58.

20. Françoise Waquet, *Les Fêtes royales sous la Restauration; ou, L'Ancien Régime retrouvé* (Geneva: Groz, 1981), 96–100; *L'Ami de la religion*, 10 March 1824, 125. See also Paul Adolphe van Cleemputte, *La Vie parisienne à travers le dix-neuvième siècle* (Paris: E. Plon, 1900), 1:489. For more on the theatrical representation of this military campaign, see Olivier Bara, "Dramaturgies de la souveraineté: Entrées royales et pièces de circonstance sous la restauration," in *Imaginaire et représentations des entrées royales au XIXe siècle: Une sémiologie du pouvoir politique*, ed. Corinne Perrin-Saminadayar and Eric Perrin-Saminadayar (Saint-Etienne, France: Université de Saint-Etienne, 2006), 43–44.

21. Forbin reportedly asked Gros to execute the painting in the same dimensions as his *Napoleon Visiting the Plague Victims at Jaffa* (see fig. 30). See Marie-Claude Chaudonneret, *L'État et les artistes: De la restauration à la monarchie de juillet, 1815–1830* (Paris: Flammarion, 1999), 177.

22. Delécluze, "Beaux-arts, Salon de 1827," *Journal des débats*, 20 décembre, 1827, 1. See also, for example, "Musée royale: Exposition de 1827, 2e article," *Journal des artistes*, no. 11 (19 November 1827): 731–732; *Le Figaro*, 29 February 1828, 1–2.

23. Vernet showed only one painting at the Salon of 1822, *Joseph Vernet Attached to a Mast during a Storm*. For an extended account of the controversy concerning the government's rejection of these two paintings from the 1822 Salon, see Daniel Harkett, "Exhibition Culture in Restoration Paris" (PhD diss., Brown University, 2005), 72–119; and Chaudonneret, *L'État et les artistes*, 102–105. Chaudonneret's exacting archival research has helped to dispel the once dominant understanding of Vernet as a victim of conservative politics with regard to his private 1822 exhibition. According to Chaudonneret, Vernet used the rejection of his two paintings to help style himself as an academic outsider and rebel against the conservative politics that dominated the Salon. While Vernet guaranteed himself a reputation as a rebellious, subversive painter, Chaudonneret maintains that he "exploited" the refusal of *The Battle of Jemappes* and *The Clichy Gate*, a position with which I concur.

24. Chaudonneret, *L'État et les artistes*, 105–108.

25. "Les succès de nos soldats en Espagne ont généralement mal inspiré nos peintres." Auguste Jal, *L'Artiste et le philosophe: Entretiens critiques sur le salon de 1824* (Paris: Ponthieu, 1824), 406.

26. "Ce qui est *romantique* en peinture, c'est la *Bataille de Montmirail*, ce chef d'oeuvre de M. H. Vernet. . . . Le *romantique* dans tous les arts, c'est ce qui représente les hommes d'aujourd'hui, et non ceux de ces temps héroïques si loin de nous, et qui probablement n'ont jamais existé." Stendhal, "Salon de 1824," in *Mélanges III: Peinture*, ed. Ernest Abravanel (Geneva: Cercle du Bibliophile, 1972), 81.

27. Étienne de Jouy, "Salon de 1819: Tableaux de genre," *La Minerve française*, 1819, 454: "Parmi les vingt-deux tableaux de chevalet que M. Horace Vernet a exposés, et qui se distinguent presque tous par l'élégance et la facilité du pinceau, par une composition ingénieuse ou spirituelle, mais surtout par ce sentiment patriotique qui a fait surnommer ce jeune maître, LE PEINTRE NATIONAL." Le Comte O'Mahoney, "Exposition des tableaux, tableaux de genre," *Le Conservateur* 5, no. 60 (1819): 382: "C'est peut-être en récompense de ce tableau que les libéraux ont décoré M. Vernet du titre de peintre-*national*. Pour nous, en attendant que *la nation* ait *un premier peintre*, nous nommerons M. Vernet un peintre étonnant."

28. Tom Crow, *Painters and Public Life in Eighteenth-Century Paris* (New Haven: Yale University Press, 1985), 254; Rancière, *Politics of Aesthetics*, 12–14.

29. "La profusion lithographique des hauts faits

qui tapisse nos marchands d'estampes." Saint-Marcelin, "Sur l'armée," *Le Conservateur* 1, no. 11 (1818): 519. Stephen Bann has argued that lithography brought about "a revolution" in the way that artists retrospectively represented the revolutionary and Napoleonic wars during the Restoration. See Bann, *Parallel Lines*, 60.

30. Alex Potts, "The Romantic Work of Art," in *Communities of Sense: Rethinking Aesthetics and Politics,* ed. Beth Hinderliter et al. (Durham, N.C.: Duke University Press, 2009), 58.

31. Lithography, as Stephen Bann has shown, was a viable option in terms of reproducing paintings. French painters, most prolifically Girodet, turned to the medium as a means of reproducing their works. See Bann, *Distinguished Images*, 133–141.

32. "*La Mort de Poniatowski* d'après Horace Vernet a été, sans doute, la gravure la plus populaire du siècle; succès dans lequel l'art entre pour peu de chose." Rosenthal, *Du romantisme au réalisme*, 329.

33. Claudine Renaudeau contends that two different versions of this painting were exhibited at the Salons of 1817 and 1819, rather than the painting being exhibited twice. She has identified important differences between the two paintings, including the presence or absence of a hat on Poniatowski's head and the presence of a black or white horse, based on engravings made after both. See Renaudeau, "Horace Vernet," 142–143.

34. L. M. Buizard, *Catalogue de l'oeuvre lithographique de Mr. J. E. Horace Vernet* (Paris: J. Gratiot, 1826), 42.

35. Henri Béraldi, *Les Graveurs du xix siècle: Guide de l'amateur d'estampes modernes* (Paris: L. Conquet, 1889), vol. 7–8, 223–228. For more on Vernet's relationship to Jazet and to the problems of fine reproductive engraving more broadly, see Stephen Bann, "Horace Vernet and Paul Delaroche: Media Old and New," in Harkett and Hornstein, *Horace Vernet,* 230–231.

36. Nina Anathanassoglou-Kallmyer, "Sad Cincinnatus: *Le Soldat Laboureur* as an Image of the Napoleonic Veteran after the Empire," *Arts Magazine* 60, no. 9 (1986): 65–75. Vernet's painting was preceded by a now-lost painting by F. N. Vigneron.

37. "Un véritable poème en deux chants, dont le titre pourrait être *la Vie du soldat citoyen.*" Étienne de Jouy and Auguste Jal, *Salon d'Horace Vernet: Analyse Historique et pittoresque de quarante-cinq tableaux exposés chez lui en 1822* (Paris: Pontheiu, 1822), 99.

38. Jazet's aquatints are listed in the Salon of 1822 catalogue, though critics do not reference it, likely owing to the politically problematic subject. The dimensions of the aquatint are 62 by 53 cm.

39. Vernet's negotiation between political divisions during the Restoration also recalls the Pellerin family's habit of producing popular prints that honored the Bourbon family while at the same time "retain[ing] a considerable inventory of Imperial prints in [their] warehouse." Day-Hickman, *Napoleonic Art*, 39.

40. Historians of liberalism such as Lucien Jaume and Aurelian Craiutu have emphasized that French conservative (or doctrinaire) liberalism looked for ways to preserve the power of the state and expand it, while trying to preserve individual rights. Some branches of Restoration liberalism, such as the Coppet group (headed by Mme de Staël and Benjamin Constant) looked more favorably upon individual liberties than the form of more conservative liberalism with which I identify the pictorial rhetoric of Vernet's *Arcole.* See Lucien Jaume, "The Unity, Diversity and Paradoxes of French Liberalism," in *French Liberalism from Montesquieu to the Present Day,* ed. Raf Geenens and Helena Rosenblatt, (New York: Cambridge University Press, 2012), 36–51; and Aurelian Craiutu, *Liberalism under Siege: The Political Thought of the French Doctrinaires* (New York: Lexington, 2003), 162–183.

41. Craiutu, *Liberalism under Siege*, 158.

42. See O'Brien, *After the Revolution*, 31–38.

43. In the eulogy read at the academy after Vernet's death, the painting was singled out as one of his most important works. M. Beulé, *Éloge d'Horace Vernet* (Paris: Didier, 1863), 11–12.

44. Gustave Planche, one of Vernet's most astute and vocal critics, recognized that Feuchère had based his bas-relief upon Vernet's *Crossing of the Bridge of Arcole.* See Gustave Planche, "Histoire et philosophie de l'art: De l'École française au Salon de 1834," *Revue des deux mondes*, 1834, 79.

45. As Christian-Marc Bosséno has shown, some of the earliest prints depict the battle in light of this official version of events, as a shared endeavor between Augereau and Bonaparte. Christian-Marc Bosséno, " 'Je me vis dans l'histoire': Bonaparte de Lodi à Arcole, généalogie d'une image de légende," *Annales historiques de la Révolution française* 313 (1998): 456–458; O'Brien, *After the Revolution*, 34.

46. This reversal, though atypical, was not unprecedented. See Olander, "Pour transmettre à la postérité," 277–281. See also Bann, *Parallel Lines,* 80.

47. While there is no way to prove that Vernet's lithograph predated his painting, this was likely the case. The artist's account books show that Vernet was paid in 1823 for a "stone for the *Vie de Napoléon,*" and by early 1827 Arnault had already published an octavo-format version of his *Vie de Napoléon* that replaced the lithographs in the luxurious folio version with reduced-size reproductive etchings of the lithographs from the original edition. Vernet's two lithographs for the folio version appeared in the first volume of the *Vie,* along with one by Théodore Géricault, *La Marche dans le désert.* Géricault's lithograph, according to a recent exhibition catalogue, was published between 1822 and 1823, suggesting that Vernet's two lithographs would have been published around the same time, a full three years before the painting was made. See Serge Guilbaut, Maureen Ryan, and Scott Watson, eds., *Théodore Géricault: The Alien Body; Tradition in Chaos* (Vancouver: Morris and Helen Belkin Art Gallery, University of British Columbia, 1997), 199. In his will, Napoleon left Arnault a generous 100,000 francs, which the author may well have used to finance the publication of the book. See William Hazlitt, *The Life of Napoleon* (Paris: Napoleon Society, 1895), 6:254; Antoine Vincent Arnault, *Vie de Napoléon* (Paris: Émile Babeuf, 1822–26), i.

48. Horace Vernet, a member of the academy, was exempt from having to submit his works to the Salon admission jury. Auguste Jal, *Esquisses, croquis, pochades; ou, Tout ce qu'on voudra, sur le Salon de 1827* (Paris: J. Tastu, 1828), 138. Nineteenth-century military historians claimed that Bonaparte and Augereau would have held the flag of either the fifth or the twelfth demi-brigade. For example, see J. de Lasteyrie, "Les Drapeaux français," *Revue de deux mondes* 101 (24 September 1872): 511–512. I would like to thank Anthony L. Dawson for his help on identifying the flags depicted in the lithograph and painting.

49. Marc Gotleib and Michael Marrinan have examined this tendency in Vernet's later paintings. See Gotlieb, *The Plight of Emulation: Ernest Meissonier and French Salon Painting* (Princeton, N.J.: Princeton University Press, 1996), 133. See also Marrinan, "Schaeur der Eroberung: Strukturen des Zuschauens und der Simulation in den Nordafrika-Galerien von Versailles," in *Bilder der Macht, Macht der Bilder: Zeitgeschichte in Darstellungen des 19. Jahrhunderts,* ed. Stefan Germer and

Michael F. Zimmermann (Munich: Klinckhardt und Biermann, 1997), 267–295.

50. For more on the emergence and politicization of the Napoleonic legend, see Hazareesingh, *Legend of Napoleon*.

51. Arnault, *Vie de Napoléon*, 38.

52. Emmanuel Las Cases, *Mémorial de Sainte-Hélène*, ed. André Fugier (Paris: Garnier Frères, 1961), 1:575–576.

53. Walter Scott, *The Life of Napoleon* (Paris: Galignani, 1837), 405; Adolphe Thiers, *Histoire de la révolution française* (Paris: Lecointe et Durey, 1827), 8: 502–503.

54. Marcel Reinhard, *Avec Bonaparte en Italie* (Paris: Librairie Hachette, 1946), 179–186; "Lettre inédite de Louis Bonaparte sur la bataille d'Arcole, 24 November 1796 (Archives nationales AF11 72)," *Annales historiques de la révolution française* 9 (1932): 354. "Imaginez-vous, mon cher Fleury, qu'ils ont abandonné le général en chef même. Il était à leur tête, tous les officiers qui étaient avec lui sont tombés, et les lâches qui étaient derrière eux fuyaient."

55. *Galerie des Arts et de l'Histoire: Composée des tableaux et statues les plus remarquables des Musées de l›Europe et de sujets tirés de l›histoire de Napoléon,* vol. 6 (Paris: Hivert, 1836), n.p.

56. Arnault complained in his memoirs that foreign publishers had egregiously copied many of the lithographs in his *Vie de Napoléon* and had "thought it advantageous to use it for counterfeit versions." The third edition of *Précis de Napoléon du Consulat et de l'Empire*, published by J. B. Dupont in Brussels in 1825, directly copied at least ten of the lithographs in Arnault's *Vie,* including both of Vernet's lithographs. For more on the reproductions of Arnault's *Vie de Napoléon*, see Katie Hornstein, "Episodes of Political Illusion: The Proliferation of War Imagery in France, 1804–1856" (PhD diss., University of Michigan, 2010), 146–148.

57. For example, Laffitte gave 50,000 francs for the subscription for a monument in honor of the former Napoleonic general turned liberal politician General Maximilien-Sébastian Foy and for the benefit of his children, organized by the liberal journal *L'Opinion.* See *L'Opinion,* 3 December 1825, 2; Jack Hayward, *After the Revolution; Six Critics of Democracy and Nationalism* (New York: New York University Press, 1991), 91.

58. François Guizot, *Des moyens de gouvernement et d'opposition dans l'état actuel de la France* (Paris: Librarie Française de l'Avocat, 1821), 163–164. Sudhir Hazareesingh writes that conservative liberals "had no inherent love of liberty: they opposed absolutism

essentially because of its wastefulness and inefficiency, and also because its frozen social hierarchies seemed to offer little scope for the upward mobility of impatient and enterprising social groups. . . . The enhancement of social equality through redistribution was firmly disavowed." Hazareesingh, *Political Traditions in Modern France* (Oxford: University of Oxford Press, 1994), 215–219. Lucien Jaume, *L'individu effacé; ou, Le paradoxe du libéralisme français* (Paris: Librarie Fayard, 1997), 16; Pierre Rosanvallon, *The Demands of Liberty: Civil Society in France since the Revolution* (Cambridge, Mass.: Harvard University Press, 2007), 127–128. For more on Guizot's conception of political authority, see Craiutu, *Liberalism under Siege,* 155–184.

59. There is some question as to who composed the text. In his memoirs, Laffitte claims that he had the initial idea for the text and was responsible for crafting its rhetoric. This claim should be approached with caution, since the memoirs were written well after the 1830 July Revolution and have been known to contain factual errors. Jacques Laffitte, *Mémoires de Laffitte* (Paris: Firmin Didot, 1932), 177–178; Guillaume de Berthier de Sauvigny, *La Révolution de 1830 en France* (Paris: Librairie Armand Colin, 1970), 196. Jennifer Olmsted has argued that Vernet's painting *The Duc d'Orléans Proceeds to the Hotel de Ville, 31 July 1830* (1832) represents a similar kind of power dynamic, in which "Louis-Philippe rules with the support of his people." See Jennifer W. Olmsted, "The Sultan's Authority: Delacroix, Painting, and Politics at the Salon of 1845," *Art Bulletin* 91 (March 2009), 87.

60. *Encyclopédie des gens du monde: Répertoire universel des sciences, des lettres et des arts* (Paris: Librairie de Treuttel et Würtz, 1833), s.v. "Pont d'Arcole."

61. Jean Lacroix de Marlès, *Paris ancien et moderne, d'après ses monuments* (Paris: Parent-Desbarres, 1837), 68; Casimir Delavigne, "Une Semaine de Paris," in *Mésseniennes et poesies diverses de M. Casimir Delavigne* (Paris: Furne, 1835), 193; Etienne Cabet, *Révolution de 1830 et situation présente (septembre 1832), expliquées et éclairées par les révolutions de 1789, 1792, 1799 et 1804, et par la Restauration* (Paris: Deville-Cavellin, 1833), 234–235.

62. One important example of how the liberty of the individual was sacrificed to the authority of the state is censorship during the July Monarchy. See Richard Terdiman, "Counter-Images: Daumier and *Le Charivari,*" in *Discourse/Counterdiscourse:*

The Theory and Practice of Symbolic Resistance in Nineteenth-Century France (Ithaca, N.Y.: Cornell University Press, 1985), 149–198.

63. Stefan Germer has, for example, argued that one of the important achievements of Jacques-Louis David's *Intervention of the Sabine Women* (1799) was to appeal to two very different audiences, leaving "the decision as to how his picture should be understood up to his viewers." See Stefan Germer, "In Search of a Beholder: On the Relation between Art, Audiences, and Social Spheres in Post-Thermidor France," *Art Bulletin* 74 (March 1992): 34–35.

64. Charles Baudelaire, "Quelques caricaturistes français," *Baudelaire: Critique d'art* (Paris: Gallimard, 1992), 212.

CHAPTER 3. A MIGHTY RECASTING

1. The full invite list was published on the front page of the 10 June 1837 edition of the *Journal des débats politiques et littéraires;* "Chronique de la quinzaine," *Revue des deux mondes* X (1837): 812.

2. Thomas Gaehtgens, *Versailles: De la résidence royale au musée historique; La Galerie des batailles dans le Musée historique de Louis-Philippe* (Paris: A. Michel, 1981), 104.

3. In 1831 the French government lowered the property tax threshold for suffrage, but only slightly. This doubled the number of eligible land-owning voters from 80,000–90,000 to approximately 160,000. The number of voters had increased to 240,000 by 1847. For more on French suffrage during the July Monarchy, see Alan Kahan, *Liberalism in Nineteenth-Century Europe: The Political Culture of Limited Suffrage* (New York: Palgrave Macmillan, 2016), 35–40.

4. Aurelian Craiutu writes: "Those who exercised political power, argued Guizot, must open and institutionalize new channels of communication in society in keeping with the demands of publicity." Craiutu, "Rethinking Political Power: The Case of the French Doctrinaires," *European Journal of Political Theory,* no. 2 (2003): 138.

5. Francois Guizot, *The History of the Origins of Representative Government,* trans. Andrew R. Scobel (Indianapolis: Liberty Fund, 2002), 52.

6. These statistics are based on the listings of exhibited works in the Salon catalogues. Not included in this tally are portraits of generals or French rulers, including Napoleon Bonaparte and Louis-Philippe d'Orléans. I counted 143 war-related subjects for the Salon exhibitions held from 1804–14, and 173 for the three Salon exhibitions held between 1836 and 1838. The vast

majority of these paintings were destined for the historical museum at Versailles.

7. Heinrich Heine, *Lutèce: Lettres sur la vie politique, artistique et sociale de la France* (Paris: M. Lévy Frères, 1855), 161. The political scientist Sandra Halperin argues that the period from 1815 to 1914 witnessed few of these conflicts because "Europe's monarchs and aristocracies feared that another major conflict within Europe would call into use the mass armies that, during and immediately after the Napoleonic Wars, had triggered revolutionary upheavals and threatened to destroy the social order." She contends, however, that the period should not be understood as a peaceful one, citing internal civil struggles throughout nineteenth-century Europe. Halperin, *War and Social Change in Modern Europe: The Great Transformation Revisited* (London: Cambridge University Press, 2004), 384, 119–120. For the return of Bonaparte's ashes, see Richard Burton, "Vendôme/Invalides: The Paris of the Bonapartes, 1802–1871," in *Blood in the City: Violence and Revolution in Paris, 1789–1945* (Ithaca, N.Y.: Cornell University Press, 2001), 78–80. For the construction of Napoleon's tomb at the Invalides and the political machinations behind the decision to entomb him there, see Michael Paul Driskel, *As Befits a Legend: Building a Tomb for Napoleon, 1840–1861* (Kent, Ohio: Kent State University Press, 1993); Hazareesingh, *Legend of Napoleon*, 155.

8. "La bourgeoisie n'était nullement tentée par l'éclat des aventures héroïques. Composée en partie de banquiers, de marchands, d'industriels, de rentiers, de propriétaires paisibles et prompts à s'alarmer, elle appartenait presque tout entière à la peur de l'imprévu. La grandeur de la France, pour elle c'était la guerre et dans la guerre elle ne voyait que l'interruption des relations commerciales, la chute de telle ou telle industrie, des débouchés perdus, des faillites, des banqueroutes." Louis Blanc, *La Révolution française: L'Histoire de dix ans* (Brussels: Société Typographique Belge, 1844), 1:174. For more on the relationship between liberalism and empire in France, see Jennifer Pitts, *A Turn to Empire: The Rise of Imperial Liberalism in Britain and France* (Princeton, N.J.: Princeton University Press, 2006), 165–167.

9. Walter Benjamin, "The Author as Producer," in *The Work of Art in the Age of Its Technological Reproducibility, and Other Writings on Media*, ed. Michael W. Jennings, Brigid Doherty, and Thomas Levin, trans. Edmund Jephcott, Rodney Livingstone, Howard Eiland, et al. (Cambridge, Mass.:

Belknap Press of Harvard University Press, 2008), 82.

10. Gaehtgens, *Versailles*, 115–121. Michael Marrinan maintains that the "richly nominative" historical museum at Versailles represented France's history as an accessible, publicly oriented narrative in keeping with the regime's political agenda, with aesthetic criteria involving style, "school," and genre largely neglected. Marrinan, *Painting Politics for Louis Philippe*, 207; see also Marrinan, "Historical Vision and the Writing of History at Louis-Philippe's Versailles," in *The Popularization of Images: Visual Culture under the July Monarchy*, ed. Petra ten-Doesschate Chu and Gabriel P. Weisberg, Princeton Series in Nineteenth-Century Art, Culture, and Society (Princeton, N.J.: Princeton University Press, 1994), 113–143. Louis Désiré Véron, *Mémoires d'un bourgeois de Paris: Comprenant la fin de l'Empire* (Brussels: Labroue, 1854), 4:139.

11. Marrinan, *Painting Politics for Louis-Philippe*, 168–171. Marrinan is concerned with the way that Vernet's paintings expressed the regime's "vested interest in 'disarming' and 'civilizing' the memory of Napoléon without, however, diminishing the power of his legend." Our accounts diverge on questions related to the efficacy of propaganda and the extent to which official political ideology determined the meaning of commissioned works of art.

12. "Salon de 1836, 3e article," *Journal des artistes*, no. 11 (13 March 1836): 165.

13. Gustave Planche, "Salon de 1836," in *Études de l'école française, 1831–1852: Peinture et sculpture* (Paris: Michel Lévy Frères, 1855), 1:334–337.

14. "Salon de 1836," *L'Indépendant*, 13 March 1836; For more on the interactions between text and image in these two works, see Samuels, *Spectacular Past*, 69–79.

15. "Salon de 1837, 3e article," *Journal des artistes*, no. 12 (19 March 1837): 183; Auguste Bourjot, "Salon de 1837, 2e article," *La France littéraire* (1837): 444; Ulysse Tencé, "Note pour servir à l'histoire des arts et lettres en 1836," in *Annuaire historique universel pour 1836* (Paris: Thoisnier-Desplaces, 1837), 253; "Salon de 1836, 3e article," *Journal des artistes*, 163; "Salon de 1837, 5e article, peinture," *L'Artiste*, no. 9 (1837): 113–114.

16. "Depuis bien des années le salon n'avait été aussi couvert de batailles; il est vrai qu'il y a environ 24 ans que ne nous faisons rien ou, à peu près, en fait de guerre; il en résulte ce qui résulte du duel; c'est qu'il n'y en a jamais plus qu'en temps de paix; parce qu'en France il faut un remplaçant à l'horrible guerre, et tel,

que l'on est obligé par désoeuvrement de jouer la vie d'un homme, les circonstances ne vous permettent pas de jouer l'existence d'un empire." "Revue du Salon de 1837, 2e article," *Revue du centre, no. 20*, 253–256.

17. "Cette malheureuse facilité de reproduction. . . . Le moindre garçon sellier charbonne Napoléon sur la muraille, avec autant de dextérité que le premier de nos peintres." "Salon de 1836: Deuxième article," *La Revue de Paris*, 3 April 1836, 106.

18. For the Benjamin note in English translation, see Gerhard Richter, *Walter Benjamin and the Corpus of Autobiography* (Detroit: Wayne State Press, 2002), 158. In her study of Romantic English wartime poetry and literature, Mary Favret argues that the strategy of demarcating temporal boundaries between war and peace is designed to "put period to and step outside of the time of war, to contain and mange it, to behold it and be *still*." But such divisions are ultimately untenable, since "wartime also has trouble measuring its distance from other times of war: it produces a history of the present always permeable to other presents, other wartimes." See Favret, *War at a Distance*, 30.

19. Letters 40 and 87 in Ximénès Doudan, *Mélanges et lettres* (Paris: Calmann Lévy, 1876), 1:223–224, 358–359.

20. In *The Railway Journey: The Industrialization of Time and Space in the Nineteenth Century* (Oakland: University of California Press, 1986), Wolfgang Schivelbusch has argued that the railroad modernized vision and transformed the way that the landscape could be perceived (52–69). *Galignani's New Paris Guide: Containing an Accurate Statistical and Historical Description of All the Institutions, Public Edifices* (Paris: Galignani, 1846), v. "Deux chemins, entendez-vous? entre Paris et Versailles; non pas entre une ville d'industrie et un port de mer, comme Liverpool et Manchester, mais entre une ville de luxe et une ville de curiosité; non pour les gens d'affaires, mais pour des visiteurs oisifs." Adolphe-Jérôme Blanqui, *Cours d'économie industrielle* (Paris: L. Mathias Augustin, 1839), 11. *Voyage pittoresque de Paris à Versailles: description historique des bourgs, villages et hameaux qui bordent les deux chemins de fer; Suivi d'une notice sur Versailles, le château, le musée, les jardins, le parc et les deux Trianons* (Paris: Schneider et Langrand, 1841), 1; *Galeries historiques de Versailles: Collection de gravures réduites d'après les dessins originaux du grand ouvrage in-folio sur Versailles* (Paris: Gavard, 1838), 17.

21. Armnad Dayot, *Les Vernet, Joseph, Carle,*

Horace (Paris: A. Magnier, 1898), 216–217. Vernet's financial involvement with the railroad was part of a larger phenomenon of speculation rampant in France at the time, and considered by its critics to be a problematic epidemic that encouraged economic and moral depravity. For more on the growth of railroads in France, see Nicholas Green, *The Spectacle of Nature, Landscape and Bourgeois Culture in Nineteenth-Century France* (Manchester, England: Manchester University Press, 1990), 83–93.

22. "Si les causeurs disent vrai, nous devons plier le genou devant M. Horace Vernet et demander pour lui un brevet d'invention; car son nom mérite d'être inscrit à côté de celui de James Watt dans l'histoire de l'industrie européenne. Il est permis, sans exagération, de voir dans le pinceau de M. Horace Vernet une machine de la force de cent soixante chevaux, et lorsqu'il aura épuisé la durée de son brevet, lorsque, grâce à la fécondité fabuleuse de ses procédés, il sera devenu propriétaire de deux ou trois départements, j'espère qu'il publiera son secret et daignera former des élèves. S'il plait à M. Horace Vernet, et si le gouvernement, enrichi par la paix, ne lésine pas, Paris deviendra la plus belle ville du monde; toutes les rues seront ornées de peinture; toutes les maisons, depuis le premier jusqu'au troisième étage, offriront aux regards des passants les épisodes les plus glorieux de l'histoire française." Planche, "Salon de 1836," 330–331.

23. "Personne n'ignore la manière dont se fabrique la peinture militaire : avec un cheval, avec un panache de général, voire même avec un nuage de fumée, on cache toute une armée ; quelques figures d'état-major, un héros dont le bras s'étend et agite une épée, un ou deux soldats mourant dans de belles poses, voilà en résumé ce genre qui plaît tant au vulgaire et qui nous console par les yeux de la longue paix dont la France jouit malgré elle." Alfred des Essarts, "Salon de 1839," *France et Europe, revue politique et littéraire*, March 25, 1839, 597.

24. Victor de Nouvion, "Beaux-arts, Salon de 1836," *La France littéraire*, no. 23 (1836): 293.

25. "Avec les proportions aujourd'hui démesurées des masses des troupes, et les dimensions des terrains qu'elles occupent. . . . À peine la vaste et spéciale étendue du Panorama pourroit y suffir." Quatremère de Quincy, "Notice historique sur la vie et les ouvrages de M. Gros," in *Recueil des notices historiques lues dans les séances de l'Académie royale des beaux-arts à l'Institut* (Paris: A. Leclerc, 1837), 161.

26. Etienne Huard, "Panorama de l'incendie de Moscou," *Journal des artistes*, 2 June 1839, 337–341.

27. For more on Langlois's life, see François Robichon, "Langlois, magicien des panoramas," in Musée des Beaux-Arts de Caen, *Jean-Charles Langlois*, 19–20. Hélène Gill has referred to Vernet as a "soldat manqué." See Gill, *The Language of French Orientalist Painting* (Lewiston, N.Y.: Edwin Mellen, 2003), 35.

28. Zoe Langlois to Louise Vernet, Paris, 15 November 1829, in Foissier, Chave, and Kuhnmunch, *Correspondance des directeurs de l'Académie*, letter 85, 85–86.

29. Entry fees for panoramas varied throughout the nineteenth century. Admission to Langlois's first panorama, *The Battle of Navarino*, was 2 francs 50 centimes, the price of a second-class train ticket to Louis-Philippe's historical museum at Versailles, and the average daily salary of a worker in the 1830s. See Robichon, "Les Panoramas en France"; and Robichon, "Langlois, magicien des panoramas," 21.

30. Jonathan Crary, "Géricault, the Panorama, and Sites of Reality in the Early Nineteenth Century," *Grey Room* 9 (2002): 18; Schwartz, *Spectacular Realities*, 149–176. Maurice Samuels, *The Spectacular Past: Popular History and the Novel in Nineteenth-Century France* (Ithaca, N.Y.: Cornell University Press, 2004); and Arsène Alexandre, *Histoire de la peinture militaire en France* (Paris: Henri Laurens, 1889), 276–277.

31. For the 1831 Salon criticism of Langlois's *Battle of Navarino*, see Auguste Jal, *Salon de 1831: Ébauches critiques* (Paris: A. J. Dénain, 1831), 215–216; other examples of Langlois exhibiting works in the Salon related to his panoramas include the maquette for *The Battle of Moskova*, exhibited at the Salon of 1839 right after the closing of the panorama of the same subject, which coincided with the opening of his second panorama related to Bonaparte's Russian campaign, the *Panorama of the Fire of Moscow*. For more on Langlois's panoramas, see Musée des Beaux-Arts de Caen, *Jean-Charles Langlois*.

32. G. B., "Panorama de la bataille de la Moskova par M. Charles Langlois," *Gazette des salons*, January 1836, 333.

33. Paul Mantz, "Panorama des Champs-Élysées," *La Revue de Paris* 16 (March 1853): 488.

34. Alexandre Lenoir, "Mémoires: le Salon de 1837," *Journal de l'Institut historique* 5, no. 33 (April 1837): 110.

35. "S'il en est ainsi, et que les efforts se succèdent rapidement, que deviendra la plate peinture encadrée? Dieu le sait." Etienne-Jean Delécluze, "Beaux-arts; Ouverture du Salon," *Journal des débats politiques et littéraires*, 1 May 1831, 1–3.

36. "Mélanges: Le Diorama de Navarin," *Petit Courrier des dames*, 5 February 1831, 35; Auguste Jal, "La Bataille de Navarin, panorama de M. Langlois," *L'Artiste*, no. 2 (1831).

37. "Le Panorama de la Moscowa," *L'Indépendant*, 20 August 1835, 1.

38. *La Revue de Paris* 23 (1831): 64–68.

39. "Vous ne vous en étiez pas aperçu, tant la transition du réel au figuré est bien ménagée." Jal, "Bataille de Navarin," 24.

40. *Gazette des salons*, 1 January 1836, 287.

41. F. P., "Beaux-Arts," *Le Moniteur universel*, 24 July 1835, 1764.

42. Samuels, *Spectacular Past*, 33–37.

43. Louise Vernet to Pigneux, Rome, 12 September 1833, in Foissier, Chave, and Kuhnmunch, eds., *Correspondance des directeurs de l'Académie*, letters 472, 269; and Nicolas Schaub, "Horace Vernet and the Conquest of Algeria through Images," in Harkett and Hornstein, *Horace Vernet*, 73–74.

44. For Langlois's *Panorama of Algiers*, see John Zarobell, "Jean-Charles Langlois's *Panorama of Algiers* (1833) and the Prospective Colonial Landscape," *Art History* 26, no. 5 (2003): 638–668. For more on ticket sales and length of run for each of Langlois's panoramas, see Musée des Beaux-Arts de Caen, *Jean-Charles Langlois*.

45. Jennifer Sessions, *By Sword and Plow: France and the Conquest of Algeria* (Ithaca, N.Y.: Cornell University Press, 2011), 6–7, 136–143.

46. For more on nineteenth-century visual representation of Algeria, see Nicolas Schaub, *Représenter l'Algérie: Images et conquête au XIXe siècle* (Paris: CTHS-INHA, 2015).

47. Sessions, *By Sword and Plow*, 85, 163–165; Blanc, *Révolution française*, 2:127.

48. H. A. C. Collingham, *The July Monarchy: A Political History, 1830–1848* (London: Longman, 1988) 221–238.

49. "Je vois la Russie marcher à la conquête du Bosphore, l'Angleterre à celle de la Haute-Asie, la France, par l'Algérie, à la conquête du désert. N'y a-t-il rien dans tout cela qui vous donne à penser?" Edgar Quinet, "1815 et 1840," in *Oeuvres complètes* (Paris: Pagnerre, 1858), 10:12.

50. On the Salles d'Afrique and the Orientalist discourses they implicate, see Melanie Vandenbrouck, "Myth-making in Versailles: The French 'Liberating Mission' in Algeria and Horace Vernet's *Prise de Smala d'Abd el Kader*," *Immediations*, January 2007, 92–109. For the interaction between July Monarchy propaganda and Vernet's Algerian battle

painting, see Sessions, *By Sword and Plow*, 96–124.

51. For more on this failure and on Auguste Raffet's lithographic album depicting the horrors of the conflict, see Schaub, *Représenter l'Algérie*, 233–246.

52. "Mosaïque," *L'Indépendant*, 10 October 1837, 3.

53. Numerous critics mentioned this fact in their reviews. See, for example, "Salon de 1839, 2e article," *Journal des beaux-arts et de la littérature*, 10 March 1839, 115.

54. This installation of the paintings at Versailles in the Salle de Constantine has been discussed by Michael Marrinan, who contextualizes the reception of these paintings through the texts that they circulated with them and frames his interpretation through Baudrillard's theory of simulation. See Marrinan, "Schaeur des Eroberung: Strukturen des Zuschauens und der Simulation in den Nordafrika-Galerien von Versailles," in Germer and Zimmermann, *Bilder der Macht, Macht der Bilder*, 267–295.

55. "Salon de 1839, 2e article," *L'Artiste*, no. 17 (1839): 228.

56. Paul Mantz, "Salon de 1845: Les Batailles," *L'Artiste*, no. 12 (23 March 1845): 177.

57. Edouard Bergounioux, "Peinture religieuse et historique: Salon de 1845," *La Revue de Paris*, 1 April 1845, 479.

58. "Revue Algérienne," *L'Illustration*, 17 June 1843, 255.

59. Like the battle paintings produced under Napoleon Bonaparte, Vernet's Algerian campaign paintings employ standard European orientalist tropes that viewed the inhabitants of Algeria as racially and culturally inferior and available for conquest; but as the Salon criticism for Vernet's *Smalah* demonstrates, this sense of cultural and military supremacy was easily cast into doubt. In this sense, these paintings reproduce racist discourses as much as they also potentially open them up to challenge. For more on the representation of racial otherness in the painting, see Melanie Vandenbrouck, "The Good, The Bad, and the Beautiful: Representing the Conquest of Algeria, 1830–1848" (PhD diss., Courtauld Institute of Art, University of London, 2009), 1:117–125; for more on the sexualized forms of violence in *Smalah* and a broader comparison between Vernet and Delacroix's approaches to representing North African subjects at the Salon of 1845, see Jennifer W. Olmsted, "The Sultan's Authority: Delacroix, Painting, and Politics at the Salon of 1845," *Art Bulletin* 91 (March 2009: 1): 96-99.

60. "M. H. Vernet a donc soumis l'ensemble de sa vaste scène a plusieurs points de vue comme un panorama, et le seul moyen, pour la bien voir et en saisir tous les riches détails, est de précéder comme devant une frise, et de faire deux ou trois stations. J'ai observé qu'en commencent de gauche à droite, ou de droite à gauche, et les sensations que l'on éprouvé sont inverses, elles ne détruisent cependant pas la clarté ni l'unité du sujet. Seulement on va de la cause aux effets, ou l'on remonte des effets à la cause, et dans l'on comme dans l'autre cas, le talent de l'artiste fait faire ce voyage avec grand plaisir aux yeux comme à l'intelligence." Étienne-Jean Delécluze, "Salon de 1845, 1e article," *Journal des débats politiques et littéraires*, 18 March 1845, 2.

61. Ibid.

62. "L'unité, nulle; mais une foule de petites anecdotes intéressantes - un vaste panorama de cabaret . . . grâce à cette méthode de feuilletoniste, la mémoire du spectateur retrouve ses jalons, à savoir: un grand chameau, des biches, une tente, etc." *Oeuvres complètes d'Honoré de Balzac* (Paris: Calmann Frères, 1879), 23: 185; Baudelaire, *Critique d'art*, 17–18.

63. Charles Blanc, "Salon de 1839, 2e article," *Revue du progrès, politique, sociale et littéraire* (1839): 348; Bergounioux, "Peinture religieuse et historique," 478.

64. Adolphe Desbarolles, "Lettre sur le Salon de 1845," *Bulletin de l'ami des arts* 3 (1845): 349. "La résistance est tellement individuelle, tellement éparse, qu'il en résulte une commisération involontaire pour ces pauvres Arabes." Eugène Pelletan, "Salon de 1845: Horace Vernet, Hippolyte Flandrin, Gleyre," *La Démocratie pacifique*, 31 March 1845, 2.

65. Théophile Thoré, *Les Salons de Théophile Thoré* (Paris: Librairie International, 1868), 111.

66. Terdiman, *Discourse/Counterdiscourse*, 120.

67. "C'est assurément le devoir de la peinture de se plier elle-même aux mille métamorphoses de ce protée de l'heure, de l'occasion et du succès, qu'on nomme l'*actualité*." "Salon de 1845, 2e article," *Moniteur des arts*, 23 March 1845, 57.

68. "Ses tableaux illustrent les bulletins, et chacun sait d'avance ce qu'il veut dire. Le texte de ses compositions est répandu à milliers par cent journaux: tout le monde a vu des chasseurs d'Afrique et des zouaves. . . . Il est tout naturel que les tableaux de M. Horace Vernet jouissent d'une grande popularité ; les gens les plus étrangers à la peinture peuvent constater l'exactitude de la reproduction d'un kepy . . . et comme ils trouvent toutes ces choses fidèlement reproduites, avec un certain aspect de trompe-l'œil dans les batailles de leur maitre favori, ils les regardent comme le dernier mot de l'art." Théophile Gautier, "Le Salon de 1845, 2e article," *La Presse*, 18 March 1845, 2.

69. Edouard Charton, the founder of both the *Magasin pittoresque* and *L'Illustration*, referred to the former as "un petit journal à gravures hebdomadaire" and the later as "un recueil pittoresque d'actualités." See Marie-Laure Aurenche, "L'Invention des magazines illustrés au XIXe siècle, d'après la correspondance générale d'Édouard Charton, 1824–1890," in *La Lettre et la presse: Poétique de l'intime et culture médiatique*, ed. Guillaume Pinson, http://www.medias19.org/index.php?id=331.

70. "Beaux-Arts—Salon de 1845," *L'Illustration*, 15 March 1845, 39.

71. Walter Benjamin, "The Work of Art in the Age of Its Technological Reproducibility," in Jennings, Doherty, and Levin, *Work of Art*, 104.

CHAPTER 4. THE PROMISE OF SOMETHING MORE

1. Stendhal, *The Charterhouse of Parma*, trans. Margaret Mauldon (London: Oxford University Press, 1997), 50.

2. Thierry Gervais has also written about what he calls a "certain resistance" on the part of the nineteenth-century press to photography. See Gervais, "Witness to War: The Uses of Photography in the Illustrated Press, 1855–1904," *Journal of Visual Culture* 9 (3): 2; Sontag, *Regarding the Pain of Others*, 21, 81.

3. Sontag, *Regarding the Pain of Others*, 51.

4. Ibid., 51.

5. "Il est néanmoins une crainte à laquelle je dois répondre. Par esprit de défiance, certaines personnes se disent : l'Empire, c'est la guerre. Moi je dis : l'Empire, c'est la paix ! C'est la paix, car la France la désire, et quand la France est satisfaite, le monde est tranquille. La guerre ne se fait pas par plaisir, elle se fait par nécessité. . . . J'en conviens, et cependant j'ai, comme l'Empereur, bien des conquêtes à faire. . . . Nous avons d'immenses territoires incultes à défricher, des routes à ouvrir, des ports à creuser, des rivières à rendre navigables, des canaux à terminer, notre réseau de chemins de fer à compléter. . . . Nous avons partout des ruines à relever, de faux dieux à abattre, des vérités à faire triompher." For the text of Napoleon III's speech, see "Chronique économique," *Journal des économistes: Revue de la science économique* 33 (1852): 199.

6. Karl Marx, *The Eighteenth Brumaire of Louis Bonaparte*, ed. C. P. Dutt (New York:

International, 1963), 15; C. A. Bayly, *The Birth of the Modern World* (Oxford: Blackwell, 2004), 145–176. For the speeches Hugo gave while in exile, see Victor Hugo, *Actes et paroles: Avant l'exil, 1841–1851; Pendant l'exil, 1852–1870*, ed. Jean Louis Cornuz, vol. 31 of *Oeuvres complètes de Victor Hugo* (Paris: Rencontre, 1968).

7. Orlando Figes argues that for England and France, the Crimean War was "a crusade for the defence of liberty and European civilization against the barbaric and despotic menace of Russia, whose aggressive expansionism represented a real threat, not just to the West but the whole of Christendom." See Figes, *The Crimean War: A History* (New York: Metropolitan, 2010), xxii. For more on the outbreak of the Crimean War, see Trevor Royle, *Crimea: The Great Crimean War, 1854–1856* (London: Little, Brown, 2000), 19.

8. Alain Gouttman, "Guerre de Crimée, guerre oubliée?" in *Napoléon III et l'Europe, 1856: Le Congrès de Paris* (Paris: Artlys, 2006), 20–21. These casualty figures are found in J. A. S. Grenville, *Europe Reshaped, 1848–1878* (Sussex: Harvester, 1976), 203. As Grenville points out, the death toll from the Crimean War is comparable to that of the American Civil War. His casualty figures differ slightly from Figes' more recent statistics: 180,000 French dead, 45,000 British, and 450,000 Russian. The Napoleonic Wars resulted in over 1 million French casualties from 1803 to–1815. For more precise casualty figures for the Napoleonic Wars, see Owen Connelly, *The French Revolution and Napoleonic Empire* (New York: Harcourt, 1999), 223; and Lynn Case, *French Opinion on War and Diplomacy during the Second Empire* (New York: Octagon, 1972), 38.

9. Case, *French Opinion on War*, 15–23.

10. Pierre Duflo, *Constantin Guys: Fou de dessin, grand reporter, 1802–1892* (Paris: Arnaud Seydoux, 1988), 2:101.

11. "J'ai vu *toute* la campagne de Crimée dessinée par lui, au jour le jour pendant qu'il suivait l'expédition à la suite de l'armée anglaise, chacun de ses dessins accompagné des notes les plus curieuses." Charles Baudelaire, *Nouvelles lettres*, ed. Claude Pichois (Paris: Librairie Arthtème Fayard, 2000), 36. Many of Constantin Guys's sketches were owned by Baudelaire's friend Nadar, who purchased them directly from the artist. As Claude Pichois has asserted in the notes to the annotated edition of Baudelaire's writings on art, Baudelaire "had the originals under his eyes." Given his professed dislike of newspapers and his

friendship with Nadar, it seems likely that his understanding of Guys's Crimean War *oeuvre* would have been based exclusively on the original drawings. See Baudelaire, *Critique d'art*, 652. "Et c'est de ce dégoûtant apéritif que l'homme civilisé accompagne son repas de chaque matin. . . . Je ne comprends pas qu'une main pure puisse toucher un journal sans une convulsion de dégoût." Baudelaire, *Oeuvres posthumes et correspondances inédites* (Paris: Maison Quantin, 1887), 117. "Je puis affirmer que nul journal, nul récit écrit, nul livre, n'exprime aussi bien, dans tous ses détails douloureux et dans sa sinistre ampleur, cette grade épopée de la guerre de Crimée." Baudelaire, *Critique d'art*, 360–361.

12. Baudelaire, *Critique d'art*, 361.

13. "Une masturbation agile et fréquente, une irritation sur l'épiderme français." Ibid., 130.

14. "Dont les maculatures et les déchirures disent, à leur manière, le trouble et le tumulte au milieu desquels l'artiste y déposait ses souvenirs de la journée"; "En vérité, il est difficile à la simple plume de traduire ce poème fait de mille croquis, si vaste et si compliqué, et d'exprimer l'ivresse qui se dégage de tout ce pittoresque, douloureux souvent, mais jamais larmoyant, amassé sur quelques centaines de pages, dont les maculatures et les déchirures disent, à leur manière, le trouble et le tumulte au milieu desquels l'artiste y déposait ses souvenirs de la journée. Vers le soir, le courrier emportait vers Londres les notes et les dessins de M. G., et souvent celui-ci confiait ainsi à la poste plus de dix croquis improvisés sur papier pelure, que les graveurs et les abonnés du journal attendaient impatiemment." Ibid., 362, 363.

15. For more on the British reception of the Crimean War in the *Illustrated London News*, see Keller, *Ultimate Spectacle*, 71–118; and Matthew Lalumia, *Realism and Politics in Victorian Art of the Crimean War* (Ann Arbor: University of Michigan Press, 1984). For the history of *L'Illustration* and detailed circulation figures, see Jean-Noel Marchandiau, *L'Illustration: Vie et mort d'un journal, 1843–1944* (Paris: Bibliothèque Historique Privat, 1987), 27. For an account of the French-British reception of images of the Crimean War, see Ulrich Keller, "La Guerre de Crimée en images: Regards croisés France/Angleterre," in *L'Evenément: Les Images comme acteurs de l'histoire* (Paris: Hazan/Jeu de Paume, 2007), 28–49.

16. Ulrich Keller, *Ultimate Spectacle*, 82.

17. Jean-Baptiste Alexandre Paulin, "Histoire de la semaine," *L'Illustration*, 18 August 1855, 114.

18. *L'Illustration*, 20 January 1855, 34. For more on the electric telegraph in nineteenth-century France, see Richard Taws, "When I Was a Telegrapher," *Nonsite.org* 14 (Winter 2014/2015): 14–47.

19. For Durand-Brager's visit with the emperor and empress, see *L'Illustration*, 24 March 1855, 178; for more on Durand-Brager, see Fréderic Lacaille, "Jean-Baptiste Henri Durand Brager," in *Crimée, 1854–1856: Premiers Reportages de guerre* (Paris: Musée de l'Armée, 1994), 118. See also Ferdinand Hoefer, ed., *Nouvelle biographie générale depuis les temps les plus reculés* (Paris: Didot Frères, 1856), 14:431–432.

20. For Général Canrobert's report and the accompanying image, see *L'Illustration*, 5 May 1855, 274.

21. *L'Illustration*, 13 May 1854, 289; Marchandiau, *L'Illustration: Vie et mort d'un journal*, 30–31. One wood engraving required at least forty-eight hours to produce.

22. "Une dépêche, accompagnée de vues photographiques, donnera des renseignements bien plus précis qu'un simple document écrit, si volumineux et si détaillé qu'il puisse être. On peut, avec un objectif, reproduire instantanément des promontoires, des côtes, des forts, des dispositions de flottes, des armées, des positions militaires, et si le stéréoscope peut être employé, rien ne saurait être comparé aux résultats qu'on obtiendra." "La Photographie et la guerre," *La Lumière*, 15 April 1854, 15.

23. Ferdinand de Lacombe, "De l'usage de la photographie dans l'armée," *Le Spectateur militaire* 35 (1861): 145 and 146–147. The article states that M. Disderi's project "fut soumis, dès le commencement de 1860, à son Exc. le ministre de la guerre, qui le prit en considération, et, par décision du 19 février 1861, appela M. Disderi à le mettre à exécution dans les corps de troupes," but does not specify exactly how photography would be integrated into the military. For more on Disdéri's dealings with the Dépôt de la Guerre, see Elizabeth Anne McCauley, *A. A. E. Disdéri and the Carte de Visite Portrait Photograph* (New Haven: Yale University Press, 1985), 51–52.

24. Edwards, *Making of English Photography*, 42–44; John Tagg, *The Burden of Representation: Essays on Photographies and Histories* (Minneapolis: University of Minnesota Press, 1988), 4.

25. The English government sent three separate photographers to the front, but only Roger Fenton's photographs there have survived. The first photographer, Richard Nicklin, was lost at sea, along with his crew and all

their work. The photographs brought back to England after the second government-sponsored expedition, led by ensigns Brandon and Dawson, by 1869 had faded and were expunged from government files. See John Hannavy, *The Camera Goes to War: Photographs from the Crimean War, 1854–1856* (Edinburgh: Scottish Arts Council, 1977), 8–9. Molly Nesbit's pioneering work on Eugène Atget and the problem of the document, *Atget's Seven Albums*, underpins my analysis of the photographs of Durand-Brager and Jean-Charles Langlois. She argues that the document "functioned in a part of visual culture that had few aspirations to greatness or avant-garde revolution; it issued from the depths of bourgeois culture; it was the aesthetic Other" (9).

26. For example, see M. Lassimonne, "Emploi de l'acide tannique en photographie," *Bulletin de la société française de la photographie* 3 (1857): 355–356.

27. Roger Fenton, "Narrative of a Photographic Trip to the Seat of War in the Crimea," *Journal of the Photographic Society of London*, 21 January 1856, 289.

28. M. Lassimonne, "Campagne française de photographie en Crimée," *La Revue photographique*, 5 May 1856, 99–100. It is unlikely that Lassimonne and Durand-Brager could have produced wet-plate collodion photographs without some kind of portable laboratory (and water!); the process was notoriously difficult, since the prepared glass negatives had to be used immediately, while still wet. Lassimonne's account is undoubtedly a rather outlandish exaggeration meant to encourage public curiosity about their expedition.

29. "Sous peu de jours notre collection sera livrée au public, et chacun alors verra que, sans emporter l'immense bazar de M. Fenton, nous avons pu recueillir une ample et belle moisson." Ibid., 100. The photographs were published by Lemercier, one of the largest publishing houses in Paris, rivaled only by Goupil. For more on Lemercier, see Corinne Bouquin, "Recherches sur l'imprimerie lithographique à Paris au XIXe siècle: L'imprimeur Lemercier, 1803–1901," (PhD diss., Université de Paris I, Panthéon-Sorbonne, 1993).

30. Sarah Greenough, "A New Starting Point: Roger Fenton's Life," in *All the Mighty World: The Photographs of Roger Fenton, 1852–1860*, ed. Malcolm Daniel Gordon Baldwin and Sarah Greenough (New Haven: Yale University Press, 2005), 24; B. A. and H. K. Henisch, "James Robertson and His Crimean War Campaign," *History of Photography* 26, no. 4 (2002): 264–265.

31. For more on the details of this distinction, see the essay by François Robichon, "Langlois, photographie et panoramiste," in *Jean-Charles Langlois: La Photographie, la peinture, la guerre*, ed. Francois Robichon and André Rouillé (Nimes, France: Jacqueline Chambon, 1992), 24–26.

32. Ibid., 210.

33. Emile Levasseur, *Histoire des classes ouvrières et de l'industrie en France de 1789 à 1870* (Paris: A. Rousseau, 1904), 2:710–712.

34. Robichon and Rouillé, *Jean-Charles Langlois*, 266–270. Mme Langlois went on to mention that the photography dealers were abuzz with excitement over the impending arrival of Robertson's photographs, contradicting her earlier statement about the market being glutted with photographs. It is likely that the market was indeed glutted, but that these merchants were trying to stir up excitement over Robertson's work.

35. "Je me dispense de mettre dans tout cela de la *fumée de canon*, par la raison que cela peut faire très bien, mais cache les détails. Ceux de vos lecteurs qui y tiendraient voudront bien faire attention que, sur des dessins ainsi jetés, il faut ménager l'espace et tout laisser au détail." Henri Durand-Brager, "Correspondance de Crimée," *L'Illustration*, 13 January 1855, 26.

36. "Je vous recommande bien la vue des camps, elle est très exacte; il faut qu'elle soit copiée bien exactement. Croyez-moi, ne cherchez pas à la raccourcir; publiez-la telle quelle, les bandes les unes au dessous des autres. Vous ne sauriez croire la quantité d'officiers de l'armée qui m'ont prié de faire ce travail: que leurs familles puissent se rendre compte de l'endroit où ils sont." Durand-Brager, "Correspondance de Crimée," 26. A week later, on 20 January, Durand-Brager again referred to his choice to leave out the smoke: "Je me suis abstenu de faire des fumées de coups de canon; je pense que vos lecteurs ne m'en voudront pas d'avoir supprimé ce détail, qui ne sert qu'à cacher les lignes."

37. Jean-Baptiste Lucien Baudens, *La Guerre de Crimée* (Paris: Michel Lévy frères, 1858), 92.

38. "Sur une grande toile, l'artiste a peint un immense panorama de la rade de Sébastopol. C'est toute *l'attaque* du côté gauche de la place vue dans son ensemble; c'est une sorte de tableau synoptique, de plan général du siège et de la défense. Mais on comprend que, dans uneuvre aussi disséminée, l'oeil ne puisse saisir les mille détails particuliers de la côte, aussi, le peintre divisant son panorama-mère, a fait une série de tableaux où chaque point de vue est répété en grand." Cléon Galoppe d'Onquaire, "Promenade à travers les ateliers II," *Revue des beaux-arts* 8 (1857): 47–48.

39. "Il commence sa campagne par deux vues panoramiques de Sébastopol, longues toiles transversales qui s'ajustent et se continuent: la forme et la hauteur des collines, la position des forts, l'aspect de la ville et de la rade, tout est exprimé avec une précision singulière; pas un coup de pinceau n'est donné au hasard; chaque touche blanche indiquant une maison, un fortin, un bastion . . . et cependant si vous n'étiez prévenu, vous croiriez avoir devant les yeux une simple vue pittoresque." Théophile Gautier, "Le Siège de Sébastopol, tableaux de M. Durand-Brager," *L'Artiste*, no. 1 (26 April 1857): 61.

40. For more on the the way that a Minié rifle functions and on its impact on the Crimean War, see Jeremy Black, *Western Warfare, 1775–1882* (Bloomington: Indiana University Press, 2001), 122–124; and J. B. A. Major General Bailey, *Field Artillery and Firepower* (Annapolis, Md.: Naval Institute Press, 2004), 188–189. The Minié rifle was exhibited at the 1855 Exposition Universelle in Paris. A guide to the exhibition of firearms noted that the rifle "has become the terror of the Russians, by the accuracy of the range of its shot." See Henri Edouard Tresca, *Visite à l'exposition universelle de Paris, en 1855* (Paris: Hachette, 1855), 558.

41. Bailey, *Field Artillery and Firepower*, 190; according to the military historian John Terraine, "In Sebastopol itself, the Russians had some 3,000 pieces of heavy artillery—far more than they could mount or man, but guaranteeing constant replacement of losses. By the time of the fourth bombardment (17 June 1855), they had 10,697 artillery men in the fortress (compared with 43,000 infantry). The Allies deployed 588 siege guns for this occasion; for the final bombardment (5–8 September), this number had risen to over 800 of which 183, including the heaviest and most powerful, were British—57 supplied by the Royal Navy. These batteries produced the greatest bombardments the world had yet seen." See John Terraine, *White Heat: The New Warfare, 1914–1918* (London: Sidgwick & Jackson, 1982), 10; the report noted that these high figures were "without any example in history." For more on siege warfare during the Crimean War, see Jean-Baptiste Philibert Maréchal Vaillant, "Report on the French Troops and Material Sent to the Crimea in 1854 and 1856," *Papers on Subjects Connected*

with the Duties of the Royal Corps of Engineers 6 (1857): 69; and Bruce Watson, *Sieges: A Comparative Study* (Westport, Conn.: Greenwood, 1993), 81.

42. "Est-ce que là une bataille? Oui, dit l'historien, et le stratège y voit une action de premier ordre; l'assaillant y a perdu au moins 9,000 hommes. Oui, c'est bien une bataille que cet effort suprême. . . . Mais, pour le peintre, où est-elle cette bataille? où la prendra-t-il? à Tchorgoun? à Traktir? ce seront là des épisodes, des passages de pont, des affaires d'avant-postes? Ce fut surtout une affaire d'artillerie . . . montrez-moi donc sur la toile une affaire d'artillerie." Bois-Robert, "La Guerre au Salon de 1857," *Musée Universel*, no. 14 (1857): 111.

43. "Un héros maintenant est composé de deux mille cinq cents hommes et s'appelle le vingt-quatrième de ligne ou la trente-deux-ième demi-brigade, et sur le champ de bataille, du haut du monticule où se tient le général en chef, la lorgnette à la main, il produit l'effet de petites raies rouges et bleues. La mort dirigée par des moyens scientifiques lui arrive de loin, anonyme comme lui, à travers des flocons de fumée." Gautier, "Le Siège de Sébastopol," 61.

44. "Des abattis d'arbres se tordent sur le sol comme des cadavres végétaux, mutilés, hachés, retournés, ébranché, réduits à l'état de squelettes par les volées de l'artillerie et de la mitraille. Boulets, obus, éclats de bombes, jonchent la terre émiettée.—Ce qui s'est dépensé de sang et d'héroïsme pour enlever cette butte blanchâtre, ce tas de gypse blafard, on n'y songe qu'en frémis-sant . . . L'intérieur d'un volcan en éruption fournirait une idée assez juste du fourneau de mine esquissé par M. Durand Brager; c'est un chaos de pierres, de roches, de mottes qui sautent, qui éclatent, qui volent en l'air parmi des fumées et des flammes." Gautier, "Siège de Sébastopol," 62. This is the portion of the article where Gautier examines the three paintings discussed earlier, *Craters, Face Droite du Bastion du Mat,* and *Lunette de Droite du Bastion Central.*

45. "Il a mis l'homme à l'échelle du paysage et le soldat en proportion avec la guerre." Gautier, "Siège de Sébastopol," 62.

46. "Sur le terrain même de la lutte, nous n'y trouvons guère de ruines visibles, si ce n'est quelques ruines végétales. L'obus a fait table rase. Au bout de quelques jours de pilon-nage, il n'y a plus rien. C'est sur ce 'rien' que le peintre moderne doit déployer l'action de ses combattants." Robert de la Sizeranne, *L'Art pendant la guerre, 1914–1918* (Paris: Hachette, 1919), 237.

47. Victor Fournel, "Mélanges, Salon de 1857," *Le Correspondant*, no. 41 (June 1857): 538.

48. "Un des points de l'exposition qui a particu-lièrement attire l'attention du public est celui où se trouvent réunis *les vingt panora-mas et tableaux* représentant les vues de Sébastopol, prises de tous les côtés, et tous les accidents de son siège." Etienne-Jean Delécluze, "Feuilleton du Journal des Débats, Exposition de 1857, première arti-cle," *Journal des débats politiques et littéraires,* 20 June 1857, 1.

49. Catherine Granger, *L'Empereur & les arts: La Liste civile de Napoléon III* (Paris: École des Chartes, 2005), 513–514. Napoléon paid Durand-Brager 20,000 francs from his *liste-civile;* there is no record of any official com-mission. For more on the Salle de Crimée, see Julia Thoma, "Panorama of War: The *Salle de Crimée* in Versailles," *Nineteenth-Century Art Worldwide* 15, no. 1 (Spring 2016).

50. See Katie Hornstein, "Episodes in Political Illusion: The Proliferation of War Imagery in France, 1804–1855" (PhD diss., University of Michigan, 2010), 289–290.

51. Gautier, "Le Siège de Sébastopol," 63. For more on the implications of this transfor-mation, see Nicholas Green, *The Spectacle of Nature: Landscape and Bourgeois Culture in Nineteenth-Century France* (Manchester, England: Manchester University Press, 1993).

52. This was the second attempt to take the Malakoff Tower; the first, failed attempt resulted in a devastating loss of British and, especially, French lives. Orlando Figes esti-mates that over 6,000 French soldiers died in the attack, as the result of a mistake in timing. See Figes, *Crimean War,* 366–372. The choice to surprise the Russians and take Malakoff went against the British strat-egy of destroying Russia's naval fleet and the town of Sebastopol with large guns. Geoffrey Wawro, *Warfare and Society in Europe, 1792–1914* (London: Routledge, 2000), 57–59.

53. Jean-Charles Langlois, *Correspondance inédit de Crimée,* 228. François Robichon has aptly characterized Yvon as Langlois's "bête noire." See Robichon, "Langlois, photogra-phie et panoramiste," in Robichon and Rouillé, *Jean-Charles Langlois,* 31.

54. For more on Yvon's *Malakoff* series, see Julia Thoma's comprehensive analysis in "The Final Spectacle: Military Painting under the Second Empire, 1855–1867" (PhD diss., Courtauld Institute of Art, 2013), 125–147. For the Salle de Crimée's installation strat-egy and political rationale, see Thoma, "Panorama of War."

55. Bois-Robert, "La Guerre au Salon de 1857," 105–112.

56. Edmond About, *Nos artistes au Salon de 1857* (Paris: Hachette, 1858), 341.

57. Ibid., 341.

58. "Le Salon de 1857," *L'Art du dix-neuvième siè-cle,* 25 July 1857, 121.

59. Charles Perrier, *L'Art français au Salon de 1857* (Paris: Michel Levy Frères, 1857), 167.

60. For more on Vernet's submission to the Salon of 1851, *The Siege of Rome,* see Hornstein, "Episodes in Political Illusion," 297.

61. Amédee Durande, *Joseph, Carle et Horace Vernet: Correspondance et biographies.* (Paris: J. Hetzel, 1864), 307. For more on the trial, see Michèle Hannoosh, "Théophile Silvestre's *Histoire des artistes vivants:* Art Criticism and Photography," *Art Bulletin* 88, no. 4 (2006). Vernet subsequently executed a painting of the capture of the Malakoff for the village of Autun, the birthplace of com-manding general Marie-Edme-Patrice-Maurice de MacMahon, who would later become the first president of the Third Republic. The painting was not exhibited at the Salon of 1857. For more on this painting and its photographic reproduction by Robert Jefferson Bingham, see Bann, *Parallel Lines,* 122–124. Vernet reportedly remarked to Yvon, "What do they take us for? Do they think that artists should be put in competi-tion with each other like cinnamon sellers?" See Henri Jouin, "Adolphe Yvon: Souvenirs du maître," *L'Artiste,* no. 4 (1893): 183. For more on Vernet's *Siege of Rome* (1852), see Hornstein, "Episodes in Political Illusion," 235–238; for Vernet's retrospective 1855 Exposition Universelle exhibition, see Julia Thoma, "Writing History: Vernet's Oeuvre under the Second Empire," in Harkett and Hornstein, *Horace Vernet,* 90–108.

62. As Steve Edwards has argued, ideas about industry structured the discourses that emerged around British photography in the 1850s and 1860s. See Edwards, *Making of English Photography.*

63. The political economist Mehrdad Vahabi has argued that "mass production came to Europe's small arms business between 1855 and 1870 as a direct byproduct of the Crimean War." See Vahabi, *The Political Economy of Destructive Power,* ed. Geoffrey M. Hodgson, New Horizons in Institutional and Evolutionary Economics (Northampton, Mass.: Edward Elgar, 2004), 212.

64. Henri Lefebvre, *The Production of Space,* trans. Donald Nicholson-Smith (Oxford: Blackwell, 1999), 276.

65. Edouard Houssaye, "Gravure du numéro:

Prise de la tour Malakoff," *L'Artiste*, 5 September 1858, 16. For more on this periodical, see Nancy Ann Roth, " 'L'Artiste' and 'L'Art pour L'Art': The New Cultural Journalism in the July Monarchy," *Art Journal* 48, no. 1 (Spring 1989): 35–39. See also *Moniteur des arts*, 22 January 1859, 94; and "Mouvement artistique," *Revue des beaux-arts* 10 (1859): 63.

66. "Dans des têtes moins grosses qu'une petite tête d'épingle, M. Marthe a su, non-seulement rappeler, mais encore conserver, la ressemblance des principaux personnages du tableau d'Yvon. . . . Cette petite gravure aura un succès énorme; son format facile, son prix très minime, et, au-dessus de tout cela, le talent avec lequel elle est traitée, lui garantissent une vogue durable." "Iconographie," *Journal des beaux-arts et de la littérature*, no. 9 (15 May 1862): 75.

67. An early practitioner of daguerreotypes, Richebourg took up the reproduction of works of art in late 1840s and photographed the Salons of 1857, 1861 and 1865. See Elizabeth Anne McCauley, *Industrial Madness: Commercial Photography in Paris, 1848–1871* (New Haven: Yale University Press, 1994), 282–286; and Dominique de Font-Réaulx, *Painting and Photography, 1839–1914*, trans. David Radziowicz (Paris: Flammarion, 2012), 95–96. As McCauley has demonstrated, photographic reproductions of works of art constituted 5.5 percent of all photographs entered into the *depôt légal* in 1853. By 1860 the figure had jumped 28.5 percent. As these statistics show, the trade in reproductions of works of art quickly assimilated itself to the nascent medium of photography. As Stephen Bann's scholarship has demonstrated, this by no means rendered established forms of reproduction, such as engraving and lithography, obsolete. See McCauley, *Industrial Madness*, 270. For more on the practice of fine reproductive lithography, see Bann, *Distinguished Images*, 121–167; for more on Bingham's career in photographic reproductions of art, see Bann, *Parallel Lines*, 118–125. Bann is chiefly concerned with the absence of critical expectations governing the judgment of photographic reproductions of art. He examines how one set emerged from the preexisting discourse of reproductive engraving. See also Laure Boyer, "Robert J. Bingham, photographe du monde de l'art sous le Second Empire," *Études photographiques*, no. 12 (November 2002): 26–47; and Chaud-de-Ton, "Salon de 1857, Lettres de Chaud-de-Ton," *Les Contemporains*, 14 July 1857, 3.

68. "Le Tableau de M. Yvon: Prise de Malakoff," *Musée des familles*, October 1857, 11.

69. Jacob Lewis has discovered that Nègre retouched portions of the photogravure plate, having contacted Yvon to ask permission to do so. See Jacob Lewis, "Charles Nègre: In Pursuit of the Photographic" (PhD diss., Northwestern University, 2012), 407–408. See also Françoise Heilbrun, *Charles Nègre, Photographe, 1820–1880* (Paris: Éditions de la Réunion des Musées Nationaux, 1980), 339. According to the photography journal *La Lumière*, Nègre's *Malakoff* "has already provided 1500 proofs of a very nice effect. . . . Printed with ordinary ink, these prints are moreover indelible." "Académie des Sciences: Séance du lundi 1er mars," *Cosmos*, 5 March 1858, 280.

70. Paul de Man conceives of allegory as a form of representation whereby meaning is constituted out of distant, indirect relationships. He states: "It remains necessary, if there is to be allegory, that the allegorical sign refer to another sign that precedes it. The meaning constituted in the allegorical sign can then consist only in the repetition of a previous sign with which it can never coincide, since it is of the essence of this previous sign to be pure anteriority. . . . Allegory designates primarily a distance in relation to its own origin." See de Man, "The Rhetoric of Temporality," in *Blindness and Insight: Essays in the Rhetoric of Contemporary Criticism* (Minneapolis: University of Minnesota Press, 1983), 207. Steve Edwards's work on English nineteenth-century photography and labor identifies "allegorical reading" as the methodological basis for his project of exploring how photography's discourses and practices were figured "in opposition to the workers' world." See Edwards, *Making of English Photography*, 14.

71. Susan Buck-Morss, *The Dialectics of Seeing* (Boston: MIT Press, 1989), 143.

CONCLUSION

1. For more on the politics of battle painting in the wake of the defeat, see François Robichon, "Representing the 1870–1871 War; or, The Impossible *Revanche*," in *Nationalism and French Visual Culture*, Studies in the History of Art 68 (New Haven: Yale University Press, 2005), 83–100. For more on the military painting during the Third Republic in general and the afterlife of de Neuville's *Last Cartridges* in particular, see Richard Thomson, *The Troubled Republic: Visual Culture and Social Debate in France, 1889–1900* (New Haven: Yale University Press, 2004).

2. For more on Ernest Meissonier, see Gotlieb, *Plight of Emulation*. See also François Robichon, *Alphonse de Neuville, 1835–1885* (Paris: Nicolas Chaudun, 2010); and Robichon, *Édouard Detaille: Un Siècle de gloire militaire* (Paris: Bernard Giovanangeli, 2007). For a more comprehensive and beautifully illustrated overview of military painting during the Third Republic, see Robichon, *L'Armée française vue par les peintres, 1870–1914* (Paris: Herscher, 1998); for the art of the Siege of Paris produced during the Franco-Prussian War, see Clayson, *Paris in Despair*.

3. The law of June 15, 1889, made military service compulsory for men and granted only a few exceptions to those with advanced university degrees.

4. For more on military painting during the Third Republic in general and the afterlife of de Neuville's *Last Cartridges* in particular, see Thomson, *Troubled Republic*, 189–197.

5. See Roger Martin, *La Peinture napoléonienne après l'Empire: Le Salon des artistes française de 1817 à 1914 et la vogue de la carte postale illustrée* (Paris: Éditions Historiques Teissèdre).

6. Henri Delaborde, "Horace Vernet: Ses Oeuvres et sa manière," *Revue des deux mondes* 44 (March 1863): 76; Henri Béraldi, *Les Graveurs du 19e siècle: Guide de l'amateur d'estampes modernes* (Paris: L. Conquet, 1892), 12:223. Stephen Bann, "Ingres in Reproduction," in *Fingering Ingres*, ed. Adrian Rifkin and Susan Siegfried (Oxford: Blackwell, 2001), 56–76. Bann has shown that burin engraving's value within the French academic tradition grew in importance during the nineteenth century. See Bann, *Parallel Lines*, 173. Vernet's nearly lifelong collaboration with Jean-Pierre-Marie Jazet, the prolific aquatint printmaker, suggests that the painter was more concerned with his work's rapid dissemination than with its aesthetic canonization through the rarefied medium of burin engraving. For Greenberg's comments, see his "Avantgarde and Kitsch" in *Art and Culture: Critical Essays* (Boston: Beacon, 1961), 3–20.

7. T. J. Clark, *Image of the People: Gustave Courbet and the 1848 Revolution* (New Haven: Yale University Press, 1999), 140.

8. Baudelaire ironically mocked the dissemination of reproductive Vernet prints in his *Salon of 1846*: "Tels sont les principes sévères qui conduisent dans la recherche du beau cet artiste éminemment national, dont les compositions décorent la chaumière du pauvre villageois et la mansarde du joyeux étudiant, le salon des maisons de tolérance

les plus misérables et les palais de nos rois." See Baudelaire, *Critique d'art*, 129.

9. Stuart Hall argued that the word *popular* had two overlapping meanings, neither of which was completely satisfactory. The first, less satisfactory definition is that of commercial culture broadly consumed. The second definition ("easier to live with") is the mores, customs, and folkways of "the people." See Hall, "Notes on Deconstructing 'the Popular,'" 446–449.

10. In a review of Stephen Bann's *Parallel Lines*, Abigail Solomon-Godeau called for historians to consider how "modernist conceptions of authenticity and singularity, value-laden distinctions between elite and mass culture, notions of aesthetic autonomy and artistic transcendence were shaped by an active dialectical process in which the industrialization of reproduction plays a significant role." See Solomon-Godeau, "Review Article," *Visual Resources: An International Journal of Documentation* 18, no. 3 (2002): 226.

11. Benjamin, "Work of Art," 39–42.

12. Charles Baudelaire, "Le Salon de 1846," in *Critique d'art*, 129–130; Jacques Rancière, *Dissensus: On Politics and Aesthetics* (London: Continuum, 2010), 126. Richard Taws has recently examined the cultural politics of the French Revolution through the production of ephemeral objects. See Taws, *The Politics of the Provisional: Art and Ephemera in Revolutionary France* (University Park: Pennsylvania State University Press, 2013).

Illustration Credits

The photographers and the sources of visual material other than the owners indicated in the captions are as follows. Every effort has been made to supply complete and correct credits; if there are errors or omissions, please contact Yale University Press so that corrections can be made in any subsequent edition.

Anne S. K. Brown Military Collection, Brown University Library: Figs. 56, 79

Images/Bridgeman Images: Fig. 59

© Christie's Gérard Blot/Jean Schormans: Fig. 26

© Fitzwilliam Museum, Cambridge/Art Resource, NY: Figs. 8, 78

Erich Lessing/Art Resource, NY: Figs. 6, 21–23, 27, 30, 74, 145

Piotr Ligier/Muzeum Narodowe w Warszawie: Fig. 45

© Patrick Müller/Centre des monuments nationaux: Fig. 61

Musée des Beaux-Arts de Caen, M. Seyve Photographe: Figs. 83–86

© Musée Carnavalet/Roger-Viollet: Fig. 89

Musée français de la Photographie/Conseil départemental de l'Essonne, Benoit Chain: Figs. 139, 140, 142, 143

© The Museum of Modern Art/Licensed by SCALA/Art Resource, NY: Fig. 128

© Nantes Métropole—Musée des Beaux-Arts de Nantes—Photo: T. Richard: Figs. 19, 20

© National Gallery, London/Art Resource, NY: Figs. 48–50

Snark/Art Resource, NY: Fig. 127

© RMN-Grand Palais/Art Resource, NY: Figs. 5, 25, 39, 44, 62, 72, 73, 101, 138

© RMN-Grand Palais/Art Resource, NY. Photo: D. Arnaudet: Fig. 81

© RMN-Grand Palais/Art Resource, NY. Photo: Daniel Arnaudet/Jean Schormans: Fig. 77, 115

© RMN-Grand Palais/Art Resource, NY Photo: Jean-Gilles Berizzi: Fig. 51

© RMN-Grand Palais/Art Resource, NY. Photo: Gérard Blot: Figs. 5,18, 36–38, 43, 60, 88, 92–94, 119, 123, 124, 130–132, 145

© RMN-Grand Palais/Art Resource, NY. Photo: Gérard Blot/Hervé Lewandowski: Figs. 98, 129, 133

© RMN-Grand Palais/Art Resource, NY. Photo: Christophe Fouin: Fig. 75

© RMN-Grand Palais/Art Resource, N. Photo: Thierry Le Mage: Fig. 30

© RMN-Grand Palais/Art Resource, NY. Photo: Jean-Marc Manaï. Figs. 39, 41

© RMN-Grand Palais/Art Resource, NY. Photo: Pierre Willi: Fig. 24

Scala/White Images/Art Resource, NY: Fig. 84

University of Washington Libraries, Special Collections: Fig. 35

By kind permission of the Trustees of the Wallace Collection, London/Art Resource, NY: Fig. 58, Yale University Art Gallery: Fig. 70

Index

visual economy, 4, 98, 175n4
Voyage dans la basse et haute Égypte (Denon), 41

Watteau, Jean-Antoine, 176n13
Wellington, Robert, 176n15
woodblock prints, 16, 81*f*, 96, 111, 123–125, 130–131,
133–134, 143, 161–163, 186n21
"The Work of Art in the Ages of Its Technological
Reproducibility" (Benjamin), 173
*Wounded French Soldiers Entering Paris after the
Battle of Montmirail,* (Delécluze), 46–47*f*

Yvon, Adolphe, 156–158, 160–165, 170, 174, 188n53,
188n61, 189n66
Yvon, Adolphe, works by: *The Capture of the
Malakoff Tower,* 158*f,* 161*f; The Malakoff
Courtine,* 160*f; The Malakoff Gorge,* 160*f*